THE OBJECT OF PERFORMANCE

THE OBJECT OF PERFORMANCE
The American Avant-Garde since 1970

Henry M. Sayre

 THE UNIVERSITY OF CHICAGO PRESS
Chicago and London

The University of Chicago Press, Chicago 60637
The University of Chicago Press, Ltd., London

© 1989 by The University of Chicago
All rights reserved. Published 1989
Paperback edition 1992
Printed in the United States of America

98 97 96 95 94 543

Library of Congress Cataloging-in-Publication Data

Sayre, Henry M., 1948–
 The object of performance : the American avant-garde since
1970 / Henry M. Sayre.
 p. cm.
 Includes index.
 1. Performance art—United States. 2. Avant-garde
(Aesthetics)—United States—History—20th century.
I. Title.
NX504.S29 1989
700'.973—dc19 88-27481
 CIP

ISBN 0-226-73557-5 (cloth)
ISBN 0-226-73558-3 (paperback)

This book is printed on acid-free paper.

CONTENTS

ILLUSTRATIONS

In memory of my sister
Ann Sayre Taggart

PREFACE

Who could explain it?
Who could have explained it?
"Only pluralism . . ." but we get
Far less for our money that way.
JOHN ASHBERY, "Litany"

Almost everyone is agreed about '70s art. It is diversified, split, factionalized. . . .
We are asked to contemplate a great plethora of possibilities in the list that must
now be used to draw a line around the art of the present: video; performance; body
art; conceptual art; photo-realism in painting and an associated hyper-realism in
sculpture; story art; monumental abstract sculpture (earthworks); and abstract
painting, characterized, now, not by rigor but by a willful eclecticism. . . . Both the
critics and practitioners have closed ranks around this "pluralism" of the 1970s. . . .
But is the absence of a collective style the token of a real difference? Or is there not
something else for which all these terms are possible manifestations? Are not all
these separate "individuals" in fact moving in lockstep, only to a rather different
drummer from the one called style?
ROSALIND KRAUSS, "Notes on the Index: Seventies Art in America"

This book is about the emergence, over the course of the last two decades,
of a distinct and definable avant-garde in American art and literature, one
which might be characterized or labeled as postmodern. This avant-garde
has organized itself in opposition to an apparently recalcitrant set of assump-
tions, shared by mainstream museums, galleries, magazines, publishers,
and funding agencies, about what constitutes a "work" of art. In short-
hand, these aesthetic assumptions, rejected by the postmodern avant-garde,
are often labeled "modernist" or "formalist," but they are perhaps best
thought of as the assumptions of modernism's formalist side, a modernism
that was defined and developed by Clement Greenberg from the late thirties
into the early sixties, subsequently modified by critics like Michael Fried
and Barbara Rose, and that held sway, especially in academic art historical
circles, well into the era examined in these pages. The avant-garde that is
the subject of this book can be said to trace its roots to a different modern-
ism (as David Antin, one of the subjects of this study, has put it—"From
the modernism you want, you get the postmodernism you deserve"), a
modernism that might be said to be founded in dada and futurism and that
is oriented, in one way or another, to performance, or at least performance-
oriented art forms.

The postmodern avant-garde has asserted its opposition to the dominant
brand of modernism—and its continued ascendancy in the art world at

large—by attempting to strip the idea of "modernism" itself of the consistency, univocality, and autonomy (in short, the consolation) of a period "style." It has done this both by "re-inventing," as it were, a neglected modernist heritage, and, more important, by offering an art of its own founded upon contingency, multiplicity, and polyvocality. Performance, which was (and remains) styleless, diverse, and conspicuously unprogammatic, has consistently proved one of the most readily available means for realizing this strategy of opposition. But its very diversity has led to an even greater confusion. It has generally been assumed that the stylistic "pluralism" of performance, and by extension the "pluralism" of all art since about 1970, is synonymous with postmodernism itself, that "pluralism" is the sine qua non of the postmodern condition. That is, formalist criticism has been quick to recognize, more or less correctly, that the contingency, multiplicity, and polyvocality of postmodern art constitutes a style in its own right and has proceeded to designate this style as, interchangeably, "pluralist" or "postmodern." The profusion of individual discourses within this postmodern "condition"—in painting alone we have had minimalism, conceptualism, neo-expressionism, neo-geo, graffiti, abstract illusionism, photorealism, "bad" painting, pattern and decoration, and so on—has remained, nevertheless, eminently amenable to a formalist approach, since no matter how pluralistic the scene as a whole has become, individual works have remained by and large stylistically coherent, formally integrated, and wholly autonomous. From this point of view, pluralism (and by extension postmodernism) has become confused with a kind of Me-Generation, do-your-own-thing, I'm-OK-you're-OK aesthetics, and the only grounds upon which one could make judgments of artistic value were, in fact, formalist ones—if the work held together, possessed its own intrinsic unity, then it had to be more or less all right. In his preface to an anthology of essays that was among the first to take on the question of postmodern art's oppositional status, *The Anti-Aesthetic*, published in 1983, Hal Foster warns against precisely such a conflation of "pluralism" and "postmodernism." For Foster, "pluralism" is a "quixotic notion that all positions in culture and politics are now open and equal. This apocalyptic belief that anything goes, that the 'end of ideology' is here, is simply the inverse of the fatalistic belief that nothing works, that we live under a 'total system' without hope of redress."[1] Even when individual works have mixed different styles within a single work—thereby intentionally dismissing, in an overtly antiformalist gesture, the idea of formal coherence, for example—they still indulge in an easygoing eclecticism. Jean-François Lyotard, the author of *The Postmodern Condition*, has complained about the "postmodern" tendency to mix various styles in the same work in the name of an avant-garde "pluralism"—a complaint he aims directly at so-called postmodernism in architecture. He writes: "Mixing neo- or hyper-realistic mo-

tifs with lyrically abstract or conceptual ones on a single surface is saying that everything is equal because everything is easy to consume. . . . [Such] eclecticism panders to the habits of magazine readers, to the needs of consumers of standard industrial imagery, to the sensibility of the supermarket shopper."[2] This is a brand of postmodernism, he says, which it is the responsibility of artists to question and avoid.

At the outset, then, I want to insist on one basic separation of terms: pluralism and postmodernism are not, despite popular usage, synonymous. "Pluralism" is the critical crutch of an outmoded and inadequate formalist aesthetics. In the following pages I have consistently tried to indicate how a formalist-pluralist methodology is stymied before the kinds of postmodern work I am interested in. I have, in addition, avoided using the word "pluralism" in this book, and I have instead employed the concept of "undecidability"—borrowed (loosely) from the work of French philosopher Jacques Derrida—to describe the condition of contingency, multiplicity, and polyvocality which dominates the postmodern scene. If pluralism can be defined as the many possible, but more or less equal, "solutions" which arise in answer to a particular aesthetic situation or crisis, undecidability is the condition of conflict and contradiction which presents no possible "solution" or resolution.

Furthermore, because postmodern avant-garde art self-consciously denies its own intrinsic unity and autonomy, most of the works of art I discuss in these pages—performance and performance-related art—cut across the traditional boundaries between media. The medium of avant-garde art is itself "undecidable," almost by definition interdisciplinary. Roland Barthes pointed out this state of affairs in the early seventies in an essay on Masson's "semiograms"—that is, his ideographic paintings. According to Barthes, Masson's semiograms offer up "a theory of the text which twenty years ago did not exist and which today constitutes the distinctive sign of the avant-garde." They are "proof that it is the *circulation* of [between] the 'arts' (or elsewhere: of the sciences) which produces movement: 'painting' here opens the way to 'literature,' for it seems to have postulated a new object ahead of itself, the Text, which decisively invalidates the separation of the 'arts.' "[3] One of the primary purposes of the following pages is to track this circulation.

But as wide-ranging as such circulation requires one to be—or perhaps because one must be so wide-ranging in order even to begin tracking the directions in which things have developed—there are many fine avant-garde artists whose names do not appear in these pages and whose work I value. There are probably many more whose work I might have discussed had I known it better. I have, furthermore, abstained from dealing with European work except where it seemed to impinge so forcefully upon the American situation—or at least my own understanding of it—that it was

impossible to ignore. In the end, I have not made any real effort to write an all-inclusive history of the contemporary avant-garde here. The following pages are, rather, an attempt to outline what I take to be the central directions and concerns of the American avant-garde as it has developed in recent years. If I have focused my attention on developments since 1970, I have nevertheless tried not to ignore important work done in this country before that year. Whenever it has seemed to me that earlier work required attention (the collaborations of John Cage, Robert Rauschenberg, and Merce Cunningham, for instance, or the innovations of the Judson Dance Theater), I have discussed it, sometimes at considerable length. The year 1970 *does* seem to me a convenient "starting point"—it marks the year, for instance, that "performance" first established itself as a distinct and definable medium in the feminist arts program run by Judy Chicago and Miriam Shapiro at Cal Arts in Los Angeles—but it is by no means more than a place to begin discussion. Many things led up to 1970, just as many things developed out of it, and I have tried to remain flexible in my approach to the period.

Finally, a word about the "style" of this book: I have attempted to strike a middle ground here between a more or less formal (though not formalist) academic criticism and a more personal, anecdotal approach to art. The former has seemed to me necessary in order to engage the best contemporary criticism. My reasons for the latter approach should become clear in the last chapter, which looks at contemporary criticism, particularly that of Roland Barthes, as a kind of performance in its own right. Perhaps it is enough to say, at this point, that I self-consciously chose to employ the idea of "undecidability" in connection with avant-garde art—as opposed to "indeterminacy," a word used almost interchangeably with "undecidability" by Marjorie Perloff, for instance, in her *Poetics of Indeterminacy: Rimbaud to Cage*—because it seemed to locate the question of the work's contingency, multiplicity, and polyvocality in the *audience* rather than in the work itself. As the avant-garde work of art denies its own autonomy, it implicates the audience in its workings. It demands a *personal* response. I have tried, therefore, to convey some measure of my own personal reaction to avant-garde art in these pages. If such an approach results in nothing else, I hope that readers will sense the fundamental contingency of my own sometimes bewildered wanderings through the avant-garde scene.

Without the support of the National Endowment for the Humanities, which both funded the initial stages of research for this project with a Summer Stipend in 1981 and subsequently encouraged its completion with a Fellowship for College Teachers in 1983–84, this book might never have been written. I am extremely grateful.

I also owe many thanks to the numerous institutions that gave me access to their collections and holdings, in particular both the Archive for New Poetry and the Center for Music Experiment at the University of California, San Diego, the video archive of the Brooklyn Academy of Music, the Video Data Bank at the Art Institute of Chicago, and the Long Beach Art Museum, whose collection of early California performance on videotape was especially useful to me. For eighteen months, beginning in 1983, the Institute of Contemporary Art in Boston ran a constantly changing, purposefully eclectic, and willfully unorganized exhibition series entitled *Currents*. Much of my thinking in this book developed in response to the installations, performance, photography, video, painting, and sculpture that I first saw in this exceptionally innovative program. I would also like to thank the many artists and galleries who patiently answered my questions, sought out reproductions, and otherwise let me interrupt them so that I might get on with my own project. Especially helpful were The Trisha Brown Corporation, Christo, Michael Heizer, Babette Mangolte, Bernard Marbot of the Département de Photographie at the Bibliothèque Nationale in Paris, Nicholas Nixon, Martha Rosler, Teresa Schmidtroth of Holly Solomon Gallery, Mary Ross Taylor of Through the Flower Corporation, Jane Weisbin of the Walker Art Center, Joel Peter Witkin, and, for their help in securing the cover illustration, Nan Graham and David Byrne.

I have many critical debts—evidenced throughout, I hope, in my citations—but allow me to thank Charles Altieri, Eleanor Antin, and Carolee Schneemann for the singular help each gave me. I owe even more to Marjorie Perloff and David Antin. Marjorie's mind sometimes moves in directions so analogous to mine that it is positively uncanny, but she is always at least one step ahead of me, and she has initiated many paths that I have simply followed. From the moment that I announced myself one summer day in 1981 in La Jolla, explaining that I was interested in oral poetics and performance theory, David has discussed almost every facet of this project with me. He has cajoled me about my errors, prompted me to think harder, critiqued my theoretical musings, and supported my every move. Very often he knew what I was trying to say before I said it. I most appreciate the fact that he seemingly believed all along that I would one day get it said. Finally, let me express my deepest appreciation to my wife, Laura Rice-Sayre, far and away my best and severest critic. She has read this manuscript at least as often as I, and she has patiently given me the time to write when her own important work was, I know, at least as pressing.

Many sections of this book were first presented as papers at various conferences and symposia. The audiences will I hope recognize how their questions moved me to revise my thinking. Early versions of the introduction and chapter 5 first appeared in the *Georgia Review* and *Contemporary*

Literature, respectively. A version of the section on Eleanor Antin in chapter 4 first appeared in *The Act*. I am grateful to the editors of these journals for permission to reprint this material here.

INTRODUCTION

The Object of Performance

One might ask what causes this pervading need to act out art which used to suffice itself on the page or the museum wall? What is this new presence, and how has it replaced the presence which poems and pictures silently proffered before? Has everything from politics to poetics become theatrical?

<small>MICHEL BENAMOU</small>

Today the only works which really count are those which are no longer works at all.

<small>TH. W. ADORNO[1]</small>

"A modernist would have to rewrite Pater's dictum that all art aspires to the condition of music," Susan Sontag announced in her series of essays *On Photography*. "Now all art aspires to the condition of photography."[2] In fact, one of the most important aesthetic developments of the seventies will probably turn out to be the art establishment's embracing of photography, epitomized by the popular success of Sontag's book itself. And at least part of the seventies' affair with photography is directly attributable to the medium's insistence on complicating—and accommodating—Pater's dictum. That is, Pater defined the art object as something we know only through "impressions, unstable, flickering, inconsistent, which burn and are extinguished with our consciousness of them." He was never interested in anything of "solidity," but only in "experience itself . . . that continual vanishing away, that strange, perpetual weaving and unweaving of ourselves."[3] For him, the art object was the mere token, the trace, of an aesthetic experience forever lost, a thing always announcing its own absence.

For Sontag, photography gives Pater's dictum the modernist turn. A photograph is, of course, an object in its own right, irrefutably present. To borrow Murray Krieger's phrase, it can be "plucked out of all discourse as its own closed system," just like any poem or painting.[4] From this sort of formalist perspective, aesthetic experience is never absent; it is always dynamically present before us, endlessly recoverable in the work of art itself. In order to justify itself as art, photography has consistently insisted that it be considered as just such an *immanent* object.[5] But what Sontag means to suggest, I think, is that the past decade's interest in photography can be traced to its double stance—its ability to be read in terms of *both* presence and absence. We experience photography as presence itself—as a formalist art object—and as a presence signifying the virtual absence of some a priori experience. I think it is fair to say, for instance, that even the tourist or family man photographs in order to capture the present—that is, with

more or less immanentist intentions—but he looks at photographs in the slide show or family album (both of which can be usefully described as the mnemonic devices of a new oral history) actually aware of that present's loss. "All photographs are *memento mori*," Sontag writes. "To take a photograph is to participate in another person's (or thing's) mortality, vulnerability, mutability. Precisely by slicing out this moment and freezing it, all photographs testify to time's relentless melt" (15).

What led the art world to read photography as the embodiment of such a dialectical play between presence and absence is, probably more than anything else, the way in which conceptual and performance art—that is, contemporary art's most antiformalist, experience-oriented forms—have come to rely on the medium as a mode of "presentation." By the late sixties it was clear to virtually everyone connected with the art world that the art object per se had become, arguably, dispensable. As early as 1966, Harold Rosenberg had titled a collection of essays on contemporary art *The Anxious Object*, and what the object was anxious about was its very survival. In 1968 Lucy Lippard's important and influential essay, "The Dematerialization of Art," announced the birth of conceptual art, in which "matter is denied." And by 1975, when Barbara Rose issued a new edition of her *American Art since 1900*, a work so universally used as a classroom text that it probably represented the consensus viewpoint, she was compelled to include a new chapter on the seventies, simply entitled "Beyond the Object."[6] As this development became more and more obvious during the last decade, it became increasingly clear as well that the museum—designed to house and display objects, after all—was as deeply in trouble as the object itself. What saved the museum, what in effect gave it access to objectless art, was the document, the record of the art event that survived the event. More often than not this document turned out to be a photograph.

I

The importance of the photographic document was probably first established by Jean Tinguely's famous *Homage to New York* (Fig. 1), the wonderful machine sculpture which destroyed itself in the sculpture garden of the Museum of Modern Art on March 16, 1960; the photographic record asserted itself most horribly in the documentation, exhibited at Kassel in 1972, of Rudolf Schwarzkogler's 1969 piece by piece amputation of his own penis. By the early seventies, at any rate, most self-respecting modern collections included some kind of performance piece, which often meant only that it "owned" a conceptual idea or, more materially, the rights to photographs documenting an event. What has surprised even the museum, however, is the power these documents seem to possess, not only in the public imagination but over the museum itself, which has been metamorphosed

FIGURE 1. Jean Tinguely, *Homage to New York*, 1960. Photo: © David Gahr 1960.

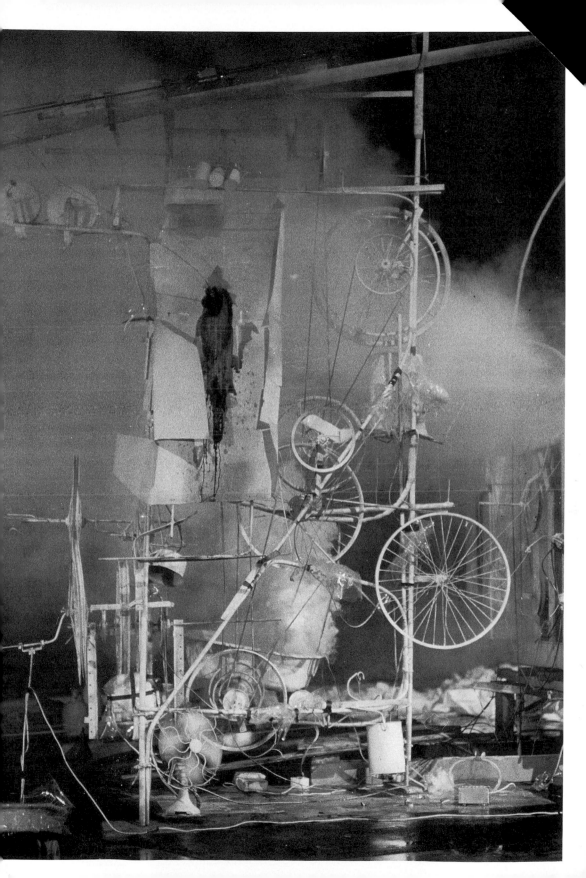

by them into something resembling an archeological depository. The intrusion of the photographic document into the painting and sculpture collections of the major museums has helped, in fact, to make explicit a transformation that has been going on at least since abstract expressionism. In a gesture that can be seen as the impetus for the aesthetic developments under discussion here, the abstract expressionists recognized that the action painting itself was the mere record of the series of moves that was the action of painting. The "work" as activity was privileged in this way over the "work" as product. A museum might well have purchased a Pollock, but it could never purchase the action of Pollock painting—the event itself, the real work. When we begin to approach paintings in an art museum, especially in a modern art museum, in the same way that we approach, say, the arms and armor collection of the Metropolitan Museum of Art—that is, when we approach them as relics—we are on the edge of admitting a profound shift in our collective attitude about the nature of art. Art is no longer that thing in which full-fledged aesthetic experience is held perpetually present; art no longer transcends history; instead, it admits its historicity, its implication in time.

But I said that we are on the *edge* of admitting this transformation because the aesthetics of presence has a final line of defense—the audience. The audience has the privilege of ignoring the artwork's contingent status as a kind of documentary evidence; in fact, the audience knows first that it *is experiencing* art (it has come to the museum in order to do so), and the real presence of the one experience (the audience's) masks—and paradoxically depends on—the absence of the other (the artist's). Even the documentary status of the photograph can be altered by the audience. When it approaches, for instance, the photographs of Tinguely's *Homage* or Vito Acconci's 1971 *Seedbed* (Fig. 2)—the famous image of a solitary woman, hands in jacket pockets, walking in the Sonnabend Gallery on the ramp beneath which Acconci was purportedly masturbating—it shares precisely the same direct, ocular vision which the photographer, eye pressed to viewfinder, witnessed at the scene. What the photographer knows for having seen, the audience knows. His presence becomes their own. They contemplate with his eyes. And the museum, of course, does everything in its power to foster the audience's sense of presence by creating exhibition spaces that bring antiquity into the present. Thomas Hoving, when director of the Metropolitan Museum of Art, was something of a master at this. From his first exhibition, the tellingly titled 1966 In the Presence of Kings, which drew together most of the objects in the museum associated with royalty in order to achieve a strikingly regal atmosphere, to the new Lehman wing of the Museum, which essentially replicates Lehman's home and which allows one not merely to experience art but to experience what it must have felt like to be Lehman and *own* it, the metamorphosis that the

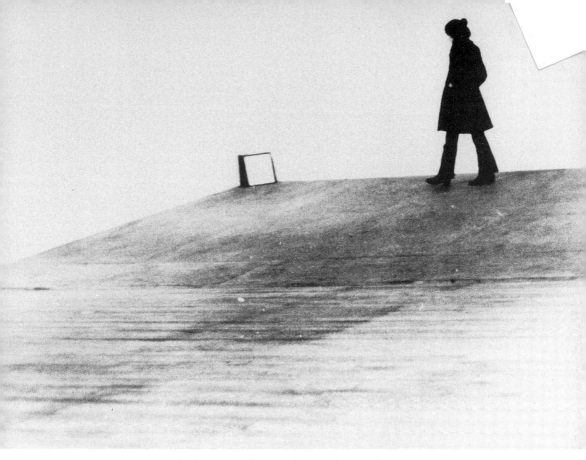

FIGURE 2. Vito Acconci, *Seedbed*, 1972. Installation at the Sonnabend Gallery, New York, January 1972. Courtesy Sonnabend Gallery. Photo: Kathy Dillon.

document/object wreaked upon the museum, transforming it into a mausoleum, is countered through an audience in whom the dead past is seemingly "brought back to life."

Granted this audience is manipulated, that its experience of presence is really the experience of what Sontag has called a kind of "pseudo-presence" (16), nevertheless it seems clear to me that by the seventies the site of presence in art had shifted from art's object to art's audience, from the textual or plastic to the experiential. *Artforum* magazine, which obviously considers itself to be closely attuned to currents in contemporary art, inaugurated the eighties with a questionnaire asking a number of artists to consider the proposition that seventies art was "characterized more by a change in attitude toward the audience than by a change in actual forms, or even content." Specifically, the magazine's editors asked, "What shifts of emphasis, esthetic or otherwise, have impermanence and specificity of project and performance art brought about?"[7] The range of response was predictably broad, but it seems to me that a kind of consensus could be discerned on three fundamental points, best articulated in the forum by Vito Acconci, Scott Burton, and Eve Sonneman:

ACCONCI: [By choosing to] use the gallery as the place where the "art" actually occurred . . . I was shifting my concentration from "art-doing" to "art-experiencing": an artwork would be done specifically *for* a gallery—in other words, for a peopled space, for a space in which there were gallery-goers. The gallery, then, could be thought of as a community meeting-place, a place where a community could be formed, where a community could be called to order, called to a particular purpose. . . .

BURTON: A new kind of relationship [with the audience] seems to be beginning to evolve, a deep shift beginning in our needs: toward a visual culture of design or applied art. The new descriptive phrases for the culture haven't been coined yet, but it might be called public art. Not because it is necessarily located in public places, but because the content is more than the private history of the maker. It might be called popular art, not because it is a mass art, but because it is not unpopular art, not a "difficult" or "critical" art. Visual art is moving away from the hermetic, the hieratic, the self-directed, toward more civic, more outer-oriented, less self-important relations with social history. . . .

SONNEMAN: The audience was given a multiplicity of choices in the final works: to observe meaning in gestures, motion, perceptual changes from black and white to color, in invented time sequences between the frames. The audience could build its own syntax of esthetic pleasure or intellectual work. It was open.

The shift in the accepted site of presence implicit in these responses, from object to audience, has had profound effects on art generally. It has opened art to the plurality of interpretation. It has had the effect, more and more pronounced as the seventies progressed, of valorizing "popular" art forms— such as photography itself—over "high" art, or at least blurring the distinction between high and low. And it has given rise to a great deal of *politically* oriented art*work*—that is, artwork explicitly addressed to the community as a social institution.

As Michael Fried has pointed out in perhaps the earliest essay to examine the aesthetic assumptions of performance art, his 1967 "Art and Object-hood," one of the distinguishing, and to him disturbing, characteristics of performance art is its *ideological* thrust. If art gives priority to the audience—the masses, as it were—then art must also divest itself of its more elitist assumptions, which tend to be defined in terms of the academy—that is, traditional literary and art criticism—most especially the academy's privileging of the art object as a formal, autonomous, and authoritative entity. Fried, for instance, is vehement in his attack on minimal art—"*Art degenerates as it approaches the condition of theatre*" (his emphasis)— because he is a formalist who recognizes the inappropriateness of a formal-ist approach to an art that "*depends on the beholder, is incomplete* without him . . . *has* been waiting for him . . . refuses, obstinately, to let him alone—which is to say, it refuses to stop confronting him, distancing him, isolating him." For Fried it is neither the condition of music nor the con-dition of photography—certainly not theater—to which art ought to as-pire, but "to the condition of painting and sculpture—the condition, that

is, of existing in, indeed of secreting or constituting a continuous and per-petual present."[8] This is a profoundly immanentist definition of the con-dition of art, and it implicitly posits that art, since it is "out of history," is by definition free of ideology—or ought to be.

II

By dismissing the immanentist position of Fried and acknowledging implic-itly or explicitly its theatrical or performative bias, the work of the Ameri-can avant-garde since 1970 has consistently engaged history. Fried's very articulation of the problem violates the aesthetic position of this avant-garde, and reveals the depth of his misunderstanding. When he says that minimal art is "incomplete" without the audience, he assumes, I think, that it *is*, somehow, complete when and if the audience is engaged. But the art of the avant-garde is never "complete." Determined, as it is, by the local and topical, the events of history itself, and by such things as the forms and operations of mechanical reproduction, from photography to television, that record this history, the art of the avant-garde is always in process, always engaged. It is, furthermore, purposefully *undecidable*. Its meanings are explosive, ricocheting and fragmenting throughout its audience. The work becomes a situation, full of suggestive potentialities, rather than a self-contained whole, determined and final.

It is of course true that a great deal of art continues to be produced that is intended by and large to satisfy and reward the approach championed by Fried, art that would preserve the autonomy of the work of art and a "dis-ciplined" criticism of it. Anyone who doubts this need only consider the exhibition organized by Barbara Rose at the Whitney in the fall of 1979, American Painting: The Eighties. In the catalogue Rose writes:

The serious painters of the eighties are an extremely heterogeneous group—some abstract, some representational. But they are united on a sufficient number of criti-cal issues that it is possible to isolate them as a group. They are, in the first place, dedicated to the preservation of painting as a transcendental high art, and an art of universal as opposed to local or topical significance. Their aesthetic, which synthe-sizes tactile with optical qualities, defines itself in conscious opposition to photog-raphy and all forms of mechancial reproduction which seek to deprive the art work of its unique "aura." It is, in fact, the enhancement of this aura, through a variety of means, that painting now self-consciously intends—either by emphasizing the artist's hand, or by creating highly individual images that cannot be confused either with reality itself or with one another.[9]

This is as precise a statement of formalist/immanentist aesthetics as one could hope for. Deprive art of everything with which Rose wishes to invest it—autonomy, uniqueness, the cult of individuality and "original" artistic "vision," the dream of universality and transcendence—and one has a rea-sonable definition of what avant-garde art seeks to be.

It is very easy to identify Rose's purist and immanentist aesthetic bias with *modernism* itself, and thus to label the work of the avant-garde, which is oppositional to Rose's brand of modernism, as *postmodern*. But this would be, at least in these limited terms, something of a mistake. Modernism has always had an "other" side. One can read cubism, for instance, as a formalist project—an attempt to establish the autonomy of the painterly surface, to free it from a slavish relation to the world—or, in collage, as something altogether antagonistic to the formalist project, as an opening to the world of things, an admission into the heretofore "pure" world of painting of local and topical "events" (the symbolic force, after all, of the newspaper headline in a cubist canvas). For Clement Greenberg, the "excitement" in the painting of Picasso, Braque, Mondrian, and so on "seems to lie most of all in its pure preoccupation with the invention and arrangement of spaces, surfaces, shapes, colors, etc., to the exclusion of whatever else is not necessarily implicated in these factors."[10] On the other hand, as William Seitz put it in the catalogue to his ground-breaking and visionary exhibition of 1961 The Art of Assemblage, the introduction of collage materials into the canvas "violated the separateness of the work of art, and threatened to obliterate the aesthetic distance between it and the spectator. . . . It must be conceded that, by the introduction of a bit of oil cloth and a length of rope [in Picasso's *Still Life with Chair Caning*], the sacrosanctness of the oil medium suffered a blow that was as deadly as it was deft."[11] These two versions of cubism—the "pure preoccupation" with form and an opening to the world at large—are not necessarily mutually exclusive. They represent, in fact, the dialectical poles between which cubism, as a style, always moved.

Yet it is one of the curiosities of American art historical criticism that Greenberg and Seitz, publishing their essays (in book form, at least) in the same year, should feel so differently. It is a further curiosity that, today, it is Greenberg's purist formalism which, in art historical circles, we too quickly associate with the idea of modernism itself.[12] That is, Greenberg's distinction between the avant-garde and kitsch has held sway. The authentic avant-garde, for Greenberg, was always properly formalist. All else was "kitsch": "popular, commercial art and literature with their chromotypes, magazine covers, illustrations, ads, tap dancing, Hollywood movies, etc., etc."[13]—in short, the very fabric of what was, in 1961, the average Rauschenberg "combine painting." Writing in 1982, in a response to T. J. Clark's critique of Greenbergian modernism, Michael Fried would still insist on seeing the "endeavors" of such artists as Rauschenberg and Acconci as "trivial" since their work continues a "popular" avant-garde initiated by Duchamp and dada and distinguished by the "easiness" of its work and its desire to "evade the issue of quality altogether."[14]

In large part as a result of this level of rhetoric—which verges on name-

calling and which defines a tradition extending from Picasso and Duchamp
through dada and surrealism to Rivers, Rauschenberg, and the entire pop-
generation as essentially valueless—the second, antiformalist modernism,
has always found itself in an *oppositional* position. It has stood against the
purist modernism championed by the likes of Greenberg, Fried, and Rose,
and it has, over the last several decades, become associated with *postmod-
ernism* proper. Says Fried in 1982: "In my 'Art and Objecthood' I argue
that the best contemporary painting and sculpture seek an ideal of self-
sufficiency and what I call 'presentness' whereas much seemingly advanced
recent work is essentially *theatrical*, depending for its effects of 'presence'
on the staging, the conspicuous manipulation, of its relation to an audi-
ence. (In the years since 'Art and Objecthood' was written, the theatrical
has assumed a host of new guises and has acquired a new name: post-
modernism.)"[15] In his catalogue for an exhibition of contemporary sculp-
ture by Vito Acconci, Siah Armajani, Alice Aycock, Lauren Ewing, Robert
Morris, and Dennis Oppenheim at the Hirshhorn Museum, Howard Fox
has put it this way: "Theatricality may be considered that propensity in the
visual arts for a work to reveal itself within the mind of the beholder as
something other than what it is known empirically to be. This is precisely
antithetical to the Modern ideal of the wholly manifest, self-sufficient ob-
ject; and theatricality may be the single most pervasive property of post-
Modern art."[16]

The "other," second modernism—a modernism which is apparently
closely aligned to what we have come to call the postmodern—contains,
from the outset, this distinct performative and theatrical mode. In the third
chapter of this book, I outline the influence of Rauschenberg, John Cage,
and Merce Cunningham on the avant-garde of the seventies, but the per-
formance model they embody—including its collaborative and intermedia
aspects—can be traced back to futurist and dada performance, to the Bau-
haus (which, in many ways, was the model for the Black Mountain College
experience out of which these artists emerged), and to the entire surrealist
enterprise. As Fried suggests, the objects of such a performative or theat-
rical production, from *Parade* to the Happening, are not immanent. They
are, rather, contingent, fragmentary, even disembodied. As such, they
evoke, rather than an aura of full presence, the continual vanishing of the
photograph. They announce their own *absence*. Furthermore, this second
modernism represents the admission—or the intrusion—into the "realm"
of high art of what Seitz, in *The Art of Assemblage*, identified as the *ver-
nacular*. Harking back to the poet William Carlos Williams's desire to
admit, into the realm of poetry, an authentic "American idiom," the ver-
nacular includes, for Seitz, such things as "beat Zen and hot rods, mescalin
experiences and faded flowers, photographic bumps and grinds, the *pou-
belle* (i.e., trash can), juke boxes, and hydrogen explosions."[17]

Seitz's vernacular is, of course, Greenberg's "kitsch," and it is the intrusion of the vernacular into the discourses of modern art—into the realm of aesthetics—that has most offended formalist sensibilities. The vernacular raises questions of decorum almost immediately, for it seems to undermine the aura of the work of art. Not only does collage composition draw upon the widest possible range of materials, admitting "mass culture" into the hallowed precincts of "art," substituting the "low" for the "high," imitation wood-grained wallpaper for the painted surface, but "high art" is increasingly susceptible to a kind of "mass" co-optation. As Thomas Crow has put it, in an analysis worth quoting at some length:

Functionally . . . the avant-garde serves as a kind of research and development arm of the culture industry. . . . The work of Toulouse-Lautrec as a designer and illustrator can be taken as emblematic. . . . His cultivated irony, perversity and compositional extremism continued previously established kinds of avant-garde attention to low-life spectacle. In his commercial work, however, certain patented modernist devices became the preferred vocabulary of an emerging sector of the entertainment industry. . . . In the twentieth century, this process of mass-cultural recuperation has operated on an ever-increasing scale. The Cubist vision of sensory flux and isolation in the city became in Art Deco a portable vocabulary for a whole modern 'look' in fashion and design. . . . The case of Surrealism is perhaps the most notorious instance of this process. Breton and his companions had discovered in the sedimentary layers of earlier capitalist forms of life in Paris something like the material unconscious of the city, the residue of earlier repressions. But in retrieving marginal forms of consumption, in making the latent text visible, they provided modern advertising with one of its most powerful visual tools—that now familiar terrain in which commodities behave autonomously and create an alluring dreamscape of their own. [18]

Such co-optation is no less true for surrealism, cubism, and Toulouse-Lautrec than it is for any number of contemporary "practices." The history of graffiti art in the early eighties is a case in point.

Probably no other form of contemporary painting has possessed more clearly vernacular roots than graffiti art. Most of its practitioners—with the exception of Keith Haring—were uneducated, self-trained "writers" whose "marks" or "tags" on public or private property announced a kind of territorialism that originated out of the turf disputes among the street gangs of Brooklyn, the Bronx, and Manhattan. Graffiti art was, at least initially, a supremely contingent form of painting: "The work has to be done quickly," an artist from the upper West Side, Futura 2000, explained to Suzi Gablik; "Its finest hour may be when it's just rolling by. I see the paintings more as a documentation of what goes on in the trains, a memento [mori?]. Obviously, nobody can have an actual train, although in a few years' time some museum will probably buy one." [19] Or, as Haring explains: "Since the work only exists for a fleeting moment, it can and probably will be erased. The moment it is seen may be all that is left of

it."[20] Graffiti art was, furthermore, extremely self-conscious about its an-
tiformalist intentions. When Fashion Moda, the first New York gallery (ac-
tually it was in the South Bronx) to exhibit graffiti, opened its Events show
at the New Museum in 1980, Stefan Eins, one of the gallery's founders
dubbed the show "The Death of Modern Art"—"Modern art, especially
abstract, is a dead-end street." The show included not only graffiti works
but, among other things, an installation by Candace Hill-Montgomery
which incorporated a pot of cooking chitlins. "Now that's *real*," Marc Brasz,
another Fashion Moda artist explained, "like living in a tenement, dealing
with your neighbors. Not like abstract art, which leads to reduction. After
you've painted a white dot on an all-white canvas, where do you go from
there?"[21]

Through the first half of the eighties graffiti could more and more be
seen throughout New York, off the streets, out of the subways, and in
the galleries. With astonishing rapidity, the graffiti artists dropped their
anonymous "tags" and assumed "real" identities and personalities. Jean-
Michel Basquiat, for example, had installed work under the "tag" of SAMO
in the famous Times Square Show of 1980, but by the summer of 1981,
when Diego Cortez organized the massive New York/New Wave show at
P.S. 1, he had "come out" as "Basquiat." One-person exhibits first at the
Fun Gallery, November 4–30—soon followed and made him an instant
celebrity. Spurred on especially by corporate buyers—from IBM, Philip
Morris, Citibank, and Chase Manhattan—prices for his work rose at aston-
ishing rates. His work was chosen for inclusion in the 1982 Documenta 7
exhibition in Kassel, and by 1984, Mary Boone had brought him up to
Soho, lavishing a catalogue on him for his one-person show in March of
1985. Such success—the attractiveness of his work—can be attributed, I
think, to the sense, which seems to be shared if not universally then at
every level of the art establishment, that graffiti art was, in the early eigh-
ties, somehow more genuinely expressive, more *authentic*, than uptown
painting. This, for instance, is the way Robert Farris Thompson put it in
the catalogue essay which Mary Boone commissioned for Basquiat's March
1985 exhibition: "He will force a new criticism upon us. He will bring into
being a tough-minded and multilingual creole discourse on form and mean-
ing to New York today, not only as a center of world art but also as a unique
gathering place of black Puerto Ricans, Haitians, Dominicans, Jamaicans,
Columbians, and Brazilians, defining a not so secret African city."[22] Bas-
quiat, for Thompson, represents the visual equivalent of Candace Hill-
Montgomery's pot of chitlins—"Now that's *real*."

It is important to remember that this work—and much else like it (what
air of authenticity did Haring, a white, middle-class art school product, gain
by virtue of his numerous arrests in the subway stations?)—depends upon
our recognition of it as a genuine vernacular expression. For the art world,

graffiti represented a cross between Grandma Moses—the authenticity of the "folk" tradition—and street-smart, Third World exoticism. Furthermore, it grew out of a curatorial taste for documentation. That is, the Events show at the New Museum, The Times Square Show, and New York/New Wave were all more interested in documenting what might be called the "visual culture" of their place and time than they were in presenting art for art's sake. These exhibitions were intended, as Diego Cortez put it, to present "a sociology of the scene."[23]

But at least as important was the art critical and historical context from which this painting emerged. As the eighties opened, it was evident that painting, as an institution, was in very great trouble indeed. Barbara Rose's exhibition American Painting: The Eighties had been, for most, a convincing demonstration of the vacuity of modernist formalism. Wrote Thomas Lawson, in an article tellingly titled "Last Exit: Painting": "Painter after painter included there had done his best or her best to reinvest the basic tenets of modernist painting with some spark of life, while staying firmly within the safe bounds of dogma. The result was predictably depressing, a funereal procession of tired clichés paraded as if still fresh; a corpse made up to look forever young."[24] Graffiti seemed, in the context of contemporary critical feeling about the state of painting, aggressively *alive*. And yet, as it became quickly absorbed into the mainstream—moving, as it did, from Fun to Mary Boone—even the "authentic" art of the East Village quickly became compromised. In his *Theory of the Avant-Garde*, Peter Bürger has argued that, after dada, no legitimate avant-garde has ever been able to survive because "the social institution that is art proved resistant to the avant-gardiste attack."[25] This has happened because, despite "the consciousness artists have of their activity"—despite, that is, the artists' intention to overturn or undermine the commodity status of art and its susceptibility to the thoroughly bourgeois tastes of mass culture—their works inevitably become, merely, "products . . . artistic manifestations that, despite their producers' intentions, take on the character of work" (58). By "work" Bürger means what I have called the *immanent* object—the autonomous, rounded, and organic whole that seeks to unify and universalize experience and transcend the temporal dimension. His feeling is that the material manifestations of the neo-avant-garde have been and continue to be reinvested by the art market with the characteristics of an art of immanence; thus even the found object, which "is totally unlike the result of an individual production process" since it is the result of a "chance" find, "loses its character as antiart and becomes, in the museum, an autonomous work among others" (57).

It is the argument of this book that a large body of work has been produced, in the last two decades, which has not lost its avant-garde status, not given itself over to the market and to bourgeois taste, or at least not mean-

ingfully. But this work has not, by and large, been painting. I think, in the
end, I agree with Joseph Kosuth's famous conceptualist dictum: "Being an
artist means questioning the nature of art. If you make paintings, you are
already accepting (not questioning) the nature of art."[26] On the other hand,
performance and performance-oriented genres could be defined as artistic
strategies conceived—like conceptual art itself—in order to defeat, or at
least mitigate, the exploitation of their material manifestations. In an im-
portant essay written for *Art in America* in April 1982, Douglas Davis
began to define the contemporary American avant-garde in these terms:

1. Against great odds—the opposition of nearly all the major critics in the
mainstream mediums and the indifference of most (if not all) major American
museums—a few artists did establish several non-traditional genres as legitimate
esthetic activities in the '60s and '70s—among them the use of the remote landscape
as a site for sculpture, language and performance as working modalities in visual
art, videotape (and broadcasting) as private (not public) tools.
2. During a period when the traditional easel painting soared in value, enriching
some dealers, collectors and artists beyond any comparable period in history, these
non-traditional genres became accepted as valid areas for collecting, mostly by pub-
lic museums committed to pluralist philosophies, at decidedly modest (if gently
rising) prices.[27]

These nontraditional genres are the subject of this book. Though painting
has seemed to be, especially in the eighties, the dominant art mode of the
era—and though, at its best, it has maintained a certain recourse to what I
see as the virtues of performance and performance-oriented genres—these
"other" genres are what I mean by the double entendre of my title. These
are the "objects" of performance, and their "object"—or purpose or end
is fundamentally different, as I see it, from the ends generally pursued by
painting.

III

As a medium, performance was initially intensely political in orientation.
In Northern California it emerged in connection with the 1967 San Fran-
cisco Be-Ins in Golden Gate Park, at the Peace March of that same year,
and during the 1969 People's Park demonstrations in Berkeley; in the
southern part of the state, it received its greatest impetus from the feminist
movement, particularly from Judy Chicago's Feminist Art Program, orga-
nized in 1970–71 at Fresno State and then again a year later at Cal Arts in
Los Angeles, a move that culminated in the formation of the renowned
feminist Woman's Building.[28]

In New York, performance had been an integral part of the art scene
since Allan Kaprow's 1959 *18 Happenings in 6 Parts*, the organization of
the Fluxus group in 1961, and the important interdisciplinary dance events
initiated at Judson Church in 1962. But, as in California, it was the political

atmosphere of the late sixties that served to make performance a recognizable art form. New York artists first organized against the Vietnam War in 1967 for an Angry Arts Festival that featured a Bad Humor Poets' Truck manned by a band of self-proclaimed "pinko beatnik poets," who stationed the truck at various spots around the city in order to "harangue the populace with plays, poems, sights [a 24-foot caricature of LBJ was attached to the truck by painter Allen D'Arcangelo], songs and the ubiquitous leaflet."[29] Performance was quickly hit upon as one of the better strategies for making art in such overtly politicized times. The Art Workers' Coalition was organized as a kind of permanent Angry Arts early in 1969 in order to take on the Museum of Modern Art, the emblem for most practicing artists of the monolithic "Art System." The museum was particularly susceptible to attack, Lucy Lippard wrote, because of its "rank in the world, its Rockefeller-studded Board of Trustees with all the attendant political and economic sins attached to such a group, its propagation of the star system and consequent dependence on galleries and collectors, its maintenance of a safe, blue-chip collection, and, particularly, its lack of contact with the art community and recent art."[30] For the avant-garde, the art establishment and the larger establishment were demonstrably one and the same, and both were to be opposed for the most urgent political reasons. In a speech at the open hearing which led to the founding of the Art Workers' Coalition, art critic and editor Gregory Battcock put it this way:

The trustees of the museums direct NBC and CBS, *The New York Times*, and the Associated Press, and that greatest cultural travesty of modern times—the Lincoln Center. They own A.T.& T., Ford, General Motors, the great multi-billion dollar foundations, Columbia University, Alcoa, Minnesota Mining, United Fruit, and AMK, besides sitting on the boards of each other's museums. The implications of these facts are enormous. Do you realize that it is those art-loving, culturally committed trustees of the Metropolitan and Modern museums who are waging the war in Vietnam?[31]

The coalition eventually issued a set of demands to the Museum of Modern Art, most of which were ignored. It managed to close the Modern, the Whitney, and the Jewish museums on the occasion of the first Vietnam Moratorium Day (October 15, 1969), but could only establish a picket line around both the Metropolitan and the Guggenheim since they refused to close. In short, the coalition had little effect on the system. But it did alert a large number of New York artists to the commodity status of their art, or rather to the horrifying possibility (horrifying especially in the context of the ongoing war) that the investment consumer, often incorporated, was metamorphosing the artist's aesthetic object into the marketplace's commodity. The strategy most often offered as a counter to this metamorphosis was, of course, to make art which was objectless, art which was conceived as uncollectable and unbuyable because intangible. In these terms, art be-

came a useful instrument of change, insofar as its absenting itself as an object undermined the economic and aesthetic norms of the art establishment.

But objectless art—no matter whether it remained purely conceptual or managed to manifest itself as performance [32]—has proved itself analogous to Borges's famous *hrönir* of Tlon, the accidental but apparently inevitable products of mental activity undertaken as pure conceptual play. Harold Szeeman, one of Europe's most sensitive critics of conceptual art, understood as early as in his 1969 survey at the Berne Kunsthalle, entitled When Attitudes Become Form, that the term "conceptualism" was a misnomer that tended to render the very material products of conceptual practice insignificant, when in fact the concept's apparently inevitable material manifestation was part of its interest. This was one of the points of the Szeeman-organized Documenta 5 exhibition in Kassel in 1972, the exhibition that unveiled the photographs of Rudolf Schwarzkogler's "amputation piece." [33] The point is, as Lucy Lippard would come to admit: "[Many], like myself, had exaggerated illusions about the ability of a 'dematerialization of the art object' to subvert the commodity status and political uses to which successful American art had been subjected." It became obvious to Lippard, and many others, that "temporary, cheap, invisible, or reproducible art has made little difference in the way art and artist are economically and ideologically exploited." [34]

The problems are probably clearest in the new oral poetry movement in literature. Like conceptual and performance art, the new oral poetry was a reaction against a formalist and academic criticism which overvalued the poem as an object in its own right, as a closed system which is wholly, steadily, and permanently before us. It has, of course, become increasingly clear to American poets, especially as they have become more and more familiar with post-Saussurian linguistics and the New French Criticism, that the sanctity of the written text—the very possibility of its *possessing* any final signification—is at least questionable. Faced with the specter of meaning thus continually absenting itself, the tendency has been to valorize, instead of the text, the experience of the text's performance. In the new oral poetry, meaningful signification is, then, relocated in the vernacular moment, the voiced utterance—the supposition is that the written text is inherently removed from meaning because it is the mere record of the moment of primary signification in the speech act. It is nevertheless true that in this scheme experiential presence merely supplants textual presence, and oral poetry falls victim to the same belief in the simultaneity of sound and sense which Plato posits in his *Phaedrus* and which underlies Saussurian linguistics, the notion of *s'entendre parler* which Derrida so convincingly deconstructs in *Of Grammatology*. [35] The work of many oral poets—in fact the work of almost any poet who can be placed in the Williams/Olson tradition which conceives of the poem as a "field of action" whose unit of

measure is the "breath" (poets like Duncan, Creeley, and Levertov)—is susceptible to the same deconstruction to which Derrida submits Saussure.

Take, for example, Allen Ginsberg's discussion of "Words and Consciousness" in his 1974 *Allen Verbatim*: "A languaged description of an event is not identical with an event, is an abstraction of the event. . . . However, if someone wanted to, they could redefine the whole use of language and say there's another use of it which is purely expressive, subjectively expressive, where the breath exhaled is a conscious articulation of feeling . . . [and] therefore spoken breath, 'Ah-om' or 'Oh' or 'Uuuh,' is identical with the event that it describes, because it is the event."[36] This idea explains the title of Ginsberg's 1977 *Mind Breaths*: the poem *is* a mind breath, an utterance which he describes in the title poem as "the vast breath of Consciousness."[37] Throughout the seventies, Ginsberg's books—the printed texts—have been, by his own definition, abstractions of the event of poetry itself. They cannot be identical with true poetry because they are not spoken. And this stance is underscored by Ginsberg's including in his latest work musical scores for the performance of many of the song/poems, a habit he began in his *First Blues: Rags, Ballads and Harmonium Songs 1971–74*, a book which grew out of his improvisation sessions with Bob Dylan in Ginsberg's apartment on the Lower East Side, and which was released on record, with other later material, by John Hammond Records in 1982.[38]

In these terms, the oral poetry-reading tradition which developed in New York City between 1960 and 1970 with Paul Blackburn at its center, and which in turn spawned a revival of poetry readings around the country, can be seen as the necessary condition of poetic art. Since no one can ever trust his own reading of a written poem, he has to experience the poet himself reading it (and Blackburn's sometimes manic desire to capture every reading on tape is a further manifestation of this desire to capture the "authentic" poem). The supposition is that in hearing we understand (*s'entendre parler*), or at least better understand. But the poetry reading is such a small—if not downright elitist—event, governed by the contingencies of time and place, that it ignores the major portion of poetry's already small audience. It would of course be possible for the new oral poetry to address that heterogeneous crowd of book readers which is its larger audience in the same way that music addresses its larger audience—that is, it could disseminate its performance by means of record and tape, as Ginsberg has tried to do. But the overwhelming impulse had been, instead, toward the printing of transcriptions of the performed piece—what has been called "the textualization" of the new oral poetry.[39]

It should be clear, then, that if the art object has, as it were, dematerialized—given way in the case of poetry to the voice of the poet talking, in the case of plastic art to the artist performing—another kind of

object has nevertheless rematerialized in the absence of the former. In the face of absence a new kind of presence asserts itself. This presence takes two related forms in postmodern work, one of which we could call *ritual*, and the other *narrative*. In ritual work this new object appears as a text or document or site which exists as a script or score or generating environment for ritual action. But the presentness of the object in ritual work is limited— it projects a larger or greater presence which is realized in the performance of the ritual activity itself. In narrative work this new object is a medium in which experience is worked through and organized. In this sense, narrative is, like ritual, a generating environment, but now for *cognitive* action. As opposed to ritual, the narrative object embodies presence, but only insofar as storytelling is an action in and of itself; the score or script of a narrative is the actual event or series of events which it rehearses or "represents." But, above all, both ritual and narrative share a concern for audience, the engagement of a community. Narrative could even be said to be a *kind* of ritual, an activity designed to unite storyteller and audience in a common cognitive, as opposed to overtly *social*, dilemma. Both implicitly envision transformation or change to result from our encounter with them.

When in 1978 Linda Burnham founded *High Performance* magazine in order to document performance art, she defended her magazine on the editorial page of the first issue by distinguishing between performance proper and its documentation. Her distinction is close to the one I am trying to draw between ritual and narrative:

When I was a child in college, there was a Ginsberg poem going around with the refrain: "I am waiting for a rebirth of wonder." For me performance art has that magic. . . . Documentation of these events is almost antithetical to that ideal. It is almost a violation to request that they be written down, photographed. But as a journalist, I deplore the loss. And as a writer of fiction, I am drawn to documentation as a form in itself. Sometimes, like the tale of a pilgrim returning from a holy place, the story is better than the actual event.[40]

The analogy between Burnham's distinction and my own is not exact. Postmodern narrative work need not document a performance per se—though it may. Nor do I mean to suggest that all performance is ritualistic—much of it is narrative in character. The point is simply that performance art exists on a continuum between ritual and narrative and its placement on that continuum depends upon its relation to its documentation, to the objects it produces. Since these objects are the means by which the work's larger audience is addressed—the means by which the art makes contact with the community at large—the audience must always reinvent the performance for itself. In its "textualization," performance art accedes to interpretation, to hearing itself spoken, perhaps unrecognizably, in the myriad dialects of the vox populi.

Painting resists such "textualization." Its status as an object in its own right—there on the wall, enclosed by its frame—seems antagonistic to such an approach. It always seems, at least initially, self-contained. The distinction I would like to make between painting and more performance-oriented genres is comparable, I think, to the distinction drawn by Gerald Bruns in his book *Inventions* between the "open text" of manuscript cultures and the "closed text" of print culture. "Print," as he says, "closes off the act of writing. . . . The text, once enclosed in print, cannot be altered." This is not the case in a manuscript culture. In the sense that the written Torah, for instance, prompts the oral tradition of the Mishnah, Talmud, and Midrash, or in the way that the Old French *Enéas* transforms Vergil's *Aeneid*, the text "opens outwardly . . . in the sense that it seems to a later hand to invite or require collaboration, amplification, embellishment, illustration to disclose the hidden or the as-yet-unthought-of. . . . The text is . . . tacitly unfinished: it is never fully present but is always available for a later hand to bring it more completely into the open."[41] A contemporary example of such an "open text" is John Cage's interest in "writing through" the works of others; in "Writing through Howl," for instance, he transforms Ginsberg's famous poem. In fact, Ginsberg often reworks texts in a manner analogous to Cage's own operations on him. Consider the poem "Returning to the Country for a Brief Visit" from *Mind Breaths*. It consists of nine brief translations of Amitendranath Tagore's Sung poetry and Ginsberg's annotation of each one. Here is part of one and the entirety of another:

> *"You live apart on rivers and seas . . ."*
>
> You live in apartments by rivers and seas
> Spring comes, waters flow murky, the salt wave's covered with oily dung
>
> *"I always remember the year I made it over the mountain pass."*
>
> Robins and sparrows warble in mild spring dusk
> sun sets behind green pines in the little valley
> High over my roof grey branches say gently under motionless clouds
> Hunters guns sounded three times in the hillside aspen
> The house sat silent as I looked above my book,
> quiet old poems about Yi & Tsangpo Rivers—
> I always remember the spring I climbed Glacier Peak with Gary. (20–21)

Ginsberg is not merely returning to the country, he is returning to the text, both the Sung text and his own textualization of it (small things, like the comma after "book," which inscribes disruption, indicate that his poem is first of all *written down*). The poem is the scene, in fact, of *translation*, in all senses of the word, an interplay between interpretation and representa-

tion, presence and absence, stasis and change, poem-as-object and poem-as-event, the translation of each term to the other and back again.

For Ginsberg, if I may borrow Bruns's formulation, writing is a form of textual intervention: "To write is to intervene in what has already been written; it is to work 'between the lines' of antecedent texts, there to gloss, to embellish, to build invention upon invention. All writing is essentially amplification of discourse; it consists of doing something to (or with) other texts."[42] Since the Sung poem is open to Ginsberg's re-vision of it, the implication is that Ginsberg's poem is in turn open to us. We can and will use it, or abuse it (the point, I think, of his "oily dung"), as we wish. This is likewise the point of a poem like John Ashbery's "Self-Portrait in a Convex Mirror," which for many is the quintessential poem of the seventies. Ashbery conceives of Parmigianino's self-portrait as a "recurring wave / Of arrival" which is also like "the game where / A whispered phrase passed around the room / Ends up as something different."[43] The poem posits two kinds of presence: on the one hand, "the portrait's will to endure" as an object in its own right over and above what we wish to make of it, and on the other, the series of presents which constitutes whatever "present" meaning the painting holds for us, each a little different from the last, each conditioned by what Ashbery labels *le temps*, the exigencies of time and place. The dialogue between the recalcitrant object and Ashbery's interpretation of it—the way each impinges upon the other, art upon life and life upon art—is the subject of the poem.

The eminence Ashbery's "Self-Portrait" holds in the decade's critical canon is probably more than anything else due to this willingness simply to problematize—and not resolve—art's relation to its audience. Photography embodies more or less the same problematics, and not surprisingly in poems like "City Afternoon" and "Mixed Feelings" photography is explicitly Ashbery's subject matter (and I would suggest that perhaps the best way to read the very beautiful "Voyage in the Blue" is as a reverie inspired by a photographic image). This is to say that both Ashbery's "Self-Portrait" and photography in general have received so much critical attention because they so thoroughly address *the* critical issue of the decade—the threat to the art object's authority and integrity which the audience's freedom to interpret presupposes.

My feeling about painting in the eighties is that it generally ignores—would even *like* to ignore—the ways in which the exigencies of time and place impinge upon it. This is not to say, however, that any number of painters have not attempted to transcend this state of affairs by drawing upon certain of the resources more readily available to the open texts of performance. They have done this, by and large, by insisting on the fundamental *undecidability* of their work and by attempting to "write between the lines," as it were, of antecedent painting. One of the best ways to think

of painting in the eighties is to see it as consisting in "doing something to (or with)" other paintings or images.

The art critical word for such a reliance on antecedent works is *appropriation*. Collage is, of course, the most common form of appropriation. Insofar as it "lifts" found materials out of their proper contexts and introduces them into the scene of painting, it simultaneously announces the transformation of these materials into "art" and undermines the idea that "art" necessarily has anything to do with the production of handmade, unique representations. Collage, like appropriation, addresses the aesthetics of photography on several levels. In the first place, appropriation is "mechanical," not "creative" or "original." Furthermore, it posits that the artist is at least as much a "seer" as a "maker"—the artist recognizes the aesthetic in the world, and frames it. Third, just as photography tends to level aesthetic experience (Botticelli's *Birth of Venus* is as endlessly replicable as an ad for Black Velvet whiskey), collage is able—in its pastiche of appropriated and painted surfaces, the images of mass culture coexisting with the signs (like brushwork) of high art—to collapse aesthetic difference.

The difference between collage and contemporary attitudes about appropriation is that in collage the force of the collision between high art and low remains oppositional. Rhetorically, it seems reasonable to use words such as "undermines," "subverts," or even "deconstructs" in order to describe how, in collage, the intrusion of mass culture operates upon the site of high art. The same, of course, could be said of photography's relation to the idea of representation in painting. In contemporary appropriation, however, high art is not so much undermined or subverted as it is recognized to be complicitous with, involved in the same operations as, mass cultural images and artifacts. That is, there is no longer any reason to read an abstract expressionist gesture—the sweep of paint across the canvas—as any more or less *authentic* than the lightning-strike "zip" across a Marvel Comic cartoon. The signature "Warhol" is no more or less "original" than "Campbell's" is a sign of "home-cooked goodness." Especially after the explosion of new and expanded art programs across America in the early sixties, any "style" could be taught and learned, any means appropriated to any end. As soon as Norman Rockwell painted a Jackson Pollock on the cover of *The Saturday Evening Post* (it was January 13, 1962), the oppositional stature of collage was permanently depleted.

One of the points of Sherrie Levine's work is to implicate the institutions of high art, its images, into the mechanisms of mass reproduction—her Mondrians, repainted in watercolor from worn, faded reproductions in art books, right down to their diminished scale, become disconcertingly similar to Warhol's Tomato Soups. "The content," she explained to interviewer Paul Taylor, "is the discomfort you feel at the *déjà vu* that you experi-

ence . . . the discomfort that you feel in the face of something that's not quite original."[44] In fact, for Levine, there is some question whether there can ever be any original gesture: "We know that a picture is but a space in which a variety of images, none of them original, blend and clash. . . . We can only imitate a gesture that is always anterior, never original."[45]

The most infamous of the appropriators emerging out of the East Village scene has been Mike Bidlo, whose reproductions of various modernist "classics"—Warhols, Pollocks, Duchamps, Matisses, Lichtensteins, Klines, Gottliebs, and Picassos—verge on forgery (Fig. 3). Everything is potentially susceptible to a kind of cultural "hype"—and the vernacular authenticity which lent graffiti art its prestige is undermined by the pseudo-authenticity that "good marketing" can potentially bestow on everything. The question, in fact, becomes, in the contemporary world, is there any vernacular at all other than the "vernacular" of the media? Does not everything, as Levine's work suggests, seem familiar? Have not we seen it in one place or another? Is not all discourse finally and ultimately *mediated*? As Fredric Jameson has put it, "All that is left is to imitate dead styles,

FIGURE 3. Mike Bidlo, studio view, New York, 1987. Courtesy Leo Castelli Gallery, New York.

to speak through the masks and with the voices of the styles in the imaginary museum."[46] Even more pessimistically, perhaps the artist is now, in Jean Baudrillard's words, "only a pure screen, a switching center for all the networks of influence."[47]

The situation of painting in the eighties apparently affirms this. All the myriad "neos"—neo-expressionism, neo-geo, and so on—announce, in their very nomenclatures, their appropriation of earlier discourses. Hal Foster complained, in *Art in America* in January 1983, that the term "neo-expressionism" signaled that "expressionism is a 'gestuary' of largely self-aware acts." By the eighties "expressionism" was no longer a "high" style; it had become part and parcel of pop psychology—"Express yourself," we are exhorted—and the vernacular had become indistinguishable from jargon.[48] The new abstraction—or neo-geo—suffers from the same collapse of authenticity. Philip Taaffe's paintings are not so much abstractions as representations of abstractions, a kind of pop op. Sherrie Levine has moved from her appropriations of recognizable abstract artists, such as Mondrian and Malevich, to what has been almost universally labeled "generic" abstraction—stripes and checkerboards—executed in colors which are vaguely reminiscent of everything from Barnet Newman to Neiman Marcus. And Peter Halley's cells and conduits (Fig. 4) refer to the imagery of the microcomputer industry (is there a "vernacular" in the Silicon Valley?) at the same time that they reinvent the imagery of Francis Picabia, with Duchamp one of the first great modernist appropriators.

Such wholesale appropriation is not, I hope it is obvious, radically removed from the kinds of appropriation fundamental to the aesthetics of collage. These artists assume, I think, the place of their images in the onslaught of visual information that composes our day-to-day experience. Their images, in fact, make sense only insofar as they refer beyond themselves, insofar as they take place in some larger context which is our own. The neo-geo abstraction of an artist like Halley can be mistaken for simple elegance unless it is contextualized, and Taaffe might well represent the founding of (yet another) Vasarely Museum if he is not questioning Vasarely's aesthetic aspirations. Let me quote Steven Henry Madoff, from a series of lectures reprinted in *Arts Magazine* in 1985 on the question "What Is Postmodern about Painting": "The structure of the image is purposefully confused and confusing. It demands that we take each kind of style, each manner of representation, decipher its individual meanings, and then come to terms with the equality of meanings, with the death of differences, and, by extension, come to terms with the *collapsing sheet* of culture as it is mangled and flattened by the way that we apprehend images in our crazily shifting existence."[49]

Madoff is talking, particularly, about the painting of David Salle. In *His Brain* (Fig. 5), Salle juxtaposes a soft-porn realistic image of a kneeling nude

FIGURE 4. Peter Halley, *Two Cells with Circulating Conduit*, 1987. Day-Glo acrylic, acrylic, and Roll-a-Tex on canvas, 77 1/4 × 138 in. Courtesy Sonnabend Gallery, New York.

to a more abstract, pseudopaisley repetitive wallpaper design (that contains, nevertheless, certain "recognizably" insect-like creatures). Painted over the kneeling nude's buttocks is a sketchy portrait of a woman apparently sucking on her fingers and a quickly painted version of what appears to be Monet's floating studio. Painted over the abstract side of the canvas is a long, opaque, and very phallic rod, the soft texture of which not only contradicts its sexual implications, but the hard-edged precision of the design beneath it. For Madoff, such images amount to the embodiment of postmodern society's incoherence. "Eclecticism" and "pluralism" are the signs of the times. Postmodern painting, for Madoff, is part and parcel of a "schizophrenic culture" which "has ascended in conjunction with and in response to the deluge of information that flows over us and seems without end." No "principles of cohesion, synthesis, and development" are discernible, no "vision of unified history" even possible.[50]

In these terms, Salle, as painter, is comparable to what the French *Tel Quel* group has labeled the *scripteur*, the writer who conceives of his work not as a creation but rather as the product of a "vast and uninterrupted dialogue" with other texts.[51] Julia Kristeva's famous word for this concept is "intertextuality"—"each text situates itself at the junction of many texts of which it is at once the re-reading, the accentuation, the condensation, the displacement and the profound extension" (75). In this way, *Tel Quel* "systematically denounces the metaphysical valorization of the concepts of 'the work' and 'the author' " (68), and substitutes for them a *théorie d'en-*

FIGURE 5. David Salle, *His Brain*, 1984. Oil and acrylic on canvas, 117 × 108 in. Courtesy Mary Boone Gallery, New York.

semble, a collective gathering of intertexts. But there are two fundamental differences between Salle's practice and the practice of *Tel Quel*. In the first place, Salle's painting tends to homogenize the various discourses it engages—rather than activating our historical sense, it tends to flatten it. In its assimilation of various historical styles, it suffers from what Hal Foster has called "the culture-effect":

The historicism [of such painting] need not be coherent; indeed, it rarely is in such work. Rather, the mix of dismissed styles and dysfunctional categories creates an *effect* of culture, insinuates a *sense* of sophistication. In a way just like kitsch, the

operation of this art conforms exactly to the expectation of its audience—its simultaneous distrust and desire for the artistic. . . . Such art, then, is as ambivalent in relation to history as its artists are (at once scandalous and servile) to its bourgeois audience, and as this audience is generally to high culture (attracted to it, suspicious of it). In the absence of any other relevance or legitimacy, the historical references in this art serve as a form of sanction. Yet these forms and modes are precisely ahistorical, severed as they are from social practice. Stripped of historical context, they are emptied. . . . These modes, treated as mere signs, are reified all the more.[52]

For *Tel Quel*, intertextuality is an inevitable manifestation of a disseminative mode of production. Like the texts of Bruns's manuscript culture, each "new" work incorporates what came before it and displaces it as well. In a manuscript culture each text in fact anticipates its own opening to revision and supplementation. But paintings such as Salle's are assimilative, not disseminative. They are closed networks of signs. Salle has admitted to being attracted to "the idea of complication" in the theater, the simultaneity of competing events and images. But he has always tried, he says, "to reconcile this with my desire to make autonomous, self-sufficient art."[53] Salle's paintings seem to me to be closed in the same way that print is closed. The work is finished, contained—and cannot be altered.

The painting of Eric Fischl evokes a different kind of response. His work prompts narrative. It invites or requires our collaboration, amplification, embellishment. As Donald Kuspit has put it: "What makes [Fischl's] narrative art distinctive is that each picture hints at a core story that is never quite completely told. The story seems well known, but isn't. It seems obvious, but there's something disturbingly enigmatic about it. . . . Under the veneer of dealing with the affluent society and its neuroses—he has acknowledged that he is dealing with the failings of suburban life, with its pretense to mythical happiness—Fischl narrates a struggle between Eros and Thanatos. . . . His pictures are stage sets on which we can act out the fiction of our most hidden selves."[54] In the terms I have been developing here, Fischl's paintings constitute a suburban vernacular—vernacular in the sense that *Catcher in the Rye* seemed vernacular in the late fifties. Probably his most famous image, *Bad Boy* (Fig. 6) is a story every adolescent boy has dreamed he could live—or even convincingly tell—a deromanticized, nitty-gritty version of *The Summer of '42* that seems vernacular by virtue of its aggressive point of view. This is painting that has escaped mediation, the moderation of the rating system. As opposed to Salle, Fischl does not even think of himself as making "art objects" per se, at least not preeminently:

I want people to feel they're present at a scene they shouldn't be at, and don't want to be at. This is something that can't be created by painting, however basic. The scene has to be taken in very fast and left as quickly, and then slowly digested. If people have to start examining this or that detail, they miss the full point of the

FIGURE 6. Eric Fischl, *Bad Boy*, 1981. Oil on canvas, 66 × 96 in. Courtesy Mary Boone Gallery, New York.

picture, which is that they're a kind of accomplice in it, an unwilling witness to the event. I want them to think about that, not just how the picture is made.[55]

Fischl's paintings are theatrical, performative. "Everything takes place in the theatrical or fictional void of the stage," he says. "Each [picture] . . . needs vast emotional space to unfold in" (40). Where Salle's work is assimilative, Fischl's is disseminative. A useful distinction can be made between the *undecidability* of work like Fischl's and the *indeterminacy* of work like Salle's. The undecidable is a function of the audience—the myriad responses the audience is capable of recognizing as the potentialities of the work—where the indeterminate is a function of the work itself, its internal contradictions and ambiguities. Fischl's use of multipaneled canvases in many of his paintings is a way to deny the autonomy of the work itself, the formalist object which Salle so reveres. "I use one panel," he explains, "to bring into view what is offscreen or off the set, out of the 'basic' rectangle, so to speak. If the basic rectangle is the modernist idea of the structure of the work, I'm a postmodernist. I want to fill out the basic rectangle with what seems peripheral. . . . I want the narrative context which dissolves the formally basic" (45).

There are other artists working in similar narrative modes—among them, Ida Applebroog in her paintings, Jonathan Borofsky in his installation works, and Faith Ringgold in her narrative quilts—but perhaps the closest analogy to Fischl's painting in the art world can be found in the performance of Spalding Gray, particularly in the material he has published as *Sex and Death to the Age 14*. Gray's performances amount to a confessional autobiography. He is Fischl's *Bad Boy* grown up—he neither hides from nor hides anything. And his performances are aggressively vernacular. In the middle seventies, with the Wooster Group, he produced *Rumstick Road*, a theatrical revelation of Gray's personal feelings about the circumstances surrounding his mother's suicide, which incorporated into the production not only old family photographs and letters, but audiotape interviews Gray had conducted with his father, his grandmother, and his mother's psychiatrist. As Richard Schechner remarked, the power of the performance rested in the fact that these devices were "used 'raw,' as is"—they achieved, that is, a fully vernacular resonance.[56] In the autobiographical monologues that Gray has developed out of the experience of *Rumstick Road*, he has attempted to match the vernacular power of the earlier piece by means of direct address. This is an excerpt from *Sex and Death to the Age 14*. Sitting at a table, Gray would talk directly to the audience:

Eddie and I used to play strip poker together; I would usually win, so Eddie would end up naked. The rule was that the loser would have to go through some mild ordeal, some little punishment, nothing very big. . . . So Eddie's little punishment for losing at strip poker was to slip down between the twin beds and crawl naked over the little dustballs, fuzzies we called them. Then he'd come up the other side of the bed smiling, covered with fuzzies and looking for more. I couldn't think of any more punishments, it wasn't my specialty, so he'd begin making up his own. I would be the witness. He'd take a little cocktail dish, the kind you'd use for pigs-in-the-blanket or smoked clams, and he would put his dick on it—still connected of course. Then he'd go downstairs and display it to Rita Darezzo, the cleaning woman, as though it were a rare hors d'oeuvre, calling, "Rita, it's cocktail time!"[57]

In a manner analogous to that of Fischl's painting, we overhear something in this monologue we wish we had not. It represents, on the one hand, an entirely familiar mythology of sexuality and desire while it remains, on the other, thoroughly sexist, classist, and even racist. It manages, at the same time, to posit the fundamental difficulties that performance art faces in confronting the community at large. Gray and his friend Eddie constitute what Richard Schechner has called an "integral audience"—a kind of "in-group" which is privy to the rules and structure of a given performance.[58] In Gray's retelling of the original event, we, as audience, are given the choice of positioning ourselves within this "in-group" or else in that other, alienated audience that is composed of Rita Darezzo and other potential

victims. We can either go along with the joke or be victimized ourselves. And the point generally, in Gray's work, is that we recognize the competing attractions—moral and aesthetic—of both positions. Like Fischl, Gray wants us to be fascinated and repelled at the same time.

These works evoke the sense of narrative presence of which I spoke earlier. Most narrative of this kind involves its audience by creating a cognitive dilemma—usually social in character—with which the audience must come to grips and which it must at least seek to understand (most often it is not the sort of dilemma which can be "resolved" in the manner, for instance, of the classical detective story since it is the narrative, usually, of an open-ended and ongoing problem). It forces them, like the open text of a manuscript culture, to embellish, amplify, even act upon the problem it sets forth. For Gray, his mother's suicide is just such a dilemma—and suicide in general becomes the dilemma we face as his audience. *Swimming to Cambodia*, the performance Gray developed out of his experience filming *The Killing Fields* on location in Thailand, is an attempt to understand what went on in Cambodia from 1966 to the present, "a task equal to swimming there from New York," as Gray put it. On the one hand, Gray is faced with making a film about a society which in the five years from 1966 to 1971 set itself up "to carry out the worst auto-homeo-genocide in modern history":

Eyewitnesses said that everyone who had any kind of education was killed. Any artist, any civil servant was butchered. Anyone wearing glasses was killed. The only hope was to convince them that you were a cab driver, so suddenly there were a thousand more cab drivers than cabs. It was just the opposite of New York, where everyone says, "I'm an artist, I'm an artist. Sure I drive a cab to make a living, but I'm really an *artist*." There if you were an artist, boom, you became dead. Little kids were doing the killing, ten-year-olds, fifteen-year-olds. There was very little ammunition so they were beating people over the head with ax handles. . . . Some eyewitnesses said the kids were laughing with a demented glee. And if you pleaded for mercy they laughed harder. If you were a woman pleading for mercy they laughed even harder. And if you didn't die the kids just took your half-dead body and threw it in an American bomb crater, which acted as a perfect grave. It was a kind of hell on earth.[59]

Gray, on the other hand, is an artist, working in a film, living in a Ramada Inn in Thailand, smoking dope on the beach, and plotting his career, his future in *Hill Street Blues*, *St. Elsewhere*, and *Knots Landing*. He is *of* the society that created the vacuum, literally manufactured the graves, which the Khmer Rouge had filled.

Another good example of the sense of community—or common cognitive confusion—that such narratives can generate is Helen and Newton Harrison's 1982 *Barrier Islands Drama: The Mangrove and the Pine*, a series of nine photopanels extracted from an eight-foot-high, one hundred-foot-long panel originally commissioned by the Ringling Museum in Sarasota, Florida, for the exhibition Five Artists in the Florida Landscape

FIGURE 7. Helen Mayer Harrison and Newton Harrison, *Barrier Islands Drama: The Mangrove and the Pine* (detail), 1982. Nine photo murals with oil and graphite mounted on canvas, varying in size from 18 × 24 in. to 96 × 144 in.

(Fig. 7). The Harrisons have explained the piece in a statement for an Artistic Collaboration exhibition at the Hirshhorn Museum in 1984:

Among the things that interested us about the Florida landscape . . . was the pressure we observed at the boundaries of earth and water. That pressure had led to the diminuation of habitat for the mangrove. Now one variety or another of mangrove grows worldwide in tropical coastal marshes and shorelines, generating earth, holding land from encroaching waters, and acting as a nursery for a multitude of creatures. The Australian pine was introduced to the Florida coastline early in the century to decorate the landscape. In its new environment the pine is an exotic, grows like a weed, and has no natural enemies. It colonizes behind the mangrove, spreads until it gains the ocean edge and displaces the mangrove, when, shallow rooted, it topples in the wind, loosing ground thereby. To walk among the graceful pines almost to the water's edge is aesthetically pleasing. To walk among the native mangroves to the water's edge is not. Thus, one can never tell when an aesthetic decision will proliferate and ruin the landscape.[60]

It is worth pointing out that the Harrisons' narrative statement is not so much an integral part of the work itself here as it is a *supplement* to it. It fills out what the image alone leaves unsaid. It politicizes—or at least reveals the ecological disaster—which underlies the otherwise aesthetic scene at water's edge. It does not necessarily seek, like ritual, to create commu-

nities out of a sense of collective celebration or action, but it does create a sense of community out of a recognition of our collective plight. It involves us in an open-ended and ongoing process, one which requires action on something more than an individual basis.

V

Perhaps the most interesting—and problematic—example of such a disseminative practice in American art in the last twenty years has been the work of Andy Warhol, for despite Warhol's reputation and his "star quality," he was more a *scripteur* than he was a creator, conducting a "vast and uninterrupted dialogue" with the texts of mass culture. Part of the difficulty of Warhol's work, in fact, has always been the degree to which, in his "pop" idiom, the vernacular and the mediated are undecidably confused. The interview, always one of Warhol's favorite forms, and one which he developed to new heights in his magazine *Interview*, is primarily a vernacular tradition. And yet Warhol seemed to delight in reducing these apparently documentary records of "speech" to the most "canned" and predictable of forms. Here, for instance, is the "Editor's Note" introducing an interview with Mimi Rogers conducted by Jann Wenner:

We invited Mimi Rogers and Jann Wenner to lunch with us at Primola restaurant on Second Avenue. Mimi is the star of *Someone to Watch Over Me* and the wife

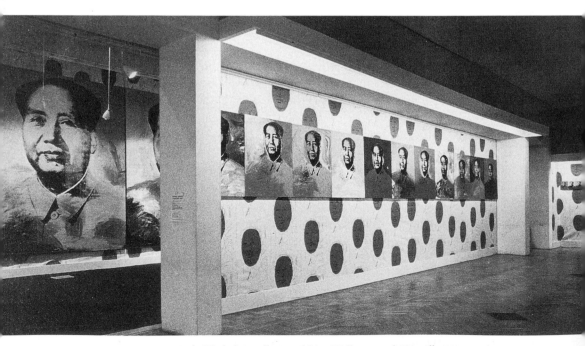

FIGURE 8. Andy Warhol, installation of *Mao Wallpaper* and *Mao* silkscreens at the Musée Galliera, Paris, 1974. Courtesy Leo Castelli Gallery, New York.

of Tom Cruise; Jann is the editor and publisher of *Rolling Stone* and best friend to his favorite movie stars, a group that includes the first-class Cruises. The chat, which took place between bites of wild mushroom salad and pesto pasta, was filled with nervous laughter, hints of gossip and Jann's cigarette smoke—sort of an innuendo-out-the-other kind of meal. What follows is an interview that Jann distilled from our conversation.[61]

This "note" reduces the interview to an entirely mediated "event," as manipulated as any presidential "photo opportunity." It rests entirely in Warhol's sensibility. Throughout his career, he consistently undermined the "authenticity" of all events, all images. Since very early on, Warhol often, though not always, removed himself from the actual production of his art, relying on a silk-screen process which allowed him to leave most of the details of making his art to others. His *Campbell's Soup Cans* not only suggested the commodity status of art but also denied Warhol's prestige as creator—they remain as much Campbell's as Warhol's. As Sidra Stich has pointed out in the catalogue to a recent exhibition of American art in the fifties and sixties, Warhol treated the soup cans as "flattened facades, surface-oriented images that give no hint of what is inside or even that there is an inside."[62] They are parodies, in other words, of both expressionist "content" and the formalist emphasis on the two-dimensional surface of the canvas itself. Warhol gave us empty—but endlessly recognizable—images of our own uniformity and superficiality. All of his books, furthermore, were cowritten, and not, one guesses, because he could not write. He even went so far as to hire a look-alike to take his place at public appearances. Warhol's "personality" was a studied lack of personality, Warhol's performance a calculated nonperformance, and his art almost not art at all. His death, in 1987, was, curiously, something of a "nonevent" in its own right—he seemed, even in the grave, as alive as he had ever been.

Warhol's peculiar power lay in his ability to turn the world upside down, to frustrate constantly the expectations of his public, even its ability to mourn him. Whenever we expected him to be the leader of the "avant-garde," he seemed, to the contrary, the most astute of businessmen. Just when we were ready to accuse him of selling out, he would manage to pull off some gesture which would restore his avant-garde status. His thorough awareness of the commodity system's ability to usurp his own "revolutionary" images—to make the outside inside, as it were—is epitomized by his series of *Maos* and his 1976 *Hammer and Sickles*. In the first place, Warhol usurped the very image of Mao itself, ripping it off from the frontispiece to the red book. And the Mao exhibit, at the Musée Galliera in Paris in 1973, not only transformed Mao into what David Bourbon has called a "society icon," just another mass-produced Warhol "superstar," but into *decor*, for Warhol hung his silk screens over a floor-to-ceiling *Mao Wallpaper* (Fig. 8). With the *Maos* and the *Hammer and Sickles*, Warhol seems

to provide his ruling-class patrons with a way to deal with their historical nemesis once and for all. As Peter Schjeldahl puts it: "They can hang it on their walls."[63]

Schjeldahl is, of course, forced to admit that "turning revolution into an uppercrust consumable would seem automatic grounds for condemnation to many critics today." Likewise, Warhol's systematic undermining of "the metaphysical valorization of the concepts of 'the work' and 'the author,' " which he accomplishes at least as thoroughly as *Tel Quel*, is called into question by the kind of practice and community Warhol ends up substituting for "the work" and "the author." Warhol's community is at the very heart of the commodity system itself, the superrich, Studio 54/Concorde set. Still, it is worth remembering that this was not always the case. The crowd with which Warhol first surrounded himself at the Factory on Union Square was a collection of gays, drag queens, speed freaks, and self-styled "superstars" whose one common denominator was "just that they were outrageous; aesthetic outlaws."[64] As Warhol and his entourage became more and more "in" throughout the sixties, however, and as hanging out at the Factory became a sort of art world substitute for social slumming, his outrageous outlaw aesthetics were absorbed by the upper crust. In fact, Warhol's underground world was consecrated and commodified by the social elite—at Studio 54, for instance—with the same ease that his *Maos* were being assimilated by the marketplace. What happened to Mao happened to Andy. Despite his calculated indifference, he was consecrated, made a star.

Ever the strategist, he transformed consecration itself into subject matter. His show Andy Warhol: Portraits of the 70s, which ran at the Whitney from November 1979 through January 1980, is an essay on commodification and consecration, which in many ways sums up the aesthetic direction of the decade as a whole. One way to read this show is to see Warhol as a social parasite, feeding off the wealth and fame of others by selling them their portraits for forty or fifty thousand dollars apiece. This was a reading that he was always more or less willing to accept, as he was willing to accept more or less anything. "I have Social Disease," he said in his anecdotal collection of society snapshots called *Exposures*: "The symptoms of Social Disease: You want to go out every night because you're afraid if you stay home you might miss something. You choose your friends according to whether or not they have a limousine. . . . You judge a party by how many celebrities are there—if they serve caviar they don't have to have celebrities. When you wake up in the morning, the first thing you do is read the society columns. If your name is actually mentioned your day is made."[65] According to this reading of himself, Warhol was the ultimate fan, snapping candids of the rich and famous with his Polaroid or his Minox and, with a fervor unmatched in New York since Paul Blackburn's poetry reading

days, taping conversations with everyone in sight for his *Interview*. But according to this reading, Warhol was merely the sycophant par excellence of his time, and everybody, most of all Warhol, knew he was more than simply this. He was the exploiter of exploiters, the poor kid from a working-class, immigrant background who turned the tables on the rich. As much as his was an art world Horatio Alger story, it was also the record of a cultural coup d'état. By appearing to aspire to the starry heights of Fifth Avenue, he brought Fifth Avenue down to the Factory. Warhol's *Exposures*, for instance, are at once icons and exposés, his Social Disease a perfect metaphor for the ills of a decadent and socially diseased society:

This book is about the people at the top, or around the top. But the top's the bottom. Everyone up there has Social Disease.
It's the bubonic plague of our time, the black and white life and death (19).

Warhol's paintings not only aspire to the condition of photography, they *are* photography—or half photography, since they are almost always photographs silk-screened onto canvas. But most important he collapses the distinction between the commodity status of the work of art (with its concomitant aesthetic autonomy) and its avant-garde function as an attack on that commodity status. Warhol recognized that to return art to social praxis, as the avant-garde wishes to do, is inevitably to return art to the marketplace, life and the marketplace being so inexorably linked in contemporary society that it is impossible to disengage them. Hence Warhol's unpopularity among leftist critics—he reveals the idealism latent in their notion of a socially engaged art. They act as if it were possible, today, to disengage *social* life from commodity *society*. It is, furthermore, important to realize that taken as a deconstruction of the art object's commodity status, Warhol's work willingly submits to the danger all deconstructive discourse must face. If deconstruction means to expose the weaknesses of whatever "system" or discourse one engages, to point out its strategic ellipses, and to undermine its authority, then there is also a certain methodological necessity for preserving—even if in abeyance, *sous rature*, in Derrida's phrase—what is denounced, so that sometimes deconstruction seems to affirm what it sets out to deny. It could even be argued, as Paul de Man points out, that it is this undecidability, this "logical tension that prevents . . . [the] closure" of postmodern art.[66]

Art critic Craig Owens was the first to recognize the kinds of problems and possibilities Warhol's example has opened for the contemporary avant-garde, especially in the East Village, where the avant-garde has blatantly embraced the culture industry. The East Village scene, which began to emerge in late 1981 and early 1982 with the opening of the galleries Fun, 51X, Nature Morte, Civilian Warfare, and Gracie Mansion, has been described as "a unique blend of poverty, punk rock, drugs, arson, Hell's

Angels, winos, prostitutes and dilapidated housing that adds up to an ad-
venturous avant-garde setting of considerable cachet."[67] But, according to
Owens, "what has been constructed in the East Village is not an alternative
to, but a miniature replica of the contemporary art market—a kind of Ju-
nior Achievement for culture-industrialists":

> [The East Village] repeats Warhol's open acknowledgment of the marketability of
> an alluring avant-garde pose—a pose created, moreover, through affiliation with a
> variety of deviant and delinquent subcultural types. . . . Whether ironic or not,
> Warhol's acquiescence to the logic of the culture industry—his transformation of
> the studio into a Factory, his adoption of the techniques of serialized production,
> etc.—stands as a pivotal moment in the history of the avant-garde, the point at
> which its function in the mechanisms of cultural economy first became visible. . . .
> By destroying the avant-garde's pretense to autonomy, Warhol has left subsequent
> avant-gardes two alternatives: either they openly acknowledge their economic
> role—the alternative pursued by the East Village "avant-garde"—or they actively
> work to dislodge an entrenched, institutionalized avant-garde production model.[68]

Warhol, then, is not the most comfortable figure with whom to sum up the
aesthetics of the seventies, but his work embodies the most important ques-
tions the decade has raised and defines the terrain which avant-garde art in
the eighties has begun to explore. He addressed the question of the mate-
rialization of the art experience directly. He refused to mask the question
either by valorizing the immediacy of the art experience or by aestheticiz-
ing art's object. He consistently forced us to ask ourselves just what the
object of performance might be.

THE RHETORIC OF THE POSE 1

Photography and the Portrait as Performance

And so I came to you, you men of the present, and to the land of culture. . . .

I laughed and laughed, while my foot still trembled and my heart as well: "Here must be the home of all the paint-pots!" I said.

Painted with fifty blotches on face and limbs: thus you sat there to my astonishment, you men of the present!

And with fifty mirrors around you, flattering and repeating your opalescence!

Truly, you could wear no better masks than your own faces, you men of the present! Who could—*recognize* you!

Written over with the signs of the past and these signs over-daubed with new signs: thus you have hidden yourselves well from all interpreters of signs!

FRIEDRICH NIETZSCHE, *Thus Spoke Zarathustra*[1]

Since 1975 Boston photographer Nicholas Nixon has taken a picture of his wife and her three sisters once a year, every year (Figs. 9, 10, 11, & 12). The first two photographs in the series, *Heather Brown McCann, Mimi Brown, Bebe Brown Nixon, and Laurie Brown, New Canaan, Connecticut* (1975) and *Hartford, Connecticut* (1976), were displayed side by side at the Museum of Modern Art in John Szarkowski's 1978 exhibition Mirrors and Windows, a retrospective of American photography since 1960. The next five, *Heather Brown, Mimi Brown, Bebe Brown Nixon, and Laurie Brown Tanchin* (1977–81), appeared as a "project" in the December 1981 *Artforum*, and five more appeared in December of 1986.[2] At first glance they draw attention to themselves only as well-made 8 x 10 contact prints, pictures of sometimes startling tonal contrast and nuance that render their subjects with uncanny precision. That is, they look professional, certainly, but otherwise they seem eminently familiar. Everything about them is recognizable. We may not know the women in them personally, but we know the photographs. There are thousands more or less like them everywhere, treasured in family albums, buried in dresser drawers, framed on desktops, and stationed prominently on mantelpieces. We recognize them so quickly, we take them in so casually, we think we understand them so completely, it is as if nothing need be said about them. They are simply family photographs—and we all know about family photographs.

In the Mirrors and Windows exhibition, Szarkowski affirmed their more or less tautological status by placing them in the "window" school of American photography. According to Szarkowski, there are "those who think of photography as a means of self-expression [as a mirror], and those who think of it as a method of exploration [as a window]." Photographs of the mirror kind "favor the virgin landscape, pure geometry, unidentifiable

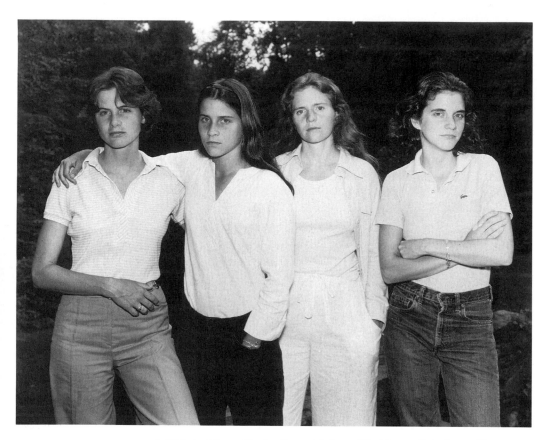

FIGURE 9. Nicholas Nixon, *Heather Brown McCann, Mimi Brown, Bebe Brown Nixon, Laurie Brown, New Canaan, Connecticut, 1975.* © Nicholas Nixon. Courtesy Fraenkel Gallery, San Francisco.

nudes, and social abstractions such as the Poor, or the Young—all subjects that strongly suggest universal verities." On the other hand, "window" photographs, such as Nixon's Brown sisters, "are more likely to deal with matter that is specific to a particular place or time."[3] This specificity is confirmed not only in the titles to Nixon's photographs but in family photographs generally, which tend to celebrate important episodes or moments in a family's history, such as the Browns' annual get-togethers. With flattery clearly not his intention, Minor White (whom Szarkowski sees as the father of the opposing "mirror" school of photography) once said that images of the "window" variety represent the kind of documentary, pictorial, and informational photograph that "no normal educated adult will find any difficulty with."[4]

It probably goes without saying that such condescension is always dangerous, and Szarkowski surely knows that White underestimates the difficulties these photographs present. At least part of their difficulty is

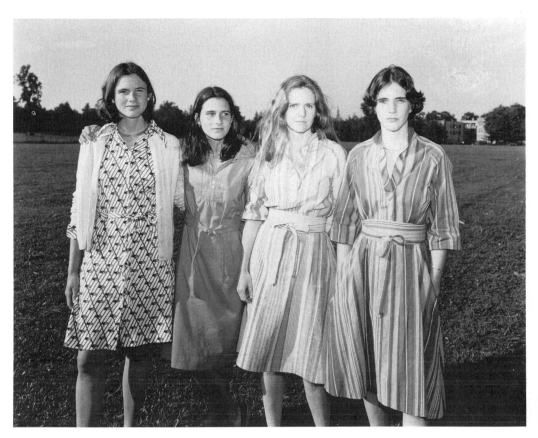

FIGURE 10. Nicholas Nixon, *Heather Brown McCann, Mimi Brown, Bebe Brown Nixon, Laurie Brown, Hartford, Connecticut, 1976.* © Nicholas Nixon. Courtesy Fraenkel Gallery, San Francisco.

precisely their tautological status, the way in which photographs of the "window" variety tend to present themselves as the result of some apparently objective process by which the real world is directly inscribed upon paper. That is, their meaning is seemingly *direct*, unmediated; they record and contain the moment in all its vernacular fullness. Yet at the same time—and this is the difficulty—most photographs of this kind, despite all their directness of vision and clarity of presentation, remain in and of themselves largely meaningless (except to the few family members who experienced the original moment of the photograph itself). It is as if they were at once full and empty of meaning—full for the privileged few who know their context, but empty for the rest of us. They seem merely personal and private, devoid of general interest. At best we tend to approach them with the same lack of enthusiasm as, say, a relative's slide show of his European holiday or a neighbor's baby book.

If Nixon's series of photographs of his wife and her three sisters seem,

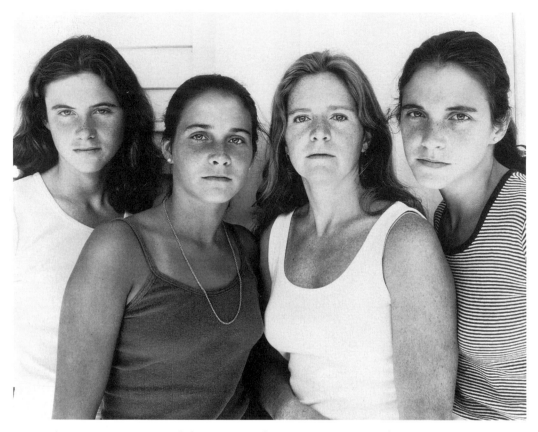

FIGURE 11. Nicholas Nixon, *Heather Brown, Mimi Brown, Bebe Brown Nixon, Laurie Brown, Harwichport, Massachusetts, 1978.* © Nicholas Nixon. Courtesy Fraenkel Gallery, San Francisco.

at first, closer to the family album or the mantelpiece than to *Artforum*, that is because Nixon is preeminently challenging the ease—and condescension—with which we tend to approach images such as the ones he gives us. In many ways the first question his work raises is just what these pictures are doing in the Museum of Modern Art and *Artforum* at all. Part of the answer, of course, is that in the context of the museum and the art magazine (as opposed to the mantelpiece) we are forced to approach them differently. The ploy is as old as Duchamp's urinal, and Nixon is by no means the only contemporary photographer to exploit it. These works of art immediately call into question what we might call the official "taste apparatus" at work in our culture. Nixon's Brown sisters and Duchamp's urinal equally undermine the canons of "high" art by revealing the aesthetic power of the vernacular. At the same time they reveal just how powerful our taste-making institutions have become by revealing that it is quite possibly their appearance in the art context *alone* that makes them art.

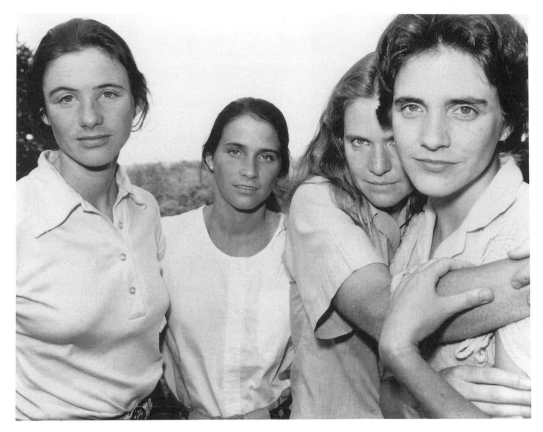

FIGURE 12. Nicholas Nixon, *Heather Brown, Mimi Brown, Bebe Brown Nixon, Laurie Brown Tranchin, East Greenwich, Rhode Island, 1980.* © Nicholas Nixon. Courtesy Fraenkel Gallery, San Francisco.

Here we attain what might be called the second level of tautology: a family portrait is a family portrait, and it is art because it is art (or, at least, because someone has declared it to be so). This phenomenon is in itself richly suggestive, evoking many notions of doubling and repetition that I take to be central not only to portraiture but to contemporary avant-garde art generally, and I will return to it later. But the ultimate source of the "window" photograph's power and interest is, I think, its very specificity, its complicity with the exigencies of historical time, its *documentary* status. The question is just what meanings such documents can begin to elicit.

I

When I initially saw the first two photographs in Nixon's series at the Museum of Modern Art in 1976, what drew my attention to them was the rather fatuous exclamation of another exhibition-goer down the way. "Oh, those lovely Brown girls," she proclaimed. Now this struck me as a particu-

larly nice thing to be able to say. Actually, it seemed to me to be the *only* appropriate thing you *could* say, because if you did not know these girls, if you could not put their photographs imaginatively back up on their parents' mantelpiece and reconstruct their boarding school successes and their Wellesley and Connecticut College careers, and the time one of them—which one was it?—dated Billy What's-his-name from Darien, you know, then they did not mean much of anything. So I was vaguely envious of this lady, who was dressed casually à la Diane von Furstenberg like the Brown girls themselves and who actually may or may not have known them but certainly knew how to drop a name.

Later, however, it occurred to me that you were not supposed to know these women at all. Knowing them ruined the photographs, wrecked not only the effrontery of Nixon's gesture but the complexity and richness of the work itself. These are very personal photographs: they speak of an extreme closeness between Heather and Mimi, the two girls on the left, always arm in arm; of Laurie, on the right, and her independence and self-assurance; of the relationship between Bebe, in the middle, and her husband, the photographer, a relationship which somehow asserts itself in these photographs in a way that makes Bebe seem the oldest and wisest of the sisters. But the point is precisely how thoroughly and necessarily this private and personal narrative is lost, leaving the viewer only with intimations of the family ties that bind these women together. The photographs, in fact, exist as violent testimony to the ways in which the public venue empties out our lives of meaning—or, perhaps better, transforms the meaning of our lives into something else, something other than its personal and private significations.

There seem to be two places where this "other meaning" might be located. The first is within the frame itself, not in any content per se so much as in the photograph's formal structure and the way this formal structure supports a certain content. That is, one way these photographs transcend the personal and private is as formalist objects. The second place where we might locate this "other meaning" is outside the frame, so to speak, in more broadly art historical contexts—in a consideration, for instance, of the way in which these family portraits fit into the tradition of family portraits generally or, more particularly, in an examination of how and why the family portrait might interest not only a practicing contemporary photographer but also the avant-garde audience of *Artforum*. But probably the most useful way to see the "other meaning" of these photographs is to view them as something of a hinge between these two separate and, as we will see, contradictory modes of discourse—one formalist, the other historical—as the site of a rich, dialogical interplay between them.[5]

The kind of rhetoric which the formalist approach to photography elicits

is typified by this excerpt from a review of a 1980 show of Nixon's photographs at the Fraenkel Gallery in San Francisco:

Working exclusively in black and white, Nixon uses an 8 x 10 camera to make contact prints which have a rich, yet understated tonal brilliance. . . . [His] photographs openly exploit characteristics fundamental to photography—the viewer is invited to inspect each detail and each formal gradation rendered fastidiously by an impeccable lens onto a large-format negative. . . . [His portraits] emphasize photographic and pictorial elements (such as tone, texture and spatial organization) over subject matter. People are transformed into shapes and forms occupying space.[6]

From this point of view, photography is about nothing other than itself, in the same way that modernist painting has always, more or less narcissistically, preoccupied itself with itself. Carol Duncan, one of the editors of the *Socialist Review*, recalls seeing a particular photorealist painting in the early seventies that sounds very much like Malcolm Morley's 1968 *Beach Scene* (Fig. 13):

It depicted a family of four on a Florida beach. The group looked like the kind of all-American families in contemporary Wonder Bread ads, except that the image had the feel of a posed snapshot in which everyone self-consciously tried to look their role as a member of a happy, fun-loving family. Thus the father—a Dick Nixon look-alike—grins too much as he plays with his son's toy car, while his wife overindicates her amusement. The work's cool, detached surface, clean-edged forms, and bright colors magnified the emptiness of the family cliche that the figures act out.[7]

A couple of years later Duncan had the opportunity to tell the artist how much she liked the painting, and she went on to say something about her interest in the image itself. The artist was outraged: "His painting, he insisted, was not about the cliche of the family nor anything else 'in' the image. It was solely about the painted surface as an arrangement of color and form. He himself was totally indifferent to the content of the photos he used for his painting and selected them only on the basis of their color and composition."[8] The desire to rid art of subject matter, to claim for it an autonomous self-reflexivity, has long been one of the primary concerns of the modernist enterprise, and it is hardly surprising to find a photography critic claiming for Nixon's work what is taken for granted in painting. The gesture is simply another instance of that seemingly never-ending—and endlessly tiresome—battle to establish photography as a legitimate art form. As a strategy, it has been largely inspired over the last two decades—and this should come as no surprise—by John Szarkowski's Department of Photography at MoMA.

Under Szarkowski's leadership the Department of Photography set out to rescue the medium from the purely descriptive and informational functions which had been established for it by such exhibitions as Edward

Steichen's Family of Man and the great photographic magazines of the mid-century, such as *Life* and *Look*, by insisting that photography had become more a means of personal expression and exploration than a tool of social documentation.[9] For Steichen, who ran the Department of Photography from 1947 until 1962, when Szarkowski took over, the photograph was interesting only insofar as it conveyed information directly to a mass audience with no more overt "aesthetic" content than necessary to make the

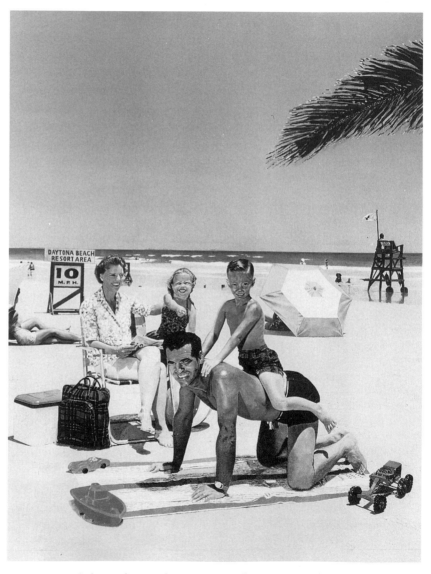

FIGURE 13. Malcolm Morley, *Beach Scene*, 1968. Oil on canvas, 110 × 89 7/8 in. Hirshhorn Museum and Sculpture Garden, Smithsonian Institution. Gift of Joseph H. Hirshhorn, 1972.

photograph seem immediate or appealing or both. Often Steichen chose images from vast pools of anonymous work and fashioned them, as in The Family of Man, into a morally edifying exhibition that was, if biased, nonetheless thematically coherent. Szarkowski's first exhibition, on the other hand, in 1962, was entitled Five Unrelated Photographers. As opposed to his predecessors in the department, Szarkowski was a trained art historian, and over the years he gradually introduced art historical rhetoric and critical discriminations into the discussion of the medium. In itself, this has by no means been a bad thing—thanks largely to Szarkowski's efforts, we understand photography today, especially its compositional principles, far better than we otherwise might. But Szarkowski has also overseen what we might call the formalization of photography, a process that has not merely obscured the medium's powerful informational and documentary capabilities but, more important, as the discussion of the family portrait will soon make clear, defined the medium as a profoundly modernist art form.

Szarkowski's critical sensibility is probably clearest when he says, in *Mirrors and Windows*, that pictures of the "window" variety might be called "disinterested or objective, in the sense that they describe issues that one might attempt to define without reference to the photographer's presence." But it is not their "objective" qualities which interest him: "Such pictures explore the ways in which photography can translate the exterior world into pictures, which is essentially not a personal but a formal issue."[10] He is interested, that is, in the way that the photograph transforms its subject matter into art. Implicitly, at least, Szarkowski sees the *art* of photography as separate from the *life* it describes. In fact photography only establishes itself as *art* insofar as it separates itself from *life*. In terms of art historical discourse, such a formalist realism originates in Poussin's famous distinction between the *aspect* of things and their *prospect*. According to Poussin, there are

two ways of viewing objects: simply seeing them, and looking at them attentively. Simply seeing is merely to let the eye take in naturally the form and likeness of the things seen. But to contemplate an object signifies that one seeks diligently the means by which to know that object well, beyond the simple and natural reception of its form in the eye. Thus it can be said that mere aspect is a natural operation, and that what I call *Prospect* an office of reason which depends on three things: the discriminating eye, the visual ray, and the distance from the eye to the object.[11]

From Szarkowski's point of view, the informational and documentary version of photographic practice is "aspectival," a merely mechanical way of seeing things. He wishes to restore contemplation and discrimination—the mind—to photographic seeing. The aim of the "prospect" is to see life better by abstracting from it.

Another way of putting this is to say that Szarkowski has turned his attention from the denotational aspects of the image and begun to concen-

trate instead on the connotational. Following the lead of art history, he has opened photography to the realm of iconology. But what interests Szarkowski is an extremely limited—and ultimately revealing—range of connotational possibilities. Take for example his 1973 exhibition at MoMA, From the Picture Press. With the help of Diane Arbus and Carole Kismaric, Szarkowski chose a series of anonymous photographs culled from the pages of the New York *Daily News* and exhibited them without their original captions or accompanying stories. The point was to demonstrate what Szarkowski called the essential "narrative poverty" of the photographic image. Bereft of the text, the only way to approach these photographs was as "short visual poems," formally coherent lyric moments which evoke the modernism of poets such as William Carlos Williams. "As images, the photographs are shockingly direct," Szarkowski wrote, "and at the same time mysterious, elliptical and fragmentary, reproducing the texture of experience without explaining its meaning."[12] For Szarkowski, as for Roland Barthes, the specific character of the photographic image results from this collision between the direct, denotational "naturalness" of the scene—the simple *"being there* of the thing"—and, at the same time, a sense of far greater mysterious, elliptical, and fragmentary meanings inherent on a connotational level in the sign.[13]

Modernism has always seen this connotational mystery to be a function of what Poussin calls "knowing the object well." That is, in Szarkowski's words, the artist discerns "discoverable patterns of intrinsic meaning" in the object by which he joins himself to a "larger intelligence." As Baudelaire maintained in "The Painter of Modern Life," arguably the essay in which the modernism I am describing is first fully articulated, "Modernity is the transitory, the fugitive, the contingent, the half of art, of which the other half is the eternal and immutable . . . [a] mysterious beauty."[14] Baudelaire, of course, despised photography because it seemed to partake so thoroughly of modernity's transitory, fugitive, and contingent side, but the project of photographic modernism has always been to locate the eternal and the immutable within the apparently transitory and fugitive scene. Szarkowski's From the Picture Press thus strips the image of its accompanying story in order to purify it of its transitory, fugitive, and contingent elements. With that textual clutter stripped away, the image's formal character and beauty is in theory exposed. In turning away from the denotational to the connotational, then, Szarkowski is locating connotational import solely in the formal dimension of the work. As he puts it at the end of *Mirrors and Windows*, the artists in the exhibition, including Nicholas Nixon, "are all, finally, in pursuit of beauty: that formal integrity which pays homage to the dream of a meaningful life."[15]

Formalism in art historical discourse has long been limited by this determination to locate the structure of meaning in the formal integrity of

the work of art, in a notion of internal coherence and harmony that amounts, in the phrase of Norman Bryson, to little more than "a connoisseurship of abstraction."[16] As Bryson has pointed out in his recent *Vision and Painting*, one of the great failures of art history has been its unwillingness to recognize that all codes of connotation operate within the social formation. In the first place, art history tends to see abstract design, order, and harmony as if they bespoke universal verities that transcend the social formation itself rather than as manifestations of a society's very desire for the consolation such ideas of order might offer it. More particularly, by locating the connotational meaning of the image in the transcendental, art history is free to leave that meaning unstated—"mysterious" and "beautiful"—beyond the realm of human discourse. A painting or a photograph, then, might reasonably be said to be at once semantically nonexplicit but syntactically specific: that is, while its final meaning is nonexplicit precisely because it is transcendental, what generates that meaning (the internal harmonies and oppositions that take place within the frame) is wholly describable. In modernist art this formal syntax of abstraction generates and supports the teleology of the image itself.

It should be clear, then, that Szarkowski's insistence on the "narrative poverty" of the image is actually a tactic that allows him to impose his own formalist narrative upon it. The manner in which Garry Winogrand's work has been canonized by the MoMA Department of Photography is a case in point. Winogrand's photographs so self-consciously abandon composition, order, and formal coherence as plastic values, so thoroughly identify themselves with casual and "inartistic" snapshot effects familiar to us all, that they would at first seem an anathema to any formalist approach. But Tod Papageorge's catalogue essay for Winogrand's huge 1977 show Public Relations at MoMA discovered in his work a consistent formal vocabulary, based on tilting the picture frame in order to create an "off-balance" sense of reality, the use of a wide-angle lens in order to pack the image with incidental information, and a conscious testing of the limits of scale in order to see "how small a thing could be in a frame and still sit as its nominal subject."[17] Whatever can be said along these lines about a photograph like Winogrand's 1957 *New Mexico* (Fig. 14), which Szarkowski included in the Mirrors and Windows show, to approach it without recourse to its cultural context in formalist terms as acute, even, as Papageorge's is at least partially to misread it.

This is not to say that certain formalist values are not important to our understanding of the work—the almost iconographic opposition, for instance, between nature and civilization, chaos and control, which is structurally underscored both in the tonal contrasts and tilted planes and parallels of the print—but it is to say that this photograph is far richer in the context of Winogrand's sweeping photographic record of bourgeois cul-

FIGURE 14. Garry Winogrand, *New Mexico*, 1957. Gelatin-silver print, 9 × 13 1/8 in. Collection The Museum of Modern Art, New York. Purchase.

ture. In this print, for instance, the banality of the scene, the almost desperate realization of the middle-class dream of owning a home of one's own, verges on a bathos that derives from the juxtaposition of the photograph's vernacular content and its formal eloquence. The particulars of the scene, in a sense, deny the art of their rendering, and this collision of values throws the whole formal idiom of the work into question. The opposite holds true as well—the formal harmonies of the scene seem to transcend its particulars—but the point, obviously, is that the photograph's dynamism originates in the confrontation. Winogrand has said that the only thing that interests him in photography is this "contest between content and form."[18] Over and over again in Winogrand's photographs we discover an admitted and purposeful "contest" between the transitive values of the work—their self-conscious and emphatic sense of the vernacular—and the intransitive, self-reflexive qualities of the formalist object. Winogrand's disquieting 1973 *Eliot Richardson Press Conference* (Fig. 15), from the Public Relations show, is virtually classical in its contrasts between light and dark, vertical and horizontal, the natural and the mechanical, the human and the machine. Its slightly tilted, off-center composition heightens

FIGURE 15. Garry Winogrand, *Eliot Richardson Press Conference*, 1973. © 1984 The Estate of Garry Winogrand. Courtesy Fraenkel Gallery, San Francisco, and The Estate of Garry Winogrand.

our sense of discomfort before it. But it seems to me that the real source of its power is the narrative of Watergate which lies behind it—the complex fabric of dissembling, posturing, and maneuvering which seemed to define so accurately the politics of the early seventies. What Winogrand's Public Relations show in fact demonstrated was how thoroughly media events such as this one are *staged*. It is as if the structural harmonies of his scenes were *poses* beneath which other more complicated and chaotic narrations are unfolding. By implication, all photography—and all art—is caught up in this same posturing. The whole business is "public relations."

II

Roy Lichtenstein's famous *Little Big Painting* (1965), the giant benday dot "action painting," was an early attempt to reveal how thoroughly the monumental, self-expressive painting of the fifties had been dominated by the same posturing that Winogrand detected in Public Relations, and Andy Warhol's Portraits of the 70s show employed an expressionist gesture similarly emptied of any sense of an authentic self-expression underlying it. By the mid-sixties, the splash and the drip, the broad sweeping uncon-

trolled brushstroke, the comma-like tracery which marked the flick of the painter's wrist, had become a *rhetorical* mode. Such gestures were meant to express emotional intensity and depth of feeling on the surface of the picture plane, but to pop artists such as Warhol and Lichtenstein these gestures reeked of the fashionable, not the authentic. The painterly surface of the abstract expressionist canvas had become a stage upon which gesture had become at best a kind of mask. These same doubts have manifested themselves again most recently in relation to so-called neo-expressionist painting. As painter Joan Snyder has put it, "People are making so-called Expressionist paintings, but it's just another way for them to make a gesture. They're not really feeling it so much. It seems like a posture."[19]

Similar questions concerning posturing and authenticity are raised not only by Nixon's portraits of the Brown sisters but, in fact, throughout the historical development of the family portrait as a genre. The family portrait originates in the Dutch Golden Age as part of a general cultural urge to give status to the bourgeois institution of marriage by placing it in a larger public frame of reference. As David R. Smith has pointed out in a study of Rembrandt's marriage portraits, most early family groups "are not addressed to the private and personal dimensions of domestic life, but to the family as an institution within the larger social order. What defines [the sitters] is neither their surroundings nor their relationship to one another, but the formal social ritual—the etiquette—of their encounter with the beholder." According to Smith, the sitters present us with a "public mask of decorum" that "acknowledges the profoundly rhetorical nature of the occasion" occurring within a setting that is not "a home, but a stage."[20] The poise and self-assertion of the sitters in family groups, then, reflect a bourgeois desire to appropriate "the cultivation of manners and polite deportment found at Renaissance courts," but in the bourgeois setting these physical attitudes soon lost their "association with courtliness alone and gained a more general connotation of virtue and moderation," values so paramount to the bourgeois mind that, "in a sense, conjugality becomes synonymous with good citizenship."[21] The tendency of Dutch painting in general, however, and Rembrandt's double portraits in particular, was to soften this formality and decorum and introduce a more casual and personal quality into the family portrait. It is this tendency which leads during the next century to the conversation piece as a distinct genre. "The outstanding contribution of Dutch artists to the development of the family group," art historian William W. Robinson writes, "was to depict the sitters on a small scale, engaged in a casual activity in everyday surroundings. Mundane attributes which define the individuality, the quality of life or social distinction of the patrons—their homes, their country-house, their place of work or their form of recreation—for the first time are deemed worthy of inclusion in the family portrait."[22] These are precisely the characteristics of the

conversation piece as practiced in England during the eighteenth century by
the likes of William Hogarth, Arthur Devis, and Johann Zoffany: a small-
scale painting presenting identifiable, real people in their natural family
circumstances, engaged in some gesture signifying conversation, communi-
cation, or even simply the harmony that exists among themselves.[23]

After photography took over the function of portraiture during the
nineteenth century, as photography "democratized" the portrait, the aspir-
ing lower classes rejected the casual depictions of activity in the conversa-
tion piece and opted for the more highly serious poise and self-assertion of
the early Dutch portrait, perhaps finding such a pose more aristocratic.
"The most uniformly condemned mistake that a photographer could make,"
Elizabeth Anne McCauley writes in her history of the portrait photograph
in Europe from 1850 to 1870, "was to construct a 'dramatic' pose."[24] For
one thing, motion and gesture seemed to violate the bounds of the medium
itself, since absolute stillness was for so long required of the sitter. Photo-
graphic perfection demanded quietude, and calm became equated, then,
with photographic decorum. The public simply came to think of static poses
with nothing but the most fixed facial expressions as appropriate and natu-
ral. Similarly, the idea of using "a real landscape" for a setting, as opposed
to the most-often favored stark and solid backdrop, was condemned, "like
a natural, movemented facial expression, [as] inappropriate to the iconic
concept of the portrait."[25] What seems staged or dramatic in one age, then,
appears natural to the next, and vice versa, but the point, surely, is that this
tension between the natural and the staged seems endemic to the portrait
genre as a whole. A photograph executed by the Paris studio of Mayer
frères et Pierson in 1858 of *The Prince Imperial on His Pony* illustrates this
tension with almost uncanny sensitivity (Fig. 16). The imperial prince,
posed before a solid backdrop, his pony held steady by his groom, sits qui-
etly for his portrait while his father, Napoleon III, tethers a blurred dog
that seems to have turned suddenly in reaction to the photographer's taking
the photo itself. "The charm of the image," McCauley writes, "derives
from the opposition between the serious, frontal, central grouping and the
peripheral, casual figures and moving dog, which should have been cropped
out of the final print."[26]

Another way to state this opposition is to see the image as simultane-
ously a composition and a snapshot. It collapses, that is, the distinction that
exists even to the present day between the formal studio portrait that most
families commission and the amateur Instamatic or Polaroid handiwork in
which most families continuously indulge. There are, I want to suggest,
two families to be photographed—one a formal, and formally coherent, art
object, and the other a much less coherent nexus of forces and oppositions
that emanate from both within and without it, a vernacular tradition that
is the preeminently historical situation of the individual family itself. The

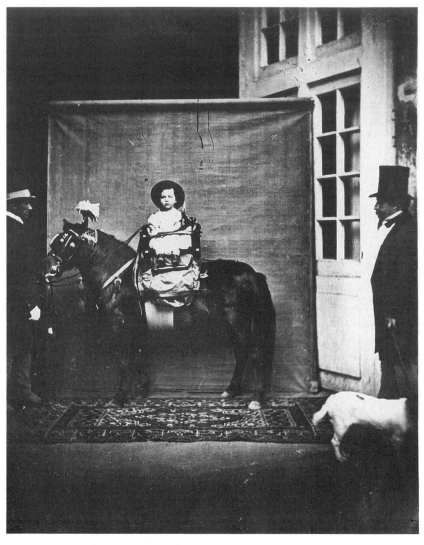

FIGURE 16. Mayer *frères et* Pierson, *The Prince Imperial on his Pony*, 1858. Courtesy Archives dèpartmentales du Haut Rhin. Collection Musée Unterlinden, Colmar, France. Photo: Christian Kempf.

first kind of family was perhaps best described by John Ruskin in 1865: "This is the true nature of the home—it is a place of peace: the shelter, not only from all injury, but from all terror, doubt and division. . . . So far as the anxieties of the outer life penetrate into it, and the inconsistently-minded, unknown, unloved, or hostile society of the outer world is allowed by either husband or wife to cross the threshold it ceases to be a home. . . . It is a sacred place, a vestal temple."[27] Substitute "art" for "the home" here, and we have an almost perfect definition of the formalist object, but

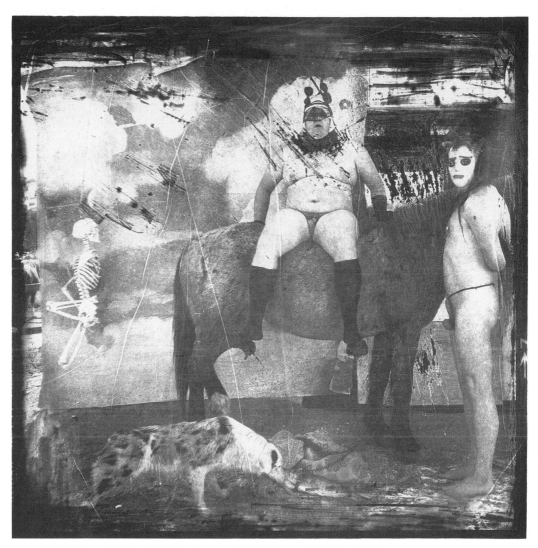

FIGURE 17. Joel-Peter Witkin, *The Prince Imperial*, 1981. Photo: © Joel-Peter Witkin.

more important, the ease with which we are able to make this substitution reveals how thoroughly the institution of the family and the institutions of art are implicated in the same rhetorical, aesthetic, and social structures. They promulgate a dream of coherence and unity against which the second kind of family stands, the family that admits the disruptive forces of the outside into the space of the postmodern portrait.

Nowhere have these forces been more thoroughly articulated than in the photography of Joel-Peter Witkin. Witkin's own version of *The Prince Imperial* (Fig. 17) "copies" the original not merely in order to parody it, but in order to submit it to history. Witkin takes to heart Marx's indictment

of the reign of Napoleon III in *The Eighteenth Brumaire of Louis Bona-parte*: "Hegel remarks somewhere that all great events and historical personages occur, as it were, twice. He forgot to add: the first time as tragedy, the second as farce." For Marx, the new Bonaparte was "clumsily cunning, knavishly naive, doltishly sublime," a personage constructed of "calculated superstition, pathetic burlesque, cleverly stupid anachronism, a world historical piece of buffoonery, an indecipherable hieroglyphic for the understanding of the civilized"—in short, a reasonably accurate description of Witkin's photograph. Just as Bonaparte enlisted in his service the "scum (*Auswurf*), offal (*Abfall*), refuse (*Abhub*) of all classes," so Witkin seems to have enlisted the same for his new portrait of the "prince."[28] Just as Napoleon III was "above all through his incapacity to do anything but the imitation or degraded representation of Napoleon I, his simulacrum," so Witkin's photograph is a simulacrum of the work of the Mayer *frères*.[29] What Witkin's work disrupts is the very dialectic between snapshot and pose that the earlier work explores, exposing (as it were) the entire *scene* as fundamentally *theatrical*. By introducing this third term, he introduces the heterogeneity of history (a work's historical reception and interpretation) into the work. In the words of Roland Barthes, the original (in this case, the Mayer *frères'* print) is "no longer consecrated by a narrow ownership (that of its immediate creator), it journeys in a cultural space which is open, without limits, without hierarchies, where we can recognize [that is, acknowledge] pastiche, plagiarism, even imposture—in a word, all forms of the 'copy,' a practice condemned to disgrace by so-called bourgeois art."[30]

As Craig Owens has put it in an essay on "the rhetoric of the pose" in the work of Barbara Kruger, "to strike a pose is to present oneself to the gaze of the other as if one were already frozen, immobilized—that is, *already a picture*."[31] It is to affirm *imposture* as the condition of portraiture. To put it another way, this time in the words of Roland Barthes, "photography is a kind of primitive theater, a kind of *Tableau Vivant*."[32] There has always been a sense of the staged in portraiture, a sense that what we see is a *tableau vivant* its characters have chosen to perform. The postmodern portrait, then, presents us with nothing resembling a self-contained work of art. It affirms, in fact, what Baudelaire despised about photography—the work of art's transitory nature, the contingency of our ability to interpret it, and the fragmentary status of its presentation.

Above all, our awareness of such posturing undermines the seeming objectivity of photography as a medium. This sense of the photograph's duplicity derives at least in part, of course, from the uses to which advertising has put it, just as, I think, our distrust of neo-expressionist gesture derives today from its extraordinary success in the "market." It is hardly accidental, for instance, that Garry Winogrand worked as an advertising

photographer for two decades, until the late fifties. In advertising, the surface of things masks some "greater truth"—nothing transcendental but, still, some larger, covert narrative. Roland Barthes's famous analysis in *Mythologies* of the *Paris Match* cover showing a black soldier saluting the French flag is a perfect example. For Barthes the image is part and parcel of an unstated but systematic effort to promulgate a myth of colonial and racial harmony.[33] It is a consummate act of *bad faith*, as if staged.

III

The difference between Barthes's *Paris Match* cover and Winogrand's work is that Winogrand is conscious of the staging of his subjects. The very appearance of his snapshot-like compositions in a fine art context draws our attention to the fact that things are not as simple and straightforward as they might appear. It would be possible to say that this staging of the self is Winogrand's real subject, and this seems to me equally true of such other contemporary portraitists as Diane Arbus, Robert Mapplethorpe, Andy Warhol, Cindy Sherman, and William Wegman. As art critic Amy Golden has noted, "The portrait is not just a picture of a person, but a picture of a person on view, poised to be looked at. The element of arranged appearances is built into the genre."[34] But it is not sufficient to say that the portrait is the unmediated record of a self-projection, a self constituted as it faces the camera. Clearly, the very presence of the camera alters its object; it is the camera that defines and requires the moment's very staginess. As Roland Barthes has put it, "In front of the lens, I am at the same time: the one I think I am, the one I want others to think I am, the one the photographer thinks I am, the one he makes use of to exhibit his art."[35] Barthes calls this collision of points of view a "field of forces"—but a better way to think of it is as the kind of situation, fueled by fluid and complex sets of competing significations, to which postmodern art likes to draw our attention in order to undermine the very idea of constituting the self. Wegman's work offers an almost perfect example.

Wegman is most famous, of course, for his series of portraits of his dog, Man Ray. Wegman's weimaraner has appeared in hundreds of photographs executed between 1970 and 1982 (when the dog died), and in all sorts of guises and poses—as, for instance, a racoon (Fig. 18) or a frog (Fig. 19). One way to look at such photographs is to see them as wholly constructed objects, so "composed" and fanciful that they seem to deny the documentary function of photography altogether. Speaking of the way Man Ray has functioned in his work, Wegman has admitted that "in a way he's like an object. You can look at him and say, now how am I going to use you."[36] In this sense, the photographs become extraordinary exaggerations—virtual parodies—of *still life*, a kind of perverse compounding of the most formal of representational genres and the exhortations of an aggravated owner—

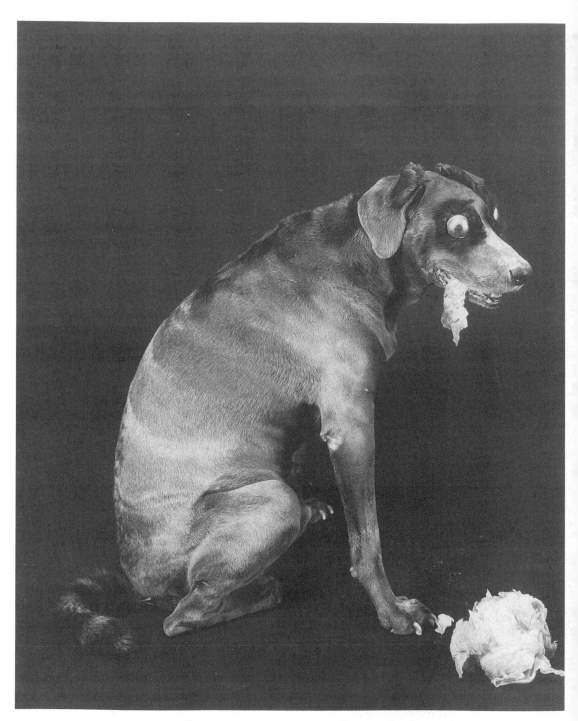

FIGURE 18. William Wegman, *Racoon Eating Food*, 1982. Color photograph (Polaroid Land 20 × 24 camera on Polacolor II film), 24 × 20 in. Courtesy Holly Solomon Gallery, New York.

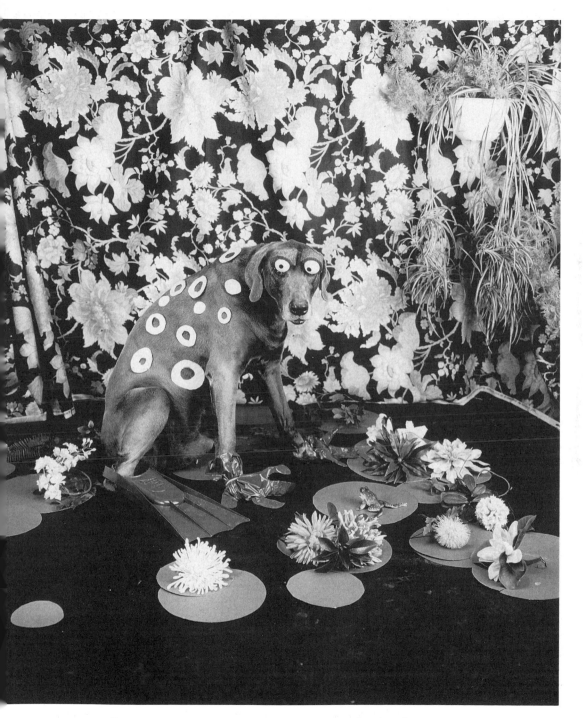

FIGURE 19. William Wegman, *Fake Frogs*, 1982. Color photograph (Polaroid Land 20 × 24 camera on Polacolor II film), 24 × 20 in. Courtesy Holly Solomon Gallery, New York.

"Be Still!" The art object is defined as something to be held in position, submitted to the artist's control and mastery (Color Plate I). On the other hand, given the dog's name, Man Ray is also a "figure" for the artist, at once Wegman's collaborator (Wegman called him his "art partner") and straight man.

This transformation of weimaraner into Man Ray, dog into artist, undermines the authority of the artist and casts doubt on the validity of his intentionality. How can Man Ray *intend* any effect? And if he can, as one begins to suspect he can the longer one looks at the record of his performance before Wegman's camera, then the whole privileged artifice of artistic intentionality comes crashing down around him. Furthermore, as I have already suggested, Man Ray is not merely a figure for the artist, he is a figure for William Wegman, an alter ego putting on Wegman's many faces, a Charlie McCarthy to Wegman's Edgar Bergen. The structure of this transference of identity (which is multilayered—the portrait of the artist as dog, the portrait of the dog as elephant, and so on) shares a great deal with many of Wegman's video productions, of which *Rage & Depression* is exemplary. Like the vast majority of Wegman's videos, this is an extremely brief performance. Wegman simply sits before the camera, a genial smile on his face, and tells the following story:

I had these terrible fits of rage and depression all the time. It just got worse and worse and worse. Finally my parents had me committed. They tried all kinds of therapy. Finally they settled on shock. The doctors brought me into this room in a straight jacket because I still had this terrible, terrible temper. I was just the meanest cuss you could imagine and when they put this cold, metal electrode, or whatever it was, to my chest, I started to giggle and then when they shocked me, it froze on my face into this smile and even though I'm still incredibly depressed—everyone thinks I'm happy. I don't know what I'm going to do. [37]

This pseudo-autobiography, the expression of a persona, is an allegory for the "art situation" as Wegman sees it: the doctors have made someone (as the artist portrays someone) who *seems* to be one thing, but turns out to be quite another. Who you see is not who is there. In fact, since Wegman is "playing" a part in this video, since this is a role, a question arises whether there is any "identity" there at all.

It is a simple move to transfer this lesson to Wegman's portraits of Man Ray—whatever Man Ray's "personality," Wegman's manipulations of his appearance only mask it. And, as opposed to the desperate persona of *Rage & Depression*, Man Ray cannot articulate the difference, cannot say what lies behind the mask other than his essential dogness. Man Ray's poses—even his name—are a series of signifiers which float above a signified (this dog) to which they bear no necessary relation. And if Man Ray has no "personality" except the one constructed for him by Wegman, then does

Wegman himself possess any identity beyond the fictional fabric of his own "self"-constructions? The self, finally, is a kind of theater, an ongoing transference of identity, an endless "acting out."

The photography of Robert Mapplethorpe raises many of the same issues. But the difference between Mapplethorpe's and Wegman's work is profound—what in Wegman's photographs remains "play" (both the theater and fun of masquerade) becomes in Mapplethorpe's a challengingly understated crisis of signification. This is not simply a matter of "style"—Wegman's comic sensibility as opposed to Mapplethorpe's cool cynicism—but a question of the attitude each takes toward the ungrounded and unbounded postmodern self. Such a proliferation of selves appears to offer Wegman a way to undermine the legitimacy of typological thinking and the authority of any given point of view. The self in his work is something "undecidable," a fluid condition of conflict and contradiction that, if it offers no possibility of final definition, does liberate Wegman to explore, even to the limits of the ridiculous, the processes by which we continually (re)constitute our identities. Mapplethorpe likewise recognizes the "undecidable" nature of the self, but rather than use this realization as a tool to examine the processes of our self-assertion, he portrays the self as the site of a dialectical argument between the self's very undecidability and its desire to be fully constituted, wholly present to itself. That is, for Mapplethorpe, the desire for self-possession and self-realization, and the impossibility of ever realizing that desire, defines the fundamental tension that makes for the undecidability of the self. For Wegman, the self is an arena of free play; for Mapplethorpe, the scene of desire. Wegman's work is constantly self-effacing (in all senses of the word), while the objects of Mapplethorpe's camera seem aggressively, but hopelessly, self-centered.

Mapplethorpe has concentrated on depicting the nude—both male and female—in order to foreground the centrality of desire to his art. His nudes are clearly avant-garde in character—that is, his subjects are people who overtly challenge the canons of bourgeois sexuality and desire: transsexuals, the homosexual S & M leather crowd, and such underground celebrities as "Mr. 10 1/2," the porn star Marc Stevens, named after the prodigious length of his sexual member. In fact, the layers of identity which inform Mapplethorpe's famous photograph of "Mr. 10 1/2" explicitly place his portraiture in the same theater of the self as we discovered in Wegman's work. In the tradition of the porn industry, "Marc Stevens" is undoubtedly a pseudonym, masking another, unknown identity, but furthermore, even the "Marc Stevens" persona is absent in his photograph, his face cropped from the image, so that he becomes his member, itself cut off from the body, separated from the self, first in formal terms, by black leather chaps, and then, metaphorically, as it lies prone on what appears to be a butcher block. The implication is that the only identity "Marc Stevens" ever pos-

sesses is a function of the performance of his phallus—and that identity is itself constantly threatened.

A similar "absenting" of the self characterizes Mapplethorpe's collaboration with the body artist and self-styled first World Women's Bodybuilding Champion, Lisa Lyon, in a series of 115 photographs published in 1983 under the title *Lady*. Ostensibly these photographs were meant to document, in the words of the book's foreword, a "revised femininity."[38] In overly simplified terms its project is vaguely feminist in orientation, giving the feminine access to heretofore masculine domains, specifically the physical mastery of the body through muscle building. But if, on the one hand, these photographs added a new dimension to the idea of feminine beauty by extending it beyond the realm of soft acquiescence into the realm of physical self-assertion, on the other, especially in the many photos where Lyon's head is either cropped or veiled, this new "dimension" can be read as just another (masculinist) reduction of the feminine to the status of a body. As much as any centerfold's, Lyon's identity is invested in the body, a body which is revealed to be a purely sexual object in, for instance, a series of four photographs that begins with a shot of a shadowed wall with nothing on it but a light socket, followed by Lyon standing in Spanish dancer costume before the wall, then by Lyon raising her skirt, and finally, with her skirt raised high enough to veil her face, naked from the waist down, her genitals replacing the light socket on the wall, one more thing to be plugged into. Or in another image, Lyon's pubic area is exposed directly above a white, blade-like triangle on the wall behind her. Like a giant phallus, it descends from her crotch. This is, of course, the classical Freudian version of woman constituted not by what she is but by what she lacks.[39] To leaf through *Lady*, in fact, is to witness someone desperately trying to assert a self but failing more and more thoroughly, the harder she tries. Paradoxically, over the course of 115 portraits, Lyon's identity threatens to disappear. She begins to emerge, as Joel-Peter Witkin has subsequently portrayed her, as a Halloween-masked caricature of Hercules (Fig. 20).

IV

If this sense of the theatricalization of the self is implicit in all portraiture, in terms of the Nixon photographs it becomes a question of just how much this family is *staged*, whether we are witness to a once-a-year agreement to get together and get along "in the manner of" families everywhere or a "truly" close-knit family group. Put another way, these photographs raise the issue of their own *integrity* as documents. They point back to the social narrative from which they have been lifted. Such works insist that we approach them, as Allan Sekula has put it, "not as privileged objects but as common cultural artifacts,"[40] in terms, that is, of the vernacular.

Sekula has pointed out that one way photographers such as Martha Ros-

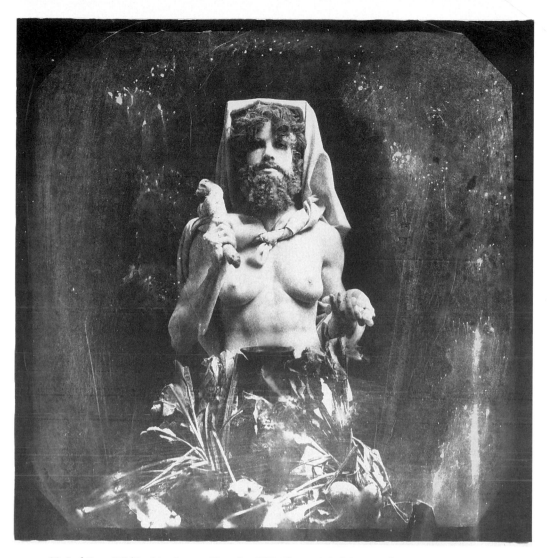

FIGURE 20. Joel-Peter Witkin, *Lisa Lyon as Hercules*, 1983. Photo: © Joel-Peter Witkin.

ler, Jim Jost, Philip Steinmetz, Chauncey Hope, and Sekula himself ensure this reading of the photographic image is "to bracket their photographs with language, using texts to counter, contradict, reinforce, subvert, complement, particularize, or go beyond the meanings offered by the images themselves." As a result, their photographs "are often located within an extended narrative structure."[41] If any one theme unites this work, it is that the photograph always exceeds its frame, that its meaning proliferates across its margins. In a work like Duane Michals's *This Photograph Is My Proof* (Fig. 21)—an image admittedly unusual in Michals's work since he normally works in a much more surrealistic vein than the other narrative photographers I have mentioned here—the accompanying text deconstructs the rhetoric of the image in ways exemplifying the best narrative

photography. That is, not only does the writer insist too much on the one-time viability of his love life, making us wonder if his relationship with the woman in the picture was ever as "good" as he imagined it to be, the photographic image is itself revealed to be an agent of dissimulation, an accomplice in his apparent self-deception. His insistence on our taking the photograph as "proof" amounts, in larger terms, to an insistence on our thinking of photography as somehow presenting a set of "objective facts." The irony, of course, is that the moment he *writes*, the moment the compulsion to interpret the image takes over, the meaning of the work *exceeds* the frame itself. And once the work is so opened—as it inevitably is—to the interpretive act, we are invited to read a different story from the one Michals tells, a pathetic little narrative about the ways in which we insist that people "prove" their love, the ultimately destructive desire to make concrete, in order to possess, not only another's most intimate feelings but also the other herself.

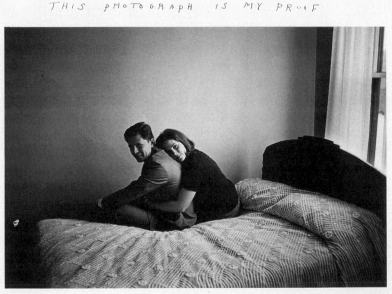

FIGURE 21. Duane Michals, *This Photograph Is My Proof*, 1967 and 1974. Silver print, 8 × 10 in. Courtesy Sidney Janis Gallery, New York.

THIS BOY WAS CROSSING HOUSTON STREET WITH A GROUP OF FRIENDS. HE LEANED NEAR ME AND SAID, "I LIKE YOU, MAMA." WHEN I ASKED TO TAKE HIS PICTURE, HE SEEMED EMBARRASSED. HIS FRIENDS YELLED, "HEY CARLOS! THAT LADY LIKES YOU!" HE INSISTED ON POSING FOR THE PICTURE AND MOTIONED HIS FRIENDS OUT OF CAMERA RANGE.

FIGURE 22. Laurie Anderson, from *Object/Objection/Objectivity*, 1973. Courtesy The Institute for Contemporary Art, University of Pennsylvania.

One of the earliest works of performance artist Laurie Anderson is a 1973 series of photographs entitled *Object/ Objection/ Objectivity* (Fig. 22) that explores precisely this theme, the tendency of the photograph to appropriate its object. Each of the photographs in the work is accompanied by its own narrative, but the whole is introduced by the following story:

On June 5, 1973 (my 26th birthday) I was eating shrimp in a little restaurant in Chincoteague, Virginia. A woman who appeared to be in her mid-50's, wearing white toreador pants, came over to my table and stared at me for a few seconds. . . .

"You're the one on The Secret Storm who's in love with the doctor but she can't marry him 'cause his mother thinks you're the one who caused the accident that . . ."

"No, I'm not her," I said. "I guess I just look like someone else."

This denial seemed to delight her.

"Of course you deny it! You don't want to be recognized! I understand, of course. You know, a lot of celebrities come in here and they all deny it!"

I smiled.

"See!" she said. "You smile just like her!"

I denied it again but the more I denied it, the more convinced she became. . . .

Partly to assert myself, I asked if I could take her picture. She said, "An old bag like me?"

Later, I realized that her mistake had made me angry. She thought she recognized me but it was an illusion. She was blind to who I really was and saw me

instead as an object (T.V. star i.e. public property). Taking her picture was my way of stealing something—of turning her into an object (subject matter); a way of shooting her.

When I returned to New York City, I realized the extent of my objecthood in the eyes of the man-on-the-street. The daily unsolicited comments (of the "hey baby" type) were attempts at turning me into an object to be cooly assessed. One day in the middle of June, I took photographs of the ten males who approached me in this way.

To my initial disappointment, and ultimate interest, most of them seemed pleased and flattered by the "honor" which began as an assault.[42]

The irony, of course, is that within ten years Anderson would in fact become a "star" herself, and though in her performances she seeks out ways to deflect our attention—by assuming other identities, for instance—like the men whom she photographed in *Object/ Objection/ Objectivity* she seems to enjoy the star status, or at least the paradoxical situation in which she finds and defines herself.

Probably no two artists have investigated the role of the "star" in portraiture more thoroughly than Cindy Sherman and Andy Warhol. Warhol's portraits, as Roberta Bernstein has pointed out in the catalogue raisonné of his prints, "are almost always about surface appearance":

In the tradition of a certain style of official society portraiture, they show what the public wants or needs to project onto people who become transformed into cultural symbols: people whose "faces seem perpetually illuminated by the afterimage of a flashbulb." Warhol's role as portraitist is not to represent or interpret the features of a person, but to present those features as already captured in a photograph, particularly one where the individual is recorded posing self-consciously for the camera.[43]

Likewise, the uncanny feeling that one gets before Cindy Sherman's work is that we all define ourselves, constantly, as if we were Warhol's cultural symbols.

In the 1984 monograph of Sherman's work published by Pantheon—something of a best-seller as art books go—Peter Schjeldahl has divided her "self-portraits" into several distinct groups: the early black and white "film stills"; the "backscreens," color shots which use backscreen projection to create a sense of filmic unreality; the 2 x 4 foot color "horizontals" of 1981; the equally large "verticals" of the following year; a series of "ordinary people"; and finally what Schjeldahl calls Sherman's "finest work to date," the sometimes very large (8 × 4 foot) "costume dramas" of 1983.[44] Each of these pieces individually evokes a larger narrative. It is almost impossible for me to look at a work such as *Untitled Film Still #28* (Fig. 23) without constructing an entire cinematic horror story around it. But the narrative implications of the individual works are really beside the point. What cannot be dismissed is that these works exist in series, and in series they posit the self as a compendium of poses, derived from film,

FIGURE 23. Cindy Sherman, *Untitled Film Still #28*, 1979. Black and white photograph, 8 × 10 in. Courtesy Metro Pictures, New York.

fashion, and advertising and constructed out of a repertoire of makeup tricks and the wardrobe of a practiced, secondhand store clothes horse who has never given anything away. It is as if, every morning, Sherman's self "puts on" what it is going to be—and what it is going to be is determined by the media and the marketplace. Such an idea of selfhood of course has far-reaching implications in feminist terms—and I will develop *that* narrative in the next chapter—but the ultimate irony of Sherman's portraits is that they address us as media representations in their own right. The costume dramas, for instance, were undertaken at the request of costume designer Dianne Benson and were originally intended to be advertisements. They have the look and feel of *Vogue* (Fig. 24). They are selling us an image. Schjeldahl puts it this way:

In the "costume dramas," Sherman lays her artistic cards on the table: We are to know (and she is to know that we know that she knows, in the spiraling complicity of the theatrical) that she is acting an actress acting a part. Staged and stagey, these pictures are as stylized as Kabuki or *commedia dell'arte* or Brecht or Rodgers and Hammerstein or any of the systems of dramatic artifice they variously (though never specifically) evoke. . . . Makeup, costumes, and lighting seemed keyed to fictive sightlines and distances—last corner seats in farthest balconies. We are

FIGURE 24. Cindy Sherman, *Untitled*, 1983. Color photograph. Courtesy Metro Pictures, New York.

awash in the force fields of performances not meant for us—this being the sensation meant precisely for us.[45]

Like Warhol before her, Sherman exploits the very marketability of the pose, our desire to "buy in."

It is, finally, into situations such as these—into the rhetoric of the pose—that Jacques Derrida places us when he speaks, in *Of Grammatology*, of that "indefinite process of supplementarity" which constitutes "the space of repetition and the splitting of the self." For the self is constituted above an "abyss (the indefinite multiplication) of representation,"[46] a series of possible selves that we can choose among, act out, discard. But our relationship to each of the selves we choose to imitate is even more complicated than it might appear. Recently a number of critics have reminded us that there are two kinds of repetition.[47] One, which we might call Platonic and which is the basis for mimetic theory in the West, believes that the original is unaffected by its repetition. It is a theory of correspondence and sameness and is the means by which we usually approach photography. In terms of the pose, it is like choosing to "model" oneself after, for instance, one's hero. But imagine choosing to model oneself after Cindy Sherman. What, who, does Sherman represent? As Stephen W. Melville has suggested, perhaps she represents the very idea of representability itself, the fact that in the portrait we give ourselves as representations.[48] Because the photograph is always *other* than what it represents, a document, it posits the self as always in excess of what is presented to us within the frame. It affirms the polysemy of representation. Such is the second, Nietzschean form of repetition, in which representation is no longer grounded in sameness but in difference. Here, repetition generates "simulacra," not copies, but traces of an "original" which has never been. This kind of repetition, I hope by now is clear, defines Nixon's Brown women, our sense that we are potentially witness to an "acting out" of the "idea" of the family rather than the embodiment of the family per se. They not only ask what *is* the family, they ask us to contemplate whether the family is itself only a simulacrum—a simulacrum, perhaps, of the very idea of community. Here, in this terrain of difference, we can begin to locate postmodern art as a whole.

A NEW PERSON(A)

Feminism and the Art of the Seventies

I met a happy man
a structuralist filmmaker . . .
he said we are fond of you
you are charming
but don't ask us
to look at your films
we cannot
there are certain films
we cannot look at
the personal clutter
the persistence of feelings
the hand-touch sensibility
the diaristic indulgence
the painterly mess . . .
he told me he had lived with
a "sculptress" I asked does
that make me a "filmmakress?"

Oh No he said we think of you
as a dancer

CAROLEE SCHNEEMANN, *Interior Scroll*[1]

Between the European avant-garde of the late nineteenth century and the new American avant-garde there exists a curious, inverse relation, as if the latter, in adopting many of the same concerns and themes of its predecessor, had done so in order to submit them to the strategies of deconstruction. It can be argued, I think, that the materials with which the original avant-garde sought to shock the middle class out of its complacency (*épater les bourgeois*) have, over the course of one hundred years, been so absorbed by our culture, become so part and parcel of everyday experience, that they have ceased to seem shocking and appear, instead, to be *natural*, the way things are. It is this "myth of the natural" that the contemporary avant-garde has sought to explode.

The reader of the previous chapter might have noticed, for instance, a certain correspondence between my description of the postmodern portrait, with its rhetoric of the pose, and the approach of T. J. Clark to the portraits of Manet. Clark has this to say about the great *Argenteuil, the Boaters* of 1874, and it applies as well to any number of other Manet portraits:

The people in the picture are posing, perhaps we could put it that way—posing not as artists' models do, but as people might for a photograph. . . . This is a picture of pleasure, remember, of people taking their ease. We need a word to express their

lack of assurance in doing so. . . . Veblen talks of individuals—he has in mind considerably wealthier women than the ones we are looking at—"performing" leisure, or "rendering" it. The verbs are useful but a bit too strident. . . . The best phrase, I believe, occurs in Norbert Elias's writings: he . . . points to "the cover of restraints" which spreads, more and more evenly, over action and affect in modern times. The "cover of restraints" in the place of pleasure—that seems to me the great subject of Manet's art. But it should be said at once, by way of proviso, that in Manet's art the restraints are visible: they are not yet embedded in behavior; they still have the look of something made up or put on.[2]

The difference between Manet's art and the art of the contemporary avant-garde is that the "cover of restraints" which is equally the subject matter of today's avant-garde is no longer visible. It is embedded in behavior and must, by some means or other, be exposed. If, in the context of today's avant-garde, words like "performing" and "rendering" no longer seem too strident, that is because they draw attention to the artificiality of the "naturalist" theater we have grown accustomed to staging among ourselves.

It is instructive, for instance, to compare Manet's treatment of such a "natural" thing as the body, in his famous *Olympia* of 1863 (Fig. 25), with a sort of centennial celebration of the original in Carolee Schneemann and Robert Morris's 1964 performance *Site* (Fig. 26). Here, quite literally, portrait is transformed into performance, art is itself "performed," "rendered," theatricalized. It is as if Schneemann and Morris were out to lift the "cover of restraints" in which the century has clothed *Olympia*.

According to Clark—his analysis not only is irresistible, but has such direct bearing on the argument at hand that it is worth developing at some length—Manet's *Olympia* greatly offended public taste in 1865, when it was first shown, because it "contrived a different kind of relation between a prostitute's class and her nudity" (117). It upset, that is, certain fixed notions of the *courtisane* and nineteenth-century society's relations to her. Above all, the *courtisane*, before *Olympia*, was a carefully constructed *pose*. She was supposed to be, primarily, beautiful, the embodiment, in fact, of Beauty. Her business, Clark reminds us, was "make-believe": "She seemed the necessary and concentrated form of Woman, of Desire, of Modernity (the capital letters came thick and fast)" (110). The falsity of her status was, nevertheless, readily apparent. Clark cites the reaction of Jules de Goncourt:

In my opinion none of them [the great *courtisanes*] escapes the class of prostitutes. They offer you nothing but a woman of the brothel. Whether they emerge from it or not, it seems to me that they smell of it for ever, and by their gestures, their words, their amiability, they constantly return you to it. None of them, thus far, has seemed to me of a race superior to the woman of the streets. I believe there are no *courtisanes* any longer, and all that remain are *filles*. (110)

According to Flaubert, this was an age in which "everything was false, false army, false politics, false literature, false credit, and even false *courtisanes*"

(111). To Clark, Manet's Paris was a society that knew, in its heart, that everything was "soaked right through with duplicity," but that also depended to an alarming degree (as Flaubert's reference to the army, politics, and credit suggests) upon its ability to accept "the rule of illusion" (111).

According to Clark, Olympia's power rested precisely in her ability to upset this "rule of illusion":

> The *courtisane* was a category, that is my argument: one which depended not just on a distinction made between *courtisane* and *femme honnête*—though this was the dominant theme of the myth—but also on one between *courtisane* and prostitute proper. The category *courtisane* was what could be *represented* of prostitution, and for this to take place at all, she had to be extracted from the swarm of mere sexual commodities that could be seen making use of the streets. These humbler tradespeople were shuffled off stage, and the world of sex was divided in two: on the one hand, the dark interior of the *maison close*, where the body escaped outright from the social order, and on the other the glittering half-public palaces of the *grandes cocottes* on the Champs-Elysées. Money and sex were thus allowed to meet in two places: either apart from imagery altogether, in the private realm, in the brothel's illicit state of nature; or in the open space of the spectacle, the space of representation itself, where both could appear as images pure and simple. (109–10)

Clark's point is that *Olympia* quite consciously moves between these two realms, an illicit token of the *maison close* insisting on the reality of her presence amidst the glitter of the Champs-Elysées. She lends the particular sexual identity of the prostitute to the myth of the *courtisane*. Put in other terms, she undermines the official representations of sexuality and desire.

Such official representations, as Clark points out, were everywhere apparent in the salons of the period. In these, Clark argues, "the painter's task was to construct or negotiate a relation between the body as particular and excessive fact—that flesh, that contour, those marks of modern woman— and the body as sign, formal and generalized . . . [a body] made over into a rich and conventional language . . . addressed to the viewer directly and candidly, but grandly generalized in form, arranged in a complex and visible rhyming, purged of particulars, offered as a free but respectful version of the right models, the ones that articulate nature best" (126–27). Olympia's name is an acknowledgment of just what these "right models" were thought to be—that is, classically Greek—and Zola's famous defense of her in 1865 amounts to one of the first truly formalist analyses in the history of modern criticism:

> What strikes me in these pictures is an extremely delicate exactitude in the relation of the tones to one another. . . . A head placed against a wall is nothing but a more or less white spot against a more or less grey background, and the clothing juxtaposed to the face becomes merely a more or less blue spot placed next to the more or less white spot. From this results an extraordinary simplicity—almost no details at all—an ensemble of precise and delicate spots. . . . Thus at first glance you distinguish only two tones in the painting, two strong tones played off against each other. Moreover, details have disappeared. Look at the head of the young girl. The

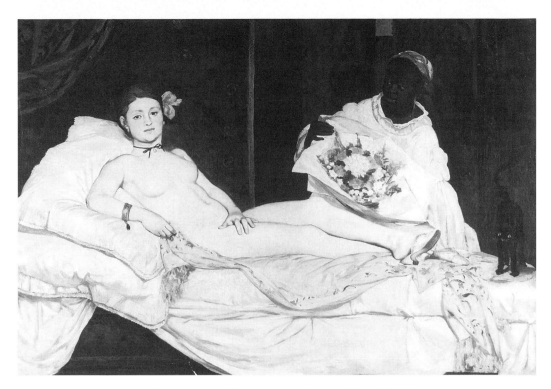

FIGURE 25. Edouard Manet, *Olympia*, 1863. Oil on canvas, 51 1/4 × 74 3/4 in. Collection Musée d'Orsay, Paris. Photo: Musées Nationaux.

FIGURE 26. Carolee Schneemann and Robert Morris, *Site*, 1964. Photo: © Hans Namuth.

lips are two narrow pink lines, the eyes are reduced to a few black strokes. Now look closely at the bouquet. Some patches of pink, blue, and green. Everything is simplified and if you wish to reconstruct reality you must step back a bit. . . . The painter worked as nature works, in simple masses and large areas of light, and his work has the somewhat rude and austere appearance of nature itself.[3]

No sooner did *Olympia* expose the myth of the *courtisane* than Zola insisted that she had nothing to say about the myth at all. Manet paints "naturally." The point is a simple one: artistically Olympia is one thing—and even though most critics despised the manner in which she was painted, this of course remained merely a question of *technique*, a formal concern—but historically she is quite something else. Historically she escapes art. As Clark puts it, Olympia "looks out at the viewer in a way which obliges him to imagine a whole fabric of sociality in which this look might make sense and include him—a fabric of offers, places, payments, particular powers, and status which is still open to negotiation. If all that could be held in mind, the viewer might have access to Olympia; but clearly it would no longer be access to a nude" (133). It should be clear that in order to avoid confronting this particular fabric of sociality, this negotiation over the body, it would be easier, as Zola insisted, to think of Manet's little *mise en scène* as painting pure and simple.

Schneemann and Morris, in fact, insist on thinking about *Olympia* in terms other than those of painting. Whatever *Site* is—tableau, theater, dance, sculpture—it re-presents painting, and leaves it behind. In statements prepared for the 1970 Conceptual Art and Conceptual Aspects exhibition at the New York Cultural Center, Morris would summarize the theoretical assumptions that inform works such as *Site*:

In a broad sense art has always been an object, static and final. . . . What is being attacked, however, is something more than art as an icon. Under attack is the rationalistic notion that art is a form of work that results in a finished product. . . . What art now has in its hand is mutable stuff which need not arrive at the point of being finalized with respect to either time or space. The notion that work is an irreversible process ending in a static icon-object no longer has much relevance. . . . What is revealed is that art itself is an activity of change, of disorientation and shift, of violent discontinuity and mutability, of the willingness for confusion even in the service of discovering new perceptual modes.[4]

In these terms, *Site* represents the mutability of *Olympia*, the activity of change that a century has worked upon her. But as performance, in its very theatricality, it also embodies change and movement within itself.

The work was performed on four occasions in early 1964: in New York on March 2 and 9 at Stage 73, 321 East 73d Street, as part of a month-long series of Monday evening dance programs arranged by Steve Paxton; at the Institute of Contemporary Art in Philadelphia on April 24, with Olga Adorno Klüver substituting for Schneemann; and finally on April 29, again

in New York, with Schneemann as Olympia for the Judson Dance Theater's Concert #16, the final "official" Judson event.[5] Writing in her dance column in the *Village Voice* in May, Jill Johnston described the last performance in terms of kinetic sculpture:

Dressed in white, wearing work gloves and a skin-tight, flesh-colored mask, Morris stands before a white box containing a tape recorder which makes the constant rumbling sound of a pneumatic drill (previously recorded from his studio window). To his right is a stack of three large rectangular plywood boards, painted white. He removes one and stands it up vertically a few yards away. He removes the second and takes it off-stage. After a few moments he returns, grasps a corner of the third, and pulls it away swiftly to reveal a reclining odalisque, backed with white pillows, her skin covered with faint white make-up so that she looks somewhat dewy and transparent. She is also a facsimile of Manet's *Olympia*. Morris makes the famous Manet painting his "found" object as a live entity on the stage. She remains transfixed while he manipulates the plywood board, making a moving sculpture of body and object, with the additional visual effect of shifting relationships between Morris, the odalisque, the small white box, and the stationary vertical board.[6]

In drawing attention to the analogy between body and sculptural object here, Morris overtly takes up one of the primary issues of kinetic sculpture in general—that is, the way in which kinetic sculpture can "fill out" its own space in a manner analogous to the way in which a dancer, or any moving "actor," can "fill out" and articulate stage space. As Rosalind Krauss has pointed out, as early as the mid-1930s Martha Graham had used Alexander Calder's mobiles as "plastic interludes" during her company's performances.[7] And yet what is striking about *Site* is the way in which it refuses to be contained by the spaces articulated within it.

Painting is transformed into sculpture, sculpture into dance. And dance itself is transformed, as it was throughout the Judson repertoire, into ordinary, vernacular movement. As Yvonne Rainer, another Judson dancer and collaborator with Morris, put it in a widely anthologized essay written in 1966:

The display of technical virtuosity and the display of the dancer's specialized body no longer make any sense. . . . It's easy to see why the *grand jeté* (along with its ilk) had to be abandoned. . . . Like a romantic, overblown plot this particular kind of display—with its emphasis on nuance and skilled accomplishment, its accessiblity to comparison and interpretation, its involvement with connoisseurship, its introversion, narcissism, and self-congratulatoriness—has finally in this decade exhausted itself. . . . The alternatives that were explored now are obvious: stand, walk, run, eat, carry bricks, show movies, or move or be moved by some *thing* rather than oneself.[8]

A revealing analogy can be drawn between the Judson Dance Theater's rejection of the aesthetic standards of classical dance and pop art's virtually simultaneous rejection of the "romantic, overblown . . . introversion, narcissism, and self-congratulatoriness" of abstract expressionist painting. For

71

Warhol, pop was not merely a means of returning painting to "ordinary" discourse, the vernacular idiom bombarding us in the media, but it was more profoundly a way of insisting that our image repertoires are constituted, as it were, *in public*. Pop, like avant-garde dance, rejects the privatization of aesthetic experience and deflates the myth of the abstract expressionist's creative ego. In his book *Popism*, Warhol lets Larry Rivers recall for him a scene at the Cedar Bar when a "very stupid," "very unpleasant," "completely drunk" Jackson Pollock was behaving badly to everyone: "I remember he once went over to Milton Resnick and said, 'You de Kooning imitator!' and Resnick said, 'Step outside.' Really." Warhol's summation is telling: "The art world was different in those days. I tried to imagine myself in a bar striding over to, say, Roy Lichtenstein and asking him to 'step outside' because I'd heard he'd insulted my soup cans. I mean, how corny. I was glad those slug-it-out routines had been retired—they weren't my style, let alone my capability."[9] The key word here is "style," for Warhol is talking about his art as much as his personal manner. Warhol's style is the style of Campbell's soup. It is not his "own." The belief in art as a mode of self-definition, the investment in the "originality" of artistic vision that arises in the Pollock-Resnick-de Kooning squabble, amounts to a parable of modern art. Clearly, Schneemann and Morris are imitating Manet in *Site*, and clearly that is the point. The very act of imitation announces this art's postmodern difference.

So, of course, do any number of other things. Morris's mask, for one, not only affirms a willful loss of ego in his relation to the work (like Warhol, he projects a studied lack of personality), but its relation to abstract expressionism is even more complex. Pollock's art can be read as a kind of mask, a layering upon canvas designed to "cover" or "hide" the personality of the artist beneath. The gestural web was, on the one hand, a device which offered Pollock a certain degree of self-protection, guaranteeing some psychic privacy; but, on the other hand, it also served to mystify the artist—and the painting. Morris's mask implies something entirely different. It is as if where an overabundance of personality simmers and seethes beneath the surface of Pollock's canvas, beneath Morris's mask there lurks a certain *lack* of personality, an *ordinariness*. David Antin remarked in 1966 that "what is absent or invisible is precisely what defines" Morris's early work. His boxes, according to Antin, "divide space into an inside (hidden) and an outside (revealed)."[10] And though one might discover the most extraordinary things inside the box—a nude Carolee Schneemann, for instance—Morris consistently finds ways to make the revelation of the inside ordinary. Schneemann becomes the *image* of a nude, as if her own body had been usurped by the image. Paradoxically, as everything is revealed, it asserts that it is all surface. If anything is remarkable it is that such nudity could appear so ordinary. This ordinariness is, in fact, the mark

of all minimalist art and is embodied here not only structurally in the simple white sheets of plywood and in the matter-of-factness of Schnee-mann's pose but also in the metaphoric connection between the work of making art and work in general established by the accompanying recording of the pneumatic drill. *Site* is preeminently a work site.

The kinds of differences I have been outlining between *Site* and more mainstream American art are, of course, quite deliberate ones. They are part and parcel of a larger list of differences developed by Yvonne Rainer in 1966 to help her explain the radical new character of the dance that had grown up during the few years previously in and around the Judson Dance Theater (dances such as *Site*). For Rainer the thoughtful artist ought to "eliminate or minimize" those things characteristic of mainstream art and dance and "substitute" a new set of "aspects":

Objects	Dances
eliminate or minimize	
1. role of artist's hand	phrasing
2. hierarchical relationship of parts	development and climax
3. texture	variation: rhythm, shape, dynamics
4. figure reference	character
5. illusionism	performance
6. complexity and detail	variety: phrases and the spatial field
7. monumentality	the virtuosic movement feat and the fully-extended body
substitute	
1. factory fabrication	energy equality and "found" movement
2. unitary forms, modules	equality of parts
3. uninterrupted surface	repetition or discrete events
4. nonreferential forms	neutral performance
5. literalness	task or tasklike activity
6. simplicity	singular action, event, or tone
7. human scale	human scale [11]

Such a list, as Rainer understands, invites dispute, but the drift is clear, and it is easy enough to locate the predominate actions of *Site* in the lower half of this chart, just as surely as Pollock's canvases can be located in the top half. And, equally clear, it is the monumentality of Manet's *Olympia*, its status as a cultural icon, and the marks of Manet's identity that can be traced across its surface, that Schneemann's pose disrupts.

Site, finally, announces the end of one kind of painting, which begins with Manet and ends with Pollock. Most fundamentally, *Site* occurs *in time*. Faced with such a work, we must suspend, as Norman Bryson has

put it, "the conception of the body in representation which our own tradition proffers to us, as something fixed, pictorial, framed; we must attend, on one side, to the means by which the individual painting directs (rather than determines) the flow of interpretation across its surface; and on the other, to the collective forms of discourse, present in the social formation and subject to their own unfolding in time, which the painting activates: activates not as citation, but as mobilisation (the painting causes the discourses to *move*)."[12] We have attended thus far to the *means* by which *Site* directs our interpretation. We must now attend to the discourses that it causes to shift.

II

In retrospect, it is easy enough to see that *Site* raises many issues of sex and gender. Most obviously, it situates "femininity" in a state of total passivity; as the object of the gaze, the feminine is, to borrow Bryson's formulation, something fixed, pictorial, framed. It is "masculinity" which mobilizes her, allows her to unfold in time, to "blossom." In a sense, Morris is Schneemann's Manet. But the ironies of such a presentation would have been—*should* have been—clear even in 1964. In *More than Meat Joy*, an autobiographical documentary history of her performance works, Schneemann recalls that "for years my most audacious works were viewed as if someone else inhabiting me had created them—they were considered masculine when seen as aggressive, bold. As if I were inhabited by a stray male principle; which would be an interesting possibility—except in the early sixties this notion was used to blot out, denigrate, deflect the coherence, necessity and personal integrity of what I had made and how it was made" (52). In the context of *Site*, that "stray male principle" is clearly activity itself, especially the activity of making art. But as passive as Schneemann may have appeared in *Site*, she was, elsewhere, very much engaged in making art. In December 1963, just months before *Site* was first performed, Schneemann had, for instance, covered herself in paint, chalk, ropes, and plastic and, in a loft environment constructed of large panels interlocked by color, mirrors and glass, lights, moving umbrellas, and motorized parts (Color Plate II), conducted "a series of physical transformations of my body in my work." She called the piece *Eye Body* (Fig. 27). Her express purpose was to use her body as an extension of her painting-constructions in order to "challenge and threaten the psychic territorial power lines by which women were admitted to the Art Stud Club, so long as they behaved *enough* like the men, did work clearly in the traditions and pathways hacked out by the men" (52). The point is that in *Site* she was using her body in a tradition hacked out by men. "I WAS PERMITTED TO BE AN IMAGE," she says, "BUT NOT AN IMAGE-MAKER CREATING HER OWN SELF-IMAGE" (194). In the text next to the small reproduction

FIGURE 27. Carolee Schneemann, *Eye Body*, 1963. Photo courtesy Carolee Schneemann.

of *Site* that is included in *More than Meat Joy*, she writes: "My own private . . . ironical title was 'Cunt Mascot.' Cunt Mascot on the men's art team. Not that I ever made love with ANY OF YOU NO! I didn't feel perceived by our group—not even sexually" (196). One is forced to accept this as her gloss on the performance itself.

Schneemann, in other words, participated in *Site* in order to cause the discourse on sexuality which had been initiated by Manet's *Olympia* to move once again, to bring it into the present. She discovered what the

feminist movement would soon discover as well—the seeming imperturb-
ability of the masculine position, a certain obdurate blindness born of
power. If, in *Site*, Schneemann discovered anything, it was probably not
too far removed from what Mary Ann Doane discovered in Babette Man-
golte's film *The Camera: Je/La Camera: Eye*:

> What is at stake are the relations of power sustained within the camera-subject
> nexus. The discomfort of the subjects posing for the camera, together with the
> authority of the off-screen voice giving instructions ("Smile," "Don't smile," "Look
> to the left," etc.), challenge the photographic image's claim to naturalism and spon-
> taneity. And, most interestingly, the subjects, whether male or female, inevitably
> appear to assume a mask of "femininity" in order to become photographable
> (filmable)—as though femininity were synonymous with the pose.[13]

It is this relegation of the feminine to the pose that in *Site* inverts Manet.
Manet instills in Olympia, at least in her gaze and in her position above
our own, a certain disconcerting *authority*. But so posed, Schneemann has
no authority, no force at all. She is literally suspended. In fact, as long as
she remained inactive, her nudity, in 1964, was technically legal. "The
law," Schneemann writes, "at this time stated that persons could appear on
stage naked without moving—that is, if they became statues. Movement
or physical contact between nude persons was *criminal*" (169). In her pose,
she *submits* to authority, the state's as well as Morris's.

It could be argued, I think, that the inherent femininity of the pose is a
function of photography itself—that the posed photograph is always Other,
even if it is of ourselves. Especially after Arbus, the portrait photograph
marginalizes us, defines us—or at least the self we see there, in the
photograph—as outside the discourse of the moment. It inscribes, that is,
difference upon being. Craig Owens has pointed out, furthermore, that this
difference is indeed the difference between life and death: "What do I do
when I pose for a photograph? I freeze—hence, the masklike, often deathly
expressions of so many photographic portraits. . . . I freeze, as if anticipat-
ing the still I am about to become; mimicking its opacity, its still-ness;
inscribing, across the surface of my body photography's 'mortification' of
the flesh."[14] One of the virtues of performance art, as Schneemann and
many others came to realize, is that in its very *activity* it sidesteps this
mortification. However (admittedly) marginalized it might be as an art
form, the work and its maker are, at least, *alive*.

It is precisely its "liveness" that has attracted so many women artists to
their own bodies as material. This was the point of Eleanor Antin's *Carv-
ing: A Traditional Sculpture*, a sculpture-in-process piece that Antin per-
formed from July 15, 1972, until August 21, 1972, in which the material—
in this case, the artist's body—was photographed every morning from four
sides over the course of 45 days during a strict dieting regimen (Fig. 28).

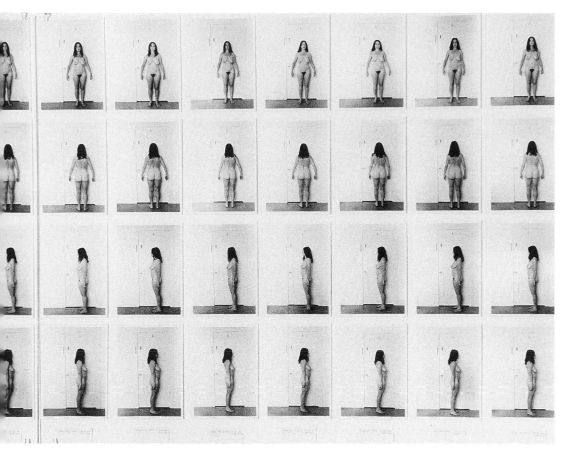

FIGURE 28. Eleanor Antin, eight days from *Carving: A Traditional Sculpture*, 1972. Courtesy Ronald Feldman Fine Arts, New York.

Antin claimed to be working in the traditional Greek mode and quoted the description of the process in Carl Bluemel's *Greek Sculptors at Work*:

The Greek sculptor worked at his block from all four sides and carved away one thin layer after another; and with every layer removed from the block, new forms appeared. The decisive point is, however, that the Greek sculptor always removed an entire layer right around the statue. He never worked just at a leg, an arm or a head, but kept the whole in view, and at every stage of the work the figure itself was a whole. . . . Thus the figure which started as a block was worked over in its entirety by the sculptor at least a hundred times, beginning with only a few forms and becoming increasingly richer, more rounded and lifelike until it reached completion.[15]

As in traditional sculpture, two considerations determine the conclusion of the work: the ideal image toward which the artist aspires and the limitations of the material itself. Antin's body sculpture encounters difficulties on both fronts. In the first place, as she points out, quoting Michelangelo: "'*non ho l'ottima artista alcun concetto che el marmo solo non in se circoscrive*' or to paraphrase in English: 'not even the greatest sculptor can

make anything that isn't already inside the marble.'" But perhaps more important Antin's "ideal image" of herself is clearly problematized terrain, tied up, as it is, in dieting, in an image of woman inspired by the fashion and fitness industries, in a mystique of thinness that, if nothing else, would require Antin to be at least a foot taller than she is. It would be fair to say, I think, that Antin is to her ideal image as Olympia was to the ideal *courtisane* of 1865. What her work underscores is her *difference* from the ideal, even as she subscribes (with tongue in cheek) to its codes.

But the real message here is that, before submitting herself to carving, before dieting, Antin is not perceived to be "lifelike." She is a block of matter, awaiting animation by the sculptor's hand. There are, of course, any number of other women artists who have exposed the "mortification" of the female body in similar terms. "Acting," in both senses of the word—being active and play-acting—counters this lifelessness. In an important essay which first appeared in English in *New German Critique* in 1977, "Is There a Feminine Aesthetic?" German critic and writer Silvia Bovenschen describes a stage performance by an aging Marlene Dietrich in ways that make clear the significant theatrical heritage of contemporary woman's performance art:

An artistic product came on stage, every moment perfected, every gesture precisely rehearsed, premeditated, every facial expression calculated for aesthetic effect. Every step, every movement of her head or hands—all these were spare, artificial. . . . In performance she was totally cool, faintly ironic, and even when she was portraying emotion everything was staged; she made no attempt to make the emotion appear genuine. When she sings—actually, it is more like talking than singing—she slurs, softens the refrains, but even this is not fortuitous. The pose is intentional. It says, you know this one already, I know you will be pleased if I sing it. . . . Behind her is an early picture of herself, only the head. Her face is older now, but even this change seems not so much the result of the biological ageing process, it seems much more something artificially arranged, a sort of displacement intended to signify historical distance. And her body is just as artificial, absolutely smooth as though encased in some unfamiliar fabric—we are watching a woman demonstrate the representation of a woman's body. . . . The myth appears on stage and consciously demonstrates itself as myth. . . . Even reactionary theories of art always credited women with ability in the performing arts. This is to a certain extent true in that women, excluded from other opportunities, often used their bodies as vehicles for expressing their artistic impulses; they turned their bodies into artistic products. Many of them were destroyed in the process. But Marlene Dietrich, the cool one, triumphs. She alone controls the image to be projected. Whereas before an actress had to satisfy the expectations of the audience, now the audience must conform to hers. The myth is on the receiving end and consumes the audience. She gazes down from the stage not once but twice, once as an image, and once as an artist, as if to say "Okay, if this is how you want it. . . ."[16]

Dietrich's power, her force as an image, is described here in terms precisely analogous to the power exerted by Olympia's gaze. And the difference be-

tween Dietrich as an image and Schneemann as an image in *Site* is precisely Dietrich's *acting*.

The notion of acting, then, contains an element of difference—the difference between who you are, the artist, and what you play, the image. And this is the essential distinction between performance and theater as media. In a discussion with John Howell, Ruth Maleczech of Mabou Mines has usefully explained the influence of performance upon avant-garde American theater:

Not so long ago the theatrical performer dealt with character and role, and the performance artist with "my" personality, and neither of those attitudes are completely true now. . . . It wasn't interesting to play parts in other people's plays anymore. Also, it probably wasn't interesting for directors to do new interpretations of often-done plays either. Something else had to happen performance-wise, and a connection to the art world has changed not only our theatre but others as well, and it's very easy to see which theatres have been influenced and which have not. It's not just due to performance art, but to Grotowski's idea that it was no longer necessary for the actor to realize the author's intention when he wrote the part. Once that became clear, then a piece becomes the story of the lives of the performers. So the context is changing and within that changing context, you see the life of the performer. We're not really working with any material except ourselves.[17]

It is, of course, the emergence of the personal into character and role that allows character or role to assert itself as something more than mere image. The personal can be anything that disrupts the naturalism of the stage, interferes with character and announces acting. The personal need not, therefore, assert itself overtly: it can exist, as it always has in art, as a kind of *tache*, as a gestural mark that indicates the presence of a controlling, artistic, often ironical point of view, one that disrupts the scenic event.

Such is the case with works like Dara Birnbaum's 1978–79 video montage *Technology/Transformation: Wonder Woman* (Fig. 29). The video is divided into two sections. The first is a montage of clips from the Linda Carter television series depicting Carter's spinning, explosive transformations into Wonder Woman, forward and backward, again and again, initially with an air-raid siren exploding across the soundtrack. The second half consists of the text of "Wonder Woman Disco" by Wonder Woman and the Disco Land Band, in white letters on a blue ground, rolling in unison to the soundtrack recording:

Get us out from under
Wonder
Woman [repeated 3 times]
This is your Wonder Woman
 talking to you
Said I want to take you down
Show you all the powers
 that I possess
Shake thy wonder maker

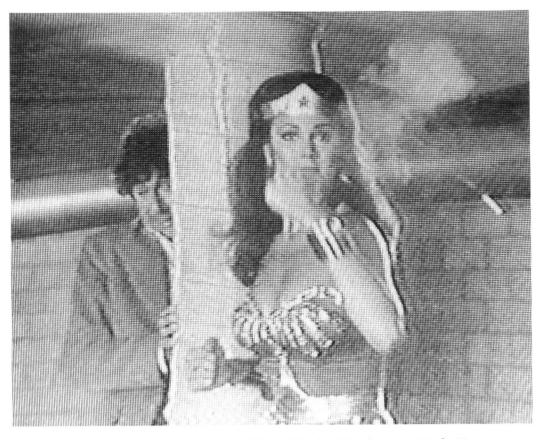

FIGURE 29. Dara Birnbaum, still from *Technology/Transformation: Wonder Woman,*
1978–79. Color, stereo videotape, 7 mins. © 1978. Photo: Dara Birnbaum.

It is Birnbaum's manipulation of the medium, the numbingly repetitive
rhythms of both the montage and the text, that announces her point of
view. The piece abounds in ironies, some obvious, others less so, but not
the least of them is the fact that on the record album from which Birnbaum
took the song all the members of the band are credited except the vocalist
"Wonder Woman." Furthermore, the video was originally shown simulta-
neously in an avant-garde film festival, where it was clearly understood as
an essay on woman's powerlessness, her subjugation to images such as that
of Wonder Woman, and in the window of a posh hair salon in Soho, the
owner of which agreed to show it not only because she thought she looked
like Linda Carter but because she believed customers might see the salon as
a kind of technological Wonder World of transformative potential in its own
right.

Kathy Acker's novels and stories activate something of the same terrain,
though on much more "taboo" grounds. What is most interesting in her
work, particularly evident when she reads in performance, are those mo-

ments when the persona ("I") collides with the person reading (Acker herself). Here are two excerpts from her 1973 novel, *The Childlike Life of the Black Tarantula by the Black Tarantula*:

A tall man comes up to me and looks at my standing naked body. He turns my body around; with his thumb and third long finger opens my mouth sticks his tongue in my mouth, around my gums, to my inner throat. His hands touch the beginning of the outward curves of my upper buttocks and the thick layer of fat developing over my ass and around my stomach. After stroking me, so I feel like a cat, his hand moves to the hair over my cunt, down to the lips of my cunt, softly; his eyes carefully note every expression on my face. I understand they are trying to sell me. How do I feel?

We climb down the rocks and sliding sand Devil's Slide to the beach, tiny cove surrounded by boulders crash the huge waves against the rocks. B, V, and I take off our clothes, I lie on the hot sand. V starts drinking, people recognize her she tries to harden her nipple by rubbing it with wet finger. I lightly rub my tongue around the center of her nipple and press my lips against it as it grows. We separate, she looks around, waves to the people on the beach who are watching us. . . . How many people are watching? We look up; try to separate. V spreads her legs at people, laughs at them, passes her book around *Female Orgasm*. Three Spanish kids are staring entranced at us; one straight couple behind us and two bisexual couples in front of us are obviously turned on. I feel weird. I'm weird.[18]

These two segments occur as the first paragraphs of separate, consecutive sections within three pages of one another. Their very juxtaposition inauthenticates both. Who is this "I"? What does she want? If these are fantasies, what kind of psyche do they depict? If they are realities, what kind of world? It becomes obvious that whatever is being spoken is culturally encoded—that is, a cultural mythology seems to be speaking through each persona, mythologies about love, success, domination, submission, exhibitionism, and so on. But Acker seems to be free of the mythologies she presents. It is as if, suddenly, something seems to be writing itself through Acker. She becomes a *medium*, a voice through which culture speaks, and not a particularly attractive culture at that. Acker's work operates along the same edge which defines the ambiguous zone of pornography itself, a zone that threatens and undermines society at the same time that it is the fullest expression of society's unspoken desires.

Martha Rosler's separation from the events she depicts is clearly articulated in her forty-minute 1977 video, *Vital Statistics of a Citizen Simply Obtained* (Figs. 30 & 31). In this tape Rosler is systematically measured in every possible way by two men. Here acting asserts itself by means of the difference between Rosler's announced creation of the tape—her directorial status—and her contradictory submission to the men within the piece itself. *Acting* as if "there is meaning in measurement," she defines herself, in a parody of Leonardo's famous *Study of the Human Body*, in terms of a chart which is traced behind her and upon which the two "researchers"

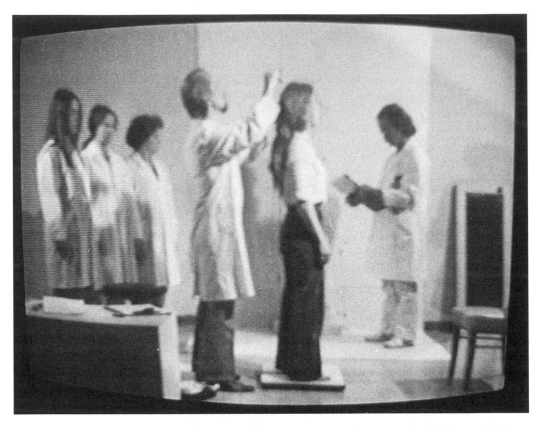

FIGURE 30. Martha Rosler, still from *Vital Statistics of a Citizen Simply Obtained*, 1977. Color videotape, 40 mins. Photo: Martha Rosler.

write her various measurements while comparing them to a set of "normal" measurements. At the beginning of the tape, and then again halfway through with some variation, Rosler reads a statement that foregrounds her intentions, separates what is happening on the tape—her acting—from her understanding of it:

Her body grows accustomed to certain prescribed poses, certain characteristic gestures, certain constraints and pressures of clothing. Her mind learns to think of her body as something different from her "self." It learns to think, perhaps without awareness, of her body as having "parts." These parts are to be judged. The self has already learned to attach value to itself. To see itself as a whole entity with an external vision. She sees herself from outside with the anxious eyes of the judged who has within her the critical standards of the ones who judge. I needn't remind you about scrutiny, about the scientific study of human beings. Visions of the self, about the excruciating look at the self from the outside as if it were a thing divorced from the inner self. How one learns to manufacture oneself as a product. How one learns to see oneself as a being in a state of culture as opposed to a being in a state of nature. How to measure oneself by the degree of artifice: The remanufacture of the look of the external self to simulate the idealized version of the natural. How

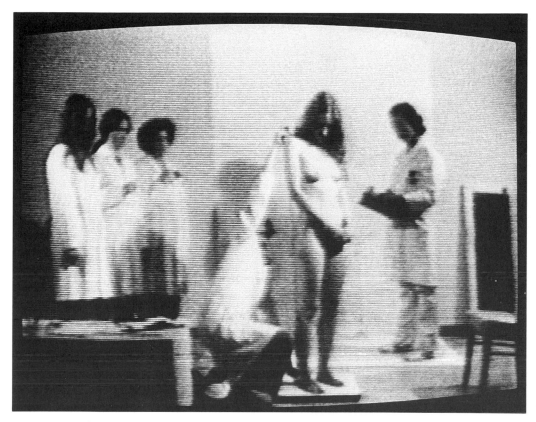

FIGURE 31. Martha Rosler, still from *Vital Statistics of a Citizen Simply Obtained*, 1977. Color videotape, 40 mins. Photo: Martha Rosler.

anxiety is built into these looks. How ambiguity, ambivalence, uncertainty are meant to accompany every attempt to see ourselves, to see herself as others see her. This is a work about how to think about yourself.[19]

Given this text, it becomes nearly impossible not to recognize the falsity of the activity depicted on the tape, the way in which the word "vital" is emptied of meaning altogether, the virtual autopsy that unfolds before us. Both Birnbaum's and Rosler's pieces make it clear, in their different ways, that *acting*—acting in a performance sense of the word, not in a theatrical sense, acting so that the personal surfaces in the image as *difference*—is what makes it obvious that the female body is culturally encoded.

The cosmetic industry has been one of the chief targets—or tools—of women's art precisely because in the act of putting on makeup the ambiguous relations between self and image, being and acting, can be so readily foregrounded. Putting on makeup is about, in Rosler's words, "how one learns to manufacture oneself as a product," how to "simulate the idealized version of the natural." This is precisely the point of *Flat Glamour Me-*

dium, a 1980 videotape by Carol Porter and John Orentlicher, which was made on location at the Barbizon School in Syracuse. Porter and Orentlicher simply allow a "glamour expert" to expose the central contradictions of the beauty industry: "Nothing should look prefabricated," she says, in what becomes a litany. "It should look natural. Everything should look like that's how they wake up in the morning." The power of Porter's work lies in the way that her subjects undermine themselves—in this case, an anxiety reminiscent of many of Cindy Sherman's poses accompanies the glamour expert's every attempt to seem as "glamourous" as she would like us to think she is. But as opposed to Sherman, she is acting in a theatrical, not a performance, sense of the word. She wants to become, she wants us to *believe* that she has become, what she depicts.

Cosmetics are not only dedicated to making over one's less-than-adequate self into a culturally encoded image (which has been determined, by and large, by men)—their application is recognizably also a kind of painting. One of the works that Antin displayed along with *Carving* in 1972 was a video entitled *Representational Painting*, in which, over the course of thirty-five minutes, she gets a facial, a makeup job, and finally changes into a fashionable blouse and hat, ready to face the world. Her persona, Eleanora Antinova, the Once Celebrated but Now Retired Black Ballerina of Diaghilev's Ballet Russe, is in many ways an extension of *Representational Painting*, an extended makeup job (which happens to take on issues of race and aging as well as more obvious feminist concerns). In *Being Antinova*, her parodic "day book" chronicling the three weeks surrounding her performance of Antinova's *Before the Revolution* at Ron Feldman Fine Arts in New York in October 1980, she is obsessed with makeup. "Spent four hours at *Madame Joli* preparing for my New York trip by having long porcelain nails attached to my stubby fingers," the book begins. And later:

It was an unhurried private time to stroke myself and listen to my body. . . . In the mirror, my light eyes blazed intensely from out of my darkening face. I took lots of time over whether to shadow them with green or silver. I was confident and ended up doing both, blending the green into the corners and the silver where the light would be expected to hit. It was like drawing with soft chalk. Those parts of the face that come forward have to be lighter than the parts that recede into the shadow. I was feeling very cheerful to be painting again. I always like doing portraits—chalk, pastel, wash. I'm good at likenesses. . . . I want my skin to gleam with rich color like the models in *Vogue*. . . . My confidence in paint, and my ability to handle it is amazing. If it wasn't such a measly profession, I might really have taken up painting.[20]

As Lucy Lippard has pointed out, "To make yourself up is literally to create, or re-create, yourself."[21] Or, as Nora R. Wainer has pointed out in an article on cosmetics and culture, "It may seem stretching a point to make cosmetics a means of artistic expression, but for many people, their per-

sons, their houses, their choice of belongings are the only means they have
to express their creative beings." [22]

The creativity of "making oneself up" becomes especially clear in the context of "punk." The punk look is a style which announces its *separation* from conventional culture. In the words of Dick Hebdige, whose book *Subculture* is perhaps the best extended study of the punk phenomenon, it is a "revolting style":

Objects borrowed from the most sordid of contexts found a place in the punks' ensembles: lavatory chains were draped in graceful arcs across chests encased in plastic bin-liners. Safety pins were taken out of their domestic "utility" context and worn as gruesome ornaments through the cheek, ear or lip. "Cheap" trashy fabrics (PVC, plastic, lurex, etc.) in vulgar designs (e.g. mock leopard skin) and "nasty" colours, long discarded by the quality end of the fashion industry as obsolete kitsch, were salvaged by the punks and turned into garments . . . which offered self-conscious commentaries on the notions of modernity and taste. Conventional ideas of prettiness were jettisoned along with the traditional feminine lore of cosmetics. Contrary to the advice of every woman's magazine, make-up for both boys and girls was worn to be seen. Faces became abstract portraits: sharply observed and meticulously executed studies in alienation. Hair was obviously dyed (hay yellow, jet black, or bright orange with tufts of green or bleached in question marks), and T-shirts and trousers told the story of their own construction with multiple zips and outside seams clearly displayed. [23]

Whatever one's reaction to punk, it should be clear that making oneself up is revealed here as a *signifying process*. That is, it *creates* meaning, and it creates it as a function of *difference*. Likewise, in the rhetoric of the cosmetics industry, woman is "nothing" until she is "created" by makeup, until she becomes different from her "everyday" appearance. In a very real sense, punk exposes the signifying process of the cosmetics industry—of glamour and style—by radicalizing and literalizing its conventions. It is possible to say, in fact, that punk is "excessively" conventional, that it is glamour *in excess*.

When feminist art conceives of makeup as a kind of painting—as perhaps the only kind of painting available to women—it announces, then, its separation and difference from conventional art. To consider Eleanor Antin "painting again" on her own face is to recognize the conventionality of painting. That is, in Eleanora Antinova we have before us a literalization of Pollock's famous phrase, "When I am *in* my painting. . . . " In performance Antin presents us with *live action*, whereas Pollock gives us *action painting*—the inert record of action, a kind of memory that Antin approaches ironically in her own "memoirs" but that Pollock invests with a monumental iconicity. Her performance is a kind of painting *in excess*, and it manifests itself as a "revolting style," a style in revolt against the "measly profession" of painting.

But why attack painting?

Some statistics: [24] In 1960, 60% of all bachelor degrees awarded in studio art and art history were awarded to women. In 1975, 10,901 bachelor degrees in art (studio and history) were awarded to women, of 16,193 total recipients, or 67%. As of 1976, approximately 50% of the professional artists in this country were women. Despite the overwhelming predominance of women in the profession, in 1970–71, of the forty-five New York galleries actively showing the work of living artists, only 13.5% of the artists shown were women. By 1976, things had barely improved: only 15% of the one-person shows in New York's prestige galleries were devoted to work by women. Worse, only 10% of the shows given to living artists at the three major New York museums in 1976 and 1977 were one-person exhibitions by women; and furthermore, of the 995 one-person exhibitions at the Museum of Modern Art from 1928 to 1972, only five were by women. Here is a breakdown of coverage in arts magazines of living men and women artists for the year June 1970–June 1971 (from the Tamarind Lithography Workshop's statistical study, *Sex Differentials in Art Exhibition Reviews*):

Magazine Ratio Comparisons (Males : Females)

	Art in America	Artforum	Artnews	Arts	Craft Horizons
No. artists reviewed	12 : 1	7 : 1	4 : 1	5 : 1	1.3 : 1
No. lines	18 : 1	10 : 1	8 : 1	6 : 1	1.3 : 1
Sq. inches of coverage	19 : 1	10 : 1	8 : 1	6 : 1	1.3 : 1
No. reproductions	13 : 1	9 : 1	15 : 1	7 : 1	2 : 1
Sq. inches of reproductions	11 : 1	10 : 1	12 : 1	8 : 1	1.1 : 1

One would expect, of course, that whatever the case at the start of the seventies, things would have improved dramatically by the eighties. Joyce Weinstein, executive director of Women in the Arts, a New York-based organization of professional women artists, pointed out that, of the 185 works in the 1977 Whitney exhibition American Master Drawings and Watercolors from Colonial Times to Present, only eight were by women. At the Museum of Modern Art's 1984 International Survey of Recent Painting and Sculpture, only fourteen women were included among the 165 artists represented. A poll of ten leading New York galleries conducted in 1975 by WiA indicated that some represented no women, others a few, but none more than three. In 1977, in a follow-up survey, women had not gained at

all. By 1979, another survey of eighteen leading New York galleries re-
vealed that, of all the artists these galleries represented, still only 20.8%
were women. In 1982 the Coalition of Women's Arts Organizations, rep-
resenting sixty women's art groups nationwide, reported that only 2% of
museum exhibitions by living artists were given to women. My own sur-
vey of one-person exhibitions by living artists at New York's leading
museums indicates that, from 1980 through 1985, there were, roughly,
thirteen shows by male artists to every one by a female artist at the Mu-
seum of Modern Art, while it was fifteen to one at the Guggenheim, and
twenty-two to four at the Whitney (and I am being generous on this last,
including a show of nine paintings from the permanent collection by Geor-
gia O'Keeffe, and another consisting of seven sculptures by Louise Nevel-
son). Even though women took over editorial direction at both *Artforum*
and *Art in America* (Ingrid Sischey at *Artforum* in February 1980 and
Elizabeth Baker at *Art in America* in March 1974), by my count, in 1983
reviews of men in *Artforum* outnumbered reviews of women by a ratio of
over 3:1, while there were 2.5 feature articles on a man for every article
on a woman. The ratios in *Art in America* in 1983 varied widely, from 2:1
in May for reviews to 6:1 in December.

These statistics reflect, of course, the domination of the gallery system
in New York and elsewhere by male artists. Mary Boone, for instance,
bragged in 1982 that her gallery represented nothing but men: "It's the
men now who are emotional and intuitive . . . and, besides, museums just
don't buy paintings by women."[25] Thus, despite the advances women have
made—and they are real enough, if inadequate—Faith Wilding was still
forced to ask in an issue of *Art and Artists* which was distributed free at
the 1986 convention of the College Art Association in New York: "Why do
so many women artists still feel invisible, discriminated against, unrecog-
nized? Why do the Guerilla Girls have to put up posters with grim statistics
about the showing of women artists in major museums and galleries? Why
have there been major protests by women artists' groups at large contem-
porary survey shows both at the Los Angeles County Museum of Art and
at MOMA, in the past two years?" (Figs. 32 & 33).[26] These statistics and
reactions to them hardly need summarizing. They outline a situation in
which the art scene was, and continues to be, dominated by men, mostly
painters and a few sculptors, an art scene in which women continue to be
excluded, and when not excluded underpaid and underacknowledged.

And yet it is my conviction that since 1970 the most interesting work in
the arts has been done, for the most part, by women. Very little of it has
been the work of painters (three notable exceptions are Ida Applebroog,
Jennifer Bartlett, and Pat Steir). The situation is not peculiar to America.
In Germany, when the two-volume *Frauen in der Kunst* (Women in Art)
was published in 1980, there was only one painting in the entire section of

illustrations. Traditional sculpture was entirely unrepresented. Instead, as Gisela Breitling has pointed out, "photo-collages, mixed-material collages, ready-mades, and photos of performances" so dominated the book that they could be said to constitute the production of "a 'quasi-official' feminist consciousness." Painting, as she says, was "taboo . . . masculine."[27] Carrie Rickey has gone so far as to say, in the *Village Voice*, "Postmodernist art is a direct consequence of feminism."[28] That is an extreme statement, but the drift seems to me right. As Craig Owens has put it, in what is perhaps the best essay on the relations between feminism and postmodernism, "Among the most significant developments of the past decade—it may well turn out to have been the most significant—has been the emergence, in nearly every area of cultural activity, of a specifically feminist practice."[29] This chapter, as a matter of fact, is a direct result of my own realization, as this book was in the process of being organized, that the majority of the artists with whom I wished to deal were women. At first this surprised me, until I recognized that I was as much a product of the gallery system as anyone else, and was therefore subject to the same, essentially sexist expectations.

But the rise of women, and women's art, to the position of a real avant-garde (and if I may return to the argument of the introduction, however briefly, Peter Bürger's insistence on the impossibility of a new avant-garde is notably flawed by his failure to engage the possibility of a new *feminist* avant-garde) has by and large occurred *outside* the museum and gallery, and hence art magazine, systems. There have been, of course, a few good feminist galleries—most notably A.I.R. in New York—and even more good feminist journals—*Heresies, Chrysalis, Off Our Backs*. But the feminist avant-garde has largely broken its ties with the mainstream. This includes, incidentally, not only the painting tradition that is directly inspired by and follows from abstract expressionism, but also the pop, minimalist, and conceptual directions that rejected, along with most women artists, the assumptions of expressionism. Women artists did enjoy, as I tried to indicate at the start of this chapter, a brief and fruitful alliance with minimal art, especially in and around the Judson Dance Theater in the early sixties. But the formalist tendencies of minimalism soon showed their inadequacies. Quoting John Cage to the effect that his work is "an affirmation of life, not an attempt to bring order out of chaos nor to suggest improvements on creation, but simply a way of waking up to the very life we're living which is so excellent," Yvonne Rainer complains that despite all she learned from Cage, "only a man born with a sunny disposition" could have said anything so vastly apolitical, so vastly unconscious of social and political reality:

What is John Cage's gift to some of us who make art? This: the relaying of conceptual precedents for methods of nonhierarchical, indeterminate organization which can be used with a critical intelligence, that is, selectively and productively, not,

WHAT DO THESE ARTISTS HAVE IN COMMON?

Arman	Keith Haring	Claes Oldenburg
Jean-Michel Basquiat	Bryan Hunt	Philip Pearlstein
James Casebere	Patrick Ireland	Robert Ryman
John Chamberlain	Neil Jenney	David Salle
Sandro Chia	Bill Jensen	Lucas Samaras
Francesco Clemente	Donald Judd	Peter Saul
Chuck Close	Alex Katz	Kenny Scharf
Tony Cragg	Anselm Kiefer	Julian Schnabel
Enzo Cucchi	Joseph Kosuth	Richard Serra
Eric Fischl	Roy Lichtenstein	Mark di Suvero
Joel Fisher	Walter De Maria	Mark Tansey
Dan Flavin	Robert Morris	George Tooker
Futura 2000	Bruce Nauman	David True
Ron Gorchov	Richard Nonas	Peter Voulkos

THEY ALLOW THEIR WORK TO BE SHOWN IN GALLERIES THAT SHOW NO MORE THAN 10% WOMEN ARTISTS OR NONE AT ALL.

SOURCE: ART IN AMERICA ANNUAL 1984-85

A PUBLIC SERVICE MESSAGE FROM **GUERILLA GIRLS** CONSCIENCE OF THE ART WORLD

FIGURE 32. Guerilla Girls poster, 1985, by permission of The Guerilla Girls.

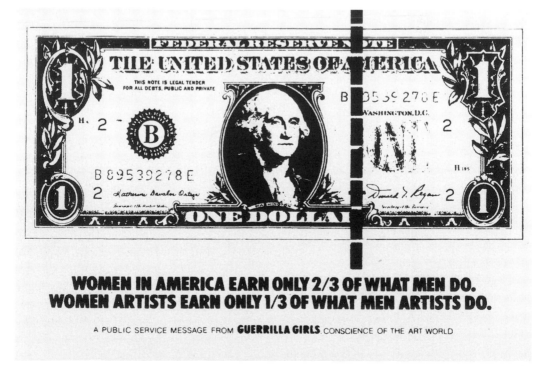

WOMEN IN AMERICA EARN ONLY 2/3 OF WHAT MEN DO. WOMEN ARTISTS EARN ONLY 1/3 OF WHAT MEN ARTISTS DO.

A PUBLIC SERVICE MESSAGE FROM **GUERRILLA GIRLS** CONSCIENCE OF THE ART WORLD

FIGURE 33. Guerilla Girls poster, 1985, by permission of The Guerilla Girls.

however, so we may awaken to this excellent life; on the contrary, so we may the more readily awaken to the ways in which we have been led to believe that this life is so excellent, just, and right.[30]

Schneemann, in a text originally written for her film *Kitch's Last Meal* (1973–77) but read twice as part of the work *Interior Scroll* (Fig. 34), which was performed in 1975 for the Women Here & Now series in East Hampton, Long Island, and again at the Telluride Film Festival in Colorado in 1977, complains of meeting the same "happy man." This particular variety of the species is a structuralist filmmaker who complains that her film is full of "personal clutter . . . persistence of feelings . . . hand-touch sensibility . . . diaristic indulgence" and so on:

> he said you can do as I do
> take one clear process
> follow its strictest
> implications intellectually
> establish a system of
> permutations establish
> their visual set. . . .
> he protested
> you are unable to appreciate
> the system of the grid
> the numerical rational
> procedures—
> the Pythagorean cues. . . .
> he said we can be friends
> equally though we are not artists
> equally I said we cannot
> be friends equally and we
> cannot be artists equally
>
> he told me he had lived with
> a "sculptress" I asked does
> that make me a "filmmakress?"
>
> Oh No he said we think of you
> as a dancer[31]

At the performance in East Hampton, to a more or less sympathetic audience, she undressed, painted herself in large strokes defining the contours of her body and face, read first from an earlier text as she assumed "action poses" from life model class, and concluded by reading the script quoted above off a scroll that she slowly unraveled from her vagina, "inch by inch." At Telluride she was provoked into an "action" because the organizers had designated her section of the program "The Erotic Woman." She convinced herself that since film "permits passive viewing," while live body action diminishes "the distancing of audience perception and fixity of projection," as a filmmaker she had "to stand out step out of [her] frame." At

FIGURE 34. Carolee Schneemann, *Interior Scroll*, 1975. Courtesy Carolee Schneemann.

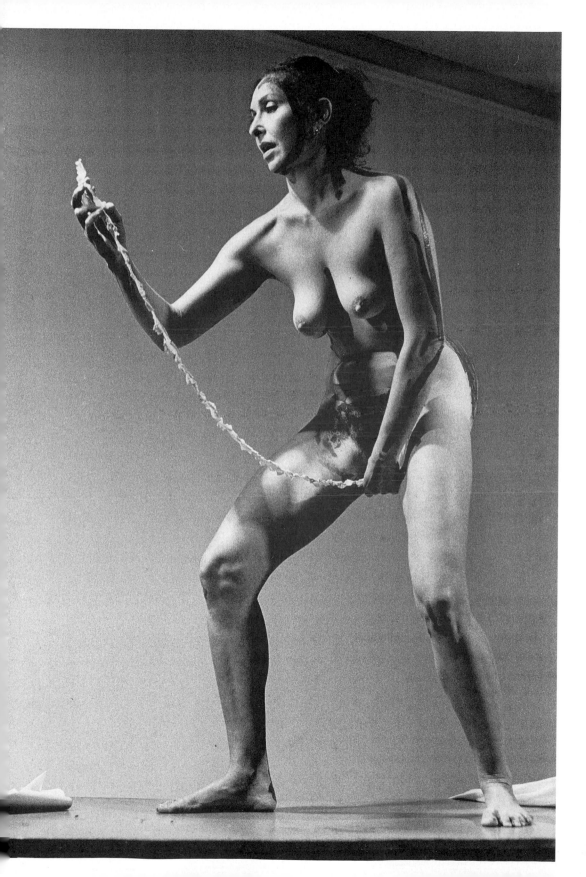

Telluride, then, she simply undressed, slowly applied stripes of mud from the stream that runs through town to her body, extended the scroll, and read. I will have more to say about *Interior Scroll* in a later chapter, but for now let it suffice to say that it announces that women's art has as little to do with minimalist or structuralist concerns as it does with abstract expressionism. It turns instead around what the filmmaker labels the "personal" and the "diaristic." It makes contact, that is, with a vernacular tradition that consists of the unrecognized—because overtly inartistic, even uninteresting—everyday lives of women themselves.

From the very beginning, the affinity of such personal, vernacular discourses to the larger political issues of being a woman in contemporary society was acknowledged by almost all women artists. As Lucy Lippard put it in a discussion with Suzanne Lacy, "In the early days of the feminist art movement, when we were talking about the personal is political, we were saying everything that we do—from how we put our socks on to how we wash the dishes and why *are* we washing the dishes?—should be seen as political, in other words, given political importance because lived experience is the ground from which all politics come."[32] Thus the task-oriented dances of the early Judson days possessed almost inherently a political dimension, though this was not always clear. In the fall of 1971, for instance, at Cal Arts, Allan Kaprow told a group of students that sweeping the floor might be a potential exercise for a performance piece. He was speaking in the context of not only Judson but also, of course, the Happening, which had from the beginning emphasized the artistic potentiality of mundane and banal objects and actions. But an angry Faith Wilding, who as a California student was still unfamiliar with developments on the New York front, jumped up to protest that half the population of the country was oppressed by such household activities as sweeping up and that Kaprow was being insensitive to the condition of women.[33]

Wilding was, at that time, a student of Judy Chicago's, and if anyone can be said to have foregrounded the social and political side of women's art in the late sixties and early seventies, it was Chicago. Until about 1969, Chicago was herself something of a formalist, even minimalist artist, as were many of her female contemporaries. In *Through the Flower*, her remarkably personal autobiography (but remarkable *only* in the context of the markedly depersonalized art world of the late sixties and early seventies), Chicago details the circumstances of the one-person show in Los Angeles which led her to develop the highly successful feminist art programs, first at Fresno State in 1970–71 and then at Cal Arts and Womanspace in the following years, programs in which, it could be said, performance discovered many of its most characteristic and powerful tools. The highlight of the show was the *Pasadena Lifesavers* series (Fig. 35). When we look at these paintings, even today, her difficulties become apparent (or perhaps it

FIGURE 35. Judy Chicago, *Pasadena Lifesavers*, 1969. Acrylic on plexiglas, 5 × 5 ft. © Judy Chicago 1975. Collection Mary Ross Taylor. Photo: Frank Thomas.

is more apparent how little things have really changed). The works are "obviously" formalist—and the temptation is to take them so—but they were richly, and personally, symbolic to Chicago. In terms of their color, they were meant to be abstract visual metaphors for aspects of Chicago's personality (a red/green group representing her aggressive "masculine" side, for instance), and, in terms of their circular format, they were meant to express, in part, her "central core," her vagina. Her description of the show which featured the *Pasadena Lifesavers* is worth quoting at some length:

I wanted my being a woman to be visible in the work and had thus decided to change my name from Judy Gerowitz to Judy Chicago as an act of identifying myself as an independent woman.

The show, held at California State College at Fullerton, directed by Dextra Frankel, was beautiful, and Dextra's installation was fantastic. My name change was on the wall directly across from the entrance. It said:

Judy Gerowitz hereby divests herself of all names imposed upon her through male social dominance and freely chooses her own name *Judy Chicago.*

But, even though my position was so visibly stated, male reviewers refused to accept that my work was intimately connected to my femaleness. Rather, they denied that my statement had anything at all to do with my art. Many people interpreted the work in the same way they interpreted my earlier, more neutralized work, as if I were working only with formal issues. Admittedly the content of the work was not clear, but it seems that people could have made an effort to see the work in relation to the statement I had chosen to include. Moreover, no one even dealt with the range of ideas expressed or with the discrepancy between my status as an artist in the world and the obvious level of my development. Instead, there was only denial. At that time, there was no acknowledgment in the art community that a woman might have a different point of view than a man, or if difference was acknowledged, that difference meant inferiority.

As I look back on this, I realize many issues were involved in the situation. I had come out of a formalist background and had learned how to neutralize my subject matter. In order to be considered a "serious" artist, I had *had* to suppress my femaleness. In fact, making a place as an artist had depended upon my ability to move away from the direct expression of my womanliness. . . .

I wanted my show to speak to people, to tell them that women possessed all aspects of human personality, that society's conception of the female was distorted and that other values in the culture that grew out of that distortion were also questionable. Fundamental to my work was an attempt to challenge the values of the society, but either my work was not speaking, society didn't know how to hear it, or both. . . .

I realized that if the art community as it existed could not provide me with what I needed in order to realize myself, then I would have to commit myself to developing an alternative and that the meaning of the women's movement was that there was, probably for the first time in history, a chance to do just that. If my needs, values, and interests differed from male artists' who were invested in the values of the culture, then it was up to me to help develop a community that was relevant to me and other women artists.[34]

Chicago's experience was by no means unique. Martha Rosler, for instance, began in graduate school as a painter doing large abstractions on unstretched canvas of the Rothko variety. But as she grew more political in the late sixties and early seventies she began to feel that "it was very important to de-aestheticize your relation to the work so that it didn't become formalized into an aesthetic commodity. . . . It's very disturbing to me that people in an art audience try to separate out a work's formal characteristics. I want to make work where the content is so clear that you *know* you're violating it by fixing only on its formal properties."[35] She began, as a result, to use media which were less formally defined—first photography, then video, performance, installations, and finally texts and critical writing—and then, also, to allow these media to disrupt one another in any given work.

Chicago, on the other hand, turned especially to performance in order to discover her suppressed "femaleness" or "womanliness." Performance, Chicago felt, "released a debilitating, unexpressed anger" (126) in both herself and her students—including both Wilding and Suzanne Lacy—that in turn opened up for them new ranges of emotion that could be channeled into their creative work. Performance offered them all a way to "act out" anger—that is, both express it and purge it. Thus the same Faith Wilding who complained at Kaprow's idea of sweeping up as a performance exercise would collaborate by the following spring on pieces designed to provoke the very anger she had felt at Kaprow's lecture. Performances at Womanhouse, a derelict mansion near downtown Los Angeles which Chicago, Miriam Shapiro, and twenty-one women students from Cal Arts transformed into a large-scale feminist installation and environment replete with performance space, ranged from two "maintenance" pieces of precisely the Kaprow genre—an ironing piece and a floor scrubbing work—to Wilding's own stunning *Waiting*, in which Wilding took on female passivity by reading a litany of all the things women wait for in our culture: to wear a bra, to go to a party, to be asked to dance, for pimples to go away, for the perfect man, Mr. Right, for an orgasm, and so on.[36] "I think that the reason our performances in Fresno and Womanhouse created so much tension, excitement, and response was that we told the truth about our feelings as women in them," Chicago explains.

Because performance can be so direct, because we were developing our performances from a primitive, gut level, we articulated feelings that had simply never been so openly expressed in artmaking. Although many women in the arts have struggled to give voice to their experiences as women, their forms, like mine, have been so transposed (into the language of sophisticated artmaking) that the content could be ignored by a culture that doesn't understand or accept the simplest facts of women's lives, much less subtle and transformed imagery. We learned a profound lesson about aesthetic perception (particularly in men) when in Fresno, the chairman of the art department, a sophisticated, liberal man, came to visit our studio. He saw an environment by Faith Wilding, a piece that dealt with the sacrifice of the female by male culture. It was a religious piece, implying crucifixion, death, and destruction, and the symbolism was very overt. Hanging around the wall were bloody Kotexes, which he perceived as "white material with red spots," so disassociated was he from the ability to perceive content or to recognize anything that did not grow out of *his* cultural experience. (128–29)

For Chicago, the direct, content-oriented performances side-stepped above all the possibility of a purely formalist response. They forced the audience, not least of all men, to address women in women's terms. "What we glimpsed in our performances," Chicago concludes, "was the opportunity to make men feel themselves 'other' and thereby force them to identify with us on a psychic level. It is not enough for us to learn to identify with men; we have done that all our lives. *Men have to learn to identify with us*" (132).

If, as Craig Owens has asserted, "it is precisely at the legislative frontier between what can be represented and what cannot that the postmodernist operation is being staged—not in order to transcend representation, but in order to expose that system of power that authorizes certain representations while blocking, prohibiting and invalidating others," if this is the postmodernist stage, then it is women who have most artfully performed upon it.[37] In fact, in the objects that have survived their performances—installations, videotapes, photographs, texts (scripts like Wilding's *Waiting* as well as books like Chicago's *Through the Flower* and Schneemann's *More than Meat Joy*)—they are particularly concerned with what can and cannot be represented. Painting (by which I mean, really, the entire apparatus of mainstream art) blocked for them certain possibilities and potentialities— Chicago's "anger" and "femaleness," Rosler's "content," Schneemann's activity. Insofar as the objects of feminist performance *represented* action, established themselves as a kind of production, entered the field of potentially fetishized artworks, they were of the same order as the art production of modernist culture. But they also represented a certain *difference*. Because they existed as a kind of afterimage, as by-products of some *other* event or transaction, they were unable to exist in and for themselves. It is perhaps useful to think of these objects, then, as *refusés*, the leavings of the event, but leavings that bear the mark of the verb within them, as objects that have *refused* to comply with the authority of what Owens calls the "system of power that authorizes certain representations" and blocks others. The objects of feminist performance constitute a postmodern *salon des refusés*.

Another way to say this is to observe that these curious artworks invoke narrative. They exist in our world as artifacts that invite us, like so many contemporary archeologists, to reconstruct the story of their making. This is precisely the way that Yvonne Rainer felt in putting together her *Work 1961–73* with Kasper Koenig, the editor of the Nova Scotia Source Materials of the Contemporary Arts series:

Kasper Koenig and I were cast in the role of amateur archeologists. Not only did we have to deal with shards (the actual objects with which my work abounds), papyrii (program notes, published texts, and literary material used in the work), and hieroglyphics (the notebooks, which, in their fastidious verbal renderings of movement, so seductively create the illusion of documentation), but with those mysterious and inscrutable petroglyphs left by the visual historian of our age, the photographer.[38]

A great deal of feminist art has been produced with this analogy to archeology in mind, with the avowed intention, in fact, of *revising* archeological history itself. Schneemann's *Eye Body* was a conscious attempt on her part to use her body not as an object but "as a primal, archaic force," an almost

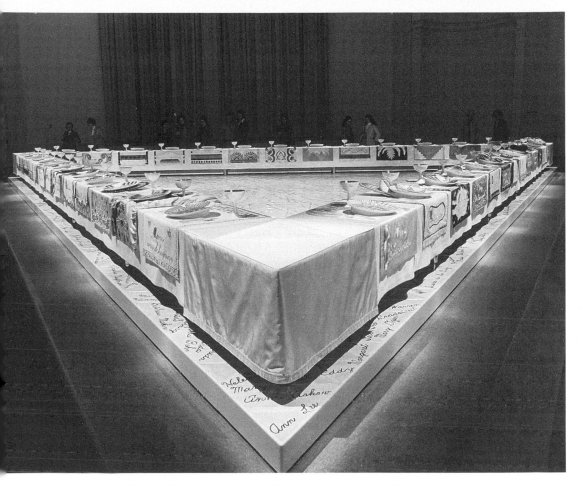

FIGURE 36. Judy Chicago, *The Dinner Party*, installation view, San Francisco Museum of Modern Art, 1979. Mixed media, 48 ft. on each side. © Judy Chicago 1979. Photo: Michael Alexander.

pure vernacular expression. She felt compelled, she says, "to 'conceive' of my body in manifold aspects which had eluded the culture around me."[39] By the early seventies, the images she explored in *Eye Body*, especially that of the snake, would be confirmed by revisionist archeologists to be part of an entire system of goddess worship, popularized by Merlin Stone in her widely read *When God Was a Woman*, that served to establish a real, if suppressed feminist mythology.[40] For Schneemann it must have been as if her instinctive attraction to her imagery had prehistorical, virtually psychogenetic roots. *Interior Scroll* was, in fact, an elaboration of the serpent imagery in *Eye Body*. The scroll itself was a conscious movement of "interior thought to external signification," and as it embodied the uncoiling of a serpent, it became the outward model of the vagina, signifying the passage and enlivening of Schneemann's internal "sacred knowledge" and "ecstacy."[41]

Judy Chicago's first work after leaving Cal Arts, the famous *Dinner Party*, incorporates a set of symbols similar to Schneemann's in the first of the thirty-nine settings on its large triangular table, symbol of female power.[42] The first plate is dedicated to the Great Goddess, and the third celebrates the Cretan Snake Goddess (Fig. 36). Lucy Lippard has elaborated the wealth of references to this new, revised archeological tradition in recent feminist art in a book that is itself an important document in the development of the idea's currency, *Overlay: Contemporary Art and the Art of Prehistory*.[43] But the point is not to trace these references here—it is rather to point out the need for the *story* itself, the strikingly widespread desire to create such a narrative, *any* narrative. There are many attendant dangers. Craig Owens, for instance, has charged that Marxist critic Fredric Jameson, in his desire to impose "the Marxist master narrative" upon the production of art, is in fact resurrecting "a modern desire, a desire for modernity." Jameson's view "is one symptom of our postmodern condition," Owens writes, "which is experienced everywhere today as a tremendous loss of mastery and thereby gives rise to therapeutic programs, from both Left and Right, for recuperating that loss." From Owens's point of view, Jameson's Marxism is simply a mechanism to disavow a loss of "virility, masculinity, potency" (he is using the words figuratively).[44] The same charge could easily be leveled—with some shift of rhetoric—at those who have celebrated the retrieval of God from prehistory in the form of a woman.

But there is, I think, narrative and narrative. Owens cites Hayden White's definition of narrative as inherently an attempt "to master the dispiriting effects of the corrosive force of the temporal process."[45] By this definition, narratives are not unlike certain photographs, the kind that captures our "best side," for instance, or, to refer again to Duane Michals's example, celebrates that moment when we *were* in love, *This Photograph Is My Proof*. But this is, I think it is clear, a fairly restricted view of narrative, one that at best represents only a partial truth. As David Antin has put it, in a conference on narrative at the Center for Music Experiment at the University of California, San Diego, in 1983, perhaps one of the most important functions of narrative is that "it's the way we explain ourselves." Narrative, Antin argues, is "a mode of cognition" that is "probably the paradigmatic way of coming to know the self."[46] If this is so, and I think it is, narrative's centrality to feminist art should be clear. It is, in fact, indispensable. Antin himself sets up a prehistorical paradigm, a set of Aztec definitions that he published, together with poet Jerome Rothenberg, in their little magazine *Some/Thing* in 1965. This, for instance, is part of a long definition of "Forest:"

It is a place of wild beasts; a place of wild beasts—of the ocelot, the cuitlachtil, the bobcat; the serpent, the spider, the rabbit, the deer; of stalks, grass, prickly shrubs;

of the mesquite, of the pine. It is a place where wood is owned. Trees are felled. It is a place where trees are cut, where wood is gathered, where there is chopping, where there is logging: a place of beams.[47]

Definition is achieved here in the act of engaging, experiencing the forest. Definition is, Antin says, "an inherent property of self-articulation," a kind

FIGURE 37. Carolee Schneemann, *Meat Joy*, 1964. Photo: © Al Giese 1970.

of narrative in its own right. Narrative, in other words, is the set of "transformations encountered by an experiencing agent . . . in achieving what this person wants or desires." Narrative is the transformation of the forest into beams—a particularly capitalist narrative—or the transformation of an old self into someone new, a Judy Gerowitz into a Judy Chicago. The point is that this is not a question of mastery, it is a question of process. It is not a question of transcending the temporal—that is what happened to the female body in the first place, as it became pure form, the idealized nude—but of *falling into it*, of acknowledging, as Manet's *Olympia* did, one's historical situation.

And what can be said of narrative can be said of vision. Luce Irigaray, the French feminist, has said that "more than the other senses, the eye objectifies and masters. It sets at a distance, maintains the distance. In our culture, predominance of the look over smell, taste, touch, hearing, has brought an impoverishment of bodily relation. . . . The moment dominates, the body loses its materiality." The body becomes instead, as Owens points out in quoting this,[48] an image, in the same way that Schneemann becomes, in *Site*, a "sight." Schneemann, of course, might be postmodern art's greatest artist of the body. A work like *Meat Joy* (Fig. 37), performed in May 1964 in Paris, a week later in London, and then on three consecutive days in November at Judson Church, is a conscious attempt to reintroduce smell, taste, sound, and touch to art. It is an admittedly indulgent "celebration of flesh as material"—not only the performers' bodies but also meat itself, raw fish, plucked chickens, uncooked sausages—all to the superimposed sounds of Rue de Seine vendors selling fish, chickens, vegetables, and flowers. But *Meat Joy* was, and continues to be, primarily visual in its stimulus. There is simply, as with narrative, vision and vision.

One can look at the female body through David Salle's eyes, insisting that it is "content-less," a question of form. But to insist on that, as Salle and his defenders do, is to miss the point.[49] To believe that such images can ever *be* without content is inherently sexist. It is to act as if there were no history or narrative, only painting. Performance alters that. Another kind of seeing imposes itself, one situated in time. One *can* see *historically*, and there *is* a difference.

Collaboration and the New *Gesamtkunstwerk*

Dancers are travelers, "space eaters" . . . using up a given space in a patterned, comprehensive way. . . . The more space the better. Dancers are pulled along a line; and their relations are conceived as parallel, perpendicular, etc. Dancers are always, indefatigably, going somewhere. In a state of non-imploring urgency, they never stop; though they may go into movement-absence, they do so in order to repopulate the space. When dancers "drop out," others come in.
 SUSAN SONTAG, "For *Available Light*: A Brief Lexicon"[1]

The feminist movement of the seventies provided at least two important "working" models for postmodern art. On the one hand, first in coopera- tive ventures such as Womanspace and then in individual works such as Chicago's *Dinner Party* and *Birth Project* and Suzanne Lacy's 1984 *Sofa* (in which 100 women, grouped according to age, social status, and ethnic back- ground, gathered in a furniture showroom in San Francisco to discuss their views on their "survival" as women), feminist art offered collaborative ac- tivity as not only an alternative to but a specific critique of the traditional modes of isolated, individually motivated artistic production accepted as the norm in Western culture. Similarly, as women artists came more and more to devalue certain of the male-dominated means of production (particularly painting and sculpture) and began to explore other media (especially per- formance), a certain taste for multi- or intermedia events began to emerge.

These directions were by no means unanticipated—the feminist move- ment simply lent them an insistence and necessity. Andy Warhol's ex- ample, for instance, offered not only a critique of artistic authority and originality but also, at the Factory, something of a model, albeit unortho- dox, of a new artistic "community." And the work of many male perfor- mance artists was motivated primarily by a desire to undermine or parody the eminence of the contemporary artist/producer. Chris Burden's famous 1976 TV ad, which ran in May on Channels 5 and 9 in New York and in September on Channel 3 in Los Angeles, usually during highly rated prime-time shows such as the evening news, consisted simply of the names Leonardo da Vinci, Michelangelo, Rembrandt, Vincent Van Gogh, Pablo Picasso, and Chris Burden repeated consecutively for thirty seconds. Not only did the ad emphasize the commercial side of the contemporary art world, but it became difficult to say whether Burden's presence in the list elevated him to the stature of the others or diminished the group to the level of Burden, exposing a universal inflation in postmodern cultural consciousness.[2]

Burden, of course, is much better known for his taste for putting him-

self, as an artist, at bodily risk, and these gestures are wrought with the same ambiguity as the television ad. On the one hand, when Burden had a friend shoot him in the arm from twelve feet with a .22-caliber rifle, at F Space in Santa Ana, California, on November 19, 1971, the temptation was to read the act as a willful subversion of ego. Similarly, Thomas McEvilley has read works such as Burden's *Through the Night Softly*, a 1973 piece in which Burden, bare-chested and hands tied behind his back, crawled on his stomach through a fifty-foot stretch of glass on Main Street in Los Angeles, as connected to "shamanic performances and primitive initiation rites around the world," in which, for instance, "shamans cut themselves while in ecstatic states" or "slit their bellies and exhibit their entrails."[3] But, as with the shaman, Burden's displays are as much exercises in power (self-control, mastery of the senses, the willingness, even, to contest with death) as they are images of contrition or self-abnegation. More than an attack on Burden's selfhood, for instance, *Shoot* seems to elevate its artist/victim to the level of that elite group "worthy" of the assassin's bullet, as if in staging his own carefully controlled assassination attempt Burden joined ranks with Andy Warhol, shot by Valerie Solanis in 1968, as one of only two artists important enough to be shot down like leaders of state. Probably nothing underscores the self-aggrandizement implicit in Burden's activity more than the fact that a videotape of *Through the Night Softly* became the centerpiece, in November 1973, of a ten-second spot that Burden ran for four weeks on Channel 9 in Los Angeles right after the 11 o'clock news. Approximately 250,000 people saw it nightly.

It is a very short step, of course, from Burden's self-mutilation to Schwarzkogler's self-destruction, and by the early seventies many artists were interested in escaping the cult of individual genius embodied by the first generation of abstract expressionists and continued, parodically or not, in the work of artists such as Burden. Collaboration seemed to offer an especially powerful alternative. In Maurice Tuchman's 1971 catalogue to Art and Technology, probably the first large-scale exhibition organized exclusively to generate collaborative works—in this case by artists, technicians, architects, and bureaucrats—Claes Oldenburg compared the personality of an artist working alone, in the studio, with one working in a collaborative environment. Oldenburg's tongue-in-cheek list (see p. 103) not only underscores the difficulty felt by artists working in the collaborative context but reveals their tendency to indulge in an otherwise antisocial, even psychopathic sense of self.

If it nevertheless seems reasonable that artists should have a certain amount of difficulty working with technicians and bureaucrats, feminist art offered what seemed to many the best model upon which to attack the romantic image of the artist as solitary genius and creator. As Richard C. Hobbs put it in the catalogue to the Hirshhorn Museum's important exhi-

Artist in Studio	Artist in Collaborative Situation
intolerant	tolerant
rigid	flexible
stingy	giving
violent	restrained
vindictive-paranoid	forgiving
proud	self-effacing
destructive (especially self)	constructive
compulsive	noncompulsive
drunk or high (looking for sublimity)	sober (indifferent to the sublime, like airplane pilots)
feverish	calm
alienated	participating
obsessive (primitive mind)	scientific
at ease	having difficulty[4]

bition, Artistic Collaboration in the Twentieth Century: "Collaboration, as it has been structured since the 1970s, is to my way of thinking largely responsible to the tenets of the feminist movement, to the desire to find a new model for successful human behaviour that does not depend on aggression and booty but instead is concerned with more human and fulfilling needs that can be grouped under the terms 'nurturance' and 'community.'" For Hobbs, from a feminist perspective, collaboration is "a concept of creating that does not separate but instead integrates, that does not make the ego the subject but instead is attuned to some function outside the individual, isolated self."[5] In the same catalogue, in an essay concentrating on the era from 1950 to 1980, David Shapiro traces the collaborative impulse of postmodern aesthetics to a different source, namely to that "supremely generative nexus of our epoch," the joint efforts of Robert Rauschenberg, John Cage, and Merce Cunningham.[6] Their collaboration began in 1952 at a sort of neo-dada evening at Black Mountain College when Rauschenberg projected slides and played scratchy tunes on an old Victrola while Cunningham danced, Cage and David Tudor made music, and M. C. Richards and Charles Olson recited poetry.[7] Between 1954 and 1964 Rauschenberg worked on at least twenty occasions with Cunningham, providing sets for dances that were often scored by Cage. By the early sixties, Rauschenberg was working as well with a number of Cunningham's dancers—Carolyn Brown, Judith Dunn, Deborah Hay, Valda Satterfield, Steve Paxton—who at Cunningham's invitation were conducting the experimental workshops that would blossom quickly into the Judson Dance Theater.

Judson, as I argued in the last chapter, was something of a protofeminist laboratory. Dance has of course always been one of the "acceptable" media

for women, as the unnamed minimalist filmmaker's putdown of Carolee Schneemann indicates: Am I, then, "a filmmakress?" Schneemann asked. "Oh No he said we think of you / as a dancer." But it is easy to forget that, until Judson, dance was a medium dominated by men, Martha Graham standing more or less alone among the likes of Balanchine and Cunningham. Judson marks the point where women—Trisha Brown, Lucinda Childs, Yvonne Rainer, Simone Forti—began to emerge as the great choreographers of the day, and this is, I think, hardly accidental. For as a medium, dance already possessed most of the attributes that would give rise to performance art in the seventies. As Shapiro notes: "Certain genres of art are already canonically placed under the sign of 'a working friendship,' the title of the correspondence between Richard Strauss and Hugo von Hofmannsthal. Opera, film, and architecture, for example, generate an aesthetic that is properly multiple, discontinuous, collaborative, oriented more to the idea of a system of group dynamic than to the expression of the individual."[8] Dance can be added to the list.

It might usefully be said that the feminist movement lent the collaborative artwork something of a philosophical imperative, while the Rauschenberg/Cage/Cunningham example provided it with a specific aesthetic. At the heart of their collaborative practice is a belief in what Lawrence Alloway has called, in describing Rauschenberg's so-called combine paintings, "an aesthetic of heterogeneity"[9]—that is, a more or less freewheeling trust that, in the chance encounter of diverse materials, objects, and images arbitrarily brought together in the work of art, certain areas of interest and moments of revelation will reveal themselves. In Cage's words, Rauschenberg's combine paintings constitute "a situation involving multiplicity."[10]

Individually, Cage, Cunningham, and Rauschenberg each worked in this manner. Of the three, Rauschenberg's large collage works are in many ways the most traditional, yet in bringing such things as stuffed birds, angora goats, automobile tires, and the Sunday comics into the domain of the canvas he broadened the possibilities of collage considerably, challenging more radically than anyone before him the integrity of the frame. Though always at least implicitly one of the themes of collage, in his works the dialogue between what lies "outside" the frame and those things normally held to lie "inside" the work of art (those things that more "properly" belong to painting, as Clement Greenberg would have it) is more overtly engaged than ever before. His delight in transferring photographic images into his works amounts to a willful collision of media, the facticity of the photographic image violating the aesthetic—that is, painterly—field of the canvas as violently as his goats and birds violate the frame. It is as if painting, for Rauschenberg, were a center of barely contained energy, a site ready to explode into the space around it.

What Rauschenberg does with objects and images, Cage does with sounds: ordinary sounds, electronically produced sounds, random noise, all might collide in the course of the composition. What determines the work is "chance." The piece, for instance, might consist of a series of operations that guide the musician by presenting him with certain choices, or it might be generated by the composer from a series of chance operations derived from the *I Ching*, or it might reflect the pattern of imperfections in the paper on which the piece was scored. As William Wilson notes, the composition will, as a result, "lack internal or organic necessity"; instead the musical act is defined "as a way of thinking about time as a system of possibilities . . . governed by operations."[11] Such a reliance on chance operations also diminishes the likelihood that the work will be tainted by expressive gestures; it excludes the self from asserting its authority over the work. The purest example is probably the famous 4'33", first performed by David Tudor in Woodstock, New York, in August 1952. Inspired by his experience in an anechoic chamber—where instead of experiencing total silence, as he expected, Cage heard both the pitched impulses of his nervous system and the low-pitched drone of his blood circulating—he decided to demonstrate that "silence" in music is actually composed of any number of "incidental" sounds originating from sources other than the musicians and their instruments. Tudor "played" the piece, which consists of three "movements" each marked "TACET," the notation informing the musician to play nothing during the movement, by seating himself at the piano and raising and lowering the keyboard cover at the beginning of each movement. He remained otherwise motionless and silent for the duration of the composition, four minutes and thirty-three seconds. Silence was constituted here by a series of sounds emanating from outside the frame of the musical score, including, at Woodstock, wind in the trees, raindrops on the roof, and the disturbed mutterings of the audience. But it was the piece itself that drew attention to these noises as sound, released their potentiality as a kind of music determined from the outside, not least of all by the audience itself.

4'33" was perhaps inspired by Cage's *Imaginary Landscape No. 4*, composed a few months earlier and originally designed to be something of an auditory antithesis for 4'33". It was a four-minute piece for twelve radios, each radio to be played by two "musicians," one turning the station selector, the other controlling the volume and tone knobs—"like fishermen catching sounds," Cage said.[12] But when the piece premiered after midnight, the anticipated grand finale of a program of new music at Columbia University in 1952, most radio stations had gone off the air and the audience was treated to an experience astonishingly similar to 4'33". That same summer, just before he would collaborate with Rauschenberg and Cunningham for the first time at Black Mountain College, Cage was busy transcrib-

ing a body of miscellaneous sounds (sirens, cows, birds, bells, and so on) onto magnetic tape and combining them all into what would become the famous electronic work *Williams Mix*. For Cage, traditional music was to such compositions as an "ash tray" was to "the whole room": "[An] ash tray can be seen as having beginning and end, and you can concentrate on it. But when you begin to experience the whole room—not object, but many things—then: where is the beginning? where is the middle? where is the end? It is clearly a question not of an object but rather of a process, and finally that process has to be seen as subjective to each individual."[13] Music for Cage finally should escape the frame of the composition, connecting to and relying upon what is ultimately "outside" the work of art, its audience. It differs, in this sense, from the works of the European avant-garde (Boulez, Stockhausen) that, according to Cage, "present a harmoniousness, a drama, or a poetry which [refers] more to their composers than to their hearers." In Cage's music, "the auditor is central. . . . The physical circumstances of a concert do not oppose audience to performers but dispose the latter around-among the former, bringing a unique acoustical experience to each pair of ears. . . . It resembles a listener's situation before and after a concert—daily experience, that is. . . . It dissolves the difference between 'art' and 'life.' "[14] Not only does it engage the vernacular, then, but in the vernacular's very complexity and undecidability it demands what Cage has called elsewhere a "polyattentiveness."[15]

Cunningham's dance requires the same sort of attention, for the same reasons. Asked to describe what differentiates his dance from older, more traditional forms, Cunningham replied:

Think of how they divide the *corps* in classical ballet: you have eight girls on each side of the stage, eight girls moving symmetrically which you can perceive at a glance. If you have these two groups of eight girls doing totally different phrases, that's not very complicated but it's already more unexpected. Now go further still, take each eight. Have four do one thing, four something else. You immediately see that you can go to the extreme: you can take all sixteen and have each doing clearly different movements. That would be done not just to be complex but to open up unexplored possibilities.

Further: in classical ballet as I learned it, and even in my early experience of the modern dance, the space was observed in terms of the proscenium stage, it was frontal. What if, as in my pieces, you decide to make any point on the stage equally interesting? I used to be told that you see the center of the space as the most important: that was the center of interest. But in many modern paintings [such as Rauschenberg's] this was not the case and the sense of space was different. So I decided to open up the space to consider it equal, and any place, occupied or not, just as important as any other. In such a context you don't have to refer to a precise point in space. And when I happened to read that sentence of Albert Einstein's: "There are no fixed points in space," I thought, indeed, if there are no fixed points, then every point *is* equally interesting and equally changing.[16]

FIGURE 38. Merce Cunningham, *Summerspace*, 1958. Dancers: Robert Kovich and Chris Komar. Photo: © Jack Mitchell.

An example of such a dance in which there were no clear fixed points is the 1958 *Summerspace*, with sets by Rauschenberg (Fig. 38). "It was about space," Cunningham says. "I was trying to think about ways to work in space. . . . When I spoke to Bob Rauschenberg—for the decor—I said, 'One thing I can tell you about this dance is it has no center. . . . ' So he made a pointillist backdrop and costumes."[17] Though his dance differs from that of the generation of younger choreographers whom he trained and inspired (by virtue of its inherent classicism, his emphasis, as Dale Harris has put it, on "sustained line, clarity of movement, speed and elevation"[18]), Cunningham shares with them a taste for centerlessness, open form. He continually devises dances in which so many things are happening at once, however classically, that the effect is not unlike watching a circus. *Varia-*

tions V, a complex piece in which the movement of the dancers triggers electronic sensors which in turn trigger an "orchestra" of tape recorders, record players, and radio receivers containing sounds composed by Cage, has been described by Gordon Mumma, a member of the Cunningham dance company, as "a superbly poly: -chromatic, -genic, -phonic, -morphic, -pagic, -technic, -valent, multi-ringed circus."[19] Cunningham himself cites approvingly the story of a schoolgirl who when asked by a *New York Times* reporter if she enjoyed watching one of Cunningham's favorite kinds of presentation, a so-called *Event*, replied, "Yes, it was like looking at the inside of a watch."[20] Harris has described the *Events* as "collages of dances culled from his *oeuvre* as a whole and lasting, non-stop, for roughly ninety minutes . . . often [consisting of] two or more theoretically discrete dances taking place at the same time." The point, as Harris notes, is that "as soon as it is incorporated into an *Event*, a Cunningham dance, whether complete or excerpted, takes on new characteristics."[21] The *Event* opens, that is, the "unexplored possibilities" of the work. It allows it to keep changing.

It takes only a moment of reflection to understand that Cunningham's dance must have a special relation to music if such *Events* can ever take place. Each discrete dance must have no need for its own discrete score. In fact, the most innovative characteristic of Cunningham's work has been his insistence on the *independence*, not interdependence, of each part of the dance's presentation. "In most conventional dances," he has said, "there is a central idea to which everything adheres. The dance has been made to the piece of music, the music supports the dance, and the decor frames it. The central idea is emphasized by each of the several arts. What we have done in our work is to bring together three separate elements in time and space, the music, the dance and the decor, allowing each one to remain independent."[22] Roger Copeland has pointed out that Cunningham's collaborations were anticipated by Bertolt Brecht in his 1930 "Notes on the Opera":

So long as the expression "*Gesamtkunstwerk*" (or "integrated work of art") means that the integration is a muddle, so long as the arts are supposed to be "fused" together, the various elements will all be equally degraded, and each will act as a mere "feed" to the rest. The process of fusion extends to the spectator who gets thrown into the melting pot too and becomes a passive (suffering) part of the total work of art. Witch-craft of this sort must of course be fought against. . . . *Words, music, and setting must become more independent of one another.*[23]

This is a consciously anti-Wagnerian statement. As Copeland points out, Wagner's dream of a world in which "there are no more arts and no more boundaries, but only art, the universal, undivided," led, in Brecht's mind, to the Nuremberg rallies. The fascist spectacle was, for him, a variety of Wagnerian opera.[24] This is why the effort of Rauschenberg, Cage, and Cunningham to strike out against the passivity of the art audience, to engage it and to make it more attentive, amounts to what Copeland calls "a poli-

tics of perception." And it is why, ultimately, the feminist movement and the Rauschenberg/Cage/Cunningham collaboration stand equally behind the new *Gesamtkunstwerk* of the seventies and eighties, a *Gesamtkunstwerk* in which the arts coexist in the same time and space independent of one another. For not only has the feminist movement reacted against the totalitarian bases of our culture; it has demanded *not* integration into the cultural muddle—women do not want to be "fused" with men—but that the culture respect their independence, their *difference*. The new *Gesamtkunstwerk* is above all an arena of difference.

II

If the Cage/Cunningham/Rauschenberg collaboration provided a *working* model for the next generation of dancers, musicians, and painters, an image of difference within collaboration that was powerfully influential, the particular aesthetic positions individually staked out by the three remained, of course, open to change and modification. As I have already said, many of the dancers at Judson, although encouraged by Cunningham to experiment as they saw necessary, rejected his more or less traditional idiom, which combined "the elegant carriage and brilliant footwork of ballet with the flexibility of spine and arms practiced by Graham," and opted instead to make vernacular, task-like dances—"to display the practical intelligence of the body in pursuit of a mundane, goal-oriented type of action."[25] Similarly, the younger composers inspired by Cage rejected many of his techniques. Instead of employing the vast multiplicity of most of Cage's compositions, they began to work, more in the spirit of 4'33", in reduced, minimal forms.[26] Many of these works, such as George Brecht's famous Fluxus "events"—executed primarily in 1960 and 1961—were visual gags that underscored the neo-dada flavor of the Happening in general and the *bruitism* ("noise" music) Cage had helped to generate in particular. In his *Drip Music (Drip Event)*, for instance (Fig. 39), Brecht literally dripped water from a chemistry pipette into a plastic bottle. His *Solo for Violin* consisted in polishing the instrument. And his *Three Telephone Events* (Fig. 40) has been systematically exploited in concert by Laurie Anderson (whether or not she is aware of the debt). These small, vernacular pieces are part and parcel of what Fluxus composer and poet Dick Higgins has called the Fluxus "'concerts' of everyday living," and they consciously refer to the introduction in 4'33" of simple everyday sound into the space of music.[27] Confronted by this "noise," we at least must come to terms with what we expect "music" to be. And we become aware especially of how elastic such terms really are. With its orientation toward an everyday task, for instance, many people would have been comfortable calling *Solo for Violin* a "dance" within one or two years of its composition, even if they still hesitated to call it "music."

DRIP MUSIC (DRIP EVENT)

For single or multiple performance.

A source of dripping water and an empty vessel are arranged so that the water falls into the vessel.

Second version: Dripping.

G. Brecht
(1959-62)

FIGURE 39. George Brecht, *Drip Music (Drip Event)*, 1961.

The Fluxus composer who probably had the greatest impact on the new music was LaMonte Young. For Young, Cage's music was "a complex of programmed sounds and activities over a prolonged period of time with events coming and going," while, he said, "I was perhaps the first to concentrate on and delimit the work to be a single event or object."[28] Young has referred to his compositions as a "theater of the single event."[29] His most famous early work was probably his *Composition 1960 #7*, which consisted of a B and F♯ chord "to be held for a long time." The score of *X for Henry Flynt* requires the performer to play an unspecified sound, or group of sounds, in a distinct and consistent rhythmic pattern for as long as the performer wishes, which, in Young's own performance, consisted of 600-odd beats on a frying pan. Works such as these are overtly a type of composition that is directly antithetical to the aesthetic of heterogeneity adopted by Cage. And yet Cage was one of the first to see their essential similarity to his work:

LaMonte Young is doing something quite different from what I am doing, and it strikes me as being very important. Through the few pieces of his I've heard, I've had, actually, utterly different experiences of listening than I've had with any other music. He is able either through the repetition of a single sound or through the continued performance of a single sound for a period like twenty minutes, to bring it about that after, say, five minutes, I discover that what I have all along been thinking was the same thing is not the same thing after all, but full of variety. I find his work remarkable almost in the same sense that the change in experience of seeing is when you look through a microscope. You see that there is something other than what you thought was there.[30]

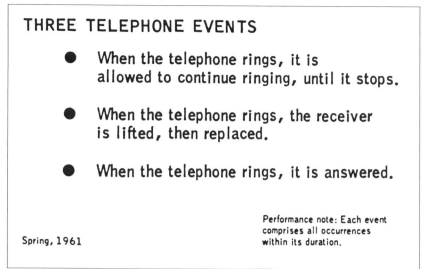

THREE TELEPHONE EVENTS

- ● When the telephone rings, it is allowed to continue ringing, until it stops.

- ● When the telephone rings, the receiver is lifted, then replaced.

- ● When the telephone rings, it is answered.

Performance note: Each event comprises all occurrences within its duration.

Spring, 1961

FIGURE 40. George Brecht, *Three Telephone Events*, 1961.

In the same way that Cage demonstrated that "silence" was composed of noises previously unattended to, Young reveals the variety which underlies the seemingly monotonous process of repetition. Young's *Drift Study*, for instance, is a carefully controlled investigation of the function of sine waves in space. The piece is based on the fact that sine waves possess the unique characteristic of having only one frequency component, whereas all other sound wave forms are composed of more than one. When a continuous frequency is generated in an enclosed space, it divides the air in the space into high and low pressure areas, the sound being louder in the high pressure zones than in the low pressure areas. Because of the simplicity of the sine wave structure, these zones become easy for listeners to locate in space as they move through it. For Young the point of *Drift Study* was simple: "This phenomenon can rarely be appreciated in most musical situations and makes the listener's position and movement in the space an integral part of the sound composition."[31] A *passive* listener, one unwilling to participate in the work by physically moving in it, would experience only a single constant frequency. The *active* listener discovers variety generated out of the unvarying monotony of the sound itself.

One of the ur-texts for such work is Erik Satie's *Vieux Sequins et Vieilles Cuirasses*, which ends in a eight-beat passage evoking "old marches" and "patriotic songs" repeated 380 times. As Dick Higgins has put it: "In performance the satirical intent of this repetition comes through very clearly, but at the same time other very interesting results begin to appear. The music first becomes so familiar that it seems extremely offensive and objectionable. But after that the mind slowly becomes incapable of taking fur-

ther offense, and a very strange, euphoric acceptance and enjoyment begin to set in."[32] In fact, just as silence paradoxically contains all manner of sound, the repetition of sound comes to evoke silence. In 1958, in *Artnews Annual*, Cage published a fifty-two-beat piece composed by Satie called *Vexations*, to be played very softly and very slowly 840 times, and he subsequently directed its eighteen-hour performance at New York's Pocket Theater in September 1963. "Is it boring?" Higgins asks. "Only at first. After a while the euphoria I have mentioned begins to intensify. By the time the piece is over, the silence is absolutely numbing, so much of an environment has the piece become."[33] Here music transforms itself into white noise.

Such music also approaches perilously close to the conditions of Muzak. But it is precisely the dialectical relations between boredom and interest, mindlessness and attentiveness, repetition and variety that this work seeks to explore. Like the repetition employed by Andy Warhol in his *Soup Cans*, on the one hand this music evokes what Jacques Attali, in his provocative history of music, *Noise*, has called "repetitive society"—a society that is determined by its growing reliance on "mass production . . . [which] signifies the repetition of all consumption, individual or collective, the replacement of the restaurant by precooked meals, of custom-made clothes by ready-wear, of the individual house built from personal designs by tract houses based on stereotyped designs, of the politician by the anonymous bureaucrat, of skilled labor by standardized tasks, of the spectacle by recordings of it."[34] If Attali's rhetoric here seems to be burdened by a nostalgia for "handcrafted" products, designs, and compositions, this nostalgia is tempered by his awareness that "the loss of meaning" we feel when confronted by the mindlessly reproduced goods of repetitive society "at the same time . . . becomes the absence of imposed meaning."[35] He offers "composition" as an alternative to "repetition" and mere "consumption." Composition takes place *outside* the economy of production and consumption. It evades, that is, the entire rhetoric of the "original," the "copy," the "handcrafted," and the "mass-produced," and locates production—at least meaningful production—in each individual. In "composition," as Attali puts it, "the listener is the operator." Thus when Cage

sits motionless at the piano for four minutes and thirty-three seconds, letting the audience grow impatient and make noises, he is giving back the right to speak to people who do not want to have it. He is announcing the disappearance of the commercial site of music: music to be produced not in a temple, not in a hall, not at home, but everywhere; it is to be produced everywhere it is possible to produce it, in whatever way it is wished, by anyone who wants to enjoy it. . . . Composition is revealed as the demand for a truly different system of organization, a network within which a different kind of music and different social relations can arise. A music produced by each individual for himself, for pleasure outside of meaning, usage and exchange.[36]

These are admittedly idealist sentiments, but they capture, in fact, the intention and aspirations of the new music—and the new *Gesamtkunstwerk* as well. This music demands an *active* audience, a new sort of *listening*. It generates not recognizable music but *vernacular sound*. As Roland Barthes has put it, given a piece of classical music, the listener "is called upon to 'decipher' this piece, i.e., to recognize (by culture, his application, his sensibility) its construction, quite as coded (predetermined) as that of a palace at a certain period." But given an example of the new music—he specifically mentions the example of John Cage—the listener discovers only a "dispersion," a "*shimmering* of signifiers, ceaselessly restored to a listening which ceaselessly produces new ones from them without ever arresting their meaning."[37] If sometimes this music *seems*, in the uniformity or monotony of its gestures, to have forsaken an aesthetics of heterogeneity, that is only because its heterogeneity lies outside itself, in the multiplicity of its various receptions. As Barthes says in another context, "Just as the reading of the modern text . . . does not consist in receiving, in knowing or in feeling this text, but in writing it anew," there is a kind of composition that requires us "to perform" it, "to *operate*" its music, "to lure it (as it lends itself) into an unknown *praxis*."[38] Such music is undecidable in the sense that in the hands of its audience it will always change.

It is a mistake, therefore, to think of the work of those composers who have been most influenced by Cage and Young and who have contributed most substantially to the new *Gesamtkunstwerk*—composers such as Philip Glass and Steve Reich on the "serious" side, Brian Eno and David Byrne of the Talking Heads on the "rock" side—as eschewing Cage's penchant for allowing the effects of chance to influence the work, for admitting the undecidable. Though so astute a critic as Michael Nyman insists that their music "shows a many-sided retrenchment from the music that has grown from indeterminacy" and concentrates instead on "mostly repetitive, highly disciplined procedures which are focused with an extremely fine definition," the key point, it seems to me, is tacked on parenthetically by Nyman—"(though the listener's focusing is not done for him)."[39] When Eno, for instance, performed LaMonte Young's *X for Henry Flynt*, he played it by smashing his forearms down on the keyboard of a piano 3,600 times, trying to strike the same cluster of notes on each impact. "Now, until one became accustomed to this fifty-odd note cluster, the resultant sound was fairly boring," he told a Trent Polytechnic audience in 1974:

But after ten minutes, it became progressively more absorbing. This was reflected in the rate at which people left the room—those who didn't leave within ten minutes stayed for the whole performance. One began to notice the most minute variations from one crash to the next. The subtraction of one note by the right elbow missing its top key was immediately and dramatically obvious. The slight variations of timing became major compositional changes, and the constant changes within the

odd beat frequencies being formed by all the discords began to develop into melodic lines. This was, for me, a new use of the error principle and led me to codify a little law that has since informed much of my work—"Repetition is a form of change."[40]

In the face of this music, in Eno's analogy, our "listening brain" begins to function like "the eye of a frog": "The frog's eye, unlike ours, is absolutely static, so that its retina rapidly becomes saturated from looking at a static situation and ceases to distinguish detail. However, the most minute change (movement) in the environment is thus considerably highlighted. So the frog disregards the common (unvarying, continuous) information and becomes more and more intensely aware of any changing (new) information."[41] Similarly, in speaking about his 1970 *Music in Changing Parts*, his first recorded composition, Philip Glass has said that he is "less interested in the purity of form than in the psychoacoustical experiences that happen while listening to the music. . . . Psychoacoustical phenomena are part of the content of the music—overtones, undertones, different tones. These are things you hear—there is no doubt that you are hearing them—even though they may not actually be played."[42] As Brian Eno has put it, the new music "must regard the irregularities of the environment as a set of opportunities, around which it will shape and adjust its own identity."[43] And three things contribute to the irregularities of this environment—the audience, the musicians themselves (who are, in a sense, their own audience), and the actual site or place of performance (the recording studio, with its mixing capabilities, or the "live" situation, with its varying acoustical characteristics). Given that *at least* one of these—the audience—is bound to change with each performance, the composition is defined as a thing always in process, always changing.

If the politics of such a relation to music are not immediately clear, it is only necessary, I think, to recall that music, perhaps more than any other art, has always been implicitly aligned with the interests of the state. In an essay sketching the systematic exclusion of women from the field of music, Eva Rieger outlines a situation that is broadly generalizable to the avant-garde's relation to music as a whole. Music, she points out, is a "masculine world": "For centuries music was used to praise God; gradually it was subverted to the praise of the secular ruler and individual heroes, and then finally the bourgeois gentleman." Woman's existence was, of course, acknowledged by music, but only from a masculine perspective. Haydn's *The Creation* is a case in point:

By merging secular and religious elements this music contributed to the popular acceptance of bourgeois norms (one of which was the subordination of women) as given by God. The earthly father, just like the Father in Heaven, is destined to rule. Adam is to lead Eve, she is to follow him, and with the words, "Your will is my law, that is God's decree," she submits to this power relationship. This also finds musical expression: while Adam conveys action by means of dotted rhythms and rising

thirds, Eve is made to signify weakness and passivity by means of suspended notes
and seconds.[44]

Similarly, the sonata form, the strictest of all classical forms, is thoroughly laden with gender-role stereotypes. As Rieger points out, the leading music dictionary in German says of the sonata: "Two basic human principles are expressed in each of these two main themes; the thrusting, active masculine principle (first theme) and the passive, feminine principle (second theme)." This second theme, Rieger says, is described as "less complete."[45] Furthermore, by the nineteenth century, "the composer himself was a 'divine genius,'" and the musical composition was seen to be a timeless document of "divine perfection," an "autonomous work of art," "absolute" in its purity.[46]

Such purist sentiments are familiar enough. They represent the reason, for instance, that a formalist like Michael Fried, in his "Art and Objecthood," which I discussed in the introduction, should think that all art ought to aspire to the condition of music. Nevertheless, as early as the beginning of this century it was possible for the futurist Luigi Russolo to propose, in his 1913 manifesto *The Art of Noises*, that the precise harmonic structures of classical composition needed to admit into its framework—obviously at the risk of destroying that framework—a virtually infinite "variety of noises . . . twenty or thirty thousand different noises":

We can delight in distinguishing the murmur of the water, air and gas in metal pipes, the mutter of motors, breathing and pulsing like animals, the throbbing of valves, the thudding of pistons, the screeching of mechanical saws, the jolting of a tram on its rails, the cracking of whips, the flapping of curtains and flags. We can enjoy orchestrating in our minds the crashing of metal shop blinds, the slamming of doors, the muttering and shuffling of crowds, the variety of din from railway stations, iron foundries, spinning mills, printing works, electric power stations and underground railways.[47]

Music, Russolo realized, had become "inviolable and sacred, a fantastic world," distinct from "the real one" which "the art of noises" would champion: *The limited circle of pure sounds must be broken, and the infinite variety of noise-sound conquered.*"[48]

Russolo obviously anticipates the compositions of composers such as Cage, Young, and Eno. What each is trying to do is break music free from the structures of power relations, the hierarchies of traditional musical discourse that so trouble Rieger. There is no "absolute" music for Russolo—but rather a music of process and change that is open to the world at large, a music composed of vernacular sounds that requires its audience to perform it and operate it, to refer to Barthes's distinction, rather than passively receive it. Repetition is a formal device, like the admission of noise into the composition, that both disrupts traditional musical discourse and prompts

us to recognize our own role as listeners in the work's creation. Repetition is a device that disrupts the very idea of the self-contained work which relies on a predetermined structure. There is always, in the repeated occurrence of a thing, a *reference* to some former occurrence, and in the *sustained* repetition of a thing, a growing awareness that *duration* alters it. "Repetition," as Eno emphasizes, "is a form of change." In classical composition such vectors are suppressed—we are treated to a "theme" and its "variations," each variation referring back to and contained by the "master" theme. But in the new music, as a phrase or motif is repeated, it is as if the "original" were "lost." Thus, the repetitive gesture is caught up in the dynamics of the Derridean *trace*. Traces, Derrida explained to Julia Kristeva in a 1968 interview, are "a formal play of differences." According to Derrida, "The play of differences supposes, in effect, syntheses and referrals which forbid at any moment, or in any sense, that a simple element be *present* in and of itself, referring only to itself." It rules out, that is, the formalist objet d'art. Whether in the order of spoken or written discourse or in the discourses of painting, music, and dance, for that matter, "no element can function as a sign without referent to another element which itself is not simply present," without reference to some previous "fact" or "event": "This interweaving results in each 'element' . . . being constituted on the basis of the trace within it of the other elements of the chain or system. . . . Nothing, neither among the elements nor within the system, is anywhere ever simply present or absent. There are only, everywhere, differences and traces of traces."[49] In terms of the new music, each repetition of a sound or phrase carries within it the traces of its previous manifestations, but also announces its difference from its previous manifestations. Experienced in time, these differences—both the same and not the-same—are, furthermore, instances of what Derrida means by that curious hybrid word *différance*, a misspelling meant to imply both difference and deferral:

Différance is the systematic play of differences, of the traces of differences, of the *spacing* by means of which elements are related to each other. . . . The activity or productivity connoted by the *a* of *différance* refers to the generative movement [the living on] in the play of differences. The latter are neither fallen from the sky nor inscribed once and for all in a closed system, a static structure that a synchronic and taxonomic operation could exhaust. Differences are the effects of transformations, and from this vantage the theme of *différance* is incompatible with the static, synchronic, taxonomic, ahistoric motifs in the concept of *structure*.[50]

Music then subjects itself, in repetition, to these transformations, and it is no longer compatible with the notion of "autonomous composition," the "master" work. Instead, in our always changing experience of it, there is only what Derrida calls its "living on." The space of music is the "becoming-space" that no closed system can ever contain.[51]

Postmodern dance could be said to be an exploration—the charting and mapping—of the conceptual terrain of repetition, an art of *différance*, "of the play of differences, of the *spacing* by means of which elements are related to each other." In part, this interest in repetition derives from the very temporality of the medium, and from the fact that in rejecting the traditional "vocabulary" of classical ballet the movements of postmodern dance could not easily be recognized by its audience. Repetition became, in effect, a teaching tool, a way to teach the audience the characteristic gestures of the particular work at hand. Anna Halprin, the West coast teacher whose students included Brown, Rainer, and Forti, introduced repetition into her work precisely in order to allow the audience to "see" her movement: "I remember thinking that dance was at a disadvantage in relation to sculpture in that the spectator could spend as much time as he required to examine a sculpture, walk around it, and so forth—but a dance movement—because it happened in time—vanished as soon as it was executed. So in a solo called *The Bells* I repeated the same seven movements for eight minutes. It was not exact repetition, as the sequence of movements kept changing."[52] Repetition is the kinetic equivalent of sculpture's permanence, a way to evoke a *sense* of sustained gestural presence. But it evokes, to borrow Sontag's language about photography, only a pseudopresence, a presence paradoxically sustained only through the process of its perpetually vanishing away.

One of the earliest Judson experiments with repetition was a work entitled *Word Words* (Figs. 41 & 42), choreographed by Steve Paxton and Yvonne Rainer and performed, as the third dance on the program of Judson Concert #3, January 29, 1963, in total silence and without accompaniment. It consisted of a ten-minute sequence of movements, danced first by Paxton, then by Rainer, and then by both in unison. Rainer recalls: "Steve wanted us to look as much alike as possible. He thought of gorilla suits, Santa Claus suits, playing around with our faces to re-draw them so they'd look alike. That didn't work. And then we decided on a chaste version of nudity. . . . At that time it was illegal to dance totally nude. We obeyed the law: I wore pasties and we both wore g-strings."[53] As one critic put it: "After the first surprise, the nudity makes no difference at all. . . . The dancing impressed itself upon the spectator as the significant aspect of the whole thing. At the end, the performers might as well have been wearing fur coats for all the difference their lack of apparel made."[54] The nudity, in short, functions here like the sustained drone of a LaMonte Young score, a single element which finally silences itself so that other, more subtle effects can begin to assert themselves. Rather than focusing on the body, we begin to focus on the body's actions. In fact, the second of Rainer's *Three Sea-*

scapes, the sixth dance on the same program as *Word Words,* was accompanied by Young's *Poem for Chairs, Tables, and Benches.* This was a work Young had written in 1960, and it was composed of the sounds made by pulling, pushing, dragging, scraping, and otherwise forcing furniture across or around or in the general vicinity of the performance space. Jill Johnston, writing in the *Village Voice* described Rainer as progressing "ONCE across the stage, like a slow motion spastic, if you can believe it, to the accompaniment of a number of tables and chairs moaning, scraping across the floor in the lobby."[55] Rainer herself, in an unpublished essay written two years later and entitled "Rreeppeettiittiioonn iinn mmyy Wwoorrkk," called this dance "the purest example of repetition in my work: traveling on a diagonal with slow-motion undulations of pelvis and vague hand gestures. . . . The movement was simple enough so that it could be observed as 'one thing.'"[56]

Taken together these dances are richly suggestive. In the first place, the chastening of the body in *Word Words,* the dance's collapsing of sexual difference, underscores the importance of removing the body from the gaze

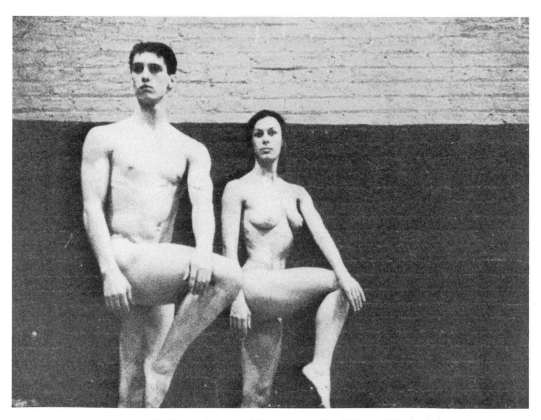

FIGURE 41. Yvonne Rainer and Steve Paxton, *Word Words,* 1963.

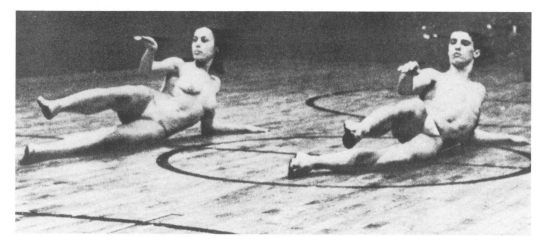

FIGURE 42. Yvonne Rainer and Steve Paxton, *Word Words*, 1963.

by returning it to acitivity, to the condition of *always doing something*. It anticipates, that is, the role that *acting* will assume in feminist performance by the end of the decade. Maurice Merleau-Ponty's ground-breaking *Phenomenology of Perception* probably lies, directly or indirectly, behind it. Published in English in 1962, just as the Judson Dance Theater was beginning to establish itself, it was unique, as a philosophical system, in its insistence that the human body, as a sensuous and experiencing entity, lies at the heart of understanding. In the first part of the *Phenomenology*, which is, indeed, devoted explicitly to "The Body," Merleau-Ponty attempts to articulate the nature of "the body image" by distinguishing between the body's peculiar spatiality and the spatiality of other objects. "The body image is *dynamic*," he says, which "means that my body appears to me as an attitude directed towards a certain existing or possible task . . . [not] a *spatiality of position*, but a *spatiality of situation*. . . . The body image is finally a way of stating that my body is in-the-world. . . . It is clearly in action that the spatiality of our body is brought into being."[57] Thus the dancer's body always projects beyond itself, beyond its present position to its next. It articulates, in Derrida's phrase, a "becoming-space." Its opposite would be something like Robert Longo's freeze-frame paintings of people dancing—or dying (Fig. 43). As the title implies, there is no movement here, no dance, not at least in the image. The metaphor of the "freeze"-frame is literalized. Longo's figures are positioned in space, never situated. As Carter Ratcliff has recently pointed out: "To be understood, the particulars of behavior must have a stable relationship with something larger, more general," but in Longo's work the figure "drifts in a vacuum."[58] Only in his monumental *Now Everybody* (Fig. 44) does he begin to locate us, shot in the small of the back, caught trying to escape from the scene, from

119

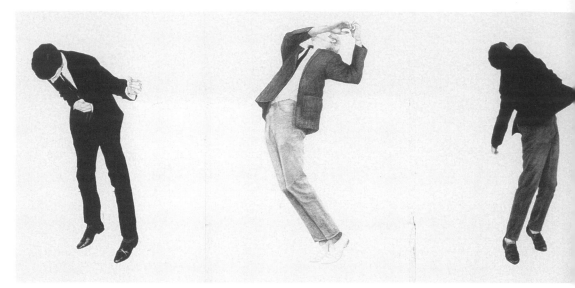

FIGURE 43. Robert Longo, *Men Trapped in Ice*, 1979. Charcoal, graphite on paper, three panels, 60 × 40 in. each. Collection Martin and Jeanette Sanders, Amsterdam. Courtesy Metro Pictures, New York. Photo: Pelka/Noble, New York.

the confines of the frame, as if we were all looters. There is, however, no real escape here, as we move from the two-dimensional painting to the three-dimensional sculpture, from canvas to floor. The implication is that we are ourselves positioned in the same space as the sculpture. We too are "trapped in ice," frozen in what Longo might call "gallery time." Longo's work demands our movement into some other sort of time and space. It draws attention, in fact, away from the work and to our own bodies, their own location. It is, in this sense, de-aestheticizing. It could be said to celebrate—or at least provide the occasion to celebrate—our own freedom of movement.

Word Words likewise projects beyond itself. The pluralization in the title alone implies a certain accumulation and a certain "living on"—as Derrida says, paraphrasing Mallarmé, "the letter *s* [is] the 'disseminating' letter *par excellence.*"[59] But this accumulation of "words" takes place in total silence. There is an implication of gestural "vocabulary building," an analogy between the discourse of dance and "normal" discourse, but there is also a sense of suspension, of words that are yet to come. The dance, that is, projects beyond itself, outside its own frame. In fact, Paxton's *Music for Word Words* was performed separately from the dance itself, on the next evening, as the overture to Judson Concert #4 on January 30. It was as if Paxton were bent on outdoing Young's score for Rainer's *Three Seascapes*, which had itself escaped the performance as far as the lobby. Paxton's score missed its performance, but showed up the next evening, asserting an

independence such as Cage, Cunningham, and Rauschenberg had never
dreamed.

Nevertheless, Young's *Poem*—the full title of which was *Poem for Chairs, Tables, and Benches, Etc., or Other Sound Sources*—was soon recognized to be the most "open" and independent of all the new music associated at the time with avant-garde dance. "The work developed into a kind of 'chamber opera,'" English composer Cornelius Cardew wrote in the London-based *Musical Times* in 1966, "in which *any* activity, not necessarily even of a sound variety, could constitute one strand of the complex weave of the composition, which could last minutes, or weeks, or aeons. In fact it was quickly realized that all being and happening from the very beginning of time had been nothing more than a single gigantic performance of *Poem*."[60] However hyperbolic Cardew's conception may be, it has the advantage of underscoring the essential heterogeneity of the work, a sense of inclusion which performances such as Carolee Schneemann's May

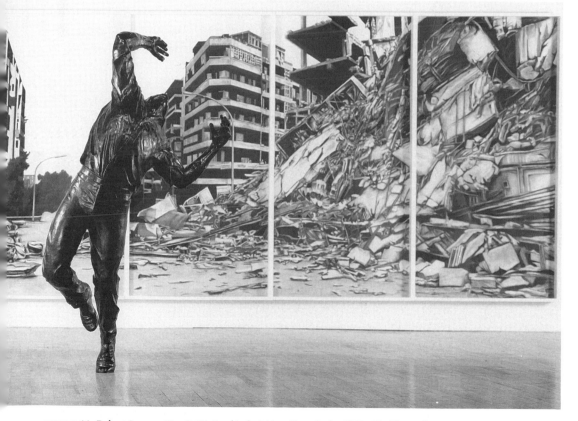

FIGURE 44. Robert Longo, *(For R. W. Fassbinder) Now Everybody*, 1982–83. Charcoal, graphite, ink on paper, four panels, 94 × 48 in. each; figure-cast bronze bonding 79 × 28 × 45 in. Collection Dr. Peter Ludwig. Courtesy Metro Pictures, New York. Photo: Pelka/ Noble, New York.

1962 *Glass Environment for Sounds and Motions* at the Living Theater—which incorporated Young's piece—helped to articulate. "My concept," wrote Schneemann, "was that the environment would determine, and at the same time transform and integrate any action or gesture of performers and audience: an enlarged 'collage,' to break up solid forms, frames, fixed conventions or comprehensible planes, the proscenium stage and the separation of audience and performer."[61]

Aside from performing in spaces where there was literally no proscenium stage to separate audience and performer (such as Judson), probably the most common way for dancers to "break up" the integrity of the dance in a similar way was to introduce into the performance what was only projected in *Word Words*—words themselves. One of the first such works was Rainer's *Ordinary Dance*, performed at the first "Concert of Dance" at Judson on July 6, 1962. The dance was a collage of pure dance movements and fragments of observed behavior, such as the contorted expressions of a woman hallucinating in the subway. Juxtaposed to this was an autobiographical narrative spoken by Rainer as she danced. In avant-garde circles, it was an enormous success, and Lucinda Childs's reaction is probably typical: "What knocked me out was the fact that it had such a valid performance quality. Even though if you think about it—and I had never seen this before—if you had said this girl is going to walk around and do this thing and talk, I would think you were kidding, or crazy. And instead, it was completely spellbinding. She could have been talking about anything. She had a manner of delivery that was very matter-of-fact."[62] Childs's sense that any textual material at all might be used in accompaniment to a dance was soon put to the test. In 1965, Rainer's *Parts of Some Sextets* was accompanied by readings from the *Diary of William Bentley, D.D.*, the daybook of a late eighteenth-century Episcopal minister from Salem, Massachusetts,[63] and that same year John Cage "scored" Cunningham's *How to Pass, Kick, Fall, and Run* by telling stories, once each minute unless the story was too long and then he would extend it to two minutes, slowing down when there were few words to say and speeding up if there were many, interspersing the stories with two or three minutes of silence. The introduction of the vernacular, in other words, undermined the formal integrity of the dance, disrupted the coherence of the work.

By 1968, when she initiated an ongoing "in progress" work which continually incorporated material into older more established routines, variously called *Performance Demonstration*, *Performance Fractions*, or *Composite*, Rainer's use of "words" in her dances had become extraordinarily complex. She usually began with the dance *Mat* from *The Mind Is a Muscle*, accompanied by a monologue referred to in her cue sheets as the "muciz" tape.[64] It is a long harangue against musical accompaniment to dance, *against*, in fact, collaboration. This is a representative sample:

I would like to say that I am a music-hater. The only remaining meaningful role for muzeek in relation to dance is to be totally absent or to mock itself. To use "serious" muzache simultaneously with dance is to give a glamorous "high art" aura to what is seen. To use "program" moosick or pop or rock is to generate excitement or coloration which the dance itself would not otherwise evoke.

Why am I opposed to this kind of enhancement? One reason is that I love dancing and am jealous of encroachment upon it by any other element. I want my dancing to be the superstar and refuse to share the limelight with any form of collaboration or co-existence. (111)

The point is that Rainer is talking complete nonsense here. *Performance Demonstration* was full of collaborative encroachments. The dance *Film* was performed, as it had been in *The Mind Is a Muscle*, behind a movie of legs and feet approaching a volleyball projected on a large screen downstage center (Fig. 45). There was a performance of *Trio A*, also from *The Mind Is a Muscle*, to the hit rendition of "In the Midnight Hour" by the Chambers Brothers, "ironically conflicting," Rainer admits, "with my priggish music lecture" (113). Above all, a spirit of collaboration existed between Rainer and her fellow performers. As *Performance Demonstration* evolved, from 1968 to 1970, into *Continuous Project—Altered Daily*, and as *Continuous Project* itself was transformed, through the early seventies, into an improvisational dance company which included Trisha Brown, Barbara Dilley, Douglas Dunn, David Gordon, Nancy Lewis, and Steve Paxton, and which became known as "The Grand Union," Rainer gave up any directorial control of the work.[65] "I no longer formally contributed anything new to the performances," she recalls, "but supported and participated in a process of 'erosion' and reconstruction as the group slowly abandoned the definitive *Continuous Project* and substituted their own materials" (125). This collaborative dance activity led her to believe that there was "a moral imperative to form a democratic social structure" (128) among the artists creating, now almost wholly by means of improvisation, the work as a whole.

The use of words themselves helped to contribute to this more "democratic" structure. By the time that *Continuous Project* was performed at the Whitney on the first two days in April 1970, Rainer had worked out a theory of the "levels of performance reality" (130) that explained what she was after in her use of texts (quotations from famous performers—Barbra Streisand, Buster Keaton, W. C. Fields, Louise Brooks) to accompany the dance. In a letter to the company as a whole, she wrote:

There are primary, secondary, and tertiary performances. Primary performance is what we are already doing—original material. Most performance is secondary, i.e., performing someone else's material in a style approximating the original or working in a known style or "genre." . . . I want our spoken stuff to be tertiary—someone else's material, or material that has actually previously been brought into existence (via media, or live), *as though* it is one's own, but in a style completely different from or inappropriate to the known original. . . . It all adds up to a kind of irony

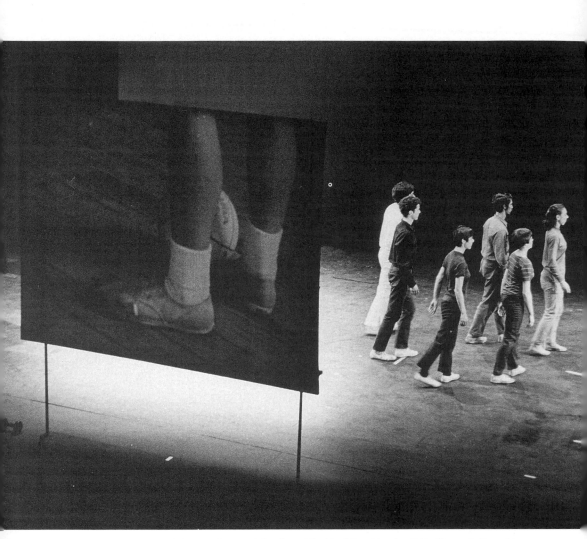

FIGURE 45. Yvonne Rainer, *Film*, from *The Mind Is a Muscle*, 1968. Photo: © Peter Moore.

that has always fascinated me. When I say "How am I like Martha Graham" I imagine that my presence is immediately thrust into a new performance "warp" (in the minds of the spectators). From that moment on people are forced to deal with me as a certain kind of *performer*, someone who is simultaneously real and fictitious. . . . I feel that the tension that is produced from not knowing whether someone is *reciting* or *saying* something—pushes a performance back and forth, "in and out of warp." The days of thwarted expectations are over. Warping is the ticket! (153–54)

Such a use of the text announces what Roland Barthes has called "the death of the author," and by extension of the director as well. For Barthes, where once there was an Author who was "thought to *nourish* the book, which is to say that he exists before it, thinks, suffers, lives for it, is in the same relation of antecedence to his work as a father to his child," there is now a

kind of text in which "there is no other time than that of the enunciation and every text is eternally written *here and now*."[66] Here the writer (no longer "Author") gives up the possibility of conveying an "intended" meaning, a "message." The work becomes "a multi-dimensional space in which a variety of writings, none of them original, blend and clash . . . a tissue of quotations drawn from the innumerable centres of culture."[67] This is the multidimensional space—the warp—that Rainer evokes when she becomes, as she says, a performer, even as she remains a creator. The key point is that such a text, such a work of art, is no longer self-referential. It does not "contain" meaning. Yet, as Barthes points out, all these quotations, traces of previous texts, are focused in one place—in the reader, or the spectator: "The reader is the space on which all the quotations that make up a writing are inscribed without any of them being lost; a text's unity lies not in its origin but in its destination."[68] The ultimate collaborator, then, the one who puts the work of art together, who makes *some* sense of it, is the one to whom it is addressed. But the "unity" the audience makes—and this is especially true of dance, the vocabulary of which continually dissolves before us—is itself a "trace" of the original. It is warped. In the same way *Continuous Project* was also, inevitably, *Altered Daily*, each performance a trace of the performance before it and the germinal seed of the performance that would follow, the embodiment of repetition and difference.

IV

Trio A, which appeared in Rainer's projects throughout the late sixties and early seventies, was probably the least overtly repetitive of her works, and yet one of the most suggestive in terms of the possibilities for repetition that it opened up. In part it was so influential because it was the focus of her essay "Some Minimalist Tendencies . . ." which, together with Michael Fried's "Art and Objecthood," was probably one of the most widely discussed contributions to Gregory Battcock's important 1966 collection, *Minimal Art*. In that essay, Rainer describes the dance as a conscious change from her previous work, "which often had one identical thing following another—either consecutively or recurrently": "Naturally the question arises as to what constitutes repetition. In *Trio A*, where there is no consistent consecutive repetition, can the simultaneity of three identical sequences be called repetition? Or can the consistency of energy tone be called repetition? Or does repetition apply only to successive specific actions?"[69] In *Trio A* Rainer discovered a specific kind of repetition that was, in effect, quite new, at least to the dance. As the three dancers perform, "small discrepancies in the tempo of individually executed phrases result in the three simultaneous performances constantly moving in and out of phase and in and out of synchronization. The overall look of it is constant

from one performance to another, but the distribution of bodies in space at any given instant changes."[70] Such a repetition was not unanticipated in the other arts. Steve Reich's experiments with phase patterns of sound, for instance, share the same sense of difference within repetition. In 1965 Reich had recorded the voice of a black preacher in a San Francisco park. He was, at first, interested primarily in "the melodic quality of his speech which seemed to be on the verge of singing."[71] Then, after selecting a short segment from this impromptu sermon on the great flood—"it's gonna rain"—isolating it, and looping it on two identical tapes so that it was repeated over and over again, he discovered that the words, played on two identical tape recorders, grew marginally out of phase with each other. This accidental desynchronization revealed new perceptual territory. Brian Eno, whose own 1975 *Discreet Music* owes much to *It's Gonna Rain*, described his own experience of Reich's composition to an interviewer in 1982: "After a while you start hearing all sorts of things in there—a pigeon in the background, a truck going past and even things that aren't there at all—the sound of trumpets and bells."[72] The point is that until *Trio A* principles of harmony, balance, and proportion required that movement in dance be synchronized. But instead of suppressing difference—one of the primary goals of rehearsal in traditional dance—*Trio A* exploits it. As a result, the individual gestures of the dance are enriched. All manner of possible variation is revealed as the three dancers carry out the same move.

Of all the dancers associated with Judson (and with Rainer) probably the two who continued to exploit the varieties of repetition most fully after Rainer quit dancing and began making film in the mid-seventies were Trisha Brown and Lucinda Childs. Childs's work is minimalist in conception, explicitly exploiting a geometry of repetition and reflection. Her work is specifically indebted to minimalist sculpture, particularly to the work that Robert Morris was doing in and around Judson in the mid-sixties. Of particular significance to her were works like the *Untitled (L-Beams)* of 1965 (Fig. 46). Three 8 x 8 x 2 ft. white painted plywood L-beams were situated on the floor by Morris in three different positions. Rosalind Krauss has described the effect:

This placement visually alters each of the forms, thickening the lower element of the first unit or bowing the sides of the third. Thus no matter how clearly we might *understand* that the three Ls are identical (in structure and dimension), it is impossible to see them as the same. Therefore, Morris seems to be saying, the "fact" of the objects' similarity belongs to a logic that exists *prior* to experience; because at the moment of experience, or *in* experience, the Ls defeat this logic and are "different." Their "sameness" belongs only to an ideal structure—an inner being that we cannot see. Their difference belongs to their exterior—to the point at which they surface into the public world of our experience.[73]

Synchrony in dance, the "sameness" of a troupe's movements, is likewise an ideal structure. Childs's work, on the other hand, continually exploits a

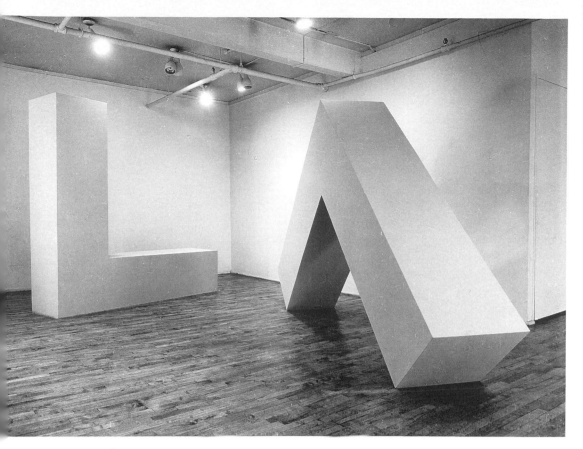

FIGURE 46. Robert Morris, *Untitled (L-Beams)*, 1965. Painted plywood, 8 × 8 × 2 ft. each. Courtesy Leo Castelli Gallery, New York.

rigorous geometric "sameness" in order to underscore the differences of which it is composed. She particularly admires, she says, the films of Bresson, "where there is repeated action, then a doubled action and a backtracking." Her dance likewise arrives "at variation not so much through making up new movements, but by constantly editing and rearranging existing movements."[74] Sally Banes's description of Childs's *Untitled Trio*, performed at the Whitney in 1973, gives a good sense of the effect of most of her work:

Phrases and fields of movement are stated, broken down, and reconstructed. . . . In a given dance, although a single movement phrase appears to be repeated over and over, with close viewing the spectator can see that within the strict limits of the phrase, small insertions are made, changes of direction alter the paths of one or a pair of dancers, the phrase reverses or inverts. . . . The relationships between the phrases constantly group and regroup the dancers into various spatial and movement permutations of two against one or all three in unison; the various elements that the slightly different phrases have in common provide momentary unison movements from which they again diverge.[75]

There is, then, a movement in and out of synchrony in Childs's work, a balance and harmony that is broken down by individual gestures and then

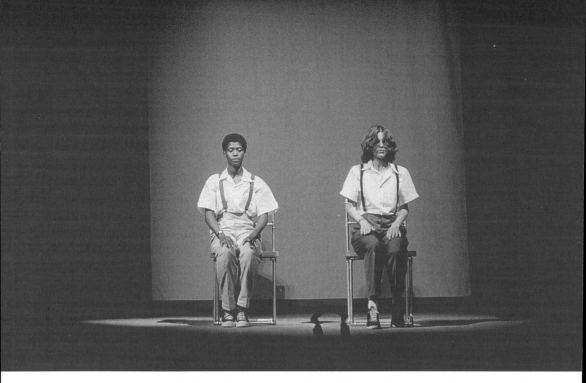

FIGURE 47. Robert Wilson, *Einstein on the Beach*, Knee Play 2, 1976. Performers: Lucinda Childs and Sheryl Sutton. Photo: © Babette Mangolte 1976, 1988.

reasserted as parallel phrases and patterns come back together again. Talking about his score for Robert Wilson's *Einstein on the Beach*, in which Childs danced both at its original production in the mid-seventies and at its revival at the Brooklyn Academy of Music in 1984, Philip Glass has commented in terms directly apposite to Childs's dance: "The difficulty isn't that it keeps repeating, but that it almost never repeats."[76]

The most elementary example of this ongoing examination of difference within repetition can, in fact, be seen in Childs's work for *Einstein on the Beach*, particularly in the so-called Knee Plays, where Childs is on stage with Sheryl Sutton (Figs. 47 & 48). Though dressed nearly identically in short-sleeved shirts, suspenders, trousers, and tennis shoes—Einstein "suits"—and though positioned similarly in space, there are important differences between them. While one engages in distinct hand gestures, the other may hardly move at all. While Sutton recites a sequence of numbers, Childs recites, again and again, in deadpan monotone, Christopher Knowles's highly repetitive, even Steinian "These Are the Days." It is rarely commented upon, but it is no accident that Sutton is black and Childs white, that their pants reverse the color scheme of their skin, and that they are both positioned, as *Einstein* opens, in front of a brightly lit white field

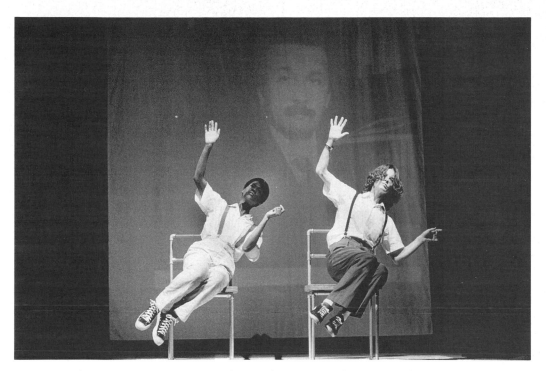

FIGURE 48. Robert Wilson, *Einstein on the Beach*, Knee Play 2, 1976. Performers: Lucinda Childs and Sheryl Sutton. Photo: © Babette Mangolte 1976, 1988.

bordered by black space. This tableau is the visual embodiment of contrast and difference.

Einstein is, of course, the quintessential example of the kind of theater of heterogeneity and independence that marks the new *Gesamtkunstwerk*. "In making *Einstein*," Wilson has said,

I thought about gestures or movements as something separate. And I thought about light as something separate, and the decor, the environments, the painted drops, the furniture, and they're all separate. And then you have all of these screens of visual images that are layered against one another and sometimes they don't align, and then sometimes they do. If you take a baroque candelabra and you put it on a baroque table, that's one thing. But if you take a baroque candelabra and you place it on a rock, that's something else. . . . This theater is about that.[77]

Dance was conceived by Wilson as the most "separate" element in this theater of differences, and its relation to the stage space is revealing. All five of the Knee Plays and the opera's three major scenes (Trial, Train, and Building/Prison) are essentially *tableaux*. As Craig Owens has noted, "Wilson's theater is pictorial; it proceeds from visual images."[78] The stage space is divided into a grid, and, within this grid, patterns of repetition are developed. Chairs, for instance, dominate the visual rhetoric of Wilson's

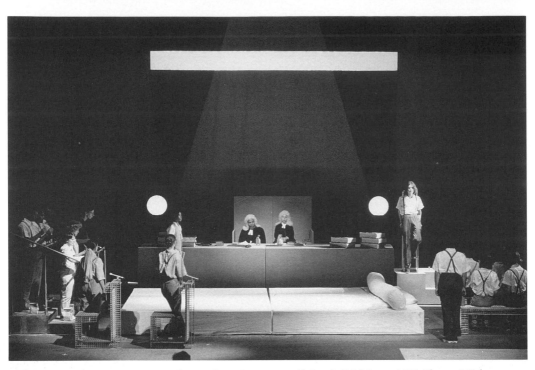

FIGURE 49. Robert Wilson, *Einstein on the Beach*, Trial Scene, 1976. Photo: © Babette Mangolte 1976, 1988.

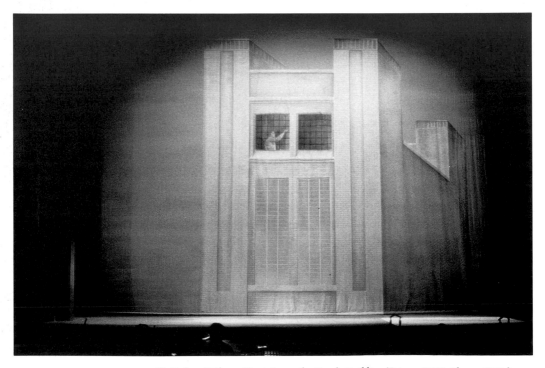

FIGURE 50. Robert Wilson, *Einstein on the Beach*, Building/Prison, 1976. Photo: © Babette Mangolte 1976, 1988.

work, and their architecture is repeated throughout the opera, culminating in the tableau of the Building/Prison (Figs. 49 & 50). These designs possess, in Owens's words, a "stark, geometric simplicity and powerful physical presentness associated with Minimal art."[79] Their effect is largely two-dimensional, or perhaps it is more accurate to say that the space they create is very shallow. But the dance is different. According to Wilson, "The Knee Plays to me were portraits; they're the closest to the audience. And I thought of the Trains, the Trials and the Building, those scenes, as still lifes. But the dances I thought about differently. I thought about them as landscapes, as fields. And so the space is the biggest. And they break apart the space. So the energy is different, the perspective is different, and it happens twice."[80] The dances, in other words, violate the frame of Wilson's design. They move in a much more three-dimensional space than the other sections of the opera. Almost devoid of the visual resources which dominate the remainder of the production (Fig. 51), it is as if they take

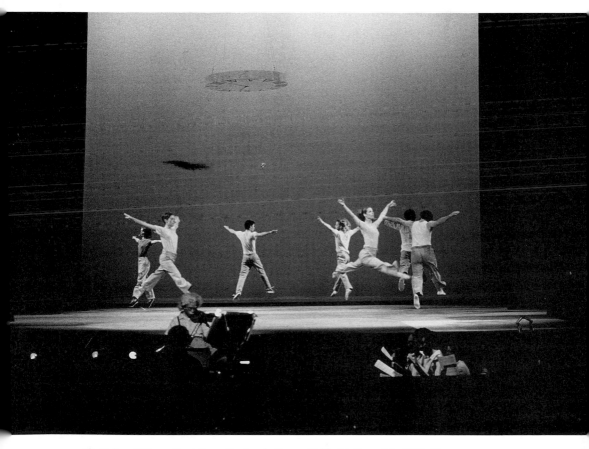

FIGURE 51. Robert Wilson, *Einstein on the Beach*, Dance, Field with Spaceship, 1976. Photo: © Babette Mangolte 1976, 1988.

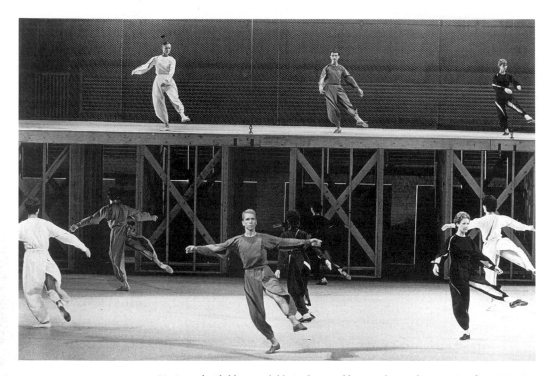

FIGURE 52. Lucinda Childs, *Available Light*, Brooklyn Academy of Music, October 1983. Set design: Frank Gehry. Photo: © Beatriz Schiller 1983.

place in open space. But the fact that the dance "happens twice" is especially important. Consisting of essentially the same choreography each time (though seven minutes of improvisation occur in the second sequence), their effect is dramatically different.[81] This is in large part due to Glass's score. Not only do the two dance sections emphasize their independence from the rest of the opera—"For me they are two pillars equidistant from either end of the opera, sharing only superficial features with the musical content of the other scenes," Glass has said—the texture of each is entirely different, though they remain "similar reflections of the same musical material."[82] The score for the first dance is dominated by the high-pitched clarity of Glass's ensemble—his organ in treble registers, flute, soprano sax, and so on—together with a single female voice; the second reverses this relation of instrument and voice, consisting of a chorus of six voices built upon the rich resonance of the bass line and counterpointed by the more distinct movement of the violin and organ.

This kind of doubling, and its attendant *différance*, has become Childs's trademark. In one of her most recent works, *Available Light* (Figs. 52 & 53), the stage, designed by architect Frank Gehry, is split into two shelves reminiscent of a fifties end table, the top shelf at the rear of the stage

(where one would, so to speak, put the lamp) narrower than the bottom one, at stage level (where the magazines might go). As the work opens, two dancers, one in red and the other in black, are located on the top shelf. In the larger space below, eight dancers, four in red and four in black, are arranged in two roughly diamond-shaped groups. The two dancers on the top shelf double the moves of the two dancers at the points of the diamonds below (thus creating a symmetry between the forward-most dancers and the action at the greatest remove from the audience). The other six dancers sometimes move in unison with the leads, sometimes not, but always in duet with someone. When Childs enters, in white, she disturbs these symmetries but creates new ones of her own.

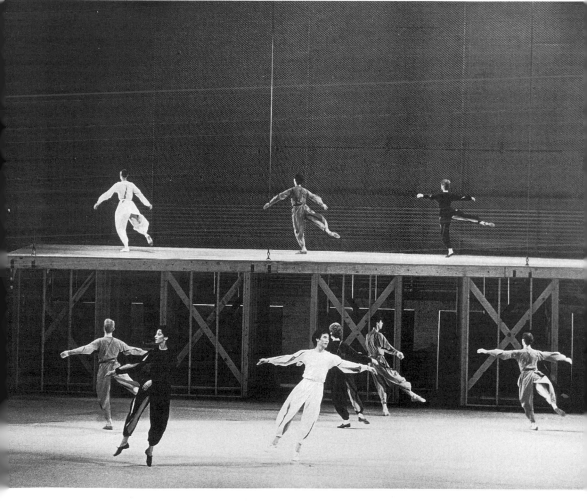

FIGURE 53. Lucinda Childs, *Available Light*, Brooklyn Academy of Music, October 1983. Set design: Frank Gehry. Photo: © Johan Elbers 1989.

For the 1979 *Dance*, scored by Philip Glass and inspired by her collaboration on *Einstein*, she commissioned Sol LeWitt to construct the setting. LeWitt positioned a large scrim screen across the front of the stage and projected on it portions of three of the five sections of *Dance* itself (Fig. 54). "The projection of LeWitt's film," says Susan Sontag,

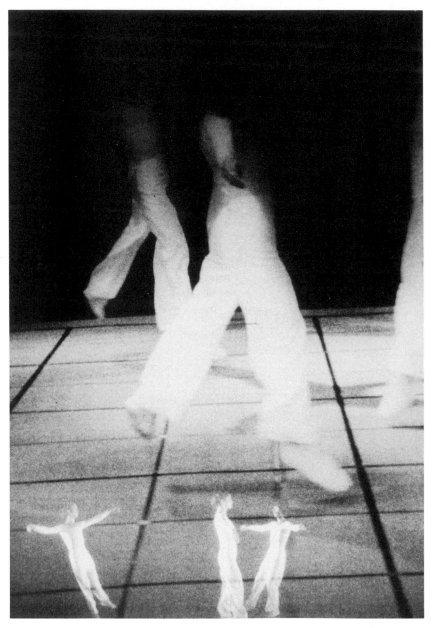

FIGURE 54. Lucinda Childs, *Dance*, Brooklyn Academy of Music, 1979. Film/Decor: Sol LeWitt. Photo: Nathaniel Tileston.

is a true setting and literal transfiguration of the dance. The synchronized ongoing of film and dance creates a double space: flat (the scrim/screen) and three-dimensional (the stage); provides a double reality, both dance and its shadow (documentation, projection), both intimacy and distance. Recording the dancers from different angles, in long shot and in close-up, LeWitt's film tracks the dancers, sometimes on the same level, sometimes above—using split screen and multiple images. Or it immobilizes them, in a freeze-frame (or series of still shots) which the live dancer passes through. . . . The film both documents and dematerializes (spiritualizes) the reality of dancing. It is a friendly, intermittent ghost that makes the dancers, seen behind the scrim, seem disembodied, too: each seems the ghost of the other. The spectacle becomes authentically polyvalent.[83]

The effect is a kinetic version of LeWitt's own modular work (Figs. 55 & 56), starkly simple geometric structures that when seen from different angles and points of view nearly always completely change in character.

In a video version of her 1977 solo dance *Watermotor*, created in 1980 for Boston PBS affiliate WGBH, Trisha Brown has achieved something of the same effect as Childs in *Dance*. Working with Peter Campus (whose own video work constantly plays with a doubling of the self, the simultaneous creation and erasure of his own image), Brown layered a transparent version of the dance upon a videotape of herself dancing the same dance. But Brown is much more interested in a different kind of repetition, one less reliant on the effects of synchrony and difference. By 1971, Brown had begun to make a series of dances which she called "accumulations." They are, in a sense, the dance equivalent to "This Is the House That Jack Built," strings of movement that are accumulated in progression: 1; 1,2; 1,2,3; 1,2,3,4 . . . and so on. Sally Banes has described the first of these works:

Accumulation (1971), done standing in one spot, starts with a movement—the rotation of the right fist with the thumb extended—that is repeated seven or eight times. The next movement, a gesture with the left thumb, is added, and the two are repeated in sequence several times. As the piece progresses, succinct gestures—a twist of the pelvis, a bend of the knee, a step back, a lift of the leg, are strung onto the end of the accumulation.[84]

A year later, Brown constructed a thirty-movement sequence called *Primary Accumulation* performed lying down with legs above the head. It was quickly complicated by making it a group piece performed in public places. Of particular note was a performance on rafts floating in the Loring Lagoon in Minneapolis in 1974 (Fig. 57). As each performer carried out the sequence, it became obvious that lying on their backs on rafts in the water they had no real way to synchronize their movements and the audience could, in effect, speed up or slow down the accumulation by moving its eyes from one raft to another. Furthermore, as the rafts turned in the water, and as the performers were seen from different angles, the same movements began to take on completely different looks.

The fascination with cumulative stories such as "The House That Jack

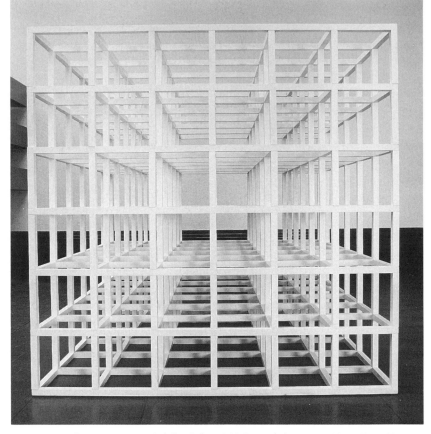

FIGURE 55. Sol LeWitt, *Open Modular Cube*, 1966. Painted aluminum, 60 × 60 × 60 in. Art Gallery of Ontario, Toronto. Purchase, 1969. Photo: Ron Vickers.

Built''—a form which goes back to the Jewish Passover service—is that each addition to the narrative *changes* our perception of the whole, just as each addition to Brown's dance (both the addition of each movement and the addition of each performer) alters our perception of it. Repetition and accumulation become a way of creating suspense and drama, the knowledge in the spectator that any sense of the whole is contingent and must inevitably be submitted to revision. Such revisionary tactics—a strategy of dance that continually submits itself to and underscores the necessity of revision—dominates Brown's work. Her continual play with *Accumulation* is a case in point. Brown's is an additive form of revision, a submission of *Accumulation* to the conditions of collage by juxtaposing the original dance to other independent elements. Initially she added a narrative to it (the poetry-like breaks in the line in my transcription are meant to give the reader a sense of Brown's own pauses in the narration):

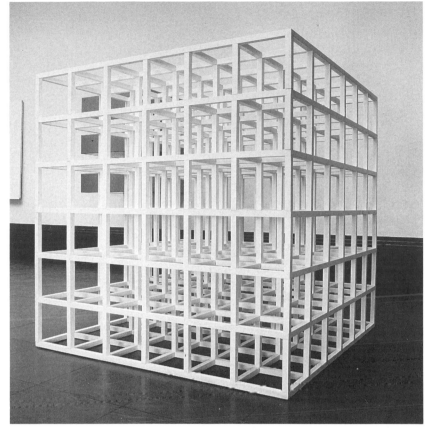

FIGURE 56. Sol LeWitt, *Open Modular Cube*, 1966. Painted aluminum, 60 × 60 × 60 in. Art Gallery of Ontario, Toronto. Purchase, 1969. Photo: Ron Vickers.

Starting
to talk . . .
while performing
this dance
is like opening
a front loading washing machine
while doing a load
of typewriters. . . .
I started
talking
while doing this dance
as a lecture form.
I like the fact
that I could not
keep track of my dancing while I was talking
and vice versa.[85]

FIGURE 57. Trisha Brown, *Group Primary Accumulation, Raft Version*, 1972. Loring Park, Walker Art Center, Minneapolis. Photo: Boyd Hagen.

Soon, however, Brown found the disruption of the single narrative relatively easy to handle and decided to add a second narrative, so that she forced herself to remember where she was in *Accumulation* and at the same time to alternate between succeeding phrases of the two stories (I have indicated the succeeding narrative lines here by a bracketed [a] and [b]):

[a] Mr Prebble called from Aberdeen and asked . . .
[b] Corkie met me
 at the airport . . .
[a] asked me if I would receive
 the distinguished alumnus award at my high school.
[b] and forewarned me that there might not be an audience
[a] I asked
 my friends what I should say to the graduating seniors.
[b] on the contrary the house was
[a] Two friends said,
 Tell them to join the Navy.
[b] overflowing.

She then further complicated this situation by splicing in what she has called the "completely different movement quality" of the dance *Watermotor*. Now called *Accumulation (1971) with Talking (1973) plus Watermotor (1977)*, the dance, Brown told Yvonne Rainer in 1979, "feels like I'm holding reins to about six horses, that they are going out from my body in a 360-degree angle on all sides, so I can't really see what I'm holding."[86]

Brown's 1973 *Roof Piece* (Fig. 58) is a much less complicated version of this willful decision to find, in Brown's words, "a delicate balance between chaos and order."[87] It is the visual equivalent of the moment in John Ashbery's "Self-Portrait in a Convex Mirror" where "A whispered phrase passed around the room / Ends up as something different." In this piece Brown situated a group of fourteen dancers over about a mile of rooftops in Manhattan in a line stretching from 420 West Broadway into an area just above Wall Street and back again. Don McDonaugh, editor of the *Ballet Review*, recalls:

FIGURE 58. Trisha Brown, *Roof Piece*, 1973. Photo: © Babette Mangolte.

They all wore orange outfits so they could spot one another. The dance was quite simple and very beautiful; she initiated a sequence of movement herself on the rooftop at 420 West Broadway, and the next person in line—it was almost like a telegraph—would look at what she was doing and then reproduce it for the next person, and it would be passed on and finally disappear out of sight. . . . In Manhattan one of the eerie things was that you were up in a completely different world, totally removed, and there were people going around shopping down below, cars were going past and trucks were making deliveries, and nobody even knew this event was taking place except for the few other people who happened to be on rooftops that day.[88]

Roof Piece is one definition of the condition of postmodern dance. It submits itself to interpretation, to the gradual erosion of the "original" in its repetition, to the status of its gestures as traces. Formally, it emphasizes its willingness to do this by violating the traditional frames of the dance—first, it literally steps outside the theater itself, operating on the rooftops, then outside the control of the choreographer (though her direction of course generates the dance itself), and finally outside the visual field of the spectator in the disappearing act of its serial repetitions.

It also represents, I think, the relative isolation of dance from the social, let alone political, arena. While avant-garde dance and music have both succeeded in providing important formal models for the avant-garde, they have remained, as it were, aesthetic. Few people know about either, and fewer are willing to read into their performances implicit political positions. And yet, it is important to recognize, in Brown's removal of her dance to a lake in Minneapolis or to a rooftop in Manhattan, a rejection of the system which would *contain* it in order to *sell* it. Brown refuses to allow her works to become "static" in a way that would also allow them to be easily defined, and therefore easily understood and "consumed." Insofar as she creates "objects" which cannot be contained in "consumer space," her work assumes a political dimension. Even though a burgeoning career and reputation have continually drawn her back to the traditional format of the proscenium stage, Brown's later dances have continued to exceed the resources of the spectator's visual field. First in *Glacial Decoy* (1979) and then in *Set and Reset* (1983), settings and costumes for both of which were designed by Robert Rauschenberg, Brown has, as it were, opened up the wings of the stage. *Glacial Decoy* begins with its dancers skirting in and out of the peripheries in what amounts to a literalization of the phenomenology of dance—it dramatizes, that is, our dependence, when confronted by the continual vanishing away of the dance's movements themselves, upon what Yvonne Rainer has called "kinetic memory."[89] The dance is never really contained by the frame of the stage. It always exceeds the immediate context. To refer again to Merleau-Ponty, its spatiality is one of *situation*, not position. If in *Glacial Decoy* we *literally* cannot see what is going on, if the dancers continually vanish away into the wings, such is the

FIGURE 59. Trisha Brown, *Set and Reset*, 1983. Visual presentation and costumes by Robert Rauschenberg. Photo: Lois Greenfield.

condition of our own perceptual relation to even those movements we can see, or rather *have just already seen*. The moment one of Brown's dancers disappears from view, we are forced to recognize that the dance itself—what was until a moment ago present before our eyes—has also disappeared. Dance is defined as a vanishing act.

The same concerns with framing occupy *Set and Reset*, though there is a progression, in the later dance, from right to left, as if the dance emerges from one side of the stage only to disappear finally off the other edge. At the heart of the piece is a sequence where the entire Brown corps is organized into a line perpendicular to the audience (Fig. 59). Arms, legs, then entire bodies begin to erupt from the stack until the line dissolves completely. Then it is reconstituted and the process begins again, after each dissolution the troop somehow managing to reorganize itself back into the lineup. The whole sequence, which is never in its details the same, reverses,

FIGURE 60. Trisha Brown, *Glacial Decoy*, 1979. Visual presentation and costumes by Robert Rauschenberg. Photo: © Babette Mangolte.

in a sense, Brown's attack on the lateral edges of the proscenium. Here, at the center of the stage, is not only an example of the inability of imposed structure to contain the dance, but also a figure for the possibility of origin. Each of the seven dancers in the corps begins from essentially the same place, and returns to it, and yet the dance—each cycle and each individual set of movements within the cycle—is different. The origin, the center, is the antithesis of dance, the place where activity ceases to happen, where bodies come to rest. The dance is what exceeds, *displaces*, origin.

Rauschenberg's sets function in ways which reinforce and complicate these concerns. Craig Owens has described the set for *Glacial Decoy* (Fig. 60) in what is one of the first essays to come to terms with Brown's preoccupation with framing:

Four rear-projected images—vertical in format, echoing the upright stance of the dancers—progress from left to right across the backdrop. . . . Every four seconds, all four photographs shift to the right, the image on the extreme right disappearing as a new one appears on the left to begin its trajectory across the stage, miming the lateral moves of the dancers into and out of the frame. . . . Surrounded by the thick black borders which appear on all of his prints, Rauschenberg's photographs represent random details isolated from their context—a cow's head, a lightbulb, a piece of sky. . . . It is the fragmentary nature of each photograph, the fact that it has arbitrarily been cropped from a larger continuum that is emphasized.[90]

Rauschenberg's set for *Set and Reset*—called *Elastic Carrier, Shiner* (Fig.
61)—is likewise a back-projected structure, but instead of projecting still
images, Rauschenberg has employed a filmic combination of stills and what
appears to be old newsreel footage. The structure hovers over the dance,
consisting of a large central cube, flanked by two pyramids, all made of
scrim. Three films, then, are projected, one through each of the structures,
so that it seems as if the images were at once transparent and opaque and
appear on two surfaces of the structure at once. Furthermore, each image
is itself a double one. The effect of this layering is not unlike looking at a
prism, only in black-and-white. His costumes, which are abstract render-
ings of the black and white patterns appearing on the screens, tie the move-
ment of the dance below to the movement of the film above, as if the one
repeated the other, as if we were confronted by Rauschenberg's *Set* and
Trisha Brown's *Reset*. But this is, of course, a *false* repetition, a structural
analogy in the guise of repetition.

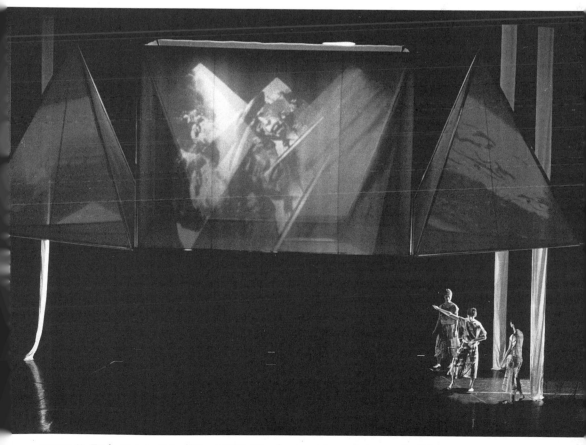

FIGURE 61. Trisha Brown, *Set and Reset*, 1983. Visual presentation and costumes by Robert
Rauschenberg. Photo: © Beatriz Schiller 1983.

It could be said that all of Brown's works—in whole and in part—are modeled on the relation of dance to decor in *Set and Reset*. There are, in *Set and Reset* itself, many instances of dancers coming in and out of sync with one another, forming duets and dissolving them, or of dancers following the gestures of another, "resetting" them, across the space of the stage—the synchronic and diachronic forms, that is, of repetition. There is, particularly, one moment in which Brown and Eva Karczag perform a relatively long duet. They are, in a way, in unison, but it is their difference which compels us: Brown is shorter and more athletic, her movements are jerky and energetic, while the taller, more elegant and graceful Karczag seems to flow through the choreography by comparison. And though, as in any duet, the time it takes for each to dance is the same, it is as if between them there were *two* times, one slower, one faster—a "warp," to use Rainer's word, a warp through which we recognize the heterogeneity of dance itself. As Derrida says, "Everywhere, differences and traces of traces . . . the *spacing* by means of which elements are related to each other."

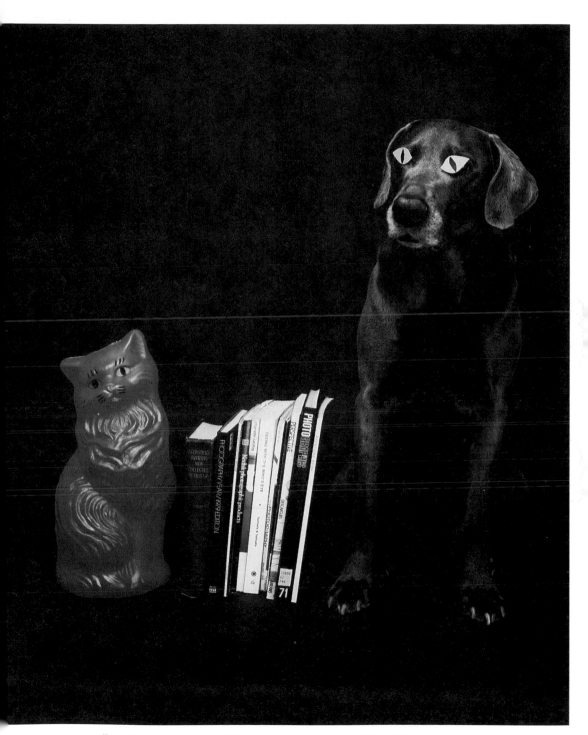

PLATE I. William Wegman, *Bookends*, 1981. Color photograph (Polaroid Land 20 × 24 camera on Polacolor II film), 24 × 20 in. Courtesy Holly Solomon Gallery, New York.

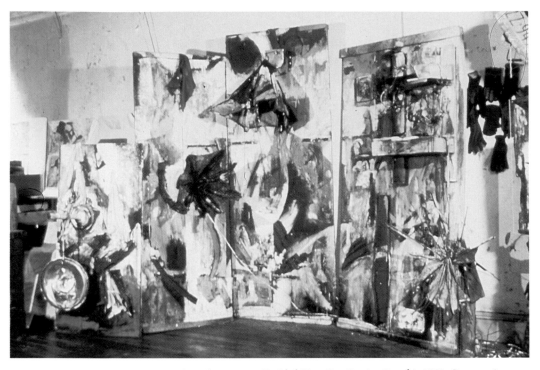

PLATE II. Carolee Schneemann, *Untitled (Four Fur Cutting Boards)*, 1963. Construction on boards: paint, lights, photographs, fabric, hubcap, motorized umbrellas, 90 1/2 × 131 × 52 in. Courtesy the artist.

PLATE III. Christo, *The Mastaba of Abu Dhabi, Project for the United Arab Emirates*, 1979. Collaged photographs, 14 × 11 in. Collection: Jeanne-Claude Christo, New York. © Christo 1979. Photo: Wolfgang Volz.

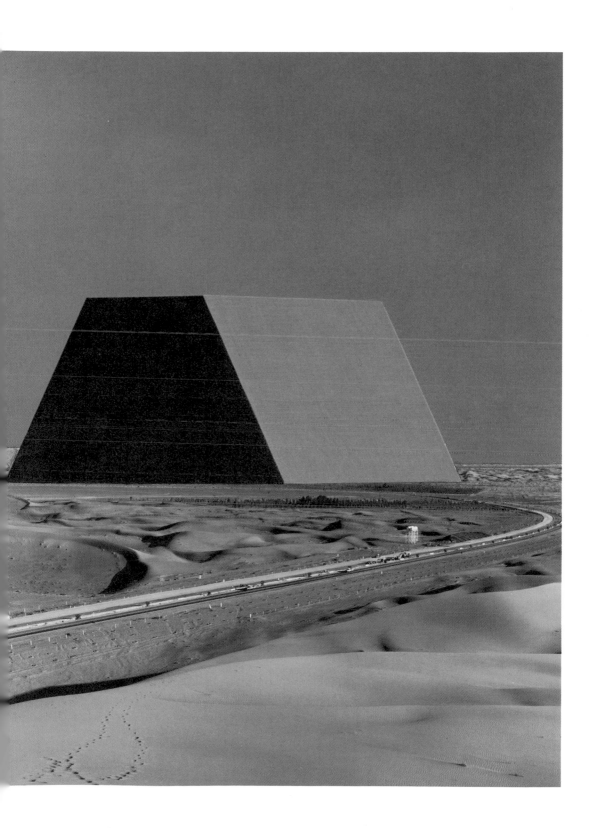

PLATE IV. William Eggleston, *Untitled (Tallahatchie County, Mississippi)*, 1972. Dye transfer process print, 13 1/4 × 19 1/2 in. Collection The Museum of Modern Art, New York. Gilman Foundation Fund.

THREE PERFORMANCES 4

Laurie Anderson, Eleanor Antin, and Carolee Schneemann

When there is an accelerating repetition of the identical, messages become more and more impoverished, and power begins to float in society, just as society floats in music.

 JACQUES ATTALI, *Noise*

Reflect on the whole history of women, do they not *have* to be first of all and above all else actresses?

 NIETZSCHE, *The Gay Science*

It is impossible to dissociate the questions of art, style and truth from the question of woman.

 DERRIDA, *Spurs*[1]

Laurie Anderson, *United States*, Parts I–IV
Brooklyn Academy of Music, February 7–10, 1983

When *Set and Reset* was performed at the Brooklyn Academy of Music in the autumn of 1983, its score was itself a "resetting" of another large-scale, collaborative event which had occurred in the same space the previous winter. Built upon a particularly haunting phrase from the fourth part of her work *United States*—"Long Time No See"—Laurie Anderson's score for violin, saxophone, and prerecorded tape (consisting of voice, guitar and percussion), with its raucous rock-and-roll idiom, was in many ways the most heterogeneous element of the dance. Not that rock-and-roll was new to avant-garde dance—David Byrne of the Talking Heads had scored Twyla Tharp's *The Catherine Wheel* in 1981 and by 1983 was completing the Knee Play scores for Robert Wilson's epic *Civil Wars*, originally scheduled, before mammoth financing difficulties undermined it, for the arts festival accompanying the 1984 Summer Olympics in Los Angeles.[2] It was, rather, the reference itself—the intertextual connection—established between *Set and Reset* and *United States* that was most unsettling, disruptive. It was as if Anderson had appropriated Brown's dance into the fabric of *United States*, as if the dance occurred under the sign of the earlier work, that seven-hour, four-part, two-evening performance *extraordinaire*.

 The connection is more than intertextual. It is more than just an example of Nietzschean repetition, the form of representation that is based not on likenesses but on differences—simulacra—the kind of representation upon which the new *Gesamtkunstwerk* is founded. It defines the effect of these strategies more precisely. That is, it locates in the postmodern work

145

a sort of *nomadism*, defines it, in the phrase of Gilles Deleuze, as a form of "nomad thought."[3] Nomadism produces work that exists beyond or outside the instruments of codification that define society proper—principally law, contracts, and institutions. It is an intentionally marginal discourse. For Deleuze, this nomad thought first erupts into Western consciousness in the works of Nietzsche:

> We read an aphorism or a poem by Zarathustra, but materially and formally texts like these cannot be understood in terms of the creation, or application of a law, or the offer of a contractual relation, or the establishment of an institution. The only conceivable key, perhaps, would be in the concept of "embarkation." . . . We embark, then, in a kind of raft of "the Medusa"; bombs fall all around the raft as it drifts toward icy subterranean streams—or toward torrid rivers, the Orinoco, the Amazon; the passengers row together, they are not supposed to like one another, they fight with one another, they eat one another. To row together is to share, to share something beyond law, contract, or institution. It is a period of drifting, of "deterritorialization." I say this in a very loose and confused way, since it is a hypothesis, a vague impression concerning the originality of Nietzsche's texts, a new kind of book. (144)

Our relation to the work of Laurie Anderson is, I think, analogous. *United States* opens with a tape of the surf crashing against an empty shore, projected images of the sea itself, and Anderson's reciting this text:

> A certain American religious sect has been looking at conditions of the world during the Flood. According to their calculations, during the Flood the winds, tides and currents were in an overall southeasterly direction. This would mean that in order for Noah's Ark to have ended up on Mount Ararat, it would have to have started out several thousand miles to the west. This would then locate pre-Flood civilization somewhere in the area of Upstate New York, and the Garden of Eden roughly in New York City.
>
> Now, in order to get from one place to another, something must move. No one in New York remembers moving, and there are no traces of Biblical history in the Upstate New York area. So we are led to the only available conclusion in this time warp, and that is that the Ark has simply not left yet.[4]

We are cast adrift here into the "deterritorialized" landscape of which Deleuze speaks. As one medium confronts another across the terrain of Anderson's work, in the heterogeneous space of the new *Gesamtkunstwerk*, as each medium fights with the other, beyond the formal laws of their own operations, we begin to understand our condition as wanderers, outsiders, nomads. Anderson compares her parable of the Ark to "a familiar occurrence":

> You're driving alone at night
> And it's dark
> and it's raining.
> And you took a turn back there
> and you're not sure now that it was the right turn,
> but you just keep going in this direction.

> Eventually, it starts to get light and you look out
> and you realize
> you have absolutely no idea where you are.

This image frames the entire work: after seven hours we return to it, in a finale called "Lighting Out for the Territories." And though, at the end, it is not so threatening a situation—"You've been on this road before. / You can read the signs. / You can feel the way. / You can do this / in your sleep"—the possibility that we are traversing what Deleuze calls "the icy subterranean streams" of the unconscious remains a distinct possibility.

Wherever we are, it is undecidable terrain. "Long Time No See," the score Anderson reset for her collaboration with Trisha Brown, is itself ambiguous: Are we meeting someone we have not seen for a long time, or have we been, for a long time, blind? In *United States*, the phrase occurs in this context:

> Over the river
> And through the woods
> Whose woods these are
> Long time no see
> Long time no see

Here the intertextual evocation of Christmas carol and Robert Frost maps the psychic landscape of the American winter season, a concomitant sense of homecoming ("to grandmother's house we go") and perpetual wandering ("miles to go before I sleep"). It is perhaps not too much to suggest that Anderson manages to "deterritorialize" the United States, to give her audience a sense that they are in some measure *outside*—or wanderers within—the very place they live.

In his essay on nomad thought, Deleuze attempts to isolate the characteristics of Nietzsche's aphorisms that contribute to the sense of drifting which he feels in relation to them. Their most important attribute is that they are grounded in "an immediate relation with the outside, the exterior." Confronted with a Nietzschean text, "you have the almost novel experience of not continuing on by way of an interiority, whether this be called the inner soul of consciousness, or the inner essence or concept" (144). There is, in this relation to the outside, a sense that the work is being *driven* by forces other than the author, that it is *informed*, as it were, by its chance collisions with whatever occurs at its margins. Anderson's multimedia presentations, the heterogeneity of her work, elicit this same feeling of relation to the outside. As in Cage's compositions, the work requires a "polyattentiveness," as image, word, and music impinge upon one another—draw each other out, so to speak. The intertextuality of all three media contributes, of course, to the work's "exteriority"—the images, lifted from all manner of sources, always seem familiar, recognizable, and

the music itself edges toward pastiche, combining effects derived from mainstream rock-and-roll, reggae, experimental jazz, the operas of Robert Wilson, and so on. But it is the peculiar lack of an organizing consciousness, of an inner essence, in her narratives that is the most destabilizing element in her work. Just before the "Long Time No See" sequence in *United States*, for instance, Anderson relates the "Song for Two Jims." It is a story—not a song—about a camping trip in the Kentucky mountains. Anderson wakes up one morning at about 3 A.M. to discover one Mr. Taylor standing in her camp with a gun. Explaining to her that it is not a good idea for a woman to be alone "in those parts," he takes her to his home, where she stays a week with Mrs. Taylor and the four Taylor kids—Jack, Jim, Rhonda, and Jim: "Two Jims—who knows why." The entire countryside around the Taylor household is full of very deep holes that were at one time drilled in the shale by Standard Oil. This is how Anderson ends her narrative:

One day Mrs. Taylor told me that she used to have another
kid, but that he had apparently fallen down one of the holes.
Her description was very abstract. Nobody tried to rescue him.
He just fell down the hole. She said: "Well one
day I saw him out there
and I was watching
and then I didn't see him out there no more."

Anderson creates here what Deleuze calls a moment of "intensity," the second defining feature of Nietzsche's thought, though "intensity" is perhaps a misleading word in this particular context. What is remarkable about Anderson's text is the *passivity* of the Taylors' lives, their apparent indifference to first the intrusion of Shell Oil and then the disappearance of their child. This passivity is mirrored in the pace of Anderson's narrative, the way, in her final quotation from Mrs. Taylor, she extends Mrs. Taylor's speech, creating a series of pauses that concludes in a long hiatus at section's end. The "meaning" of the narrative lies in the very meaninglessness of the Taylors' lives, its power in their powerlessness, its intensity in their passivity. Meaning, here, to use Anderson's phrase, is, curiously, "on the move." It is as if it continually were to *fall away*, into the very hole "the kid" fell through, into the hiatus—the abyss—at story's end. As Anderson has explained in an interview:

Someone wrote that *U. S. Part II* was a lot of in-group word play and asked "What does it mean?" This person is, I believe, a dance critic. I'd never ask what a dance "means." In all of the work I've ever done, my whole intention was not to map out meanings but to make a field situation. I'm interested in fact, images, and theories which resonate against each other, not in offering solutions.[5]

The name "Jim Taylor," in Anderson's story, is fluid, mobile. It posits identity as a lack of identity. It shifts arbitrarily between its two referents in a

FIGURE 62. Laurie Anderson, *United States*, Part II, 1980. Orpheum Theater, New York. Courtesy Holly Solomon Gallery, New York.

perpetual displacement, rising to refer to one of the two Taylors even as it falls away from the other, but always, therefore, *exceeding itself*, pointing beyond its internal reference, outside.

Mrs. Taylor's story has no meaning beyond its "intensity," our sense that whatever meaning it possesses, or might potentially possess, *exceeds* it. It does, however, lead to what Deleuze identifies as the third and final characteristic of nomad thought—humor and irony: "Those who read Nietzsche without laughing—without laughing often, richly, even hilariously—have, in a sense, not read Nietzsche at all. . . . Laughter—and not meaning. . . . One cannot help but laugh when all the codes are confounded" (147). Not only does the evocation of such laughter—the laughter one feels in the face of what Deleuze calls "divine jest"—inform Anderson's work, but it is as if she had taken Nietzsche's laughter to a new extreme. For Anderson purposefully invokes Nietzsche, not only in her image of the wanderer, her new Zarathustra "speaking thus," but particularly in the song "O Superman." Anderson accompanies the song with the familiar signs of traditional shadow puppetry (Fig. 62), signs that in this context are destabilized. "You can read the signs," as she says, but you do not know what they mean. The

song is dedicated to Massenet, the turn-of-the-century French composer, and it is a pastiche of a tenor aria from Massenet's *Le Cid*, substituting, in its opening bars, "O Superman, O Judge, O Mom and Dad" for the original's "*O Souverain, O Juge, O Père*," secularizing the original's prayer more or less in the way the that Nietzsche parodies, for instance, Wagnerian opera. But this song creates, more important, a new version of Nietzsche's Superman. If for Nietzsche the Superman is to man as man himself is to the ape—"Man is a rope, fastened between animal and Superman," says Zarathustra[6]—and if, then, the Superman represents an evolutionary force in our development, the result of that evolution becomes, in Anderson, virtually sardonic—certainly, madly, laughable. For Anderson's Superman is not merely *more* than human but *inhuman*—mechanical, electric, robotic. The Superman (or Supermom—a kind of ambisexuality begins to dominate) becomes Technology:

> So hold me Mom, in your long arms,
> in your automatic arms,
> your electronic arms . . .
> your petrochemical arms,
> your military arms,
> in your electronic arms.

What Anderson does throughout this piece—and throughout *United States* as a whole—is periodically to alter her voice by means of a harmonizer which drops it a full octave, giving it a deep male resonance. This voice, she has explained, is "the Voice of Authority, an attempt to create a corporate voice, a kind of 'Newsweekese.'"[7] And it is so obviously the product of "high tech" manipulation that its authority becomes synonymous with technology.

Much of the power of Anderson's work derives, on the one hand, from her willful celebration of the modes of power implicit in technology—"I have a sort of irresponsible attitude in terms of energy: the more 'tech,' the better as far as I'm concerned," she told one interviewer[8]—and, on the other hand, from her insistence on undercutting her own high tech enthusiasms. "I am in my body," she says, "as other people are in their cars." Her violin bow sweeps back and forth, cutting the lights projected across the stage with the monotony of a windshield wiper. The violin itself has been manipulated electronically, with a tape playback head mounted on the body of the instrument and a strip of recorded audiotape on the bow instead of horsehair. But as *United States* develops, this high tech energy seems to move closer and closer to a state of entropy. As much as "the Voice of Authority" sounds like Richard Nixon, for instance, it also begins to sound ominously like a 45 rpm recording played back at 33 1/3. In a segment entitled "Odd Objects," just before the "Big Science" sequence which ends Part III, Anderson describes why the Chrysler Corporation ran into finan-

cial difficulty. It was the result of communications delay between the company's computers and its robot welders on the line.

When a problem develops further up the line, it takes a long time for the computers to tell the robot welders to stop. So the robot welders continue to make these welding motions, dropping molten steel directly onto the conveyor belt, even though there are no cars on the line, building up a series of equidistant blobs. It takes several hours for the computers to tell the robot welders to stop. At the rate of eighty cars per hour, a typical plant is capable of manufacturing approximately 100 of these blobs before the plant can totally shut down.

This same "delay" in communications is imaged, at the very heart of Part III, in a narrative called "New York Social Life," by a proposed talk show for cable television entitled "The Gap": "It's gonna be about loneliness, you know, people in the city who for whatever sociological, psychological, philosophical reasons just can't seem to communicate, you know. . . . It'll be a talk show and people'll phone in but we will say at the beginning of each program: Uh, listen, don't call in with your *personal* problems because we don't want to hear them." In another image from the same narrative, a friend named Mary calls and says, "Listen, Laurie, uh, if you want to talk before then, uh, I'll leave my answering machine on . . . and just give me a ring . . . anytime." The point is that in this entropic system of delays we are replaced by our "answering machines." Born of "Mother" Chrysler—out of her "robotic arms"—we all become "blobs," technology's vapid image of Pollock's gestural "drip."

In a review of Part II, written soon after it premiered at the Orpheum Theater in New York in October 1980, Craig Owens has, I think, located precisely the destabilizing effects of these vocal "delays." He points out that most performance art is rooted in establishing "the copresence of the performer and spectator, much in the way that Minimalist sculptural installations require the presence and participation of the viewer in order to demonstrate the way in which perception is wholly immersed in and dependent upon the temporal and spatial conditions of viewing." But Anderson's stage "presence" is undermined. "She no longer performs directly for her audience, but only through an electronic medium. While the media literally magnify her presence, they also strip it from her. Her work thus extends and amplifies the feeling of estrangement," the condition of the nomad.[9]

Anderson presents us, then, with the specter of an Information Age Superman wandering, in *nouveau* bohemian style, through postindustrial America (Fig. 63). The disorientation and estrangement one feels in the face of her work, in fact, results as well from a calculated disjunction between her high tech trappings and her self-consciously bohemian pose. For the bohemian is an image she surely cultivates. As early as 1974–75 she conducted a series of street concerts, first in New York and subsequently in

FIGURE 63. Laurie Anderson, *United States*, Part II, 1980. Orpheum Theater, New York. Courtesy Holly Solomon Gallery, New York.

FIGURE 64. Laurie Anderson, *Duets on Ice*, June 1975. Genoa, Italy. Courtesy Holly Solomon Gallery, New York.

Genoa, Italy, called *Duets on Ice* (Fig. 64), in which she played her violin, accompanied by hidden tapes, all the while standing in ice skates embedded in ice. When the ice melted, the performance ended. If for Charles Dickens, writing in 1851, the bohemians were "wild and wandering, occasionally mysterious, often picturesque . . . a tribe of unfortunate artists of all kinds—poets, painters, musicians, and dramatists—who haunt obscure cafés in all parts of Paris, but more especially in Quartier Latin,"[10] it is clear that Anderson has simply transplanted the *type* into Soho. "I like to combine electronics with the violin," she has said, "it's like combining the 20th and the 19th centuries."[11] In the simplest terms, she has at once identified herself with and rejuvenated Manet's *Old Musician* (Fig. 65). Like the outcasts which inhabit the world of Manet's painting—the gypsy girl, the *saltimbanque*, the ragpicker, the musician, the absinthe drinker, the wandering Jew—like Manet himself, Anderson establishes herself as another of the *refusés*, those who work outside the mainstream, one of the avantgarde. And yet a certain high tech mindlessness—the inhuman character

FIGURE 65. Edouard Manet, *The Old Musician*, 1862. Oil on canvas, 73 3/4 × 97 3/4 in. National Gallery of Art, Washington, D.C. Chester Dale Collection.

of "Big Science" itself—threatens to subvert her position. In "The Visitors" Anderson tells the story of a group of American minimal artists on a goodwill trip to China who were asked if it was true that all Americans have robots in their houses? Yes, was the reply of one of the artists especially interested in theories of information and truth. Then they were asked if it was true that Americans live on the moon.

The artist said, "Yeah, it's true. A lot of us live there. In fact, we go there all the time."

In this province, however, the word for moon was the same as the word for heaven. The hosts were amazed that Americans traveled to heaven. They were even more amazed that we were able to come back—that we went to heaven all the time.

To the Chinese, that is, these artists were Supermen—the Ideal incarnate—not merely embodying a new, transcendent order of being, but almost literally becoming extraterrestial. And yet at this moment Anderson projects behind her an image of seven figures with violins for heads. The visitors are "fiddle-heads"—that is to say, empty-headed. It *is* true that they have robots in their houses—and they are the robots themselves.

In the final analysis, then, Anderson submits her own position in the avant-garde—and the avant-garde as a whole—to the kind of "intensity" of relation that defines nomad thought, to the "flux" of signification in which, as a concept, the term is alternately filled with and then emptied of meaning. In the same way, in her transformation of her voice into the male "Voice of Authority"—especially in combination with her short hair and coat-and-tie costume—she submits her own identity to perpetual nomadism.[12] She effects, that is, what Annette Kuhn, in an essay on "Sexual Disguise and Cinema," has called "a 'willful alienation' from the fixity of that identity."[13] She is both the Voice of Authority and its ironic supplement, the champion (and child) of Technology and the agent of its deconstruction. She is nomad. She cannot be fixed or situated—hung on a wall or framed. She is simply "out there."

What she brings us, for better or worse, is what she calls in *United States*, Part I, "The Language of the Future." Where before, in the past, we had a language "of the rabbit, / the caribou, / the penguin, / the beaver," now we have "a language of sounds, / of noise, / of switching, / of signals." A technological vernacular, that is, has replaced the natural:

> Current runs through bodies
> and then it doesn't.
> On again.
> Off again.
> Always two things
> switching.
> One thing instantly replaces
> another.

"Every noise," Jacques Attali reminds us, "evokes an image of subversion."
If, in contemporary society, the noise of the technological is repressed and
controlled, it is allowed to reappear, Attali points out, "at certain ritualized
moments: in these instances, the horn emerges as a derivative form of
violence masked by festival. . . . The noise of car horns on New Year's Eve
is to my mind for the drivers an unconscious substitute for Carnival, itself
a substitute for the Dionysian festival preceding the sacrifice. A rare mo-
ment, when . . . a harmless civil war temporarily breaks out throughout
the city."[14] Such is the logic which provokes all of Anderson's work. Her
very first performance was, in fact, a work entitled *Automotive*, performed
in Rochester, Vermont, in 1972. It was inspired by the fact that at the
weekly Saturday evening summer concerts, everyone stayed in their cars.
People simply drove up, parked around the bandshell, and instead of ap-
plauding, honked their horns:

Majestic sounds. A hundred cars, trucks, motorcycles all honking! The applause
sounded better than the concert. So a friend [Geraldine Pontius] and I decided that
we would have a concert of cars. We scored three pieces for various pitchs, but at
first we couldn't find anyone in Rochester who really wanted to be in a car con-
cert. . . . Then we decided the way to do it would be to audition cars. So we set up
a little booth at the local super market, "Is your Dodge a C#?" And people would
then go, "Oh well, I hope so." . . . It was a wonderful concert. We had the audience
in the gazebo and the orchestra of cars parked around them. The rim of the moun-
tains, green mountains, around, created a wonderful sort of supersonic stereo
effect.[15]

Anderson is the artist of a "new noise," working in a new territory. She
has an almost uncanny ability to locate festive impulses within technologi-
cal society, to draw those impulses out of us. As we recognize in her wan-
derings our own homelessness, her noise becomes recognizably ours. This
recognition is all she gives us—the sense that we are in it together, that
her strategy of subversion is potentially, at least, our own.

II

Eleanor Antin, *El Desdichado (The Unlucky One)*
Ron Feldman Fine Arts, New York, December 9, 1983

In *El Desdichado (The Unlucky One)*, Eleanor Antin assumes one of her
familiar roles, the dispossessed picaro king. Like Anderson, Antin presents
us with a nomad figure whose authority and position are undermined by
"his" lack of a "homeland," whose identity is subverted by Antin's "cross-
dressing," and who is further alienated across time by Antin's drawing of
the contemporary gallery space into the Latin Middle Ages. "An Allegori-
cal spectacle," as the program announces, Antin's king witnesses a series of

FIGURE 66. Eleanor Antin, *El Desdichado (The Unlucky One)*, 1983. Courtesy Ronald Feldman Fine Arts Gallery, New York. Photo: Jennifer Kotter.

hangings, then combats first a white knight and then later death (Fig. 66), woos a princess (Fig. 67), and sets sail in quest of a mythical White City. The performance itself raised a number of questions for me, not the least of them resulting from the fact that, although I had liked it a good deal, very few others, apparently, had felt the same way. A famous dealer, sitting directly in front of me, had slipped out the back in disgust not halfway through, and with him any number of others. A couple of people had been more audacious about their exits, standing up and wandering out through the installation itself as Antin performed. Those who remained at the end—and by and large, it should be said, most people stayed the course— were, to put it nicely, unenergetic in their appreciation, and, after a desultory bow or two, Antin herself had retreated glumly to the back rooms.

The performance had been plagued, of course, by the usual array of troubles—awful acoustics which often swallowed Antin's words and which were exacerbated by a late-arriving lout who, after Antin's performance had begun, beat at the front door of the gallery until someone opened up and then, out of sight but well within earshot, vigorously insisted that "Ron" would "hear about it" if he was not seated (he was turned away). The seating was uncomfortable, consisting largely of the floor and a few scat-

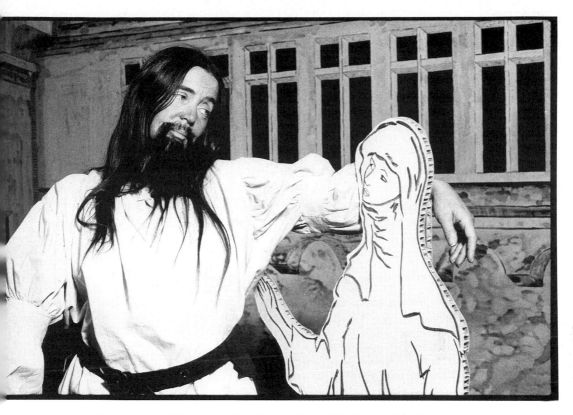

FIGURE 67. Eleanor Antin, *El Desdichado (The Unlucky One)*, 1983. Courtesy Ronald Feldman Fine Arts Gallery, New York. Photo: Jennifer Kotter.

tered pillows, and this discomfort was exacerbated by a capacity (or over-capacity) crowd wedged into close quarters in winter dress. This, in turn, helped to contribute to a general restlessness and inattention throughout Antin's performance. Finally, there was the seemingly unavoidable feel of amateur theatrical production that accompanies most performance in galleries, where there is almost never time to rehearse, and a certain aesthetic anathema to rehearsal anyway.

Antin's presentation, in other words, stood in total opposition to the highly refined stage theatrics of a performer like Laurie Anderson. In fact, in *El Desdichado*, Antin was intentionally parodying Anderson. She created a purposefully "low tech" musical "machine" consisting of electric caterpillars, spiders, grasshoppers, bells, horns, and so on. Early in the performance, when the king asks for a song, the reply is an even more pointed attack: "How about some flashing lights? You might get a kick out of it. I could distort my voice."[16] But the performance audience is used to such goings-on, even expects them. It is all part and parcel of being what Richard Schechner has called performance art's "integral audience." As distinct from the "accidental audience," which is "a group of people who, individually or in small clusters, go to theatre," the integral audience consists of:

people who come because they have to or because the event is of special signifi-cance. . . . Avant-garde performers who send out mailings or by word of mouth gather people who've attended previous performances are in the process of creating an integral audience for their work, a supportive audience. Every "artistic commu-nity" develops an integral audience: people who know each other, are involved with each other, support each other.

Furthermore, as Schechner points out, the behavior of the two types of audiences differs drastically, and the irony is that *the accidental audience pays closer attention than does an integral audience. . . .* An integral au-dience often knows what's going on—not paying attention to it all is a way of showing off that knowledge."[17] Antin expresssed her own dissatisfaction with such an audience in her book *Being Antinova.* Reflecting on the turn-out for her first performance as Eleanora Antinova in October 1980, she writes:

This performance is not open to the public. Invited guests think a lot of them-selves. . . . Why did we keep the performances secret? Why didn't we advertise? Because the gallery is small, because the salon atmosphere would be ruined by crowds, because Antinova needs an intimate atmosphere. I know, I know, but fuck Antinova. I—Antin—can't perform before a small group. It's humiliating. And I blame the ones who come for those who didn't. I'm always counting the house.[18]

While such an understanding of the kind of audience in attendance at *El Desdichado* would help to explain some of their behavior—and Antin's own evident depression after the performance—in itself it was not enough to account for the sense of disappointment and even distaste which had been shared by so many. *El Desdichado* was not *United States*, Parts I–IV, but then it was not meant to be, as much as Antin, in an ironic mood, might admit to coveting Anderson's star status.

The reviews would later confirm that *El Desdichado* had been received less than favorably. Thomas McEvilley's in *Artforum*, which did not appear until April, served as a kind of nasty summation: "This performance was juvenile hour, a high school assembly show, a skit for a civics class or a Renaissance fair. . . . Few performance artists seem equipped to produce long texts, and Antin is not one of them. . . . The narrative was a relentless string of cliches—*The Seventh Seal*—warmed over and censored for morn-ing TV." But his displeasure with the performance itself aside, McEvilley's most interesting observation concluded his review: "What intrigued me," he wrote, "was the number of important critics who attended—and not necessarily critics who have written about performance. I counted five or six, and I don't recognize many. In recent months I have seen performance art ten—a hundred—times better in dark grungy places where one never sees such people."[19] I had sensed the same thing—that, for whatever rea-son, perhaps the preperformance hype in the *Village Voice*, *El Desdichado* had been the art world place to be that particular weekend in Decem-

ber—and, until McEvilley's review, I had been tempted to attribute the general dissatisfaction with the evening to an unknowledgeable audience, one that did not understand the aesthetics of performance, however much it might have understood about art generally. That is, indulging in a kind of critical hubris, I was willing to believe that there had been a small "integral" audience in attendance, consisting of people like myself (and the likes of McEvilley), more or less self-styled performance aficionados who had enjoyed themselves, but there had been an "accidental" audience as well, who had not enjoyed themselves, people who might or might not know something about art but did know much about performance.

Such a point of view had been reinforced throughout the winter in Cambridge, where Frank Stella had been delivering the Charles Eliot Norton lectures at Harvard. Many of the same faces that had been at Antin's performance in December appeared once a month in Cambridge at Stella's. They may not have liked Antin, but they adored Stella. He had entitled his lectures "Working Space," and his project, as he put it, was to outline what it would take to "make painting real" again—"real like the painting which flourished in sixteenth-century Italy."[20] Caravaggio became the hero of this inquiry because, Stella claimed, "he speaks directly to us today about fullness, roundness, and volume." He creates a space in his painting—a "backside"—that overcomes the predominance of silhouetted figuration in the Renaissance. Thus Caravaggio's art is a "private, living theater," which possesses by virtue of its "pictorial coherence" and "togetherness" an absolutely convincing "pictorial drama": "Here we feel the true liberation offered by art." After Caravaggio "real" painting can never again "defer to architecture"—that is, both literally and figuratively, it cannot submit to forces outside itself: "Real freedom for painting can only be discovered in the creation of its own space."

Now, clearly, in a move which is most likely indebted to the example offered by Michael Fried's *Absorption and Theatricality: Painting and Beholder in the Age of Diderot*, such an argument is designed to support Stella's notions about the direction contemporary art ought to be headed in.[21] In front of painting today, "we are splattered by wheels spinning in a rut of pigment." Or else the pigment seems to lie inertly on the canvas "like a dead dog." But most important for Stella, painting in the eighties is spatially impoverished: "By 1970 modern abstract painting had lost the ability to create space. . . . We have illustrated space which we can read— what we have lost is created space which we can feel." Given such a definition about what art ought to be—and given that almost everyone in Cambridge seemed to agree—the difficulties Antin's performance presented to her audience seemed obvious. In the broadest terms, her "working space" was simply different. Stella offered up a profoundly formalist definition of art as a self-contained, self-reflexive, and coherent whole most

especially concerned with discovering—or, perhaps better, "re-inventing"—what Clement Greenberg called "the effects peculiar and exclusive to itself," the essential and irreducible characteristics of the medium, though it should perhaps be made clear that a crucial issue distinguishes Greenberg's formalism from Stella's. For Greenberg, painting rendered itself "pure" when it rid itself of the necessity, in modern abstraction, of representing three-dimensional space, which is, Greenberg says, more properly "the province of sculpture."[22] Stella feels, rightly or not, that he has discovered in Caravaggio a "basic quality" that might "still be used—in the sense that all that activity, of both the painting and the figuration, exists in live space. There is space all around the figures, and it's that space around and behind things—that feeling of things not being pasted on top of each other but really having room behind them—that I think it's possible to get in abstraction."[23] But the point is that Stella is still after a pictorial "space" that he believes remains "peculiar and exclusive" to his medium.

El Desdichado, by contrast, seems "mediumless" in the manner of most performance art operating in some zone between theater and painting, text and tableau. Like the episodic picaresque tales upon which it is modeled, it lacks formal narrative coherence, and its self-proclaimed allegorical intentions deny any pretension toward self-reflexivity or containment. It defers consistently to architecture, specifically to the cramped confines of the gallery, but also in its refusal to create, in Stella's words, "its own space." It is, especially by virtue of its status as an ephemeral event, wholly antiformalist.

Still, what gave me pause when McEvilley's review appeared in April was that here was a critic who understood these things, who I supposed understood and even endorsed the antiformalist direction of Antin's work, and *still* did not like it. To dismiss the negative reaction to *El Desdichado* as resulting from the predominantly formalist tastes of the art world (however real they are) seemed suddenly as inadequate as explaining its reception away by invoking the vagaries of behavior Schechner attributes to the "integral audience." The difficulty lay elsewhere—or *partially* elsewhere, as I will explain, in a kind of unexamined, formalist pocket of counterinsurgence in the avant-garde camp—and the only clue I had was McEvilley's questioning of Antin's ability as a writer, with which I disagreed. In both *Being Antinova* and its companion piece, the ongoing *Recollections of My Life with Diaghilev* by Eleanora Antinova, selections from which were awarded a Pushcart prize in 1982, Antin had surely demonstrated that she was equipped to produce long texts, McEvilley's protestations to the contrary. The more I thought about it the more convinced I became that it was the text of *El Desdichado*—that body of talk, partially garbled by the exigencies of place, misheard and misunderstood—that had alienated her audience.

At base, Antin's audience was reacting against the *literary* pull of her work, its emphasis on the word, or at least its *understanding* of the literary pull of the work. This is a problem Laurie Anderson avoids by keeping her narratives short, Wegman-like in duration. Whereas Anderson's language constantly "falls away" into other media, almost everything about *El Desdichado* (and, I am beginning to think, almost everything about Antin's work as a whole) is designed to draw attention to the fabric of its language, but not in a formalist sense. That is, to borrow a distinction from Fredric Jameson, she draws attention to the *rhetoric* of her work as opposed to its *style*. Jameson sees rhetoric as addressed to a "relatively homogeneous public or class" (Schechner's integral audience, for instance), while style represents "the sapping of the collective vitality of language itself" and "emerges, not from the social life of the group, but from the silence of the isolated individual: hence its rigorously personal, quasi-physical or physiological content, the very materiality of its verbal components. . . . What was hitherto a cultural institution—the storytelling situation itself, with its narrator and class public—now fades into the silence and solitude of the individual writer."[24] Rhetoric, in this sense, is analogous to, even dependent upon, the vernacular, the recognizable manifestations of collective and communal style. The analytic practices of literary formalism, to the contrary, depend upon an individual style, upon the "originality" or "uniqueness" of the individual, the very absence of the collective rhetoric to which Antin's language draws attention.

Antin, naturally, understands that most of us still approach literature—and the literary elements of art—in terms of style, and she constructs a performance in which style and rhetoric interact—in which, to be more precise, a seemingly stylized language emerges as, or reveals itself to be, a rhetoric. To put it another way, it is possible, I think, to hear as rhetoric what McEvilley heard, at the performance at Feldman, as cliché, "empty" style, an expression emptied of originality by collective usage. *El Desdichado* (again, like most of Antin's work) is a kind of puppet theater, overtly so near its end, when five consecutive dialogues are performed as puppet shows (Fig. 68). Such theater oscillates between theatrical and figurative art, and Antin's particular brand of puppetry blurs the boundaries even more—for her puppets cannot move. They are two-dimensional cutouts, at once sculpture and drawing, masks for Antin's voice that recall paper dolls—and play with paper dolls—as much as puppetry. They constitute a theater, then, that is perhaps as *gender*-determined as any. It does not seem to me that very many men, myself included, can fully appreciate the play unfolding here, the levels of psychic involvement such play at paper dolls can generate. We are unable to recognize, that is, its rhetorical dimension, its collective and vernacular as opposed to its individual voice. Perhaps the way boys play "war," the complexities of which are probably equally un-

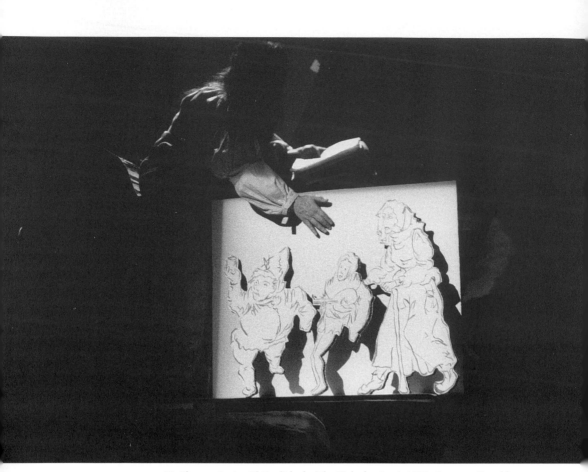

FIGURE 68. Eleanor Antin, *El Desdichado (The Unlucky One)*, 1983. Courtesy Ronald Feldman Fine Arts Gallery, New York. Photo: Jennifer Kotter.

appreciated by the opposite sex, is a comparably charged arena of play in male culture. If so, I would imagine—and Antin's thematic concerns support such a notion—that in paper dolls young women fashion the rhetoric of their lives, the narrative structures of the social formation (who does the cooking, who calls whom for a date, Ken or Barbie?). They learn, that is, to sublimate the questions of power, aggression, and submission that inform and impinge upon their (gender-determined) existence. Antin has admitted this last in a conversation with Kim Levin about the videotapes in which she first used paper dolls in the mid-seventies, "Adventures of a Nurse" and "The Nurse and the Hijackers": "If something pains me too much I tear the doll up, which I used to do as a child by the way."[25]

But one aspect of the obvious differences in social values which playing at paper dolls and playing at war culturally instill goes to the very heart of Antin's work in *El Desdichado*—that is, the one role is physically passive and verbally active while the other is physically active and verbally passive.

This amounts, in the broadest aesthetic terms, to a conflict between narrative and image, the temporal and the spatial, the verbal and visual sides of performance art. Roland Barthes has pointed out that today, in an important historical reversal, the text "enlivens" the image: "In the past, the image used to illustrate the text (made it clearer); today the text burdens the image, loads it with a culture, a morality, an imagination; there used to be a reduction from text to image; today there is an amplification from one to the other."[26] And, even more to the point, in Antin this text defines the image as *culturally* encoded by predominantly "male" values. It is, in other words, no accident that Antin *images* herself as "the king."

Antin consistently manipulates and undermines her visual imagery—the image of authority—through her language. From the time of her earliest videotapes, she has worked to establish a deep sense of division between the animation of her voice and the frozen perpetual smiles—the inanimate quality—of her characters' painted faces. The face is static, but the voice is dynamic, transforming and informing the face at each inflection. In *El Desdichado*, this drama between voice and image is brought to the fore immediately in the dialogues between the king and his talking horse. "Let's rest, boss, I'm tired," the horse says as the performance begins. But it is Antin, in her role as talking horse, speaking to Antin, in her role as king. I am reminded of Jane Belo's description of a Balinese horse dance:

The player would start out riding the hobbyhorse, being, so to speak the horseman. But in his trance activity he would soon become identified with the horse—he would prance, gallop about, stamp and kick as a horse—or perhaps it would be fairer to say that he would be the horse and rider in one. For though he would sit on the hobbyhorse, his legs had to serve from the beginning as the legs of the beast.[27]

As Richard Schechner has pointed out, this is "an example of the performer's double identity"—related to crossdressing—in which "the 'portrayal' is a transformation of the performer's body/mind" and "the 'canvas' or 'material' is the performer."[28] And yet what Antin's text always does is remind one just who is "boss." Even as Antin "becomes" the horse, she simultaneously rides it. She controls the scene, as it were, and the price of this perhaps inevitable exercise of artistic power is Antin's true subject.

That is, every image, every puppet figure on Antin's stage, is polysemous before the arrival of the text. Roland Barthes has interrogated the consequences of this polysemy as thoroughly as anyone: "Polysemy questions meaning. . . . Hence, in every society a certain number of techniques are developed in order to *fix* the floating chain of signifieds, to combat the terror of uncertain signs: the linguistic message is one of these techniques. . . . The linguistic message . . . constitutes a kind of vise which keeps the connoted meanings from proliferating."[29] *El Desdichado* begins by addressing this "terror of uncertain signs." No sooner does the horse ask his boss for a rest than this exchange takes place:

KING: This may not be a good place [to rest]. Last night a spotted dog crapped under my window.

HORSE: So what?

K: He had only three legs.

H: So what does that mean?

K: By itself probably nothing. But this morning the innkeeper told me that last week a merchant passed by on his way to the city to sell monkeys and a woman sat down on a hill of termites and now she's pregnant. The man who learns to read signs is master of the future.

H: But you don't know how to read them.

K: I'm learning. I know one when I see one. That's the first step. Rome wasn't built in a day.

The king's announced project, then, is to learn to read images, to "master," as he says, the future by *determining* the meaning of things. Barthes continues:

[Such] anchoring can be ideological; this is even, no doubt, its main function; the text directs the reader among the various signifieds of the image, causes him to avoid some and to accept others. . . . Anchoring is a means of control, it bears a responsibility, confronting the projective power of the figures, as to the use of the message; in relation to the freedom of the image's signifieds, the text has a *repressive* value, and we can see that a society's ideology and morality are principally invested on this level.[30]

As the king and his horse subsequently witness a series of hangings, they construct narratives to explain the crimes each of the victims must have committed. They are based on nothing other than a cursory examination of the victims' physiognomies:

H: [That one's] a rapist.

K: How do you know?

H: Shifty eyes. And look at those thumbs.

However arbitrary, what is clear is that these narratives—or narratives like them, which no doubt were told at the trial—constitute the morality and ideology of the society in its most repressive mode. They *justify* the hanging.

As is hinted by the horse's arbitrary reading of the rapist's eyes, the "meaning" of any given sign is, furthermore, never determinant in *El Desdichado*. If the horse thinks that a baker is guilty of having mixed sawdust with his flour, thereby killing any number of innocent peasants, the king explains that it is just as likely that the baker is innocent, the victim himself of a miller who owns both a flour mill and a sawmill and who uses the waste products of one to increase the profits of the other. Similarly, the "White City" may be a utopian paradise which the king seeks, or it may be a city of bones, a great hospital where people "generally die." But the point is nevertheless clear: what determines—however arbitrarily—the meaning of the image is the text, the various narratives that the image generates.

The success of Antin's performance depends upon our understanding this narrative process—how it functions both structurally and aesthetically. Barbara Herrnstein Smith has defined narrative in a way that seems particularly useful in this context, as a verbal act "consisting of *someone telling someone else that something happened.*" That is, narrative is a "*social transaction*"—a rhetoric, in Jameson's terms—which not only suggests that every narrative "is produced and experienced under certain social conditions and constraints and that it always involves two parties, an audience as well as a narrator, but also that, as in any social transaction, each party must be individually motivated to participate in it: in other words, that each party must have some *interest* in telling or listening to that narrative."[31] Such a definition allows us to understand that narrative is the primary *action* of Antin's work *and* that this verbal activity draws out of the performance a sense of *ritual* deriving from the fact that telling or listening to a narrative establishes an implicit contract between narrator and audience which in turn establishes a sense of *community*. And it is perhaps worth saying again that this sense of *community* depends, in large part, on the presence of Schechner's "integral audience" and the intimacy of the gallery space. Schechner has pointed out that what distinguishes ritual from "entertainment" is not so much "fundamental structure" (there are a great many narratives, for instance, which are entertainments, not rituals) but *context*, in the case of performance the context of a small, knowledgeable, supportive, and *interested* audience.[32]

But if the social transaction of Antin's narration is a rhetoric, it is worth remembering as well that the word "rhetoric" possesses certain negative connotations precisely because, in Smith's terms, each party has an *interest* in speaking and listening to the rhetoric at hand. Rhetoric is a powerful propagandistic tool. It persuades, but it also, potentially, dissimulates. When we tell stories, we are often creating the mythologies by which we live, not the least of them being that the stories themselves often pretend to make sense of—display the coherence at the heart of—life itself. It is possible to see narrative as Marx saw religion, as an "opiate" designed to give us a *false* sense of community. Narrative in this sense serves the purpose of institutionalizing the dominant order, cementing and authorizing the working structures of power that are in place in a given society. To borrow a distinction from anthropologist Victor Turner, a narrative of this kind is not properly *ritual* in character, but is, rather, a type of *ceremony*. Ceremony, for Turner, "is a declaration against indeterminacy. Through form and formality it celebrates man-made meaning, the culturally determinate, the regulated, the named, and the explained. It banishes from consideration the basic questions raised by the made-upness of culture, its malleability and alternability." Ceremony, in other words, bans the narrative undecidability that Antin's picaro king represents, the very un-

decidability defined by a wandering teller of tales, of unclear sexual determination, who alternately speaks for and speaks to his (or her) horse depending upon which "role" he (or she) happens to be "inhabiting," this figure who, like the audience itself, can decide on no one reading of what is seen or what is heard. Ritual, by contrast, according to Turner, "is a transformative self-immolation of order as presently constituted." It projects, that is, the necessity of an "authentic reordering" of the social situation.[33]

The power, finally, of Antin's particular brand of performance is that her narratives are always double-edged, that they always remain precariously "ungrounded," moving between narrative's ritual dreams and its ceremonial functions. Just as in *The Angel of Mercy*, Antin's Eleanor Nightingale must contemplate the horrible truth that each life she "saves" will in all probability return to the front to take two others, the great paradox of *El Desdichado* is that narrative itself is both a positive and negative force—it kills (at the hangings, for instance) ceremoniously, by *authorizing* the *rule* of meaning, and yet simultaneously it establishes itself as the promise of a new, transformed *community*. In this new community, as the king envisions it, "the days are spent in learning, debating, reading, storytelling, writing, painting, walking, exercise. . . . And while poverty makes men deceitful, worthless, cunning, contriving, perjured, and wealth makes them insolent, proud, ignorant, pretentious, traitorous, boasting, insulting, communal life makes all at the same time rich and poor, rich since you have everything, poor since you own nothing. . . . No woman shall have intercourse with a man unless she chooses to and she shall decide whom it shall be. . . . Gone are the drooling old men who legislate to the heart and tell it to do this and do that." Such visions have always, of course, moved humankind to change. They have also doomed men to a life of illusion, to the mad pursuit of impossible dreams. Narratives both enliven the world and burden it, in the same way that *El Desdichado* evokes, on the one hand, the nobility of Cervantes, and on the other, the clichéd vapidity of *The Man of La Mancha*. Antin's performance helps us to see (or should help us to see, if we are awake to narrative's possibilities) both sides—ritual and ceremony, the promise of meaning and its cost.

III

Carolee Schneemann, *Fresh Blood: A Dream Morphology*
University of California at San Diego, February 15, 1985

If Laurie Anderson is a nomad in her own land and Antin a wanderer in time, there is another kind of terrain in which a performer might wander, in which the battle between the "rule" of meaning and the undecidability of the sign wages on—the mental landscape, that is, of the dreamworld. *Fresh Blood* is a performance based on a dream of Carolee Schneemann.

She is in a cab in London with three men on her way to a concert when one of the men says that he is bleeding: "We wonder how this cut came about, confined as we are. I have a sudden fear it might be from my umbrella; perhaps I inadvertently jabbed his leg getting into the taxi. He smoothly opens the trousers along the crease over his thigh: we can see vivid, fresh 'flower' of blood spurting there."[34] As dreams go, this one is perfectly susceptible to classical Freudian interpretation. "All elongated objects," Freud writes, "such as sticks, tree-trunks and umbrellas (the opening of these last being comparable to an erection) may stand for the male organ."[35] Flowers, of course, represent the female genitalia, and the blood menstruation.[36] At least overtly, Schneemann seems engaged here in a classic example of sexual inversion. "It is a fact," says Freud, "that the imagination does not admit of long, stiff objects and weapons being used as symbols of the female genitals. . . . There is a general inversion of sex, so that what is male is represented as female and *vice versa*. Dreams of this kind may, for instance, express a woman's wish to be a man."[37] But it should come as no surprise that this is a reading Schneemann is not willing to accept. "She is aware," she says in the prologue to *Fresh Blood*, "of dismantling those analytic, authoritarian hierarchies which male conventions [have] projected onto the scope and implication of the female creative imagination—even our dreams and unconscious recognitions were subjected to pervading male interpretations." Schneemann inverts Freud's inversion, reinvents his narrative. Her dream reflects female experience, which she will not allow to be appropriated by the male "rule."

Dream work is not unlike the photographic images, described in chapter 1, which Szarkowski included in his 1973 From the Picture Press exhibition: "As images, the photographs are shockingly direct," Szarkowski wrote, "and at the same time mysterious, elliptical and fragmentary, reproducing the texture of experience without explaining its meaning." As Schneemann says at the very beginning of the performance, "WE ALL KNOW WHAT AN UMBRELLA IS . . . BUT WHY DO I DREAM OF IT?" In Freud's terms, dream work possesses a *latent* content that is of far greater significance than its *manifest* content—a narrative, that is, that takes place at the level of connotation. *Fresh Blood* works out a *female* morphology of the dream, exposing a latent content outside the conventions of representation.

The work itself is composed of three distinct sections. The first, what we might call the prologue, outlines the critical and philosophical terms of the work. Schneemann rises up from the back of the stage space, in front of a series of images consisting of various V-shaped forms, removes the top to her costume so that she is bare-breasted, and dances with a translucent umbrella, casting shadows across the projected images (Fig. 69). The second section consists of a narration of the dream itself, and a second, shorter, but

related dream, as well as a description of what she calls the "immediate dream surround," the circumstances of her life the night of the dream that led up to it and inform it. Throughout this section Schneemann sits on the floor and reads from index cards. The images continue to appear on the wall behind her. The third section is an analysis of the dream itself, with Schneemann standing again, and pointing out certain formal and symbolic elements in the projected images. Each of these last two sections is interrupted twice by the intrusion of a second performer who enters the performance by means of the standard "Knock, knock, who's there" joke: she knocks until Schneemann admits her interruption and responds "Who's there?" and short dialogues follow.

A multitude of things inform this performance from the "outside." In the first place, there is Freud and the entire system of pyschic signification that his work represents. Not only do Schneemann's dreams assume, at least initially, classical Freudian connotations, and the "knock-knock joke" sections recall Freud's *Jokes and Their Relation to the Unconscious*, but her work is, to use Freud's word, "*unheimlich*," uncanny. In its simplest terms, the *unheimlich* is that which does not "belong to the home"; it is unfamiliar. But, "in reality," as Freud says, "this uncanny is . . . nothing new or foreign, but something familiar and old-established in the mind that has been estranged only by the process of repression."[38] The spirit of the uncanny is evoked, in Freud's first example, by "doubts whether an apparently animate being is really alive," in those instances that "excite in the spectator the feeling that automatic, mechanical processes are at work, concealed beneath the ordinary appearance of animation."[39] Such effects are clearly a component of Laurie Anderson's *United States*. In *Fresh Blood* they are elicited by the fact that the entire prologue is on tape. When I saw the performance I assumed, as I believe everyone else assumed, that as Schneemann slowly rose from backstage and began her performance she was speaking into some sort of microphone attached to a reverberation device. Only after several minutes did it become clear that her voice was being projected not from her mouth but from speakers. This was associated with a second, even more distracting or disorienting dislocation. While it was true that Schneemann was half nude, the focus of attention was *not* upon Schneemann herself. What seemed animate in the first part of the performance was not the human figure on stage, but its shadow (its *umber*) as it danced two-dimensionally with its umbrella across the screen at the rear. What held one's attention, in other words, was not the performer herself but her *projections*—the tape of her voice, the image of her shadow, the slides of her own drawings—those traces of herself which somehow *exceeded* her. Similarly, in the second part of the performance, by sitting before us and reading her dreams to us, Schneemann underscores the fact that it is not her *presence* before us that animates the work, but something

FIGURE 69. Carolee Schneemann, *Fresh Blood—A Dream Morphology*, 1983. Photo: Ginerva Portlock.

"other," something that occurred in a dream, in some other place, at some other time, in some other set of circumstances. It is, finally, the admission of the "other," the repressed, into the discourse of the moment that is Schneemann's subject. For her dream is about, in her words, "both cunt and cock." It is about the fact, as she relates in the "immediate dream surround," that on the night she dreamed her umbrella dream she began to menstruate. It is about the difference between "reactive male mythologies" in which "men wound each other to 'spill blood,' blood revenge, blood lust, bad blood between them, blood brothers" and the "blood nourishment" of the female, "the proportionate periodicity of menstrual blood."

She publicly announces and portrays, in performance, what is taboo. In 1974 she defended her use of the naked body in her work by saying that she intended "to break into the taboos against the vitality of the naked body in movement, to eroticize my guilt-ridden culture and further to confound this culture's sexual rigidities." She wonders, near the end of *Fresh Blood*, "IF BLOOD WERE A MENTAL PRODUCT WOULD IT BE ACCEPT-ABLE?" What made *Meat Joy* such a powerful work in 1964 was the introduction, into the performance, not merely of human flesh, but of actual *meat*—not metaphor, but the thing itself.

This raises one of the fundamental issues of Schneemann's work—her unwillingness to accept art solely as a formal or mental construct and her concomitant insistence on its active physicality. "I refer to the 'dream body,'" she says in the prologue to *Fresh Blood*, "an implicit emphasis denied to the primacy of body in Freud's use of 'dream mind.'" At first, such an insistence seems at odds with the dislocation of physical presence which I have just described as operating in her work. But they are—body and image, the physical and the mental—two sides of the same coin. From the time of her earliest works, even as she distinguished between two kinds of relation to her work, she insisted on their interrelation:

The steady exploration and repeated viewing which the eye is required to make with my painting-constructions is reversed in the performance situation where the spectator is overwhelmed with changing recognitions. . . . With paintings, constructions and sculptures the viewers are able to carry out repeated examinations of the work, to select and vary viewing positions (to walk with the eye), to touch surfaces and to freely indulge responses to areas of color and texture at their chosen speed. During a theater piece the audience may become more active physically than when viewing a painting or assemblage. . . . They may have to act, to do things, to assist some activity, to get out of the way, to dodge or catch falling objects. . . . The eye will be receiving information at unpredictable and changing rates of density and duration.[40]

As she put it in an early version of *Fresh Blood*: "Early on I felt that the mind was subject to the dynamics of its body. The body activating pulse of eye and stroke, the mark signifying event transferred from 'actual' space to constructed space. And that it was essential to dance, to exercise before going to paint in order *to see better*."[41] In *Fresh Blood*, it is as if, in fact, the very presence of the body were what allows us to concentrate on the image. Without it, these would be just images, as narratively impoverished as Szarkowski's images From the Picture Press. It is the body which makes the images legible, just as the images become the body's story.

These images are culled from all manner of sources, especially feminist research in archeology and her own earlier work, from that "outside," that is, which is her cultural—albeit repressed—female history and her personal past as a woman artist. As Julia Ballerini put it in an essay on Schneemann's work since 1980:

In all her montages, films, performances there is an insistent repetition of disparate motifs—within each work and from work to work. Constant relocations of themes suggest continuity from montage to montage, montage to film, film to film, film to performance, performance to performance, performance to montage. Yet the formulative autonomy of each work is equally insistent; the motif is readjusted, repositioned, dismembered and remembered in each new context. Repetitions redistribute visual codes again and again, shoring sympathetic and antipathetic messages up against one another. [42]

The most obvious such reoccurrence in *Fresh Blood* is the reemergence of the umbrella from her 1963 *Untitled (Four Fur Cutting Boards)*, the work against which she had staged *Eye Body*, her earliest performance (Color Plate II). In this construction, two motorized umbrellas constantly fold and unfold against their collage backdrop, a sort of metaphor for the rhythms of human activity, sexual or painterly. In the catalogue essay to the 1983 exhibition of her early work, Ted Castle has captured their full ambiguity: "The umbrella is offensive (piercing) and defensive (shielding). It is both weapon and comforter. It is stylish and utilitarian. It is useful in both fine weather and foul. It is peculiarly human, it is ambiguous, it is forthright, it is used by both men and women and it is both phallic and vulviform, depending on how you look at it." [43] It is, of course, "how you look at it" that becomes the subject of *Fresh Blood*.

On the one hand, you can look at an umbrella as Freud does, phallocentrically. On the other hand, you can see it, as Schneemann does, as the manifestation of what she calls "vulvic space." In the drawings for *Fresh Blood*, it is represented in both ways (Fig. 70). It depends on whether you

FIGURE 70. Carolee Schneemann, drawings for *Fresh Blood*, 1980. Courtesy Carolee Schneemann.

point it up or down. The umbrella is, in Schneemann's mind, closely related
to the serpent, the scroll she unwinds from her vagina in *Interior Scroll*.
Not only does the scroll represent "the movement from interior thought to
external signification"—that is, the very act of interpreting dreams—but
snakes themselves which, as she learned from Mackenzie's *The Migration
of Symbols*, "originally symbolized the cosmic energy of the female womb
which protected and nourished the embryo as [ancient peoples] believed
the ocean originally did the earth."[44] Blood, in other words, *fresh* blood,
menses, is a sort of snake image, comparable to the scroll in the earlier
work. "I saw the vagina as a translucent chamber," she says in her notes to
Interior Scroll, "of which the serpent was an outward model."[45] It is hardly
accidental that the umbrella with which Schneemann dances in the perfor-
mance of *Fresh Blood* is itself translucent—that which simultaneously casts
a shadow, its umber, and allows light to pass through it, that which allows
the image to be seen even as it shades it, like the dream itself.

Schneemann, in short, will not submit to the rule of phallocentric dis-
course, the voice of authority, even as she admits it into her own:

> umbrella cunt *umbrella both cunt and cock* unfurling
> it expands and contracts covers the body the head
> is a hollow shaft a tissue thin fabric rigid supports
> umbrella is ridged ribbed tactile ridges of cunt cock
> is wet covered with rain rain pours down. . . .
> umbrella/cunt/cock: rises up opens out
> all wrapped up furled unfurled cunt clasping cock[46]

It was at this moment, when I heard these words in the performance
of *Fresh Blood*, that for me, another "outside" source began to inform
Schneemann's work. It was not a source Schneemann, as she later assured
me, was aware of herself. It was my own, brought to the work by my self.
It was "spurred" by the "eruption" (Vesuvius is one of her images of the
simultaneity of male and female forms) of the word "phallocentric" out of
my own discourse into the space of Schneemann's. Suddenly there was,
before me, in Schneemann's performance, an instance of Derrida's *Spurs*,
a woman no longer contained in the phallocentric space of Western dis-
course—Derrida's word is "phallogocentric," combining the phallus with
the word—but a woman who is an "affirmative power, a dissimulatress, an
artist, a dionysiac. . . . She affirms herself, in and of herself."[47] Further-
more, in a collision of texts that can only be called "uncanny," Derrida's
essay revolves around a short fragment from Nietzsche, isolated in quota-
tion marks and found among his unpublished manuscripts: "*I have forgot-
ten my umbrella*."[48] Such fragments, Derrida knows, must "remain in
principle inaccessible" (125). However, as he quickly points out, "the um-
brella's symbolic figure is well-known . . . the hermaphroditic spur of a
phallus which is modestly enfolded in its veils, an organ which is at once

aggressive and apotropaic [i.e., designed to avert evil], threatening and/or threatened" (129). And so, he says, "it must mean something," it must "come from the most intimate reaches of this author's thought" (131). On the other hand, "it is always possible that it means nothing at all or that it has no decidable meaning. . . . If Nietzsche had indeed meant to say something, might it not be just that . . . whatever lengths one might carry a conscientious interpretation, the hypothesis that the totality of Nietzsche's text, in some monstrous way, might well be of the type 'I have forgotten my umbrella' cannot be denied" (131–33).

For Derrida, *style* is itself a kind of umbrella. The pun is manifold, but briefly style is "a long object, an oblong object, a word, which perforates even as it parries" (41). "In the question of style," Derrida writes, "there is always the weight . . . of some pointed object. At times this object might be only a quill or a stylus. But it could just as easily be a stiletto, or even a rapier. Such objects might be used in a vicious attack against what philosophy appeals to in the name of matter or matrix" (37). For Nietzsche, as well as for Derrida, woman is a question of style, but hers "is not a determinable identity" (49). She is of the type "I have forgotten my umbrella," unlocatable, *unheimlich*. In his introduction to *Spurs*, Stefano Agosti concludes by "wondering if traditional logocentric writing"—for instance, the writing of Freud—"represents a means . . . for taking 'shelter from the sun' . . . black, a shadow-writing, writing for protection" (21). Traditional writing is, so to speak, umber, under the umbrella, like the shaft. But there is, he suggests, another kind of writing, a "white writing" which "forces what it says into the margins and then seizes upon these margins in such a way that nothing may settle there." This is, I would suggest, where the writing of the wanderer, of Schneemann—and Anderson and Antin—exists. "I have in mind," says Agosti, "the dream machinery." But more generally, he means any writing "of an obscure sort, the sort that obliterates what it imprints and disperses what it says. It shelters nothing. Rather it exposes" (23).

Nothing in Schneemann's work admits this Derridean gloss. It comes from the outside in, a kind of "unruly" interruption into the scene, a violation of the integrity of the piece. Or else it is just the other way around—this reading a kind of serpent unwinding from the interior of the work, the text that it has borne, willy-nilly. Then, everything in *Fresh Blood* allows this reading's "misrule." Whatever the case, the question remains, finally, *unsettled*—which is where, wherever that is, it probably should be.

5 "SO MUCH TO TELL"

Narrative and the Poetics of the Vernacular

> Now standing visible & loud
> before us
> ha ha ha
> so so so
> so so so
> hee hee hee
> see see see
> hum hum hum
> it says & rises
> lonely lost
> the spirit that wanders through America
> JEROME ROTHENBERG, "The Little Saint of Huautla"[1]

In the title poem to his 1979 volume, *As We Know*, John Ashbery describes a sense of the present that begins, as one grows older, to dominate consciousness, a present composed of one's memories. "All that we see is penetrated by it," he says, this "present that is elsewhere." Examining ourselves, we realize that "the whole is to be reviewed," that we are the accumulated narratives of our lives. There is no present except as summation:

> The way we had come was all we could see
> And it crept up on us, embarrassed
> That there is so much to tell now, really now.[2]

In his "Self-Portrait in a Convex Mirror," the present had been imaged as a "recurring wave / Of arrival." In this book we are confronted instead by a

> fixed wall of water
> That indicates where the present leaves off
> And the past begins, whose transparencies
> Admit impressions of traceries of leaves
> And shallow birds among memories.[3]

As the present, in all its "reality" and immediacy, begins to allow the traces of the past—history, the "outside"—to inform it, Ashbery's embarrassment reveals itself to be that of a modernist falling into the postmodern condition. There is, he understands, more to the present than the present, as a poetics of immanence gives way to the force of history. The way in which we understand our lives, in the present, is, perhaps, the subject of the poem, the way in which we have come to know what we know.

One way to think of the modernist enterprise is as a systematic endeavor to institutionalize, in art, the idealisms of the past, a desire to locate in the

art object the unity, the transcendence, the *meaning* that had once been found in God but can nowhere be found amidst the confusions of daily life. Art *had* to be separated from life, because life was so obviously contingent. Thus Greenbergian formalism had eschewed narrative content as *"literary,"* had longed for a painting that was "self-contained," had defined a decorum in art appreciation which subscribed to the pragmatic position that since life was hard enough as it was, art should offer us, rather like Alka Seltzer or Rolaids, some sort of relief. Ashbery submits himself in "As We Know" to the contingencies of the half-remembered, the half-forgotten, the stories we have constructed around our lives. What he has forsaken are the certainties of the formalist enterprise. He has become, like Anderson, Antin, and Schneemann, a wanderer in his own world, with at best, as he says, "a home to get to, one of these days."

There are, then, two separate poetics of the present—a largely modernist one which sees in the "present," in the immediacy of experience, something like an authentic "wholeness," a sense of unity and completion that is the "end" of art, and another, postmodern one which defines the present as perpetually and inevitably in media res, as part of an ongoing process, inevitably fragmentary, incomplete, and multiplicitous. This would be a straightforward enough situation, except that for so many the recognition of the latter in no way mitigates their nostalgia for the former. It is as if, having lost formalism, we necessarily long for its return, as if, having lost the present—or, rather, the *fullness* of *presence*—we are somehow embarrassed to admit it.

Yvonne Rainer's work since she began to shift her interests away from dance and toward film is a case in point. Both the emergence of "talk"— that is, extraformal content—in the space of her dance and her commitment to process, as exemplified by her *Continuous Project—Altered Daily*, indicate her recognition of the contingency of the present. But it has been her relation to narrative, the storytelling side of talk, that has caused her, I think, the most aesthetic difficulty. On the one hand, the possibilities of narrative intrigue her. When, in the early seventies, she visited India because she needed to have her "batteries recharged," as she put it in an interview about the experience, she was most impressed by the Kathakali. "Art doesn't make any sense to Indians unless it deals with a story," she explained.

That's what's so essentially different from Western dancing in the last ten years or from New York modern dance. Every gesture, each mudra of the Kathakali, is *read* and is well known by the spectators. . . . Without knowing the stories or the specific meanings of the gestures, I found myself getting involved. . . . It became astonishing to me that I have dealt with dramatic elements in my dance but have never fitted them together to make a story. In fact, my whole emphasis has been to avoid any clear continuity. . . . My means, my medium, my vocabulary are so

totally different from what I saw that I don't know how I'll be able to do this, but I now want to create a new continuity in the way I transcribe and transpose my experience into performance.[4]

Nevertheless, and despite the interest and attraction, her relation to narrative has remained equivocal. As Lucy Lippard has put it in an article on Rainer's first three films—*Lives of Performers* (1972), *Film About a Woman Who . . .* (1974), and *Kristina Talking Pictures* (1976)—"an audience expecting to lose itself in a 'story' [in any of Rainer's films] will be frustrated until it accepts *how* Rainer uses narrative. Rainer claims that the story is 'an empty frame on which to hang images and thoughts which need support. I feel no obligation,' she says, 'to flesh out this armature with credible details of location and time.' " Her films, says Lippard, "are essentially series of tableaux connected by an unseen network of tensions and references."[5] They are structured, that is, in ways not unrelated to Robert Wilson's operas, collage strategies that tend to slide, in Rainer's own words, "between the narrativity of Scylla and the formalism of Charybdis."[6]

Another way to say this is to suggest that we relate to them in the same manner we relate to Nicholas Nixon's or Garry Winogrand's photographs—as objects whose dynamism results from the contest between their own formal integrity and the extraformal discourses which they admit. What is interesting is that the intrusion of outside narratives remains somehow "suspect" for Rainer, whatever the attraction of narrativity in the first place. In a discussion of her two newest films, *Journeys from Berlin* and *Kristina Talking Pictures*, these suspicions are manifest:

Action has been replaced by speaking, and by words, by language, and language in all its manifestations—print, speaking, monologue, recitation, voice over. . . . It's sort of part and parcel of low budget filmmaking, but for me it has a moral and political dimension that continues to be vital and useful. The action film is certainly the opposite of a contemplative film. . . . [For the audience, there is] room and space and time to contemplate . . . their own place within certain issues. You may say the way in which I use this, this very slow pacing, extended time, repetitive framing, long shots—that is, shots of long duration—this derives from the music concert of the sixties, LaMonte Young and John Cage. You listen and your mind starts going away. . . . There's that kind of possibility, or hazard. . . . But it's something that continues to attract me as an alternative to what I call the thralldom of traditional narrative cinema, where your mind gets taken away by these strategies for identification, vicarious voyeuristic action and enactment.[7]

The irony, of course, is that action—the very idea of *acting* so as to retrieve the art object from the status of a self-contained *contemplative* field—played a very large part, especially in feminist art, in the postmodern assault on modernism in the first place. But "acting," for Rainer, is a kind of "naturalist" activity, part and parcel of creating a believable and coherent dramatic "world." In other words, she does not see acting in terms of postmodern performance, as the emergence of the "personal" onto the stage in

a way that interferes with character and announces itself as "acting." She admits, rather, to an "aversion to the 'acting' and 'acting out' required by narratological character" because, she explains, "it still seems that the refusal to invest my film performers with the full stature and authority of characters shares at some level the same impulse that substituted 'running' for 'dancing' many years ago."[8] The *story*, for Rainer, like the *grand jeté*, remains embedded within a structure of beginnings and endings, of climaxes and causalities, that her films seek to exceed. The story is a self-contained, well-made object. "In cinema," Rainer concludes, "the battleground is narrativity itself."[9] The question is how to tell a story without reducing its characters and situations to mere coherence, to "naturalist" discourse, how to tell a story without embarrassing oneself.

I

The question of narrative—and its relation to discourse—can be said to lie at the heart of a broad-based, largely informal, but distinctly recognizable poetic movement that can be defined for the most part by its tendency to regard poetry as an oral, performance-oriented, largely narrative or ritual medium. Conceived as a form of *social* praxis (either politically engaged or ritualistic in orientation), this poetry opposes itself to a written and text-oriented, predominantly lyric tradition in which the poem is situated as a self-reflexive object, a wholly contained aesthetic field. In the simplest terms this new brand of poetry is practiced by a group of poets who regard the text, for better or worse, as the acknowledgment in the act of writing itself of some a priori voiced or spoken moment, vernacular in character, of which the text is the mere record. Though its chief practitioners rank among the most notorious outlaws of the American poetry scene—David Antin, Jerome Rothenberg, Jackson Mac Low, and John Cage—the major tenets of the "movement" (insofar as it can be called a "movement") have been incorporated into more mainstream and "establishment" poetics, to varying degrees and in various ways, by such writers as Allen Ginsberg, Gary Snyder, Robert Creeley, Robert Duncan, and Edward Dorn. It is indeed possible, I think, to say of poems such as James Merrill's *Mirabell*, which is in large part the transcription of a Ouija board's utterance, and John Ashbery's "Litany," with the polyvocality of its "simultaneous but independent monologues," that if they are not directly indebted to the oral poetry movement's redefinition of contemporary poetics in terms of the vernacular, then they are at least representative of an aesthetic drift recognizable in all the arts and most thoroughly investigated and articulated, in their own medium, in the performance of such poets as Antin and Rothenberg.

In large part because of its self-willed outlaw status, the oral poetry movement has been exiled from the mainstream of American poetry, what-

ever influence it has had upon the scene as a whole.[10] It is seen as conducting its business outside the framework of American poetry's tacit laws, laws agreed upon by the academic tradition defined in the fifties by the *Kenyon*, *Hudson*, *Sewanee*, and *Partisan* reviews, and flourishing still, in only slightly modified form, in these same journals, in the *American Poetry Review* and in MFA writing programs everywhere. As a result, whenever oral poetics is discussed in academic circles, it tends to produce, in David Antin's phrase, "instant panic and revulsion."[11] When Marjorie Perloff, for instance, gave a talk in Washington based on the last chapter of her *Poetics of Indeterminacy*, Harold Bloom, who was on the panel with her, had hardly heard the names Antin and Cage pronounced when he denounced the proceedings as ridiculous, declared Antin and Cage to be nonpoets, and stormed off the stage. But when Antin first spoke of the academics' "panic and revulsion" before the specter of a new poetics, he was describing the establishment's reaction to that earlier fifties avant-garde, the revulsion felt by a generation of poets headed by Delmore Schwartz, Robert Lowell, Allen Tate, Randall Jarrell, and Karl Shapiro before the rise of an ostensible "antipoetry" among Beat, Black Mountain, and New York writers. Nevertheless, as I have just indicated, the situation had changed so little by the early seventies, when Antin was writing the essay "Modernism and Postmodernism," from which I have quoted, that his description of the situation in the fifties was fully intended to represent the present state of American poetry as well. The Schwartz-Lowell-Tate generation was being supplanted by a new, younger academic set, and the Beat, Black Mountain, New York avant-garde had shifted location to Boulder, Bolinas, and San Diego, but the antagonism between academic and avant-garde poetics still remained. Tate's 1968 call to order—to the effect that "formal versification is the primary structure of poetic order, the assurance to the reader and to the poet himself that the poet is in control of the disorder both outside him and within his own mind"—seemed only a little stodgy at the time (and, I dare say, seems only a little more so even now).[12] Any number of poets would have wholeheartedly endorsed it, from Lowell to Merrill to Wilbur and Snodgrass, and those who might have quarreled with it, namely the free versists, would not even have begun to dream of challenging its aesthetic thrust. That is, poetry's business was—and still is, for the most part—ordering the world, resolving the world's paradoxes and antinomies by arriving at larger poetic unities. If a free versist, such as the Lowell of *Life Studies*, could manage to overcome the disorder of his line with the larger order of his poem, then the more power to him. As a matter of fact, throughout the modernist period free verse was not so much an antistructural gesture, though it was often mistaken for one, as it was a highly formalized device for conveniently depicting the disorder one feels before both world and mind. For many modernists, and not least of all such "fa-

thers" as Pound and Williams, mastering the vagaries of the free verse line, like mastering the heterogeneity of the long poem, was tantamount to mastering the world as a whole.

While Antin certainly wishes to attack the Schwartz-Lowell-Tate tradition's deep belief in the virtues of formal versification in his "Modernism and Postmodernism" essay, he nevertheless sees their metrical imperative as only the most obvious manifestation of a more deep-seated formalist imperative underlying most American poetry, including the varieties of free verse. If contemporary American poetry no longer feels compelled to take on a recalcitrant reality by ordering it metrically, it still feels obligated to order the world imaginatively. The so-called confessional mode, with its idealizing interiorization, its turning away from the world and to the self in order to discover there some overriding purposiveness or sense, represents one direction such a formalist imagination might turn to. A different tack has been taken in the "surrealist" verse of poets like James Tate, Charles Wright, W. S. Merwin, Mark Strand, and their many imitators. As Robert Pinsky has pointed out, these poets have created an organizing stylistic lingua franca, consisting of an imagistic vocabulary of vast samenesses, and irreducible totalities. Theirs is the language of "silence," "blankness," "opacity," "light," "ice," and "air," and their project, in Pinsky's words, is to "reveal unsuspected, essential parts of the invisible web of thoughts covering the world."[13] In fact, both the "confessional" and "surrealist" schools seek a poetry of epistemological transcendence. They seek to realize an imaginative order which transcends perceptual fact.

Antin, on the other hand, claims far less—or at least something very different—for himself and for the kind of poetry he champions generally. As a poet Antin considers himself to be simply "a man up on his feet, talking" (MP, 131). The poem, in turn, can never unify experience, make reality cohere: "Reality is inexhaustible," Antin writes, "or, more particularly, cannot be exhausted by its representations because its representations modify its nature" (MP, 133). Poetry, that is, may complicate or even explode reality, but it can never contain or fully understand it. Poetic form finds its exemplar in the figure of Charles Olson, for whom "'well-formed' means . . . an adequate traversal of the poet's energy states" (MP, 122). Rather than unity, the univocality of the definitive text, Antin chooses as a model the polyvocality of Allen Ginsberg's Howl, that almost undigestible "amalgamation of Whitman, Williams, Lawrence, Blake, and the Englished versions of the French, German, and Spanish modern styles out of the chewed-up pages of old copies of Transition, View, Tiger's Eye, and VVV" (MP, 128). Most important, he insists on establishing a new "relation between text and poem," one he admits that is "not quite an idea of an 'oral' poetry, not yet," not in 1972, but one that no longer identifies "the text of the poem with the poem itself" (MP, 132).

"Modernism and Postmodernism" amounts to the oral poetry move-
ment's first manifesto. There have since been many other attempts to adopt
and develop "the idea of an 'oral' poetry." Some of the more important
appear in a series of statements prepared especially for the First Interna-
tional Symposium on Ethnopoetics at the University of Wisconsin, Mil-
waukee, in the spring of 1975, including anthropologist Dennis Tedlock's
"The Way of the Word of the Breath," Gary Snyder's "The Politics of Eth-
nopoetics," and Jerome Rothenberg's "Pre-face to a Symposium on Ethno-
poetics."[14] Rothenberg's "Pre-face" is a representative summary of oral
poetry's intentions:

> What do we say about the function of our poetry, the thing we do? That it explores.
> That it initiates thought or action. That it proposes its own displacement. That it
> allows vulnerability & conflict. That it remains, like the best science, constantly
> open to change: to a continual change in our idea of what a poem is or may be.
> What language is. What experience is. What reality is. That for many of us it has
> become a fundamental process for the play & interchange of possibilities.
>
> And it has come out of a conflict—more or less deeply felt—with inherited
> forms of poetry, literature, language, discourse: not in every instance but where
> these are recognized as repressive structures, forms of categorical thinking that act
> against that other free play of possibilities just alluded to. Against these inherited
> forms, the conventional literature that no longer fed us, we have both searched for
> & invented other forms. (*PSE*, 135)

One of the constraints from which Rothenberg wishes to free the poem is
its status, to borrow John Crowe Ransom's well-worn phrase, as a "precious
object." The poem must *act in the world*; its wholeness must be experi-
enced in a communal or social context. It is, of course, this sense of the
poem's social and political nature—its status as shared experience—that
explains the new oral poetry's commitment to the idea of ethnopoetics.
Gary Snyder's "The Politics of Ethnopoetics" takes as its starting point, for
instance, Dennis Tedlock and Rothenberg's editorial statement of intention
for the inaugural 1970 issue of *Alcheringa*: "We hope . . . to emphasize
by example and commentary the relevance of tribal poetry to where we are
today; [and] to combat cultural genocide in all of its manifestations" (*PE*,
19–20). Snyder sees the ethnopoetic project as standing against the "val-
ues, goals, interests, [and] political and economic institutions prevailing in
industrialized and industrializing societies" (*PE*, 28). But he is equally in-
terested in protecting traditional cultures from a less obvious menace—
those who believe, as he once did as an anthropology student in the fifties,
that "it would be quixotic to . . . invest any political effort in the actual
defense of their cultural integrity because the assumption was almost au-
tomatic that there was a melting pot process of assimilation (that was prob-
ably o.k.) under way and what we had to look for at the other end of the
tunnel was a hopeful, international, one world, humane modernism, fueled
with liberal and Marxist ideas" (*PE*, 25). For Snyder, this last point of view

represents just another, more subtle version of cultural imperialism, a humanistic but still "civilizing" expansionism. Ideally, then, ethnopoetics would not help to promote the assimilation of traditional cultures to postindustrial civilization. Rather, it would help to promote cultural identity and integrity: "An expansionist imperialist culture feels most comfortable when it is able to believe that the people it is exploiting are somehow less than human. When it begins to get some kind of feedback that these people might be human beings [via, for instance, ethnopoetics] . . . it becomes increasingly difficult" (*PE*, 30). For Snyder, the political thrust of ethnopoetics entails an alignment against the homogeneous, single world which is imaged in the essentially imperialist concept of the "melting pot" and the advocacy, instead, of a plural world of distinct, coequal, and balanced "ecosystems."

In this context, the forms of "categorical thinking" from which Rothenberg wishes to separate his poetry are clearly identifiable with the imperialist and expansionist drive of the industrial nations—because poetry is the body of consumable "precious objects" produced by poets for the literary marketplace. As Rothenberg has said elsewhere, the poetics of "biospheric imperialism" must be overthrown.[15] By emphasizing the contingency and uniqueness of its performance, the oral poem has the advantage, at least, of not being a tangible object—a text—and thus seemingly avoids direct implication in the marketplace (though, as I have said before, in reality the marketplace is always able to discover ways in which to package and sell even the most disembodied art objects). What interests me in all this, however, is that ethnopoetics, both in its anti-industrial stance and in its biological and ecological call for the preservation of "primitive" cultures, can also be read, at least in part, as another version of pastoral, and whenever poetry discovers itself in the realm of the pastoral, it is in danger of reverting to a brand of sheer escapism. As Renato Poggioli has so often pointed out, the withdrawal from worldly things and the aesthetic self-gratification which the pastoral mode promotes are clearly at odds with the commitment and responsibility one would expect of a political poetry.[16] The urge to retreat from the complexities of modern society is one of the moving forces behind Snyder's work—and life—and this urge is a powerful force in Rothenberg as well: "Increasingly," he writes, "the model, the prototype, of the poet has become the 'shaman': the solitary, inspired religious functionary of the late paleolithic. . . . In a deeper, if often more confused sense, what is involved here is the search for a primal ground: a desire to bypass a civilization that has become problematic & to return, briefly, often by proxy, to the origins of our humanity" (*PSE*, 133). If the academic poet retreats from social issues by escaping into an aestheticized sense of the poem, the oral poet is in danger of bypassing his own social commitment by escaping into a sense of the poem as idealized "primal

ground," a *new wilderness*, in Rothenberg's phrase, where he can realize, however briefly, an "untamed realm of total freedom." [17]

The mantra, as it has been adapted to the poetic practices of both Snyder and Ginsberg, is a manifestation of precisely this idealized notion of poetic speech:

The phenomenal world experienced at certain pitches is totally living, exciting, mysterious, filling one with a trembling awe, leaving one grateful and humble. The wonder of the mystery returns direct to one's own senses and consciousness: inside and outside; the voice breathes, "Ah!"

Breath is the outer world coming into one's body. With pulse—the two always harmonizing—the source of our inward sense of rhythm. Breath is spirit, "inspiration." Expiration, "voiced," makes the signals by which the species connects. . . . In mantra chanting . . . a new voice enters, a voice speaks through you clearer and stronger than what you know of yourself; with a sureness and melody of its own, singing out the inner song of the self, and of the planet. [18]

"Ah!" is meant to articulate here something like the concantenation of the romantic sublime, the closest we can ever come in speech to expressing a world which fills one with a sense of trembling awe and mystery, and the beautiful, the positive pleasure we feel before a purely *pastoral* world, one imbued with such *harmony*. It suppresses, that is, all difference.

And, as I commented in the introduction, it is a very short step from the voice breathing "Ah!" to the voice breathing whole poems, a step Ginsberg had in mind when he titled his collection of poems written in 1972–77 *Mind Breaths*. The title poem to that volume begins with Ginsberg's sitting "crosslegged" in the Teton Village in Wyoming. He breathes first "upon the aluminum microphone-stand a body's length away" and that breath then moves outward "over the mountain . . . to Idaho," on westward through Reno, San Francisco, Guam, Fiji, and Sydney, continues to drift along on a "puff of opium out of mouth yellowed in Bangkok," blows over "Father's head in his apartment on Park Avenue Paterson . . . the vast breath of Consciousness" which finally

> returns vast gliding grass flats cow-dotted into
> Jackson Hole, into a corner of the plains,
> up the asphalt road and mud parking lot, a breeze of restless
> September, up wood stairways in the wind
> into the cafeteria at Teton Village under the red tram lift
> a calm breath, a silent breath, a slow breath breathes outward
> from the nostrils. [19]

This sort of psycho-, physio-, bio-, cosmological poetics has its roots, of course, in Charles Olson's "Projective Verse," and it permeates oral poetics. It amounts to the poetic equivalent of Jackson Pollock's famous claim: "When I am *in* my painting . . . there is pure harmony." That is, when Ginsberg is *in* his poem, the world is brought to order, geography collapses into self, self into some transcendent vast Consciousness. Just as Pollock's

canvas is the record of the act of painting, Ginsberg's text is the transcription of what we might call the "breath-event." Art is the act of making, not the thing made.

This is such an important distinction for contemporary poetics that it cannot be overemphasized. Among other things, it goes a long way toward explaining the fascination of the oral poetry movement with speech act theory.[20] Oral performance, the claim goes, like performative utterance, does not just say something, it does it (a fact that explains, I think, the aggressiveness of so many oral and performance pieces, with their disconcerting insistence on intruding on the audience). But more important, a written text is always a thing made; a voiced utterance is an act of making. Poets are never *in* the manifold instances of their published texts, and the written text thus suffers from a lack of authenticity. Its very "being" is gone. Just as in the late paleolithic era authority rested with the shaman, in contemporary poetics that authority has shifted to the poet. And the *poet's* authority has been wrested from the authority of the *text*. "Speaking for myself, then," Rothenberg writes, "I would like to desanctify and demystify the written word, because I think the danger of frozen thought, of authoritarian thought, has been closely tied in with it. I don't have any use for the 'sacred' in that sense—for the idea of the book or text as the authoritative, coercive version of some absolute truth, changeless because written down & visible."[21] In the changing contexts of performance situations, oral poets achieve harmonies or unities, they make sense of things, but that sense is contingent—spoken, as it were, on the wind—and inevitably lost. Nevertheless, and as the passage on mantra chanting from Snyder suggests, if the written text is demystified and desanctified, then the spoken word—by virtue of its very contingency and invisibility—is reconstituted with mystery and awe. In the "breath-event" we discover the new sublime—that is, the old sublime reconstituted in the lyrical self.

So if the rules have changed, the game has remained, in this sense, the same. Both academic poetics and oral poetics are ultimately founded on the notion of the poem—whether situated in speech or written as text—as privileged utterance, privileged because somehow transcendent. The one may claim to possess and hold the transcendental (it is this capture which makes the poem so precious), while the other claims to possess the transcendent only as a moment inevitably lost. But for the one, art is the manifestation, for the other the process, of arriving at *the same place*—metaphysical wholeness. This strain runs through all American poetics—old and new—and it accommodates all strategies, written and oral.

The same difficulty informs much feminist art as well. As Gisela Ecker has pointed out in the introduction to her collection *Feminist Aesthetics*: "It is tempting to mistake features of women's art as representations of 'women's nature,'" so that, for instance in the work of Judy Chicago,

"menstrual blood, clitoral images, feminine body language and pregnancy are used to bring into play aspects of female sexuality" that are universal, transcending the particular historical situation of women in contemporary society.[22] It is as if to recover this imagery were somehow to step out of history. The ubiquity of ritual oriented performance works in women's art is motivated by this same need, and it is a need some feminists share with Rothenberg, one of whose earliest anthologies was a 1966 collection entitled *Ritual: A Book of Primitive Rites and Events.* Inspired by the groundbreaking work of first Arnold van Gennep, whose *Rites de Passage* was published in French in 1908, and then the more recent work of Victor Turner, both Rothenberg's poetry and a great deal of feminist art share an interest in the *communal* nature of ritual activity. The assumption is that in ritual activity we escape the fragmentation and contingency of the modern condition and enter into a kind of quasi-religious, timeless wholeness. Consider, for instance, Richard Schechner's distinction between the two motivations for performance—efficacy and entertainment. In the New Guinea highlands, he points out, under the pressure of the colonial police, warfare between tribes was transformed into dancing. The performance, that is, had a certain efficacy. But before long it was not only to guarantee peace that the dances were staged, "but also because people like dancing for its own sake." There is, in other words, a certain continuity between the two poles of efficacy and entertainment, but the efficacy side of things has real attractions to those seeking to transcend any particular historical situation—feminist, ecological, or whatever—and it is, of course, closely related to ritual:

EFFICACY ⟵──────────⟶ ENTERTAINMENT	
(Ritual)	(Theatre)
results	fun
link to an absent Other	only for those there
abolishes time, symbolic time	emphasizes now
brings Other here	audience is the Other
performer possessed, in trance	performer knows what he's doing
audience participates	audience watches
audience believes	audience appreciates
criticism is forbidden	criticism is encouraged
collective creativity	individual creativity[23]

This is a set of oppositions with which we are now familiar—it recalls, for instance, Yvonne Rainer's set of distinctions between minimalist and more traditional dance—and though Schechner is wise enough to know that all ritual will eventually "fall" into entertainment, there is in his writing a distinct desire for a more efficacious and ritualistic performance, for it is only in "this liminal time/place [that] *communitas* is possible."[24]

Taking possession of this communal moment, then, is not unlike the desire of essentialist feminists to reclaim the female body as a noncolonized, ahistorical space. It is to assume, among other things, that there is a primal body to reclaim, a prelapsarian wholeness which predates the disruptions of historical process. But this is not the only way to read the essentialist feminist position, and neither is it the only way to read the oral poetry movement's interest in ritual. It is, perhaps, more useful to see ritual activity as fundamental to the production of history itself, as part and parcel of what Victor Turner has called the process of "social drama." Rather than seeing ritual as an attempt to "step out" of history, Turner defines ritual as one of the primary means by which the processes of history may be disrupted, one of the primary tools employed by cultures to change the direction of history itself. "Social dramas," according to Turner, can best be described as having four phases:

These I label: breach, crisis, redress, and *either* reintegration *or* recognition of schism. Social dramas occur within groups bounded by shared values and interests . . . having a real or alleged common history. . . . Whether it is a large affair, like the Dreyfus Case or Watergate, or a struggle for village headmanship, a social drama first manifests itself as the breach of a norm, the infraction of a rule of morality, law, custom or etiquette in some public arena. This breach may be deliberately, even calculatedly, contrived by a person or party disposed to demonstrate or challenge entrenched authority. [25]

Not only does this moment of "breach" correspond to the oral poetry movement's challenge to the entrenched authority of the "text," but it is useful, I think, to see this moment of breach as the inaugurating "moment" of the avant-garde generally.

Such an application of Turner's thesis of social dramas to the history of the avant-garde in general offers us some useful perspectives on the ways in which the avant-garde has functioned and continues to function in the art world. For Turner, "art" is itself a manifestation of the third stage of the social drama. That is, after the "breach," which precipitates "crisis"—a period, that is, of increasingly critical debate, antagonism, and even violence—certain "redressive machinery" is put into operation in order to "'patch up' quarrels, 'mend' broken social ties, 'seal up punctures' in the 'social fabric'" (*RT*, 10). Such redressive machinery has always included the juridical process and the ritual means provided by religious institutions, but, especially in modern times, it has included, in addition, the arts: "By means of such genres as theatre, including puppetry and shadow theatre, dance drama, and professional story-telling, performances are presented which probe a community's weaknesses, call its leaders to account, desacralize its most cherished values and beliefs, portray its characteristic conflicts and suggest remedies for them, and generally take stock of its current situation in the known 'world'" (*RT*, 11). Rather than being activity that is

restorative in character, this sort of ritual is *transformative* in nature. It does not seek to return to some primal or originary moment, to restore a lost culture, so much as it seeks to move forward the society that has generated the breach. Because at least implicitly it announces the terms by which redress with entrenched authority might be achieved, it is categorically implicated in the historical process, not divorced from it.

II

By the late seventies, Turner's theory of social dramas had become—almost simultaneously for Richard Schechner and his Performance Group and for the oral poetry movement as well—a new model for avant-garde activity. Schechner and Turner met in 1977, and Schechner quickly enlisted him to work with the Performance Group at his summer institute.[26] At about the same time, in a 1977 essay entitled "New Models, New Visions: Some Notes towards a Poetics of Performance," written for a 1976–77 symposium on postmodern performance at the Center for Twentieth Century Studies at the University of Wisconsin, Milwaukee, in which Turner also participated, Jerome Rothenberg put forward this observation as one of his paradigmatic new models for performance: "Social conflicts are a form of theater (V. Turner) and . . . organized theater may be an arena for the projection and/or stimulation of social conflict."[27] In its descriptions of "breach" and "crisis," Turner's theory has much in common with traditional models of the avant-garde, but in its emphasis on "redress" and "reintegration," it seems particularly at odds with traditional assumptions about the "fate" of the avant-garde, its inevitable "end." For instance, the first two of Renato Poggioli's four "moments" of the avant-garde, "activism" and "antagonism," sound remarkably like Turner's "breach" and "crisis." For Poggioli, "activism" originates out of the avant-garde's political and military usages; it is "the tendency of certain individuals, parties, or groups to act without heeding plans or programs, to function with any method—including terrorism and direct action—for the mere sake of doing something, or of changing the sociopolitical system in whatever way they can."[28] "Antagonism," Poggioli explains, is a form of *directed* activism; that is, it is not as gratuitous as the activist moment, but consciously acts against someone or something: "That something may be the academy, tradition; the someone may be a master whose teaching and example, whose prestige and authority, are considered wrongful or harmful. More often than not, the someone is that collective individual called the public" (*TA*, 25–26). If these "moments" clearly are versions of Turner's "breach" and "crisis," Poggioli's last two moments, "nihilism" and "agonism," are almost diametrically opposed to Turner's "redress" and "reintegration." "Nihilism" seeks no redress from society; rather it seeks to tear society completely down. The nihilism of the avant-garde "finds joy . . . in the act

of beating down barriers, razing obstacles, destroying whatever stands in its way" (*TA*, 27). Such destructive impulses lead eventually to a moment when the avant-garde "no longer heeds the ruins and losses of others and ignores even its own catastrophe and perdition. It even welcomes and accepts this self-ruin" (*TA*, 27). Such, finally, is the "agonistic moment."

The different "endings" projected by Turner and Poggioli arise, I think, from their differing senses of purpose and motivation. For Poggioli, the avant-garde is a group manifestation that sees itself as isolated and privileged, "cut off from any organic relation with society as a whole" (*TA*, 93). It is an "intellectual elite" (*TA*, 90), formed very much in the terms of Schechner's "integral audience"—"people who know each other, are involved with each other, support each other"[29]—for the purpose of furthering its own aesthetic program. Most important, that aesthetic program is not only isolated from the social fabric as a whole but fundamentally antagonistic to it. Here is Poggioli on the avant-garde's sense of poetic language:

[It is] the necessary reaction to the flat, opaque, and prosaic nature of our public speech, where the practical end of quantitative communication spoils the quality of expressive means. . . . In this realm the most typical avant-garde antinomy establishes an antagonistic relation, more general and elementary in character, between poetic language and social language. This antinomy, an extreme position, is also the dominant attitude. It was expressed with characteristic violence in a manifesto appearing in the review *transition*. There, under the title "Revolution of the Word," one reads the following declaration: "The writer expresses. He does not communicate. The plain reader be damned." This text amply proves that hostility toward the common idiom, everyman's language, is simply one of the many forms of avant-garde antagonism toward the public. (*TA*, 38–39)

If anything separates the oral poetry movement from this model of the avant-garde it is its adoption of the common idiom—the vernacular—and its concomitant desire to involve itself in the public arena, not isolate itself in some rarified aesthetic atmosphere. "Much of the post-war avant-garde," Richard Schechner rightly claims, "is an attempt to overcome fragmentation by approaching performance as a part of rather than apart from the community."[30] That is, while Turner and Schechner both know that reintegration may not always be possible, that an irreparable schism may indeed lead to the exile or secession of the dissident (avant-garde) faction, the *aim* of all dissident activity is fundamentally redressive, consciously oriented toward reintegration into the community at large. As a result, oral poetry tends to be dialogic—or at least theatrical—in character. Its very orality—which implies the presence of a public—is strategically designed to militate against the isolated and private experience of reading a text. Rather than excluding the "plain reader," Rothenberg, for instance, seeks to create a situation "in which the novice can enter the experience,

can learn by hearing & participation." He begins "by having students hear & notate their own speech," and "by encouraging . . . a reconsideration of those forms of poetry (song & ballad, street rap, heightened speech, & so on) which may be part of the auditors' lives (i.e., the poetry they really use)."[31]

For Rothenberg, these strategies are designed to break down larger barriers between art and life itself. He has recalled that his first "Realtheater Pieces" were based on his experiences at various Happenings in New York, which, especially in Allan Kaprow's hands, were among the most prosaic and vernacular events in the art world in the early sixties, eliminating, as they did, "art contexts, audiences . . . roles, plots, acting skills, rehearsals, repeated performances, and even the usual readable scripts" and substituting for them "everyday life routines: brushing your teeth, getting on a bus, washing dinner dishes, squeezing oranges," a strategy derived from the example of Erving Goffman's *The Presentation of Self in Everyday Life*.[32] Rothenberg's "Realtheater Pieces," however, were much less prosaic than Kaprow's Happenings. Here, for instance, are the first two of the six actions composing "Realtheater Piece Two," the setting of which is a courtyard of a church or other religious structure decorated with a number of good-sized trees cut down and replanted in the performance area, with actual animals hung alive from the branches:

Action One
The audience receives long, richly colored gowns, distributed by
male attendants wearing short white gowns & otherwise unadorned.
The members of the audience remove their street clothes & put on
the long gowns.
Action Two
The attendants set fire to the trees.[33]

Everything about this piece, from the setting to the ritual removal of street clothes and the donning of gowns, announces the separateness of this event from everyday life. In fact, as the piece proceeds, each member of the audience is led forward into a pit at the center of the performance area, and a bull is slaughtered on a grating above. Long before the final, sixth "Action" concludes by commenting that a male child may be substituted for the bull, "but only where there is little danger of interference by the police," it is evident that Rothenberg is not presenting a *script* for an activity in which any of us might *actually* engage. What is, however, "real" about this piece is our sense of its plausibility—in the Roman tauroboleum, initiates were soaked in the blood of slaughtered bulls—together with our sense that what makes it, frighteningly, possible is the communal and ritual nature of the activity it describes. It is a prescription for social violence, a parable designed to reveal, in the late sixties when it was written, the mechanisms by which we were "initiating" our youth in Vietnam. While deeply implicated

in questions of "life and death," the bloodletting is removed from life itself, inscribed in a ritual space that "frees" the audience to indulge their instinct for cruelty in the name of purification and salvation.

In his critical writing, Kaprow has distinguished between two distinct forms of avant-garde art, avant-garde "artlike art" and avant-garde "lifelike art": "The root message of all artlike art is *separateness and specialness*; and the corresponding one of all lifelike art is *connectedness and wide-angled awareness*. Artlike art's message is appropriately conveyed by the separate bound 'work'; the message of lifelike art is appropriately conveyed by a process of events which has no definite outline. . . . You can't 'talk back' to, and thus change, an artlike artwork; but "conversation" is the very means of lifelike art, which is always changing."[34] So dedicated is Kaprow to the notion of the "lifelike" that he prefers, now, to think of his work in terms other than those of "art." He constructs "activities," "work routines," or "events"—the word "Happening" carrying with it too great a weight of art world associations—that are designed to draw to social processes and interactions the same heightened attention that we normally accord works of art. Rothenberg, on the other hand, both in the "Realtheater Pieces" and in most of his other work, is still making "artlike art," work that announces its own "separateness and specialness," yet because of its orientation to group and communal activity, it possesses the "connectedness" of which Kaprow speaks as well. To look at his collection of New Directions imprints, it would seem that Rothenberg's work is "bound" by the text. Yet one cannot even begin to appreciate a work like *Poland/1931* until one experiences it in performance. On July 11, 1971, at the National Poetry Festival in Allendale, Michigan, the work was performed by Rothenberg, accompanied by other voices, folksongs, harmonica and percussion, a slide show, and dancing. The first line of "Satan in Goray," for instance, reads in print, in its entirety, "Sect." In performance it was repeated at least twenty times, in a myriad of voices, accompanied by a syncopated 4/4 percussion, and transformed into sound poetry or a chant:

Se e e ct t t t
Se e e ck k t t[35]

The work, in other words, is susceptible to all manner of change and mutation. Rothenberg sees his work as mediating between Kaprow's position, the almost total abandonment of "art" per se, and more traditional notions about art.

In the essay he wrote for the symposium on postmodern performance in Milwaukee in 1977, Rothenberg emphasized

an unquestionable and far-reaching breakdown of boundaries and genres: between "art and life" (Cage, Kaprow), between various conventionally defined arts (intermedia and performance art, concrete poetry), and between arts and non-arts (*mu-*

sique concrete, found art, etc.). . . . There is a continuum, rather than a barrier, between music and noise; between poetry and prose (the language of inspiration and the language of common and special discourse); between dance and normal locomotion (walking, running, jumping). . . . Along with the artist, the audience enters the performance arena as participant—or, the audience "disappears" as the distinction between doer and viewer, like the other distinctions mentioned herein, begins to blur. . . . Many artists have come to see themselves as essentially the initiators of the work ("makers of the plot but not of everything that enters into the plot"—Jackson Mac Low), expanding the art process by inviting the audience to join them in an act of "co-creation" or to respond with a new work in which the onetime viewer/listener himself becomes the maker. The response-as-creation thus supercedes the response-as-criticism.[36]

Rothenberg's work falls across the continuum he outlines here. In their textual versions, his poems are apparently conventional, yet they always exceed their textualization. In his famous translations of the Navaho "horse-songs" of Frank Mitchell, he moves from music to noise, from the most vernacular usage to the most sacred, inviting our own participation and "sounding" of the text even as we read:

> Some are & are going to my howinouse baheegwing hawuNnawu N
> nngahn baheegwing
> Some are & are going to my howinouse baheegwing hawuNnawu N
> nngahn baheegwing
> Some are & some are gone to my howinouse nnaht bahyee nahtgwing
> buhtzzm bahyee noohwinnnnGUUH . . .
> & from the place of precious cloth we walk (p) pon (N gahn) but
> some are gone to my howinow bahhegwing hawunawwing
> with those prayersticks that are blu(u)(u) but some are & are
> (wnn N) gahn to my howinouse baheegwing
> with my feathers that are b(lu)u but some are & are going to my
> howinouse baheegwing
> with my spirit horses that are b(lu)u but some are & are going to
> my howinouse baheegwing
> with my spirit horses that are blue & dawn but some are & are
> gone to my howinow baheegwing nngnnnng[37]

Each of these lines moves from sensible utterance to meaningless syllables, from language to music to noise, especially across the word "house" as it mutates from "howinouse" to "howinow." Simultaneously, as one reads the poem aloud, the noise or music of individual words, such as "blue," becomes apparent—"blu(u)(u)" and "b(lu)u"—and nonsense syllables begin to "sound" like meaningful words, as, for instance, "nahtgwing" sounds like "not going" or "noohwinnnGUHH" sounds like "knowing."

As his interest in the mystic poet Frank Mitchell suggests, Rothenberg clearly identifies the role of the poet with that of the shaman: "The poet like the shaman typically withdraws to solitude to find his poem or vision, then returns to sound it, give it life. . . . He is also like the shaman in

being at once an outsider, yet a person needed for the validation of a certain kind of experience important to the group. . . . The act of the shaman—& his poetry—is like a public act of madness. It is like what the Senecas, in their great dream ceremony now obsolete, called 'turning the mind upside down.' It shows itself as a release of alternative possibilities" (*PSE*, 134). The shaman, in other words, is an avant-garde figure who mediates between the isolation, separation, and specialness that Poggioli sees as endemic to the avant-garde and the purposiveness and "connectedness" that Kaprow wishes to restore to avant-garde activity. In this "mediating" position, the shaman, for Rothenberg, is an archetypical nomadic performer, closely related to the performance artists that I described in the last chapter. Rothenberg's great anthologies, especially *Technicians of the Sacred* (originally published in 1968 and reissued in a revised and expanded edition by the University of California Press in 1985), *Shaking the Pumpkin* (1972), and *A Big Jewish Book* (1978), are an attempt, as he puts it in the "Preface" to the last of these, to recover the "long forbidden voices" of the exiled. "The female, the proletariat, the foreign; the animal and vegetative; the unconscious and the unknown; the criminal and the failure," he says, citing fellow poet Robert Duncan, "all that has been outcast and vagabond must return to be admitted in the creation of what we consider we are."[38] But of all wanderers, Rothenberg most closely identifies with the figure of the Jew. What attracts him especially to Jewish work, he says, is the Jewish "sense of exile both as a cosmic principle . . . & as the Jewish fate." The Jew is, furthermore, "exiled in the word," and in this sense, he says, "all poets are Jews."[39]

The figure of the poet/Jew is central to Rothenberg precisely because the dialectic between the written and the oral, the obscure and the commonplace, elitist discourse and the vernacular, is fundamental to the Jewish tradition. In the first chapter to his book *Inventions: Writing, Textuality, and Understanding in Literary History*, Gerald Bruns has outlined this dialectic in terms particularly relevant to the oral poetics movement. Bruns notes that the word "secret" derives from the Latin "*secernere*," to set apart, separate, or distinguish, and its natural opposite, therefore, is the commonplace: "The commonplace is native to the discourse of civil men, the staple of public if not private confidence. . . . It is the wisdom of everyday life. A commonplace is stored in memory and kept ready for use, nor does it ever need explaining to anyone. . . . A commonplace is worth remembering, but not worth writing down."[40] Writing, on the other hand, represents, especially in the Jewish tradition, "the Law," scripture, the Torah. It is never "commonplace," and, in fact, it is difficult, understood only by the few (the rabbis). Because of this difficulty, the inaccessibility of the law to the people at large, the written text must traditionally be "translated" into the vernacular. As Bruns puts it:

The Torah . . . is fixed, but it is permissible and, indeed, necessary to unfix it orally, for otherwise who will understand it? . . . The Torah is not reducible to the form of a text. It is rather to be spoken of as a composition of textual and oral traditions— the writtten Torah, and the Mishnah, Talmud, and Midrash, which taken together are figured as the "Oral Torah," whose basic hermeneutical task is to soften the rigidity of the letter without, however, violating its sacredness. . . . For the point is certainly that the fixity of the letter does not produce a corresponding fixity of meaning; on the contrary, the hermeneutical function of the Old Torah is precisely to maintain the openness of what is written to that which is unforeseen or which is yet to come—new situations of human life and new sources of understanding which will require what is written to be fulfilled in ways that cannot be accounted for by the letter alone.[41]

In *A Big Jewish Book*, Rothenberg provides an example from the Mishnah of the Babylonian Talmud, in which the course of action a person should take when he comes in contact with a thing or follows a path that is "unclean" and then "prepares clean foodstuffs" is set out in a series of "rulings" by the rabbis. Rabbi Akiba rules one way, "the sages" another, Rabbi Yose yet another, and Rabbi Judah yet another again. The thrust of the discourse, Rothenberg notes, "is not toward closure but a simultaneity of opposite conclusions, typified in the Talmud by the 'contradictory' propositions of the schools of Hillel & Shammai, etc.: not to eliminate conflict but to recognize its presence at the heart of discourse."[42] In this sense, writing is always exiled from public domain. It comes out of hiding— which is to say, it becomes *efficacious*—only when it emerges in speech. Bruns points out that in the *Homilies of Origen*, which date from the third century A.D., it is Christ who makes the law understandable: "When we hear the books of Moses read, by the Lord's grace the veil of the letter is lifted and we begin to understand that the Law is something spiritual. . . . [And] if we are capable of interpreting the Law like that . . . the reason is . . . that the person reading the Law to us is the Lord Jesus Christ him- self. . . . If Jesus reads it to us we can take it in its proper sense; when he reads it we grasp its spiritual meaning."[43] Thus the oral tradition does not merely "unfix" the written text, it opens it to the contingencies of history, time and place, revealing the fundamental *undecidability* of the word, the ability of Jesus, in this case, to transform the law into prophecy. For Roth- enberg, this is the fundamental purpose of the poetic performance—to un- fix the text by speaking it, and in speaking it to open the audience to new possibilities, new understandings.

III

In 1984, at the annual College Art Association convention, in Toronto, Bar- bara Kruger participated in a session on art and politics. On this particular occasion she chose, as is the habit of many artists, to let her works "speak for themselves." She had brought a slide tray of her works, large-scale

photographic collages which incorporate short verbal texts into the com-
position, and she began to project them on the screen at the front of the
room, leaving each of them up for ten or fifteen seconds. This particular
meeting room, however, was very large and able to accommodate the
maybe three or four hundred people at the session reasonably comfortably,
but it had a very low ceiling, and though a few people in the front could
see all of any given slide, most of us could, at best, see only its top, leaving
at least half, and sometimes all, of Kruger's captions hidden from view.
Very quickly a groundswell of protest arose, and people started calling for
her to read the pieces out loud. She acquiesced, started the series again, and
read, more or less, as follows (Figs. 71 & 72):

> We won't play nature to your culture.
> You kill time.
> We will undo you.
> You are not yourself.
> I am the real thing.
> I am your reservoir of poses.
> Your assignment is to divide and conquer.
> The commodity speaks:
>> Buy me, I'll change your life.
>> You are getting what you paid for.
>> Put your money where your mouth is.
>> What you see is what you get.
>>> [These last four statements improvised as a
>>> sort of aside while "The commodity speaks"
>>> image was on the screen.]
> You make history when you do business.
> We construct the chorus of missing persons.
> Your money talks.
> Your moments of joy have the precision
> of military strategy.
> You destroy what you think is difference.
> Your manias become science.
> You are an experiment in terror.
> You construct intimate rituals which allow
> you to touch the skin of other men.

This, to me, was a powerful poem, in many ways an oral realization of the
law, the operative codes of our culture, in a way that made the possibility
of our transforming them a reality. It was as if Kruger had "unfixed" the
tradition.

Kruger's text is overtly social and political in orientation. Her lines turn
outward. The closest she comes to acknowledging the separate, isolated
"self" of the traditional avant-garde is when she says "The commodity
speaks," thereby identifying her own speaking voice, as female, with the
object of desire. But this self is a part of a larger community, so much a
figure for "today's woman" rather than the private "author." Kruger's work

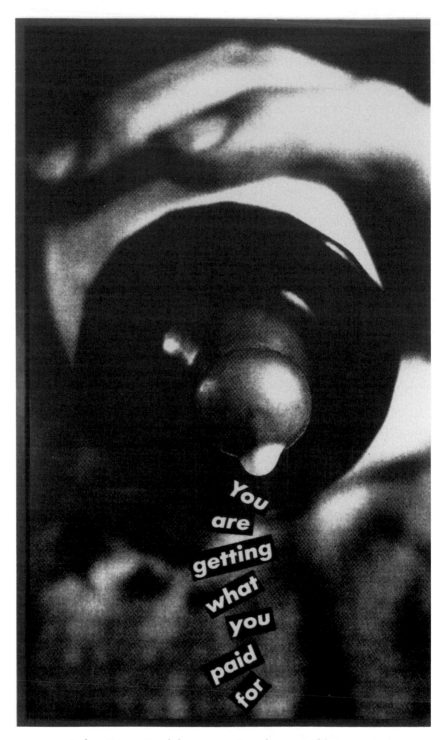

FIGURE 71. Barbara Kruger, *Untitled* (You are getting what you paid for), 1984. Photograph, 72 × 48 in. Courtesy Mary Boone Gallery, New York.

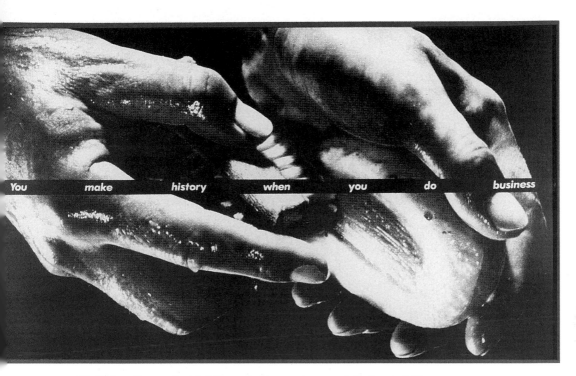

You make history when you do business

FIGURE 72. Barbara Kruger, *Untitled* (You make history when you do business), 1982. Photograph, 48 × 96 in. Courtesy Mary Boone Gallery, New York.

amounts to a direct, even aggressive address which actively *engages* her audience. These lines, then, escape the frame of the image into which they are incorporated. Or, from a different point of view, they intrude upon the system of signification which constitutes the image and offer a competing system of signification, an *other* discourse.

Kruger's texts exist outside the framework of traditional poetics, not simply because they are more readily identifiable as "art" or "photography," but because they violate the traditional frames of poetic discourse itself, *the page* and *the book*. They exist, like oral speech itself, in a space which Derrida has defined in *Dissemination* as *hors livre*—outside the book.[44] The book is a structure of unification, totalization, fixedness. Dissemination, as Barbara Johnson puts it so succinctly in her introduction, "is what subverts all such recuperative gestures of mastery."[45] Everything in Kruger's texts works to subvert gestures of mastery, not only by their overtly feminist and anticapitalist polemics, but especially in the strategic deployment of her texts into the space of art. Words reverberate not only against other words, but also against images. Kruger's favorite words seem to be the pronomial shifters "we" and "you," words which we can fill with signification because they are literally empty, waiting to "point" at their references. The meanings of "we" and "you" *shift* reference depending

upon the context in which they are deployed. Consider the phrase "You are not yourself." On the one hand, it is a common enough equivalent for "You are out of sorts today." On the other hand, it is a four-word treatise on the social construction of male—or female—identity in contemporary society. In the context of sentiments such as "We will undo you," which immediately preceded it in the slide presentation, the phrase defines, in fact, the very fragility of identity itself. This shifting reference functions in a similar way, as we have seen, for the documentary photograph. It too is "empty" until we fill it out, until we reconstruct the "story" or duration from which it has been abstracted. Thus Kruger brings together two "open" systems. When she says "I am the real thing," one takes it initially as a statement of personal self-worth, then as perhaps an assertion of sexual and/or artistic prowess and authority, then, concentrating on the word "thing," as a statement of the commodification of female identity (her status as a version of Coca-Cola). But finally, with the recognition of the context of these words—that is, *in a photograph*, a pseudoreality, a black-and-white simulacrum of the real thing—it reveals itself to be a pathetic posture, a self emptied of meaning. ("I am your reservoir of poses," Kruger says in another image.) It asks us to think of the pronominal shifter in terms of gender and sexual politics, as a female body which can be filled with signification only when it is considered to be empty. And in the context of art, the phrase begins to question the category of the *original* itself, the *identity* of the *work* of art, its clearly bogus aura of unreproducibility. The "I," in other words, becomes the work itself speaking, announcing its mastery, its authenticity, its own uniqueness at the same time that it undermines its own authority through its status as a photograph—and a "found" one at that, another element in Kruger's collage.

A related approach to the deployment of texts *hors livre* can be seen in the work of Jenny Holzer. In 1976, while still a painting student at the Rhode Island School of Design, Holzer started putting up posters all over Manhattan which contained sets of forty or so "Truisms" (Fig. 73). They were arranged in alphabetical order, summarizing in a vernacular idiom "my version of everything that could be right or wrong with the world":

I got the idea from someone—I assume it was a man—who went around plastering Times Square with posters that warned men to stay away from the vice in the area, warning them that they would get leprosy and tuberculosis if they crossed this imaginary circle that he'd supposedly put around it. I was amazed at how the word "leprosy" on a poster could stop you short, and at how effective these posters were. He was tireless. They were absolutely everywhere. I could see his things wherever I went, and they stopped me in my tracks. I would see that other people were amazed by them, too. . . . I would see people doing their reading right in the street. So it gradually dawned on me that the short texts I was writing would look good on posters and that I could put them up anywhere.[46]

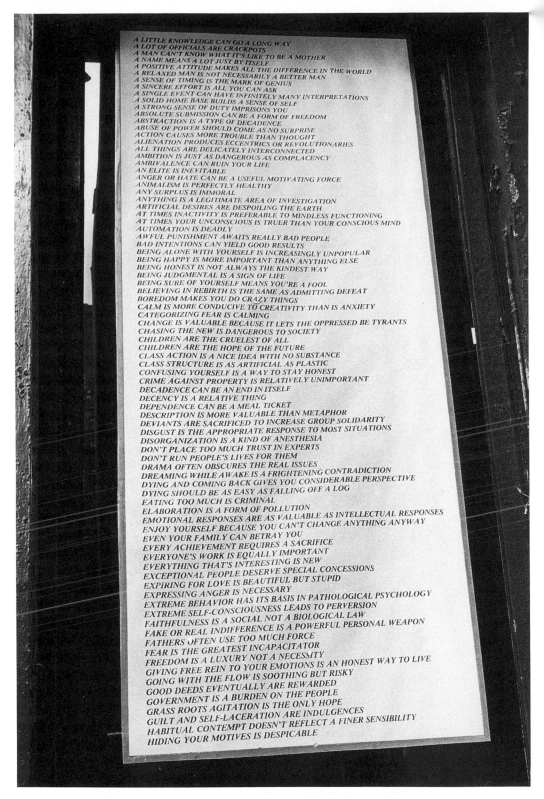

FIGURE 73. Jenny Holzer, *Truisms*, 1978. Photostat installation at Franklin Furnace, New York. Courtesy Barbara Gladstone Gallery, New York.

The "Truisms" were themselves designed to be "stumbled across": "When I show in a gallery or a museum," Holzer says, "it's almost like my work is in a library where people can go to a set place and know they'll find it and have a chance to study."[47] In fact, they are now available in most libraries—a set of ninety of the "Truisms" was published on the inside covers of *Fiction International* in 1985.[48] Consider these two more or less typical truisms, which appear one after the other:

> IT IS HEROIC TO TRY TO STOP TIME
> IT IS MAN'S FATE TO OUTSMART HIMSELF

Or these three, which also appear consecutively:

> WOMEN LOVE POWER
> YOU ARE A VICTIM OF THE RULES YOU LIVE BY
> YOU ARE GUILELESS IN YOUR DREAMS

Each of these statements is meant to be taken, first of all, by itself, on its own terms. What Holzer does is demonstrate the impossibility of such a practice. In sequence, each "truth" informs the other "truths." Each truth is invaded from the outside, so that, for instance, if it is indeed heroic to try to stop time, is it not possible that such heroism is one more example of man's outsmarting himself? And what, precisely, is the relation between women and power? Do they—or do they in their dreams—victimize themselves? In effect, like the law in Rothenberg's excerpt from the Mishnah of the Babylonian Talmud, Holzer's idiom of the "Truth" consists of a series of contradictory propositions. Their thrust is not toward closure but openness. They emphasize the conflicts that lie at the heart of all discourse.

In 1982 Holzer moved a number of these "Truisms" off the street and up onto the Spectacolor Board in Times Square, where they were printed out like the news itself. "PRIVATE PROPERTY CREATED CRIME," the board flashed at the Times Square crowds. "YOUR OLDEST FEARS ARE THE WORST ONES," it flashed again (Fig. 74). It is probably not clear, however, why I want to call this work *poetry*—as opposed, say, to prose— or "art." Kruger's work, as presented here, had the advantage of *seeming* poetic because of the accidental manner of its presentation at the College Art Association meeting. It became recognizably poetic, that is, because in sequential, oral presentation it became *litanic* in its rhythms and structures—and since Whitman such litanies have become a recognizable rhythmic structure of so-called free verse. The "Truisms" lack the litanic structure of Kruger's lines. They are much more amorphous, much more prose-like. But they possess, I would like to suggest, a very real *visual* rhythm. This is especially apparent as the words move right to left, left to right, up and down, or as they cease moving at all, on the electronic signs—a medium which Holzer has continued to use. Asked about this movement by an interviewer, Holzer explained that she consciously uses

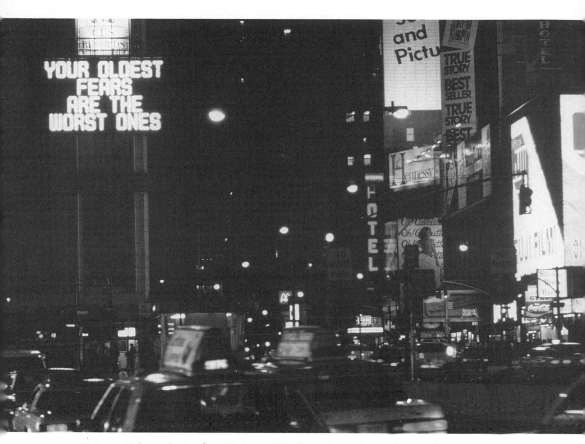

FIGURE 74. Jenny Holzer, selection from *Truisms*, 1982. Times Square Spectacolor Board, New York. Courtesy Barbara Gladstone Gallery, New York. Photo: Lisa Kahane.

the *time* each message appears on the sign. "A great function of the signs," she says, "is their capacity to move, which I love because it's so much like the spoken word: you can emphasize things; you can roll and pause which is the kinetic equivalent to inflection in the voice. . . . I write my things by saying them or I write and then say them, to test them. Having them move is an extension of that. . . . It almost gets musical." It becomes a question of "rhythm, pauses, pacing."[49]

This is a prosody for which we have no adequate descriptive language, but its prosodic effects nonetheless surround us daily. To borrow William Carlos Williams's phrase, these rhythms are part and parcel of the contemporary "American idiom." Holzer inserts her language—and in the billboard/poster effects of her work, so does Kruger—into the visual rhythms of what Guy Debord has labeled the society of the spectacle. Such a hypothetical prosody is regulated, one suspects, by the rhythms of television, the two to three-second shot and the ten-second commercial message, and

its logic—if it can be said to possess a logic—is that of collage, as it moves randomly from one independent message to the next. In what has become one of the seminal essays on the medium, David Antin has analyzed the use of time in television in order to contrast it to the use of time in video art. But what he has to say about standard television is worth quoting at length because it has such obvious applicability to the experience of Holzer's "Truisms," especially as they appear in such contexts as the Spectacolor Board in Times Square:

For television, time has an absolute existence independent of any imagery. . . . It is television's only solid, a tangible commodity that is precisely divisible into further and further subdivisible homogeneous units. . . . The smallest salable piece turns out to be the ten-second spot, and all television is assembled from it. The commercial is built on a scale of the minute out of multiple ten-second units. It comes in four sizes—10, 30, 60 and 120 seconds—of which the thirty-second slot is by far the commonest. . . . A half-hour program might have something like six minutes of commercial time fitted to it in three two minute blocks at the beginning, middle and end of the program. But these six minutes of commercial time might promote the commodities of twelve different sponsors, or twelve different commodities of some smaller number of sponsoring agencies. The commodities could be nearly anything—a car, a cruise, a furniture polish, a breakfast food, a funeral service, a scent for men, a cure for smoking, an ice show, an x-rated movie, or a politician. In principle they could apply to nearly any aspect of human life and be presented in any order, with strategies of advocacy more various than the commodities themselves. . . . In half an hour you might see a succession of four complete, distinct and unrelated thirty-second presentations, followed by a twelve minute half of a presentation, followed by a one-minute presentation, one thirty-second presentation and two ten-second presentations, followed by the second and concluding half presentation (twelve minutes long), followed by yet another four unrelated thirty-second presentations. But since this would lead to bunching two two-minute commercials into a four-minute package of commercial at every hour ending . . . the program makers have recently developed the habit of presenting a small segment of their own program as a kind of prologue before the opening commercial, to separate it from the tail end of the preceding program, while the program makers of the preceding program may attempt to tag onto the end of their own program a small epilogue at the end of their last commercial, to affix it more securely to their own program. Meanwhile the station may itself interject a small commercial promoting itself or its future programs. . . . This means that you may see upward of fourteen distinct segments of presentation in any half hour, all but two of which will be scaled to commercial time. Since commercial time is the most common signature, we could expect it to dominate the tempo of television, especially since the commercial segments constitute the only example of integral (complete and uninterrupted) presentation in the medium.[50]

I would like to suggest that each of Holzer's "Truisms," flashed across the Spectacolor Board, possesses if not exactly the same ten-second pace of the commercial's tempo, then the commercial's same psychological force. The disjunction which she seeks between successive messages is, likewise, the equivalent of viewing first a car ad, then a cruise ad, then a furniture polish

ad, and so on. Furthermore, her messages embody something of the same terse *authority* as the commercial—"The night belongs to Michelob," "When you care enough to give the very best," "Promise her anything but give her Arpège"—as well as its ability to sound at once original and clichéd. As Holzer says, in the spirit of any good advertising executive, "To write a quality cliché you have to come up with something new."[51] And these last observations are equally applicable to Kruger's posters: a recent one literally rewrites the Arpège ad—"Promise us anything, but give us nothing." While both Kruger and Holzer share the syntax of the spectacle, it should also be clear that the repetition of independent units of equal duration, especially in Holzer's work, is the stuff of rhythm, a matter of prosody. This is a prosody which denies the construct of the "book" and the "page," and opts instead for the structure of the television commercial, the neon lights of Times Square, and the highway billboard, the Burma Shave ads that once lined the highways of the Midwest, flashing by us every fifteen seconds, mile after mile. What Kruger and Holzer do not allow us to forget is that these modes of address possess a syntax—even, in the proper hands, a poetics.

IV

On May 23, 1987, above the beach at Santa Monica, a three-line poem, based on these same sorts of visual, public rhythms, appeared in the sky. Composed by David Antin expressly to be seen by the mammoth Memorial Day crowds below, the poem was traced out by skywriters, one line at a time, white smoke on a blue ground (Fig. 75). As the planes wrote the first line, the crowd turned its attention heavenward:

IF WE GET IT TOGETHER

As the planes circled back to begin the second line, these first words disappeared, drifting away on the shore breezes. Directed by Antin from "Sky-poem Control" on the beach below, the planes traced out the second line:

CAN THEY TAKE IT APART

Like the first, it slowly dissolved from view. Then finally the third and last line was written across the sky, just above a bank of clouds that had begun to work its way off the Pacific onto the beach:

OR ONLY IF WE LET THEM

Each segment of each line, and then each line itself, revised the meaning of the poem even as it appeared, requiring of its audience a collective memory. Always in the process of its own dissolution and revision, the poem was never "wholly" present to its audience below.

Aside from the clear rhythm of this work—the slow pulse of each successive line—it shares with Holzer's work the same apparent necessity to

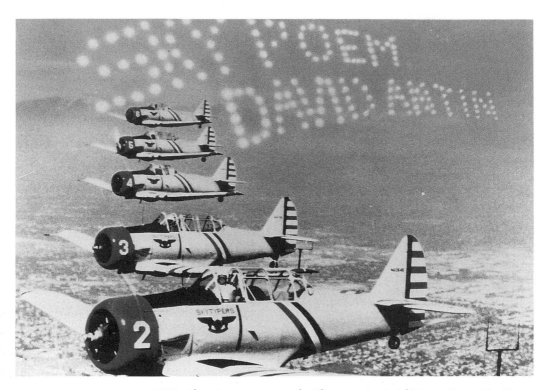

FIGURE 75. David Antin, announcement for *Skypoem: An Aerial Literary Event*, May 23, 1987, Santa Monica, California.

address a *large* audience. "I came to the signs," Holzer admits, "as another way to present work to a large public. . . . Because signs are so flashy, when you put them in a public situation you might have thousands of people watching. So I was interested in the efficiency of signs as well as in the kind of shock value the signs have when programmed with my peculiar material. These signs are used for advertising and they are used in banks. I thought it would be interesting to put different subjects, kind of a skewed content, in this format."[52] Antin's motives for skywriting are virtually identical— here is a medium used almost exclusively for advertising into which he has inserted the rather skewed content of poetry, and all above the largest Southern California beach crowd of the year.

We are so used to thinking of the lyric self, the artistic ego, as yearning for public recognition and acknowledgment that it is easy to misread Holzer's and Antin's interest in addressing a large audience as a manifestation of their desire for fame. Theirs is, to the contrary, an antisubjective, or antilyrical, position. Holzer's *Sign on a Truck* project (Fig. 76) was designed to provide, during the last days of the 1984 presidential campaign, an occasion for public dialogue. Consisting of an 18' x 13' television screen

mounted on a mobile truck, Holzer positioned the work in Grand Army Plaza in New York City. The general public, as they passed by, were invited to appear "live" on screen and state their views on the election. Although these live segments were interspersed with slicker artists' contributions—by Holzer, Vito Acconci, Keith Haring, and others—and with a series of Holzer's "Truisms," such as "We are united in the tolerance of our differences," rather than assuming an authoritative function, the artists' work seemed designed to draw the attention of passersby. In this format, the art world (or at least Holzer's part of it) addressed the public, the public addressed the art world, and everyone, sometimes heatedly, addressed one another. In Holzer's videotape of the event (also called *Sign on a Truck*), it is very clear that, in and around Grand Army Plaza in New York City at least, the 1984 election pitted women and minorities against investment bankers. Though the political sentiments of Holzer and her fellow artists

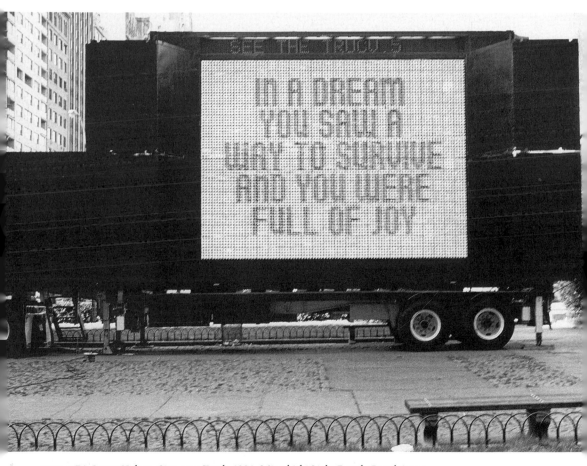

FIGURE 76. Jenny Holzer, *Sign on a Truck*, 1984. Mitsubishi Light Board, Grand Army Plaza, New York. Courtesy Barbara Gladstone Gallery, New York. Photo: Pelka/Noble.

were clearly aligned with the women and minorities interviewed, her purpose was not so much to influence the outcome of the election—by the time *Sign on a Truck* made its appearance, the outcome was evident to everyone—as to provide a forum in which everyone might better understand not only the differences between the candidates themselves but also the differences in priorities that informed the community as a whole.

What Holzer and Antin wish to do is submit their addresses to public scrutiny, engage the public at the level of discourse, initiate a discussion that is larger than their own private concerns. In a videotape made by the City of Santa Monica to record the event, Antin explained his intentions this way:

Even though the text of this is fixed, I had to write a text that wouldn't be so fixed. It wasn't fixed because one line goes away, and then another line goes away. And then no one is quite sure what exactly it refers to, and there's a family of possible things it could refer to, all of which are interesting. Who are "we"? Who are "they"? What is it we "get together"? What is it that can be taken "apart"? And what is it we can lose? And the image of both the losing and the winning . . . raises all these possibilities for so many people. And I'm aiming it at a lot of people. . . . As somebody pointed out there are probably hundreds of different texts that people generate out of what I did. . . . So a lot of different poems got written today.[53]

Antin's deployment of the pronominal shifters here—the slippery "we" and "they"—is very closely aligned with Kruger's use of the same device. And while the poem is literally textualized, written down, Antin finds a way to free it of the fixity of the text by having it written in an ephemeral medium, so that it fades into the sky like a voice fading away in the distance, traced only in the memory of those who have read it. Like Nietzsche's phrase "I have forgotten my umbrella," discussed in the last chapter, the poem remains dramatically open to interpretation because the specifications of context and interpretation vary from reader to reader. The sky becomes a palimpsest upon which, in our memories, as the last line fades away, we rewrite the poem.

Antin's work is generally directed at smaller, more intimate groups than the Santa Monica beach crowd. He delivers improvised "talk-poems" to audiences of various sizes, which he records on tape and subsequently transcribes for publication. This talking is, above all, anything but meditative. To be in Antin's audience is not to overhear someone remembering or contemplating private thoughts or emotions—and this is the difference, it seems to me, between Antin's talk pieces and the work of Spalding Gray—but to watch and listen as a speaker addresses your own concerns and reacts to you as you listen to him. Antin's metaphor for this exchange is *tuning*, the title, in fact, of his most recent book of talk-poems. For Antin, "tuning" describes the activity we share with him in deciding to come to "this place here," where Antin is talking:

 now the point of doing these pieces
 for me is that it gives me a chance by a kind of subtle but
ordinary human concentration to get a sense of where youre
 coming from and how and to allow that sense to put some
 pressure on my own way of moving to bring me into
 somewhat closer range of you close enough to compare our
ways of moving our sense with each other and in this
situation i find a fundamental human act this negotiation in
 a common space though there is no single good or common
 name for it and i dont think there is any good description
 of how it works and what it does the action that occurs when
two or more people moving in different ways at different angles
 through a place having different senses of it try to
 compare these senses display adjust maintain or change
 them and perhaps come to an agreement to share a way
 of moving for a while or a considered refusal of agreement[54]

The desire to "tune," to come to an agreement, is *redressive* in character.
Such a "tuning" together, such adjustment and readjustment to difference,
is facilitated by Antin by means of the narratives around which he con-
structs his talking. These stories create cognitive dilemmas with which his
audience must come to grips. It is the audience's recognition of the "nar-
rative event" as outlining the terms of a common plight or *crisis* that helps
create, in Antin's work, a sense of common purpose arrived at in a common
place (by means of the "commonplace" activity of "talking"). Thus "tun-
ing" is another word for community achieved at the conclusion of social
dramas. Narrative is a fundamental component of the redressive stage of
the social drama, for it is an attempt, in Victor Turner's words, "to rearti-
culate opposing values and goals in a meaningful structure, the plot of
which makes cultural sense. Where historical life itself fails to make cul-
tural sense in terms that formerly held good"—the problematical frame
into which Antin fits all his talk pieces—"narrative and cultural drama may
have the task of *poesis*, that is, of remaking cultural sense, even when they
seem to be dismantling ancient edifices of meaning, that can no longer re-
dress our modern 'dramas of living' "(*RT*, 87). Antin's narratives serve pre-
cisely this function, though they refuse to make final cultural sense of any
given situation. Instead Antin lays out the terms of the problem, and leaves
it for us to construct whatever meaningful structure we can, whatever plot
makes cultural sense. That is why he considers his work dialogic—and
not monologic—in character. He sees himself as initiating a discourse
through which cultural sense might eventually emerge.

Antin's method of narration is rabbinical in nature as well. If we accept,
that is, that his stories address a common cognitive or cultural dilemma—
something we do not agree on as a group—then the *oral* performance is
designed to reveal the terms and conditions of that dilemma, to bring the

problem out into the open. The hermeneutical function of his talk pieces is to create a situation wherein new possibilities might reveal themselves—hence, his investment both in orality, which destabilizes the fixity of the text, and on improvisation, which allows for contingent elements to affect the composition of the piece. Here is a passage from a talk-poem called "the sociology of art" which bears on the critical issues at hand:

> all other
> things being equal we should come to see a fundamental differ-
> ence between what we are calling oral societies and literal societies
> in an oral society they will keep to the right way and in a literal
> society they will keep to the right thing and since the right thing
> is itself a literal exemplar of other right things in such a society
> you will have an attempt to adhere rigidly to the right thing if you
> are convinced that you already have the right thing
> ...
> once youre convinced
> that you have the right thing youll demand absolute adherence to it
> and if theres any difference of opinion about whether it is the
> right thing or not youre likely to have something of a conflict
> between the party that believes they have the right thing and the
> party that believes they havent the result of this will be that
> any change in any thing will seem much more important
> loaded so to speak when a thing is involved with a notion
> of its rightness so that a literal society will exaggerate any
> change at all in a thing it takes seriously and it will seem to this
> society that any changes at all in its things the things that
> it notices are terrifically radical and such a society will
> imagine itself struggling between order and revolution however
> trivially it may be changing it is therefore a much more rigid
> and inflexible society than an oral society which we can imagine
> as continually accumulating small variations somewhat randomly
> in the sense that the work under hand is continually varying
> in the direction of the needs of the moment and habit of the hand
> of the human being who is making whatever hes making
> ...
> there will be a constant fluidity in the working of
> this oral society their workmen artists will always be modifying
> things in an easy going way without really thinking about trying
> to be different because whatever difference there may be
> this workman will be likely to regard it as the same which
> will lead to the slightly paradoxical conclusion that oral societies
> are probably always changing and fluid [55]

I have quoted this passage at length for several reasons. I want to establish, on the one hand, the discursive, *unpoetic* quality of Antin's work. Its diction is imprecise, vernacular, almost oppressively burdened by the word "thing," for instance, and the kind of language we are trained early on never to use in our writing as much as we might in our speech—words like

"terrifically" and "loaded." On the other hand, I want to make the rather
obvious point that this writing *looks* strange—not like poetry (it occupies
the page in great prose-like chunks), but not like prose either (the result of
Antin's spacing and lack of justified margins both left and right). Further-
more, this passage demonstrates just how deeply implicated Antin is in the
issues which occupy the rest of the oral poetry movement. Clearly, he is as
committed as any to the fundamental distinction between oral and literate
cultures, and again, the oral culture is imaged as fluid and free, while the
literate culture is described as inflexible and authoritarian, "fixed" and
"arrested." And yet, for all Antin's championing of oral societies, his
text is written down. This kind of dialectical play—like the sliding refer-
ence of Kruger's pronomial shifters or the contradictions among Holzer's
"Truisms"—is fundamental to his aesthetic position. He privileges neither
speech nor writing and uses each to undercut the other. "I have two forms,"
Antin told Roy Harvey Pearce's seminar, "The Long Poem," in the summer
of 1978, "one of them is a written form in a text, and I'll send it out in
book form, the other one is talk."[56] Talking and writing are separate but
equal aspects of his art:

<pre>
 i was trying to put together a book which
 i do not by transcribing literally my pieces because
 i feel theres nothing sacred about them theyre my pieces
 so that when i put them in a book they dont come out
 exactly as i spoke them sometimes even a lot more like
 speaking them than when i speak them but thats the result
of my having to deal with them again when i put them down
 its also a result of my love for the present you see it would
 be a great mistake to believe that my love for the present
only occurs when im talking because once ive established
my love for the present through my talking i dont give it up
 when im writing when im sitting in front of the typewriter
 i feel like im sitting in front of a typewriter and ill be
 damned if i am going to feel a profound sense of obligation to
another moment that now no longer exists at this moment
 so when im typing i feel like typing when im talking
 i feel like talking so this book is an intersection of my
insistence on the present the first time and my insistence
 on the present the second time[57]
</pre>

This text comes from a long meditation on "the present" which Antin de-
livered at the Los Angeles Bookfair in 1979. It begins with Antin's deliber-
ating before his audience about whether or not to read to them from *talking
at the boundaries*:

<pre>
 but in looking at my own book and feeling
 that as i look i lose my sense of the present my sense
 of the present disintegrates for me
</pre>

when i look into my book and
take my words go back to them and recover them i lose
track of anything i would call the present and i have a taste
for the present (84)

Now what Antin proceeds to do, instead of reading from *talking at the boundaries*, is tell a story, reconstruct before an audience situated in the present of his talk a series of incidents which happened *in the past*. That is, having established his taste for the present, he retreats into the past, more particularly into an extended narration of the day not long before when closing the door to his van at the post office in La Jolla he had cut off his finger, was subsequently rushed by cab to the hospital in order to have it sewn back on, only to discover, from the cabbie, that a PSA airliner and a small private plane had just crashed over North Park in San Diego. He had been experiencing, in the "shroud of pain" that enveloped him, a sense of the present that went on and on "like a hot shower . . . but it was as different from being myself as being in hot water is from being dry" (97). The self, in other words, does not normally operate with such a totalizing sense of presentness. The cut-off finger is a trope for full presence that undermines the idea of itself by locating presence outside Antin's own self. But it is the plane crash, across town, that finally alienates Antin from presence altogether:

and suddenly i felt sick
all this time
i had felt all right in my shower and then the image of
this big plane smashing into the little one and the two of them
falling into this little area of san diego wiping out all those little
pastel colored stucco and frame houses with old people and
kids in them in one flick of the hand and suddenly im
feeling nauseous and i say "where was it" and he says "out near
the intersection with route eight"
and i said "oh my god"
because i could see all those little tract houses folding up into
splinters and plaster and chicken wire and i asked how it
happened and he started to tell me what he knew and its
curious
i couldnt feel my hand and i was no longer aware
of being in the shower
. .
only i was sick to my stomach from the image of something
that was not present or was a present i had not counted
on this present i had not counted on the airline
crash was somehow more present than my severed finger (98–99)

I hope it is clear that the image of the PSA plane crash—that *story*—alienates Antin from the present in the same way that Antin's cut-off finger piece probably distanced his audience from their own sense of being present at

the Los Angeles Bookfair. Image and narration are both *re*presentations, "fossilized" speech, paradoxically more present, like good writing can be, than presence itself. The talk-poem "how long is the present" can probably be most usefully taken as an extended trope for the kinds of dialectical interchanges upon which our "sense" of the present is constructed. In a very real way, the present persists as long as there is a story being told. Antin is not at all embarrassed that there is so much to tell, because only in the telling—in discourse—can something like possible dimensions of the present, the complex network of events which inform it, begin to establish themselves. In this talk-poem, most obviously, an event from the "outside," the story of the plane crash across town, invades Antin's more or less simplistic—holistic, self-absorbed, and self-contained—sense of the present. In addition, a large part of the story's power revolves around the way in which it becomes present to us, invades our consciousnesses from the "outside" in a manner analogous to the way the story of the plane crash invades Antin's consciousness. The story becomes part of our present as we experience Antin's recounting of it. In fact, the entire episode is a trope for Antin's sense of what happens when we begin to arrive at that sense of "coming together" that he calls "tuning." It is important to recognize that the story of the plane crash comes to him—over the taxi radio, from the taxi driver himself—as speech. Once he *hears* that discourse, and adjusts to it, he steps outside himself and begins to compare his way of moving to that of the others. And just as the plane crash puts "pressure" upon his own way of moving, his talk-poem ideally has the same effect upon us.

Antin recognizes this sense of the present as embodying a "sense of urgency."[58] Improvised oral performance is a way to establish this sense of urgency immediately. But Antin is quick to counter it by drawing attention to the tape recorder he always has running before him. The very scene of Antin's performance opposes talking to recording, speech to its transcription. Antin admits that there are "rather considerable deviations between the crude transcript and the finished version," between the performance and the transcription of the talk-poems. For instance, "in a fairly recent piece ["dialogue"] I actually followed a text fairly closely and then because, in the context of the performance, there was a story I mentioned . . . and I didn't tell it. And when I was writing the piece it occurred to me, it seemed reasonable, to tell it, and so I told it. So that in the written version of that one there's a very long story which was not in the telling in the performance because the performance literally didn't have time to accept it."[59] The finished books themselves highlight this interchange between text and performance by introducing, in italics, short narrative sketches, composed at the typewriter, which frame the performance texts themselves with the broader narrative of Antin's public life. They recall the occasion of each talk-poem, situate its presence in the past, and paradoxically establish our

reading of the written book as, if not exactly full presence, then at least more present than the talk pieces themselves. It is as if another way of moving—or *two* other ways of moving, the written text and our reading of it—had converged upon the situation. Rather than privileging speech or writing, Antin problematizes their interaction.

It is as if neither the oral performance nor the written text were complete without the other, like the written law and the oral Torah, as if each *projected* the other's existence—and yet they are wholly discontinuous. That is, if they constitute the "whole" work, that "totality" can never be experienced. Antin's poetics, finally, are *undecidable*, like the Torah itself. It is not a question of which of the associations of any particular reader are relevant, but of how the different associations of different readers and listeners—the community of his audience—"tune" differently to his presentation. At the end of an Antin talk-poem we are confronted with a sense of life as inherently problematical. As Charles Altieri has put it, "To read or hear Antin . . . is to find oneself in the process of imagining and testing a model of what human beings are as communicative animals . . . [in the process of coming to] an understanding of the cultural roles stories perform, and above all an implicit understanding of the place talk might play in our lives."[60] We are confronted with a "figure of mind" that is dialectical—or dialogical. But, most important, the talk-poem implicates us all in its vision, actually requires our participation in it. Antin's talk-poems are a form of address. "Art works," he told Roy Harvey Pearce's seminar, "are acts of conversation." They function like Jackson Mac Low's performances: "The poet creates a *situation* [not an object] wherein he invites other persons & the world in general to be co-creators with him."[61] It is in this sense of the text as situation that Antin's typographic idiosyncrasies explain themselves. As Derrida has pointed out in *Dissemination*, inscription itself signifies the displacement of the sign by the following sign.[62] Inscription is the very mark of temporalization, process, and contingency, and embodies not only the forward-looking thrust of narrative but acts as a hinge between the already given and the projected. This is especially true of Antin's peculiar kind of inscription, freed of all markers of beginning and end. Antin's text establishes a movement which is inseparable from the dialectical play of the work itself. Even as it is spoken, it projects its inscription. Even as it is inscribed, it projects its dissemination in us.

OPEN SPACE

<div align="right">6</div>

Landscape and the Postmodern Sublime

> The avant-garde task is to undo spiritual assumptions regarding time. The sense of
> the sublime is the name of this dismantling.
>
> JEAN-FRANÇOIS LYOTARD, "The Sublime and the Avant-Garde"

> "A long time ago, so long ago that your father's father before him did not know this
> thing himself but had it told to him and then taught it in turn, a magician built a
> great wall of cloth. It was 2 million square feet and ran for 24 1/2 miles, from the
> farm up there to the sea, where the old ones say it plunged into the waves and
> vanished forever. . . . The wall ran through the field down there, then across that
> hill, then rushed down the other side and began running in the distance. . . ."
>
> An imaginary legend[1]

In the late 1960s a small group of artists, friendly with each other, occa-
sionally helping each other out, began to make art in the open space of the
land. For Michael Heizer, Walter De Maria, Dennis Oppenheim, Robert
Smithson, and Nancy Holt, the gallery had come to impose certain limita-
tions upon the work of art which they sought to exceed. It was as if, in fact,
the gallery had become art's "frame," had imposed a way of seeing on them
that was, in many ways, even stricter than Renaissance perspective. For the
gallery wall, with its four corners echoing the structure of the frame, so
reinforced the two-dimensional surface of the picture plane that it had be-
come nearly impossible to see sculpture, for instance, except as a three-
dimensional object set against a rectangular field. And the gallery space
itself—as Brian O'Doherty defined it in the mid-seventies— had become a
hermetic "white cube": "A gallery is constructed along laws as rigorous as
those for building a medieval church. The outside world must not come in,
so windows are usually sealed off. Walls are painted white. The ceiling
becomes the source of light. The wooden floor is polished so that you click
along clinically. . . . The art is free, as the saying used to go, 'to take on its
own life.' "[2] In this world, as Michael Heizer put it in 1969, the "object
refers to itself. It has little exterior reference. It is rigid and blocks space."[3]
The gallery *contained* art, immobilized it. Furthermore, in the gallery, art
became another commodity, something bought and sold, *possessed*. As
O'Doherty put it:

For many of us, the gallery space still gives off negative vibrations when we wander
in. Esthetics are turned into a kind of social elitism—the gallery space is *exclusive,*
isolated in plots of space; what is on display looks a bit like valuable scarce goods,
jewelry or silver: esthetics are turned into commerce—the gallery space is *expen-
sive*. What it contains is, without initiation, well-nigh incomprehensible—art is
difficult. Exclusive audience, rare objects, and difficult to comprehend—here we

have a snobbery social, financial and intellectual which models (and at its worst parodies) our system of limited production, our modes of assigning value, our social habits at large. Never was a space to accommodate the prejudices and enhance the self-image of the upper middle classes so efficiently codified.[4]

In the context of the late sixties—the Vietnam War, the Art Workers' Coalition, Gregory Battcock's attack on the "art-loving, culturally committed" trustees of the Metropolitan and Modern museums for their corporate support of the war itself—the idea of somehow escaping a gallery system so deeply implicated in upper-middle-class American values was, to say the least, appealing. To work outdoors—and not just outdoors, but in the remote outdoors, say, in the Nevada desert or on a frozen river on the border between Maine and Canada—to make works whose scale exceeds the gallery itself, or to fashion in the landscape objects which are ephemeral, designed to be either incorporated into the environment by the natural processes of nature itself or removed, after a time, by the artist, is not merely to exceed the gallery space; it is, in a fundamental sense, to deny its primacy. In the gallery or museum, Heizer felt, art is a "malleable barter exchange item," but art in the land offers a fundamentally different experience from art in the museum or gallery. It becomes, he says, "part of the material of its place and refers beyond itself."[5] Outside, in the land, art defines itself as "open space."

It would be a mistake, however, to see this work as a "return to the land," to think of it as an art world version of the utopian "hippie" communes and farms that sprang up across America during the same era. No one thought that by exceeding the gallery they could evade it. Smithson, for instance, saw the gallery as part of the dialectic of his art. "I like the artificial limits that the gallery presents," he explained to Oppenheim and Heizer in a 1970 conversation. "I would say my art exists in two realms. . . . I got interested in this indoor-outdoor dialectic. I don't think you're freer artistically in the desert than you are inside a room."[6] In the same conversation, Oppenheim admitted to feeling drawn back to the gallery space: "It seems to me that a lot of problems are concerned with presentation. . . . Recently I have been taking galleries apart, slowly. I have a proposal that involves removing the floorboards and eventually taking the entire floor out. I feel this is a creeping back to the home site."[7] But, clearly, Oppenheim is "creeping back" with something less than a repentant attitude. The problem, as all of these artists recognized, is that by moving out of the gallery system, the work threatened to disappear as surely as Oppenheim's *Annual Rings* (Fig. 77), executed on the St. John River at the U.S.-Canadian border in December of 1968, melted from view. "A lot of problems," as he says, "are concerned with presentation."

In confronting the problem of presentation—how to have the work seen when it is not physically present—these artists developed an aesthetic po-

FIGURE 77. Dennis Oppenheim, *Annual Rings*, 1968. By permission Dennis Oppenheim.

sition with far-reaching consequences. As Oppenheim put it at the time, "It seems to me that one of the principal functions of artistic involvement is to stretch the limits of what can be done and to show others that art isn't just making objects to put in galleries."[8] The essence of this art is its conceptual basis. It is no accident that when Lucy Lippard published her survey of conceptual art, *Six Years: The Dematerialization of the Art Object 1966–72*, these artists were included, for these works represent the "concept" realized, and most of us experience them only at a conceptual level. That is, even though it is possible to visit certain sites where these artists have worked,[9] it is nevertheless true that by and large we experience them only at the level of their documentation. We can imagine what it must be like to see a thunderstorm run through Walter De Maria's *Lightning Field* (Fig. 78), but even if we visit the place the chances are we might not see an actual storm, for as De Maria notes in a 1980 description of the project for *Artforum*, the "observed ratio of lightning storms which pass over the sculpture has been approximately 3 per 30 days during the lightning season

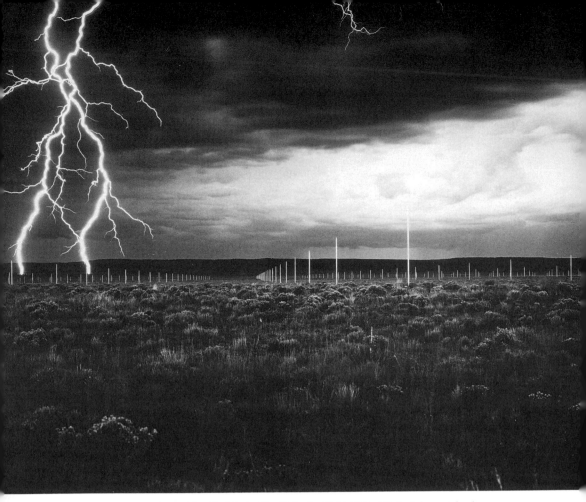

FIGURE 78. Walter De Maria, *The Lightning Field*, 1971–77. Stainless steel poles; average height of poles: 20 ft. 7 1/2 in.; overall dimensions: 5,280 × 3,300 ft. Near Quemado, New Mexico. © Dia Art Foundation 1980. Photo: John Cliett.

[May through September]."[10] The *Field* is larger than any individual experience of it. In *place*, the experience of the work is ephemeral, fleeting. In the hard light of day, it registers on the senses as a cold steel grid, a clear measuring and demarcation of space. A subtle shift in the quality of light, and it becomes a veil or scrim stretched across the landscape. In moonlight, it becomes a phantom, an otherworldly presence. But, says De Maria, "The sum of the facts does not constitute the work or determine its esthetics."[11] The aesthetics of this work are not unlike the aesthetics of the new music, compositions before which we experience only a "dispersion," to quote Barthes again, "a *shimmering* of signifiers, ceaselessly restored to a listening"—now to a seeing—"which ceaselessly produces new [signifiers] from them without ever arresting their meaning."[12] *Lightning Field* requires us to perform it, operate it, recognize and participate in the polysemy of its experience. In this sense, it defines an imaginative zone, a field

upon which the imagination can play; it creates imaginative energy as if by transforming the lightning itself.

What De Maria has come to accept is that something like this same energy is generated by the documentation of the work. He chose to represent himself, for instance, at the 1987 survey of contemporary art at the Pompidou Center in Paris—*L'Epoque, La Mode, La Morale, La Passion*—with an installation piece called *Large Rod Series Circle/Rectangles* and three color photographs of the *Lightning Field*. The *Rod Series*, which one can experience firsthand, is nevertheless both physically and imaginatively dynamic. At a cursory glance, the rods appear to be eight uniform circular poles, but they are in fact polygons of anywhere from five to thirteen sides. At the Pompidou they are arranged flat on the floor in a circle shape, 146 1/2" in diameter, reminiscent of the sun. But instructions accompany them indicating that they can be rearranged into two rectangular shapes as well, one about 95" long and the other just over 362" long. They invite us, in other words, to imagine their transformation. And this is precisely the function of the documentary photographs of the *Lightning Field*. They *suggest* vastly more than they depict. They *project* a hypothetical experience. It is in this hypothetical territory, in the open spaces of the imagination, that earth art has situated itself.

I

One of the most singular forces in the development of this new open space has, paradoxically, been largely absent from the scene. At age thirty-five, on July 20, 1973, Robert Smithson was killed when the plane he had hired in order to photograph what would be his final work, the *Amarillo Ramp*, crashed into a rocky hillside near the site. He left behind him a number of minimal sculptures, mostly modular pieces made between 1964 and 1968, several more complicated, multimedia and ambiguously positioned works which he labeled "nonsites," conceived and built between 1967 and 1969, and five large-scale, site-specific earthworks, beginning with the 1969 *Asphalt Rundown*, a mammoth Pollock-like "drip" or "pour" of asphalt down the side of a quarry in Rome, Italy, and including, most famously, the 1971 *Spiral Jetty*, in the Great Salt Lake in Utah. There remained, as well, a film, which had grown out of his work on the *Jetty*, a large body of photographs, and a great number of writings—documents and traces, in some ways the refuse of the work itself, and yet (and not by reason of his accidental death— unlike the editors at Random House poring over the manuscripts of Hemingway) a body of work in its own right, in some ways more substantial now—today, in the late 1980s—than the sculptures and the nonsites and the earthworks themselves. The *Spiral Jetty*, for instance, is today under water, the victim of a rising Great Salt Lake. The *Partially Buried Woodshed* at Kent State University is overgrown (a turn of events Smithson

anticipated). Most of us have never seen any of the five "actual" Smithson earthworks. We know them through their documentation, their reproduction in art books and magazines. This is the extent of our knowledge— and what the example of Smithson suggests is that this is not necessarily a "lesser" knowledge. It may even be that in the feelings for the remote, the inaccessible, and the nearly invisible that his earthworks generate in us—that is, in the dissolution of the object itself, over time—there exists a sort of sublime.[13]

The process of dissolution—more precisely entropy—is in many ways the focus of Smithson's work. Certain sites, he says, appeal to him more than others—sites that have been "in some way disrupted or pulverized."[14] In the first article he wrote for *Artforum*, the 1966 "Entropy and the New Monuments," he praises the work of minimal artists like Robert Morris and Sol LeWitt for its "monumental inaction," its awareness of "the ultimate collapse of both mechanical and electrical technology" (10–11). This is a complicated taste, but in essence, while at the time most people saw minimal art as a form of ultimate abstraction, a reduction of art's means to its most elemental tools—the grid, the straight line, the repetition of simple formal elements—Smithson sees it as an ultimate realism. "Near the super highways surrounding the city," Smithson writes, "we find the discount centers and cut-rate stores with their sterile facades. On the inside of such places are merchandise; rank on rank it goes into a consumer oblivion. The lugubrious complexity of these interiors has brought to art a new consciousness of the vapid and the dull. But this very vapidity and dullness is what inspires many of the more gifted artists" (12). Thus LeWitt's constructions evoke "a future of humdrum practicality in the shape of standardized office buildings." They "neutralize the myth of progress" (13). And Robert Morris conveys "a mood of vast immobility": "He has even gone so far as to fashion a bra out of lead . . . for his dance partner, Yvonne Rainer, to help stop the motion of her dances" (12). In the work of these artists, finally, "art vanishes into a series of motionless intervals based on an order of solids . . . [that] all but annihilates the value of the notion of 'action' in art" (10). But for Smithson, rather than invalidating action, such works seem to yield untold possibilities for making art. They *require* an imaginative response.

By the time this article appeared in June 1966, Smithson had been scouting out "entropic" sites for a couple of months. He approached them consciously avoiding what he would later call the "Humpty Dumpty" syndrome. The Humpty Dumpty rhyme is, for Smithson, "a nice succinct definition of entropy" (189): once he has had his great fall, all the king's horses and all the king's men cannot put Humpty together again. "Entropic" sites exist in the same condition. They cannot be "restored," though many people would like to think so. Mining reclamation laws, as Smithson

points out, insist that the landscape be restored to the way it was before it
was mined: "You can imagine the result when they try to deal with the
Bingham pit in Utah which is a pit 1 mile deep and 3 miles across. . . . One
person at Kennecott Mining Company told me that they were supposed to
fill that pit in. . . . They said it would take something like thirty years and
they'd have to get the dirt from another mountain. It seems that the rec-
lamation laws . . . deal with a general dream or an ideal world long gone.
It's an attempt to recover a frontier or a wilderness that no longer exists"
(194). Smithson avoids such a nostalgic relation to place. Instead, he takes
what he is given and works from there.

One place which particularly attracted him was Passaic, New Jersey, and
"A Tour of the Monuments of Passaic, New Jersey" appeared in December
1967, again in *Artforum*. Smithson had been born in Passaic and lived as a
child in nearby Rutherford, where the poet William Carlos Williams had
been his pediatrician. Williams's poem *Paterson* lies behind the piece: "I
guess the Paterson area is where I had a lot of my contact with quarries,"
Smithson told an interviewer in 1972, "and I think that is somewhat em-
bedded in my psyche. As a kid I used to go and prowl around all those
quarries. And, of course, they figured strongly in *Paterson*. When I read
the poems I was interested in that, especially this one part of *Paterson*
where it showed all the strata levels under Paterson. Sort of a proto-
conceptual art, you might say" (148). Smithson had visited Williams in the
late fifties in Rutherford, and Williams had shown Smithson his collection
of paintings—paintings by Marsden Hartley, Charles Demuth, Ben Shahn.
"It was a kind of exciting thing for me," Smithson recalled (148). His own
"Tour of the Monuments of Passaic," at any rate, "could be conceived," he
told another interviewer, "as a kind of appendix to William Carlos Wil-
liams' poem *Paterson*" (187).

Williams's poem is epic in scale and intention. It means, in rehearsing
the history of Paterson, New Jersey, to reveal the vitality of "the American
idiom," the inherent beauty of the vernacular and everyday things. What
is remarkable about it is its own admission of failure, its inability to dis-
cover "the language" or arrive at a vision that is in any sense whole. It is a
long, rambling poem, unfocused in a way that is at remarkable odds with
the precision and clarity of vision Williams often achieves in his short lyr-
ics. In fact, he could never bring himself to finish the poem. He had pro-
jected four books, but then wrote a fifth, and when he died in 1963, was at
work on a sixth. Paterson, New Jersey, could not be contained. It was not
susceptible to the lyric impulse—the fixity of vision—which marks his
other work. Smithson's "appendix" is, at one level, a parody of Williams's
epic intentions. It begins in a purposefully matter-of-fact tone: "On Sat-
urday, September 30, 1967, I went to the Port Authority Building on 41st
Street and 8th Avenue. I bought a copy of the *New York Times* and a Signet

paperback called *Earthworks* by Brian W. Aldiss. Next I went to ticket booth 21 and purchased a one-way ticket to Passaic. After that I went up to the upper bus level (platform 173) and boarded the number 30 bus of the Inter-City Transportation Co." (52). Next, in a depressing litany, Smithson details the contents of the *Times* art section:

A "Collectors', Critics', Curators' Choice" at A.M. Sachs Gallery (a letter I got in the mail that morning invited me "to play the game before the show closes October 4th"), Walter Schatzki was selling "Prints, Drawings, Watercolors" at "33 1/3%," Elinor Jenkins, the "Romantic Realist," was showing at Barzansky Galleries, XVIII–XIX Century English Furniture on sale at Parke-Bernet, "New Directions in German Graphics" at Goethe House, and on page 29 was John Canaday's column. He was writing on *Themes and the Usual Variations*. (52)

This is the state of contemporary art, a theme and the usual variations in its own right—almost comically commercial, depressingly unimaginative. In Book 5 of *Paterson*, Williams had celebrated "a world of art" that has "SURVIVED" through the ages. The implication of Smithson's "appendix" is that the world of art has now come down to this.

Once off the bus in Passaic, Smithson discovers a series of "entropic" monuments. The first is an old steel bridge connecting Bergen County and Passaic County near the corner of Union Avenue and River Drive: "an open grating flanked by wooden sidewalks, held up by a heavy set of beams, while above, a ramshackle network hung in the air. A rusty sign glared in the sharp atmosphere. A date flashed in the sunshine . . . 1899 . . . No . . . 1896 . . . maybe (at the bottom of the rust and flare was the name Dean & Westbrook Contractors, N.Y.)" (53). A second monument is a long pipe extending from a pumping derrick in the middle of the river across a set of pontoons to the shore and then along the shore for three blocks until it disappears into the ground: "One could hear debris rattling in the water that passed through the great pipe" (54). Yet a third monument, named by Smithson "The Fountain Monument" (Fig. 79), consists of a "pale limpid pool" emptying into the Passaic through six large pipes. It suggests to Smithson "six horizontal smokestacks that seemed to be flooding the river with liquid smoke." Even more perversely, "The great pipe was in some enigmatic way connected with the infernal fountain. It was as though the pipe was secretly sodomizing some hidden technological orifice, and causing a monstrous sexual organ (the fountain) to have an orgasm" (54). A dull and endless circularity informs this pair of monuments, the one pumping water out of the Passaic, the other discharging perhaps the same water back into it, and the monuments become for Smithson the image of "a kind of self-destroying postcard world of failed immortality and oppressive grandeur" (54). Here the landscape becomes "no landscape," a "zero panorama" (54)—360 degrees of virtual emptiness—like the parking lot that covers the old railroad tracks which at one time ran through the middle of the city:

FIGURE 79. Robert Smithson, *The Fountain Monument*: Side View, 1967. Instamatic snapshot, Passaic, New Jersey. Photo: courtesy Estate of Robert Smithson and John Weber Gallery, New York.

That monumental parking lot divided the city in half, turning it into a mirror and a reflection—but the mirror kept changing places with the reflection. One never knew what side of the mirror one was on. There was nothing interesting or even strange about that flat monument, yet it echoed a kind of cliche idea of infinity; perhaps the "secrets of the universe" are just as pedestrian—not to say dreary. Everything about the site remained wrapped in blandness and littered with shiny cars—one after another they extended into a sunny nebulosity. The indifferent backs of the cars flashed and reflected the stale afternoon sun. I took a few listless, entropic snapshots of that lustrous monument. (56)

Everything about this landscape is entropic, and Smithson is himself transformed into a sort of listless "camera eye" in the face of it. And yet, one thing exceeds the inertia of the moment. Entropy seems to provoke in Smithson not the image (the image here is "Instamatic") but the word, not the place itself (Passaic—even the name evokes passivity, inaction) but Smithson's *idea* of the place.

Such ideas, rising out of the inadequacy of representation, are characteristic of the sublime. Before the sublime—the absolutely immense object or

the absolutely powerful event—the visible object dissolves and the mind is thrown back on itself. What Smithson encounters at the center of Passaic is "no center—instead a typical abyss or an ordinary void" (55). Faced with nothingness his only resort is to words. Likewise for Edmund Burke in his *Philosophical Inquiry into the Origins of Our Ideas of the Sublime and the Beautiful*—a work Smithson knew well[15]—before the sublime, the artist can never depend upon painting, but must opt for poetry. It is more important, for Burke, to display the effect of things on the mind than to describe things—let alone paint them—clearly. Given the obscurity, or the indistinctness, or the vastness, or the undecidability of the sublime object, complete depiction was an impossibility anyway. And how could one ever image, visibly, matters of soul? Smithson's "Tour"—the essay—is a manifestation of the soul, of a soul returned to its source, its birthplace, to find nothingness, emptiness. It escapes despair through parody, and not merely the parody of Williams's epic art.

There is, of course, great parodic difference between Smithson's sublime and Burke's. Whereas the sublime comes into play, for Burke, before deserts, mountains, pyramids, and storms at sea, it is generated, for Smithson, out of the detritus of Passaic, New Jersey. And Smithson's use of the word "monument" depletes the "postcard" world of the "grand tour." "Has Passaic replaced Rome as the Eternal City?" he asks (56). His last Passaic monument is, in fact, a "desert," a locale intentionally meant to evoke the sublime:

This monument of minute particles blazed under a bleakly glowing sun, and suggested the sullen dissolution of entire continents, the drying up of oceans—no longer were there green forests and high mountains—all that existed were millions of grains of sand, a vast deposit of bones and stones pulverized into dust. Every grain of sand was a dead metaphor that equaled timelessness, and to decipher such metaphors would take one through the false mirror of eternity. (56)

This desert is indecipherable, timeless, vast—that is, sublime. The rhetoric is deliberate, and comic. What Smithson describes is the children's sandbox in Taras Shevchenko Park, Passaic.

Such parody, I want to insist, is not merely the stuff of pastiche. Smithson is not simply mocking the "sublime style," deliberately casting the "monumentality" of the sublime in ridiculous circumstances in order to expose its inadequacy or even its falsity. Smithson's sublime is real enough. Faced with the entropy of his world, such universal dissolution, he feels sufficient terror. His parody is meant, rather, to expose a certain weakness in the theory of the sublime, or to locate, perhaps, its postmodern turn. Before deserts, mountains, and storms, the sublime manifests itself as wholly other. Before a pyramid, it is as if someone other than ourselves—someone larger than life—must have conceived and built what stands before us. But everything in Passaic, New Jersey, is, we are certain, *some-*

thing we have made. It is as if we were watching our very undoing, not by the catastrophic forces of nature, but by our own hands. This landscape cannot be reclaimed. Smithson has identified the circumstances out of which his work must, like his essay, rise.

In a suggestive essay linking the eighteenth and nineteenth centuries' notions of the sublime to those of the contemporary avant-garde, Jean-François Lyotard notes that a fundamental difference between the two rests in the question of where each locates the feeling; today, he says, "the inexpressible does not reside in an 'over there,' in another world or another time, but in this: that 'it happens' . . . now, and here," and the sublime is "kindled by the threat that nothing further might happen."[16] Another word for this threat is entropy, the threat that what is happening will slowly, irreversibly dissolve itself, run down, come to a full stop. As Burke recognized, the sublime manifests itself when this entropy which threatens us is in some way "suspended, kept at bay, held back." Lyotard explains:

This suspense, this lessening of threat or danger, provokes a kind of pleasure which is hardly positive satisfaction, but is rather more like relief. This still qualifies as privation, but it is privation in the second degree: the spirit is deprived of the threat of being deprived of light, language, life. Burke distinguished this pleasure in privation from the positive pleasures, and he baptized it with the word "delight."
Here then is a breakdown of the sublime sensation: a very big, very powerful object threatens to deprive the soul of any and all "happenings," stuns it. . . . The soul is dumb, immobilized, as good as dead. Art, by distancing this menace, procures a pleasure of relief, of delight. Thanks to art, the soul is returned to the agitated zone between life and death, and this agitation is its health and life.[17]

What Smithson meets in Passaic, the "very big, very powerful" force he confronts, is entropy itself. The very first monument, the bridge, stuns him into virtual immobility, as if he were caught in the still time of the photographic image: "When I walked on the bridge, it was as though I was walking on an enormous photograph that was made of wood and steel, and underneath the river existed as an enormous movie film that showed nothing but a continuous blank" (53). What suspends the stultifying effects of entropy is the essay itself, the words Smithson discovers to *exceed* the image. And if his writing did not provoke an entirely "positive satisfaction," it does manage, I think, to distance the menace. It anticipates, that is, Smithson's later position, his desire to move into such entropic sites and make something of them. "Across the country," he would write, "there are many mining areas, disused quarries, and polluted lakes and rivers. One practical solution for the utilization of such devastated places would be land and earth water re-cycling in terms of earth art" (220). Just before his death in 1973, he would propose to the Kennecott Mining Company that he convert the Bingham Pit into a work of art.

"A Tour of the Monuments of Passaic, New Jersey" ends with a demonstration of entropy and a meditation on art's ability to keep it at bay:

I should now like to prove the irreversibility of eternity by using a *jejeune* experiment for proving entropy. Picture in your mind's eye the sand box divided in half with black sand on one side and white sand on the other. We take a child and have him run hundreds of times clockwise in the box until the sand gets mixed and begins to turn grey; after that we have him run anti-clockwise, but the result will not be a restoration of the original division but a greater degree of greyness and an increase in entropy.

Of course, if we filmed such an experiment we could prove the reversibility of eternity by showing the film backwards, but then sooner or later the film itself would crumble or get lost and enter the state of irreversibility. Somehow this suggests that the cinema offers an illusive or temporary escape from physical dissolution. The false immortality of the film gives the viewer an illusion of control over eternity—but "the superstars" are fading. (56–57)

This suggests that the proliferation of documents—texts, photographs, films—that Smithson produces in the course of making his art offers a "temporary escape" from the entropy that he detects at work everywhere around him. Yet these documents, which seem to reverse the ruin to which he is witness, threaten to add to it. As in *400 Seattle Horizons*, a work composed of 400 Instamatic snapshots documenting various Seattle landscapes executed by Smithson for Lucy Lippard's 1969 exhibition *557,087* at the Seattle Art Museum, at a certain point a documentary overload occurs.[18] *400 Seattle Horizons* does not define Seattle so much as fragment it, explode it. Such a *surplus* is itself a form of entropy.

II

The possibility of a cognitive entropy appealed strongly to Smithson—it amounted, for him, to the postmodern condition, and it had to be overcome. He began a 1968 essay on the various uses of language by contemporary artists, "A Museum of Language in the Vicinity of Art," with a meditation on the entropic potentialities of his own essay. An artist advances, he says, into the "babels of language" in order to "get lost," to discover "dizzying syntaxes," "voids of knowledge," and "meaningless reverberations." His writing amounts, that is, to a body of *information*. Its relation to "art" is comparable to the relation of two radio signals adjacent to each other on the radio band but overlapping. Independently each would make sense, but heard simultaneously each is noise to the other's information. On the other hand, information creates order. It is the inverse of entropy. Insofar as the introduction of noise into the system can be seen as the introduction of energy back into the system, then noise is potentially liberating. The language of the essay becomes for Smithson a "mirror structure," the reflections of which amount to a "monstrous 'museum' constructed out of multi-faceted surfaces that refer, not to one subject but to many subjects within a single building of words." Language, he concludes—and the emphasis is his—"*becomes an infinite museum, whose*

center is everywhere and whose limits are nowhere" (67). Language releases energy, possibility.

Smithson's own most concerted effort at developing this linguistic "mirror structure" in his own work is the famous *Incidents of Mirror-Travel in the Yucatan*, which was published, with nine photographs documenting a series of "mirror displacements" constructed by Smithson in the Yucatan landscape, in *Artforum* in September 1969.[19] If we discount its two epigraphs, the essay begins in the present tense—"Driving away from Merida down Highway 291. . . . " But this sense of the present—of movement and action in the present—begins to dissolve into an entropic landscape, a series of horizons so vastly similar—like *400 Seattle Horizons*—that it is as if there could be no meaningful movement, no difference or distinction, at all: "One is always crossing the horizon, yet it always remains distant. . . . The distance seemed to put restrictions on all forward movement, thus bringing the car to a countless series of standstills" (94). In order to get a better sense of place, his eyes drop to the map in his lap: "a tangled network of horizon lines on paper called 'roads' . . . congealed into a mass of gaps, points, and little blue threads (called rivers)." Frustrated still, he turns to the *Tourist Guide and Directory of Yucatan-Campeche*, with a picture on its cover of the Mayans meeting the Spanish at Chichen Itzá. Printed in its top left corner is the following:

"UY U TAN A KIN PECH" (listen how they talk)—EXCLAIMED THE MAYANS ON HEARING THE SPANISH LANGUAGE.

and in the bottom left corner this:

"YUCATAN CAMPECHE"—REPEATED THE SPANIARDS WHEN THEY HEARD THESE WORDS. (94)

The Spanish name for the place is simultaneously a mirror reflection—a repetition of the sound patterns—of the Mayan exclamation and a dizzying distortion of sense. What is an expression of *difference* for the Mayans is, for the Spanish, an expression of *identity*. The same relation exists, of course, between the region and the map which depicts it, between the place itself and the vision of it Smithson holds driving down the highway, his monocular vision always directed at the vanishing point on the horizon straight ahead. In each displacement—the displacement of the site itself, in all its complexity, by Smithson's single-minded "sight," his urge to get somewhere, then the displacement of Smithson's sight by the map, and finally of the map by the guide book—there is an increasing distortion, a dissolution of place which mirrors, paradoxically, the displacement of Mayan by Spanish meaning.

The project Smithson proposes for himself is to "reflect" this dissolve in nine separate arrangements of mirrors in the Yucatan landscape. This is his description of the "The First Mirror Displacement":

Somewhere between Uman and Muna is a charred site. The people in this region clear land by burning it out. On this field of ashes (called by the natives a "milpa") twelve mirrors were cantilevered into low mounds of red soil. Each mirror was twelve inches square, and supported from above and below by the scorched earth alone. The distribution of the squares followed the irregular contours on the ground, and they were placed in a random parallel direction. Bits of earth spilled onto the surfaces, thus sabotaging the perfect reflections of the sky. Dirt hung in the sultry sky. Bits of blazing cloud mixed with the ashy mass. The displacement was *in* the ground, not *on* it. Burnt tree stumps spread around the mirrors and vanished into the arid jungles. (95)

The position of the first displacement is crucial—Uman and Muna are anagrams of one another, *almost* palindromes, mirrors of one another which are not strictly parallel. Between these quasi-mirror images, Smithson situates the mirrors, reflections within the indirect reflections which reverberate between Uman and Muna. The names likewise sound like "human" and "moon," evoking in the manner of the Spanish meeting the Mayans for the first time, our earthly world and the heavens above, a concomitation of regions that the mirrors themselves, reflecting both the sky above and the ashes piled on top of them, effectuate—the "perfect" reflection sabotaged. In the kind of reversal only language can master, bits of cloud suddenly "blaze" in the mirrors, as if reflecting and re-creating the fire that had once scorched the earth. The "burnt tree stumps" that spread around the mirror and vanish into the jungle are barely visible, the jungle itself nowhere in evidence in the photograph, though it "frames" the milpa. In fact, I can count only ten mirrors—Where are the other two? Displaced, outside the frame? (In "The Second Mirror Displacement" there are, unaccountably, *thirteen* mirrors. Throughout the essay, Smithson refers to "the twelve mirrors," but what about this *excess*?) The photograph is itself an incomplete reflection, or an inaccurate one—parallel to the placement of the mirrors, but a displacement in its own right. Like the space visible within the mirrors, the space it describes is "present," but incomplete, spatially flat.

As "The Fourth Mirror Displacement" (Fig. 80) makes clear, the photograph effects an even greater displacement on the site. While the reflection of the mirror incorporates the dimension of time, reflecting each successive change in light and sky and altering as we move around it, in the photograph the dynamics of the place and our movement through it—the site's duration in time—is lost. So too is our status as an agent whose movement generates this shift in parts of the site reflected. In the same way, words pretend to capture a "meaning" that is itself dynamic:

South of Campeche, on the way to Champoton, mirrors were set on the beach of the Gulf of Mexico. Jade colored water splashed near the mirrors, which were supported by dry seaweed and eroded rocks, but the reflections abolished the supports, and now words abolish the reflections. The unnameable tonalities of blue that were

FIGURE 80. Robert Smithson, "The Fourth Mirror Displacement," from *Incidents of Mirror-Travel in the Yucatan*, 1969. Photo: courtesy Estate of Robert Smithson and John Weber Gallery, New York.

once square tide pools of sky have vanished into the camera, and now rest in the cemetery of the printed page. . . . Such mirror surfaces cannot be understood by reason. Who can divulge from what part of the sky the blue color came? Who can say how long the color lasted? Must "blue" mean something? Why do the mirrors display a conspiracy of muteness concerning their very existence? When does a displacement become a misplacement? (97)

The reflection of blue in the mirror in the photograph is only one blue in a range of blues, a range that has vanished into the single image. Likewise, in the face of this multitude of tonalities, what does "blue" mean? "The mirror displacement cannot be expressed in rational dimensions," Smithson says. We are faced with the "unnameable," with what "cannot be expressed," with the "mute" and the "meaningless," with a world, that is, of absent signifieds and illusory signifiers. The mirror displacements seem to be a stratification of absences, absences piled upon absences. The writings and the photographs documenting them add further strata to the pile. "I did a series of pieces called *Stratas*," Smithson recalled in an interview for the Archives of American Art at the Smithsonian Institution in 1972. "Virginia Dwan's piece called *Glass Strata* is eight feet long by a foot wide, and looks like a glass staircase made out of inch-thick glass; it's very green, very dense, and kind of layered up. And my writing I guess proceeded that way" (154). The writing and the photographs refer to a site that is, in Smithson's words, "open and really unconfirmed and constantly being changed" (155). These documents are what he calls "nonsites."

Until about the time of his trip to the Yucatan in 1969, the Site/Nonsite pieces had occupied him exclusively. He would visit a site, usually one like Passaic, deeply mired in entropic forces, document it, and then select "samples" of the site which he would then transport to the gallery and display in a "three-dimensional abstract map that points to a specific site" (155). As *Non-Site, Franklin, New Jersey* (Figs. 81 & 82) makes clear, each modular unit in the three-dimensional map refers to a specific sector of the site. Smithson has outlined the differences between sites and nonsites in the following chart:

Sites	Nonsites
1. Open limits	Closed limits
2. A series of points	An array of matter
3. Outer coordinates	Inner coordinates
4. Subtraction	Addition
5. Indeterminate certainty	Determinate uncertainty
6. Scattered information	Contained information
7. Reflection	Mirror
8. Edge	Center
9. Some place (physical)	No place (abstract)
10. Many	One (115)

FIGURE 81. Robert Smithson, *Nonsite, Franklin, New Jersey*, (aerial map), 1968. Collection Museum of Contemporary Art, Chicago. Photo: courtesy Estate of Robert Smithson and John Weber Gallery, New York.

FIGURE 82. Robert Smithson, *Nonsite, Franklin, New Jersey*, 1968. Collection Museum of Contemporary Art, Chicago. Photo: courtesy Estate of Robert Smithson and John Weber Gallery, New York.

But this is a somewhat cryptic, even unhelpful formulation. We have, on the one side, landscape—unfocused, open space—and on the other the gallery—self-contained and closed. But the two are reversible. Lawrence Alloway has defined the relation of site to nonsite in a way which helps us to see this reversibility. The nonsites, he says, constitute "a sculpture of absence": "The site is identified [initially, at the nonsite, in the gallery] by information supplied by the artist in the form of maps, photographs, ana-logical objects (bins and trays cued by the original lay of the land), rock samples and verbal captions. The nonsite, by this accumulation of refer-ences, acts as the signifier of the absent site."[20] And yet, in a dialectical play that Smithson himself surely understood, in the experience of it, the nonsite is itself a site that redefines the *original* site as the nonsite. This shift of identity or status is fundamental to the dialectics of Smithson's work.

Consider Smithson's formulation of the dynamics of the Mono Lake site/ nonsite relation. The "central focus point," he says, is the nonsite: "The site is the unfocussed fringe where your mind loses its boundaries and a sense of the oceanic pervades, as it were." At the site, as in Yucatan, "there's no way of focussing on a particular place." At Mono Lake itself, our sense of location is displaced: "The Mono craters are a chain of volcanic cones. Most of them were formed after Lake Russell evaporated. That's why I like it, because in a sense the whole site tends to evaporate. The closer you think you're getting to it and the more you circumscribe it, the more it evaporates. It becomes like a mirage and it just disappears." It is the maps, the photographs, and the sculptural forms of the nonsite which appear to allow the viewer some sense of the place itself, but from the perspective of a Los Angeles or New York gallery. Confronted by these documents, in the gallery, the viewer begins to realize that "actually every-thing that's of importance takes place outside the room" (176–77). The center, therefore, shifts. The gallery—or an essay like *Incidents of Mirror-Travel*—is at the edge of the event, at the fringe. The maps and the sculp-tural forms which fill the room, or the photographs and the text, tend themselves to evaporate. They appear to be a mirage of the actual place. The information contained in the room or the essay seems fragmentary, scattered. The documentary evidence now constitutes a physical space in its own right that points to an abstract landscape somewhere beyond, a source, as it were, which may or may not any longer bear some resemblance to the map one sees, the text one reads. As Smithson says of his site/nonsite dialectic, "Both sides are present and absent at the same time" (115).

It is useful, as I suggested earlier, to think of Smithson's work in terms of performance, the activities of a man working, creating "objects" and "events" deeply implicated in the temporal dimension, things which fade away, dissolve from view. "If you visit the sites," he says at the end of *Incidents of Mirror-Travel*, "you find nothing but memory-traces, for the

mirror displacements were dismantled right after they were photographed" (103). If the work defines what he calls, in this last paragraph, "the dimension of absence," this is perhaps as useful a definition as one might propose for the art of performance. "Yucatan is elsewhere," Smithson concludes, and so is the performance. All that remains is its traces, these presences which define the dimensions of absence.

III

If what empowers the postmodern work of art is the dialectic between presence and absence, between experience and its memory traces, no one has more systematically investigated the possibilities of this dialectic than Christo. His work is hardly ever "present"—in 1968 he wrapped the Kunsthalle in Bern, Switzerland, for a period of one week; a year later 1 1/2 miles of the Australian coastline were covered in one million square feet of erosion control mesh and thirty-five miles of polyprophelene rope for a period of ten weeks; in 1972, *Valley Curtain* survived for only twenty-eight hours before high winds began to rip it apart; for forty days in 1974 he wrapped surviving sections of a wall built 2,000 years ago by Marcus Aurelius in Rome; *Running Fence* was in place for only two weeks in the middle of September 1976; the paths and walkways of Loose Memorial Park, in Kansas City, Missouri, were wrapped in orange nylon for twelve days in 1978; *Surrounded Islands*, in Biscayne Bay, had a two-week life in 1983; and *The Pont-Neuf Wrapped* remained in place for a total of sixteen days in 1985. In other words, between 1968 and 1987 Christo's work, in its major manifestations, was *absent* from public view more than 99.75% of the time.

But it is not at the level of "presence" that Christo's art exists. It lives, rather, on a more conceptual level, in various documentary forms (plans, maps, photographs, collages) which generate for the work, in the social and cultural imagination and virtually independent of its creator, a power and force of its own.[21] In its unrealized manifestations Christo's work proceeds as a series of *projections*, which *exceed* their eventual embodiment—and survive it as a record of process. They are the documentation of projects at the level of planning, at the level of *plotting* ideas into being. Christo's project for the *Mastaba of Abue Dhabi* (Color Plate III), designed to be constructed of 390,500 oil barrels laid over a concrete and sand core and large enough to contain within its volume several forty-eight-story skyscrapers, is itself a projection composed of traces, a funerary monument erected out of empty oil drums. An *excessive* gesture in its own right, the *Mastabu* projects the story of our culture's excess. It would stand in the desert as the spectral record of the depletion of our natural resources.

I mean to suggest that Christo's work, which is so often involved with cloth, with fibrous materials that at some point must be unfolded and then

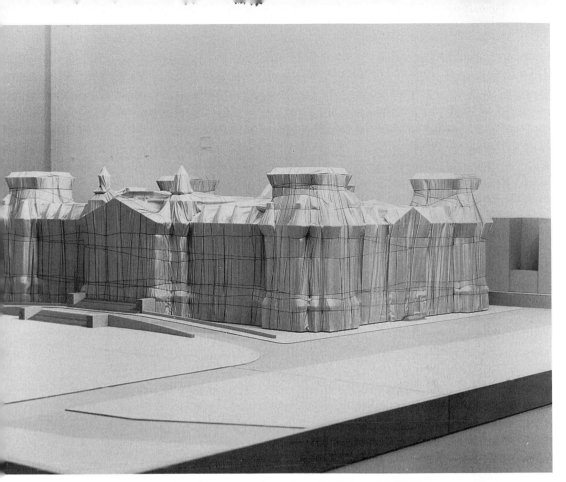

FIGURE 83. Christo, *Wrapped Reichstag, Project for Berlin*, 1981. Scale model: 25 1/2 in. × 5 ft. × 6 ft. 4 in. Fabric, twine, wood, paint, and cardboard. © Christo 1981. Photo: Wolfgang Volz.

wrapped around or extended across the scene, is also the *unfolding* of a story. In 1972, for instance, Christo proposed wrapping the Reichstag in Berlin for fourteen days (Fig. 83). In a symposium, "Time and Space Concepts," sponsored by the Pleiades Gallery in 1975 and moderated by Harold Rosenberg, he explained at some length what he had in mind. These are some excerpts from what he had to say:

I was very interested to do an urban project in a very special town somewhere. And I was fascinated for some reason by the East-West relation. You know, I come from the East country, communist country. I think that the value of our twentieth-century world, living apart, separately, measures all existence for the last sixty years and balances the peace and the war, intellectually, philosophically. . . . And the only town where these two relations meet and where the same ethnic type is living together, and separately, is Berlin. . . . And of course the only structure in Berlin which is under the jurisdiction of the Soviet Army, of the British Army, of the American, the French, and the German government is the former German parliament, the Reichstag. . . .

The Reichstag is a structure built in the late nineteeth century. It was the symbol of the incredible power of the German Bundestag founded by Bismarck, and the reality of the structure was a continuous metamorphosis all the time. . . . And it was never used to fulfill its symbolic purpose, you know. Shortly after, during the Weimar Republic it was the symbol of democracy. Hitler hated it and he burnt it. . . . After that he restored it and used it for his own policy. Marshall Zhukov lost two thousand people taking the building in 1945. It seemed completely stupid because the building had no strategic interest except one or two Nazi commandos were defending the building. The building was almost destroyed. The federal government of Germany spent seventy-five million dollars to restore the building as a completely new parliament and they cannot use it because the Soviets won't permit that the building be used for parliamentary purposes with the fear that it will be a revival of German Nazi nationalism. The building for the last hundred years was in a continuous metamorphosis. I was telling the people really all the time the building was changing physically, it can be wrapped for fourteen days and be a work of art. . . .

Now the making of the Reichstag, that is the first time I engage this international relation of the completely different sets of people, of the value. Especially it involved the Eastern world. And of course, that creates a volume of energy, especially people against and for the project. Now that each time the project creates its own power of that momentum because there are so much forces for, also that there are so much forces against. And that really creates the power of the project. And of course, what makes the project build in time and relations we cannot predict, because it's almost like the real life.[22]

This narrative has the advantage of outlining Christo's art in all its crucial dimensions by pointing out, I think, how little his work depends upon its actual embodiment. The *Wrapped Reichstag* has never come into being—though I doubt Christo has entirely given up on it. And yet, in another sense, it does exist—and not just conceptually, at the level of anecdote. There are plans, drawings, scale models—the narrative of its failure. Christo must, of course, bring most of his projects to fruition—"If I was only talking about wrapping the Reichstag with no believable means," he says, "nobody would be interested."[23] Nevertheless, to my mind, through its absence, its perhaps perpetually delayed projection, the *Wrapped Reichstag* is even more eloquent than in any imaginable realization. Christo's work depends upon a visual and visionary intrusion into the site, and while his gestures are meant to draw attention to the place itself—to transform it, renew it, or underscore its inherent beauty or meaning—in all probability he will not succeed in Berlin. And yet, I think, the Reichstag has changed. A story very like the other Christo stories—attorneys battling in the courts over wildlife preservation in Miami, or over land-use laws in California, all in the papers, all with as many people against the project as for it—has taken place, except in Berlin the issue has been largely one of jurisdiction and international cooperation, or lack of it. By starting the discussion, Christo has drawn attention to the symbolic power of the Reichstag itself.

Nevertheless, the power of Christo's documentation lies in its ability to make us believe that he can make anything come into being. I am willing to bet, for instance, that a majority of people, browsing through a book like Dominique Laporte's *Christo* and just looking at the photographs, would assume that Christo had indeed wrapped the Reichstag. In the symposium "Time and Space Concepts," Harold Rosenberg, discussing the documentary status of their work with Christo, Les Levine, Dennis Oppenheim, and Alan Sonfist, pointed out that, for many of us, the only way we will ever know projects like Christo's is through their documentation:

The transitory nature of certain types of works makes them inexpedient for the gallery. . . . As a matter of fact, I've seen works by Oppenheim in movies of the works and they weren't accessible in any other way. You have that problem. That's to say, the gallery, in the case of environmental works, in quotes, they, the gallery, is replaced by the media. That is, the works don't really take place in the social mind. They take place in the media first. That is, you have movies of them, like Christo's movie and his [Oppenheim's] movie. He had a movie, for example, in which they took a lot of stuff, a whole day's product, paper products of the stock market, you remember that one? They carried it in bags to the top of a roof somewhere. It got to be about three feet deep if I'm not mistaken. Then they danced around on it and the wind blew it away and all this time it was being filmed. So this is a terrific environment of the displaced floor of the stock market. But nobody invited me to go there and be there. On the other hand, I could see the movie. So, I got a secondhand environment. And that's what you usually get. Very few people, I'm sure, in this room have seen Christo's *Running Fence* or his *Packaged Cliff* [*Wrapped Coast*] in Australia. But we've all seen—. . . . An environment is not an environment, usually. What the environment is, is actually a reproduction in one form or another.[24]

Rosenberg's analysis—which, incidentally, the artists all agreed with—is interesting on a number of counts, not least of which is the fact that in order to speak of the power of the photographic or filmic trace he tells a story. Oppenheim's work forces him to construct a narrative. But most important is his sense that the media have replaced the gallery—that art takes place in the media first. His understanding of this is the one advantage that Smithson has always held over Heizer, who introduced Smithson to the deserts of the West and to whom, in many ways, Smithson was indebted for the idea of working on a large scale in the environment. Smithson was more attuned to the idea of presenting himself in the media than Heizer. He understood the value of a properly placed article in *Artforum*. And his death, which almost inevitably recalled the untimely, accidental ends of many a cult hero, from James Dean to Buddy Holly, further cemented his media reputation. Today, Christo may be the most accomplished at organizing the media's attention in his direction, but all good environmental artists construct their works with its eventual photographic reproduction in mind, even if they regret the necessity.

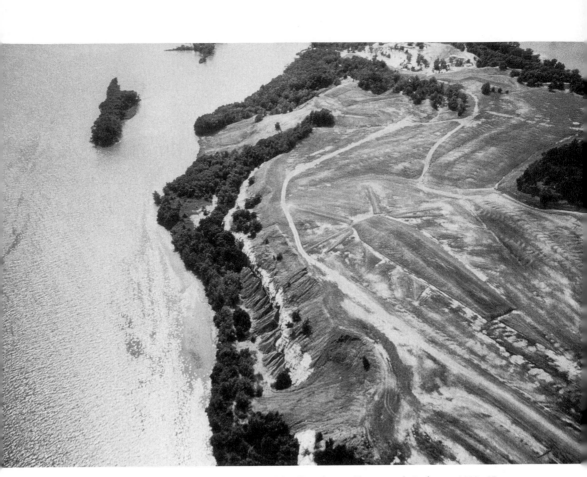

FIGURE 84. Michael Heizer, *Catfish Effigy*, from *Effigy Tumuli Sculpture*, 1983–85. Compacted earth on plateau, entire complex ca. 1 mile long × 1/2 mile wide. Location: Buffalo Rock. Ottawa, Illinois. Collection the State of Illinois.

For most of these artists, it is a question of activating the dialectic between what Smithson calls "site" and "nonsite," between presence and absence, the dialectic which itself generates the necessity for a potential audience to imagine what it must be "really like" to experience the work itself. On such imaginative play the life of the work—its "living on"—depends. This is why the aerial or topographical view has come to be the primary visual form of the earthwork. As Klaus Kertess has put it in an article documenting Michael Heizer's 1985 earthworks, *Effigy Tumuli Sculpture* (Figs. 84 & 85), at Buffalo Rock, Illinois, seventy-five miles southwest of Chicago, "the view down" has "largely supplanted the view through (the painting as window, the picturesque) and the view up (religious art, statues on pedestals and such)." [25] Such views carry us *out* of the site. They allow us to see it all. And yet they establish a discontinuity between actual experience and documentary experience. They are *other*

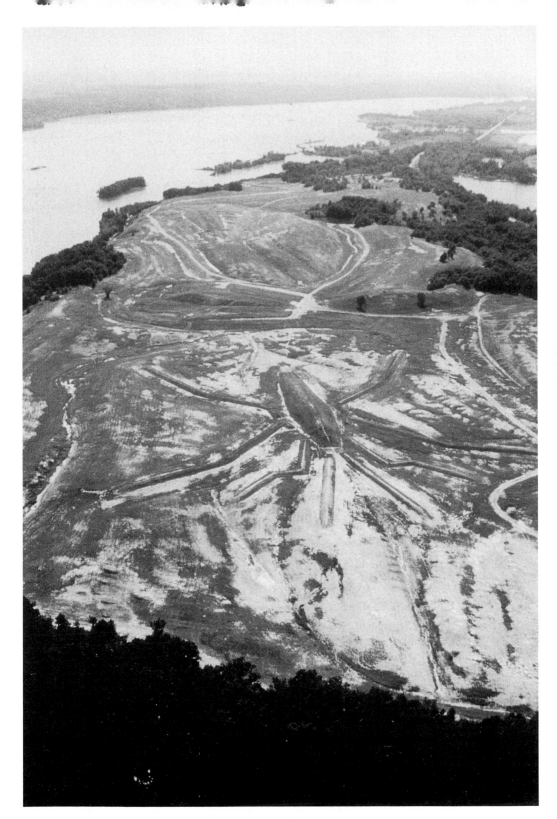

FIGURE 85. Michael Heizer, *Water Strider Effigy*, from *Effigy Tumuli Sculpture*, 1983–85. Compacted earth on plateau, entire complex ca. 1 mile long × 1/2 mile wide. Location: Buffalo Rock. Ottawa, Illinois. Collection the State of Illinois.

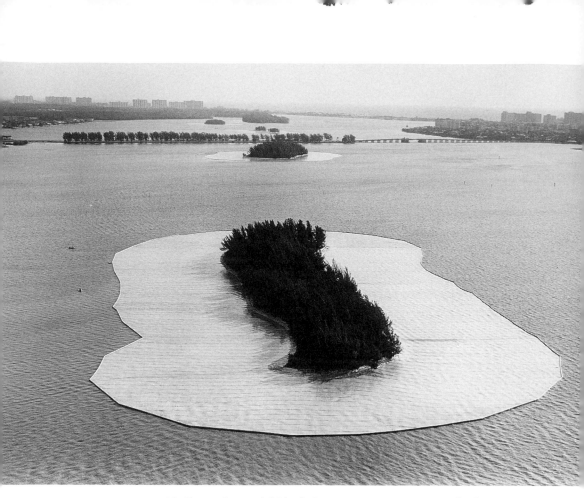

FIGURE 86. Christo, *Surrounded Islands, Biscayne Bay, Greater Miami, Florida*, 1980–83. © Christo 1983. Photo: Wolfgang Volz.

than the experience of being there, in place. "The world seen from the air," Smithson wrote in a proposal submitted to the Dallas-Fort Worth Regional Airport in 1967, "is abstract and illusive." The possibility of aerial photography suggests to him that the site "is but a dot in the vast infinity of universes, an imperceptible point in a cosmic immensity, a speck in an impenetrable nowhere—aerial art reflects to a degree this vastness" (92–93). Christo's *Surrounded Islands* seem to take on an almost intergalactic aspect, planets floating in space, surrounded by pink atmospheres. Or conversely, as Smithson says elsewhere, "If you are flying over a piece, you can see its whole configuration in a sense contracted down to a photographic scale" (180). In the aerial shots of the *Surrounded Islands*, we recognize that each island is *framed* by the polypropylene screen, or focused like a bloodshot eye (Fig. 86).

The aerial view, in fact, posits experience in terms of scale. Our sense of the *Jetty*, as Smithson knew, varies in accordance with our point of view.

Down low, out on it, it dissolves structurally, becoming, as Smithson wrote, "mud, salt crystals, rocks, water." Conversely, Smithson writes in the *Jetty* essay, "A crack in the wall if viewed in terms of scale not size, could be called the Grand Canyon." Likewise, when our gaze descends to the crystals at our feet, we discover that "each echoes the Spiral Jetty in terms of the crystal's molecular lattice. Growth in a crystal advances around a dislocation point, in the manner of a screw" (112). In order to see a structure, in other words, we need to be outside it, in the way that we stand above the crystals or fly over the *Jetty* and "look down" on them—and I mean this in both senses of the phrase. For the aerial view—as Kertess puts it, "the privileged view, the bird's-eye view, the view once only permitted the gods and stars"[26]—like the photograph itself, is a gesture of possession and mastery. It is literally an "elevated" point of view, a position of eminence. Part of the point of Heizer's very great *Double Negative* (Figs. 87 & 88), which could be said to have inspired all the large-scale earthworks under discussion here, is that to be down *in* it is to enter, as it were, into a scar or wound. While erosion, the carving away of the Virgin River Canyon, is everywhere around one, and will no doubt eventually consume the work of art itself, this erosion is a natural process, beside which the geometric and mechanical gash of the bulldozer seems an obscenity. And yet from above, Heizer's work is elegant, its simplicity—and ecological innocuousness—a sort of humble measure of the vast forces at work in the desert at large. Heizer's work engages two times: one is human time, in the context of which it seems an outrage; the other is geological time, in the context of which it seems almost irrelevant. The first is revealed on site, the second in the "aerial" view.

For these artists the aerial view—and this is crucial—almost never exists alone. It is, rather, part of the package: other photographs from ground level, texts, films, videos, perhaps a visit to the site itself. The entire "illusion" of "mastery" is suspended. If such aerial views offer, in the same way that for Derrida the book offers, an image of unification and totalization, these other documents (or experiences) subvert it. Even in its documentation—*especially* in its documentation, because documentation is, finally, the *form* dissemination takes—we are always, we find, *outside* the work itself (*hors d'oeuvre*), in an open space. It is as if we were always only beginning to set out, to track or map—to *trace*—the lay of the land.

IV

From this point of view, one which seeks to subvert the unity of the image and the work, the primary advantage of an art of reproduction—the art of the trace—is that it depends upon the implicit levels of connotation contained in all photographic images, the fact that these images tend to demand "captions," seek to have their stories *filled in*. As in Smithson's photograph

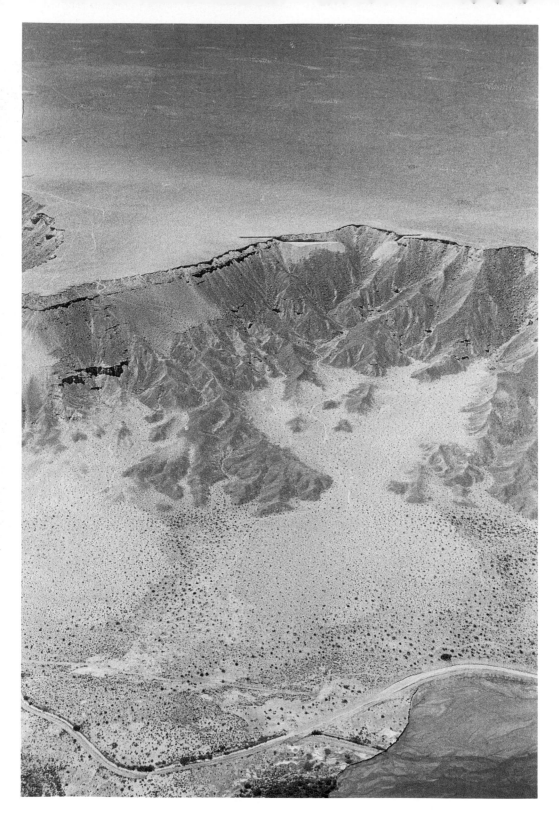

FIGURE 87. Michael Heizer, *Double Negative,* 1969–70. 240,000 ton displacement in rhyolite and sandstone, 1,500 × 50 × 30 ft. Location: Mormon Mesa, Overton, Nevada. Collection Museum of Contemporary Art, Los Angeles. Gift of Virginia Dwan.

FIGURE 88. Michael Heizer, *Double Negative*, 1969–70. 240,000 ton displacement in rhyolite and sandstone, 1,500 × 50 × 30 ft. Location: Mormon Mesa, Overton, Nevada. Collection Museum of Contemporary Art, Los Angeles. Gift of Virginia Dwan.

of "The First Mirror Displacement," things appear to *live on* outside the frame—that is, they extend physically in space and stretch backward and forward in time. As Stanley Cavell has put it, when the frame of a photograph is established, "the rest of the world is cut *out*. . . . The camera has been praised for extending the senses; it may, as the world goes, deserve more praise for confining them, leaving room for thought."[27] The camera, in other words, invites the imagination to engage the scene, to extend the limited image of the photograph beyond the frame.

Film, of course, works somewhat differently. As documentary evidence its flow of images seems to possess the duration that the photograph lacks.

Film *fills in* the story in a way that the single photograph, or even the series of photographs, cannot. And yet, as a temporal art, film dissolves into the same abyss of time as the work itself. We are forced, in the way that Rosenberg recalls the Oppenheim movie, to recreate it, as a story, a narrative—or else, of course, we can see it again. This *repeatability* distinguishes it from the ephemeral event it documents, but in successive viewings, film becomes, as any writer on the temporal arts knows, as "framed" as any single photograph. All "shots" possess their limits, all films their "point of view." Just as surely as there is no totalizing photograph, there is no totalizing film. Always there remains the thing unseen, dimensions larger than the camera eye.

Smithson's film of the *Spiral Jetty* is a case in point. Until the long final sequence the film is marked by what Lawrence Alloway calls a "slightly stooped . . . low-keyed" style, in contrast, for instance, to the high-pitched intensity of his rhetoric both in the film and in the essay documenting the work.[28] The site was chosen, in the first place, for the sense of vastness that Smithson felt before it: "As I looked at the site, it reverberated out to the horizons only to suggest an immobile cyclone while flickering light made the entire landscape appear to quake. A dormant earthquake spread into the fluttering stillness, into a spinning sensation without movement. This site was a rotary that enclosed itself in an immense roundness" (111). This immensely round horizon is virtually ignored until the end of the film. As Alloway points out, the camera looks down, just in front of the feet, or close-up at rocks, debris, machines. For Alloway these sequences are shot with a red filter, which softens the inherent contrast of the scene, in order to "suggest an entropic equalization of energy"[29]—in order, that is, to level the imagery. But Smithson's verbal experience of the color is much more intense: "I closed my eyes, and the sun burned crimson through the lids. I opened them and the Great Salt Lake was bleeding scarlet streaks. My sight was saturated by the color of red algae circulating in the heart of the lake, pumping into ruby currents. . . . Swirling within the incandescence of solar energy were sprays of blood. . . . I had the red heaves, while the sun vomited its corpuscular radiations. . . . Surely, the storm clouds massing would turn into a rain of blood" (113). Conversely, there is a moment, in the documentary essay, when Smithson counters his own verbal gymnastics, his flare for hyperbole, by bringing our vision "down to earth," to the level of the film. This is what he sees "from the center of the *Spiral Jetty*":

North — Mud, salt crystals, rocks, water
North by East — Mud, salt crystals, rocks, water
Northeast by North — Mud, salt crystals, rocks, water
Northeast by East — Mud, salt crystals, rocks, water
East by North — Mud, salt crystals, rocks, water

```
            East — Mud, salt crystals, rocks, water
         East by South — Mud, salt crystals, rocks, water
    Southeast by East — Mud, salt crystals, rocks, water
  Southeast by South — Mud, salt crystals, rocks, water
       South by East — Mud, salt crystals, rocks, water
              South — Mud, salt crystals, rocks, water
       South by West — Mud, salt crystals, rocks, water
  Southwest by South — Mud, salt crystals, rocks, water
   Southwest by West — Mud, salt crystals, rocks, water
       West by South — Mud, salt crystals, rocks, water
               West — Mud, salt crystals, rocks, water
       West by North — Mud, salt crystals, rocks, water
   Northwest by West — Mud, salt crystals, rocks, water
  Northwest by North — Mud, salt crystals, rocks, water
       North by West — Mud, salt crystals, rocks, water        (113)
```

In fact, it is fair to say that this passage is far more "low-key" than the film could ever hope to be. "Eyesight," Smithson remarks just before this numbingly litanic review of vast samenesses, "is often slaughtered by the other senses, and when that happens it becomes necessary to seek out dispassionate abstractions. The dizzying spiral yearns for the assurance of geometry" (113). This catalogue of directions is no "dizzying spiral." It is a "dispassionate abstraction," a slow turn around the circumference of the compass, a perfect circle encompassing the site.

Neither film nor photograph can achieve the variety of effects that Smithson attains in his writing. And not only is the point of view of the film as limited as that of the photograph—and nowhere near as richly various as Smithson's prose—in a certain sense film could even be said to be a more *primitive* form of documentation than photography. We can compare photographs of the *Jetty*, the fragmentary visual experience of being on it (or rather *in* it) to a totalizing aerial overview. But when at the end of Smithson's film we fly over the site, we have to *remember* what it was like to be down there. I am reminded of André Malraux's description of the conditions that art history and criticism had to work under before the wide dissemination of color reproductions:

What, until 1900, had been seen by all those whose views on art still impress us as revealing and important; whom we take to be speaking of the same works, referring to the same sources, as those we know ourselves? Two or three of the great museums, and photographs, engravings, or copies of a handful of the masterpieces of European art. Most of their readers had seen even less. In the art knowledge of those days there existed an area of ambiguity: comparison of a picture in the Louvre with another in Madrid, in Florence, or in Rome was a comparison of a present vision with a memory. Visual memory is not infallible, and successive periods of study were often separated by weeks of travel.[30]

Film forces us to rely upon this visual memory in the same way that actual experience does. We can only compare our present vision of the *Jetty*

seen from above with our memory of it seen from below. The "still," of course, resolves this problem, but the "still" returns film to the condition of photography.

It is around these terms—the "filmic," the "photographic," and the "still"—that Robert Morris organized what remains one of the most important discussions of the kind of work I am addressing here, an essay entitled "The Present Tense of Space," which appeared in *Art in America* early in 1978. For Morris, actual experience—the body in motion, the eye endlessly changing focus and direction—is "filmic," and our memory of it is "photographic": "Is one's everyday living space represented in the mind as though some sort of in-motion 'filmic' changing imagery, resembling the real time experience of walking through it? Or does it come to mind as a few sequences of characteristic but static views? I believe that static, characteristic images tend to predominate in the scenery of memory's mental space. The binary opposition between the flow of the experienced and [the] stasis of the remembered seems to be a constant as far as processing imagery goes."[31] In other words, if the experience of space is "filmic"—"Real space is experienced in real time," writes Morris—when we "shift to [the] recall of the spatial experience . . . objects and static views flash into the mind's space. A series of stills replaces the filmic real-time experience" (70). Morris clearly values, in this piece, the "real-time" experience afforded by a newer kind of sculpture, like Smithson's *Jetty* and his own *Observatory* (Fig. 89), which he had just completed in Holland as this essay was written. Approximately 300 feet in diameter and consisting of two concentric circular structures with various openings to the outside, *Observatory*, as its name implies, is meant to generate perception, not contain it. "Now images," Morris writes in the *Art in America* essay, which are "the past tense of reality . . . [must] begin to give way to duration, the present tense of immediate spatial experience." Like the oral poets who are his contemporaries, his reasons for insisting on this are largely formal—that is, he is reacting *against* a firmly established and highly formalized sculptural tradition, specifically against its investment in what he labels "the gestalt object." Such works are comprised of "wholistic, generalized gestalt" forms which provide "a structural unity first for objects and then for spaces" (78). He has in mind his own early minimalist work—as well as that of Sol LeWitt, Donald Judd, early Smithson, and so on—which can be immediately perceived as a whole and whose structural integrity and simplicity makes for an object that, like the "well-formed" poem, is "specific, singular, dense, articulate, and self-contained" (73). As opposed to this kind of art, which is essentially independent and separate from the viewer— framed, as it were—Morris longs for the "full presence" of aesthetic experience, a mutual coordination of the eye and the space it occupies that is the visual equivalent to Derrida's *s'entendre parler* or Ginsberg's and Sny-

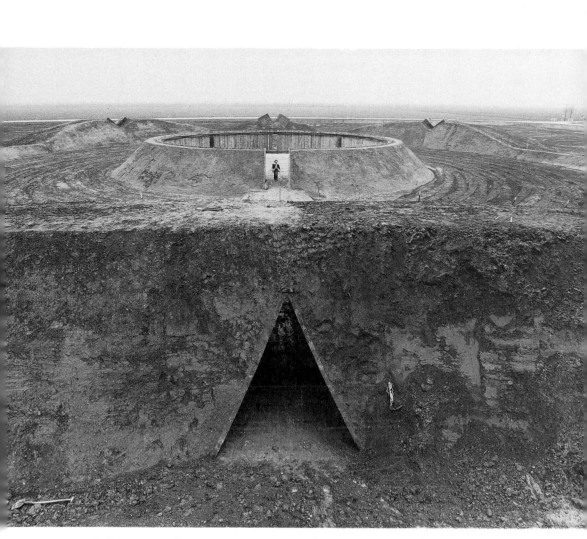

FIGURE 89. Robert Morris, *Observatory*, 1971; reconstructed 1977. Earth, wood, and graphite, approx. diameter 300 ft. Permanent installation Oostelijk Flevoland, the Netherlands.

der's mantras, a sculpture that "corresponds with the perception of space unfolding in the continuous present" (72), a spatial experience before which "there is no memory" (79) and which "extends presentness as a conscious experience" (80). Photography (like writing, insofar as it is "fossilized speech") is this work's greatest enemy: "It could be said that the work under question not only resists photography as its representation, it takes a position absolutely opposed to the meaning of photography" (79). The photograph "stills" the modality of experience, it makes singular the multiplicity of views that the work embodies, its focus is monocular, it ignores—or so it would seem—both time and the subjectivity of experience. But—and this is the important observation of Morris's essay, the

observation with which he concludes—"if the work under discussion is opposed to photography it doesn't escape it" (79):

> A further irony is that some of this kind of work is temporary and situational, made for a time and place and later dismantled. Its future existence in the culture will be strictly photographic. . . . Smithson's outside mirror pieces . . . defined a space through which one moved and acknowledged a double, ever-changing space available only to vision. There was an exactness as well as a perversity implied by his photographing and then immediately dismantling these works. Exact because the thrust of the work was to underline the non-rememberable . . . perverse because the photograph is a denial of this experience. (79–80)

In the very last sentence of the piece, Morris begins to realize why the photograph may be not only inevitable but, in fact, indispensable. "The pursuit of the contradictory," he says, "[may be] the only basis for perceiving dialectical reality" (80). In other words, the space defined by the new "situational" sculpture Morris champions is not—and can never be— merely "present." Even in the "filmic" experience of it, we "remember," at each successive view and from each successive perspective, our experience of other views, other perspectives. The present is always in a dialectical relation to the past, and the photograph affirms this.

Furthermore, insofar as the filmic gives us a sense of *being there*, of actually experiencing the scene, it is, I would say, a less successful form of documentation than that which is photographic. As a medium, documentation depends upon the discontinuity between our experience of it in *this* place *here*, in the present, and its depiction of *that* event's occurrence *there*, someplace else, in the past. Roland Barthes makes this point in what seems to me a crucial distinction for understanding the centrality of documentation to postmodern practice:

> The type of consciousness it [the photograph] implies is indeed unprecedented; the photograph institutes, in fact, not a consciousness of the thing's *being-there* (which any copy might provoke), but a consciousness of the thing's *having-been-there*. Hence, we are concerned with a new category of space-time: immediately spatial and anteriorly temporal; in the photograph an illogical conjunction occurs between the *here* and the *then*. . . . Its reality is that of *having-been-there*, for in every photograph there is the always stupefying evidence of: *this is how it was*: we then possess, by some precious miracle, a reality from which we are sheltered.[32]

The photograph, in other words, almost by definition, establishes a dialectic between presence and absence, between the presence of our experience of it and the absence of that to which it refers. For Barthes, film stands in "radical opposition" to photography because it gives way to the illusion of *being-there*.[33] It constitutes what is at least a phenomenological sense of *presence*. The scene, in film, is here, before us. In the photograph, the scene is always *other*. The work remains *unsettled*, caught between the legends it might generate and the story of its end, between the vitality that lan-

guage provides it and the "babels" it might inspire, between absence as mere nothingness and absence as the arena of free play and creation. The sublime is, perhaps, created on this edge, and this alterity may be its necessary condition. "*Is it happening?*" as Lyotard asks. No, it happened *then*. Does that mean that it is over and finished? Has it ceased to be? Is it *dead*? No, again, at least maybe not. Confronted, once more in Lyotard's words, with "the threat that nothing further might happen," we are "relieved," by the document, by the suggestion of this "living on." Deprived of the experience of the event, we nevertheless know it, perhaps even more fully than if we were there.

CRITICAL PERFORMANCE

The Example of Roland Barthes

In this glum desert, suddenly a specific photograph reaches me; it animates me. . . .
The photograph itself is in no way animated (I do not believe in "lifelike" photo-
graphs), but it animates me: this is what creates every adventure.
ROLAND BARTHES, *Camera Lucida*[1]

Some years ago, at the 1978 Modern Language Association convention in
New York, David Antin proposed to a large afternoon audience, convened
to ponder "The Question of Postmodernism," that everyone's evident in-
terest in things "postmodern" could probably be laid at the feet of Richard
Nixon. First, the Vietnam War, then Watergate had created a sensitivity,
even among academics, to the ways in which certain conditions of language
were not necessarily conducive to the production of meaning, or not con-
ducive at least to the production of very valuable or believable meanings.
Double-talk, like Vietnam body counts, the famous "There will be no
whitewash at the White House," and Zieglerisms ad nauseum were what
Antin had in mind, but Antin's suggestion was hardly received with enthu-
siasm. Anyone in attendance will probably recall an amused if somewhat
surprised Antin loudly maintaining over a chorus of guffaws, catcalls, and
various protestations of disbelief, "No, really!"

His audience was hostile, in the first place. It had gathered to throw
tomatoes generally at the very idea of "postmodernism"—a word that, in
those days, caused the same "instant panic and revulsion" among academics
that Antin's own poetry was capable of generating—and particularly to bait
Julia Kristeva, who was on the program with Antin, and who, by virtue of
representing the "French" postmodernist position, was doubly threatening.
But this hostility was, I think, absolutely central to the formation and dif-
fusion of poststructuralist thought in the United States in the seventies.
That is, it helped to define an academic avant-garde, consisting mostly of
young intellectuals, graduate students, and assistant professors, almost all
of them associated with literature departments still dominated by formalists
of an essentially American New Critical persuasion (which is to say, "close
readers"), in an era when literary studies were becoming increasingly less
attractive to students and were held in increasingly lower esteem by uni-
versity administrations. In short, there was a sense of meaning and purpose
to the poststructuralist project in America—if the prestige of literary stud-
ies was at stake, it probably deserved to be, given its dominant critical
prejudices—and, with the example of *Tel Quel* as a model, groups of intel-
lectuals sympathetic to the poststructuralist position began to unite in com-

mon cause. The most notorious of these, because of their own prestige and relative maturity, soon became known as the "Yale mafia," a group which was centered on J. Hillis Miller, Geoffrey Hartman, Paul de Man, and Harold Bloom at Yale, supplemented by the regular appearance of figures like Derrida on the faculty, and which soon began to attract large numbers of graduate students of a poststructuralist persuasion. But it was largely in the literary journals—*Glyph* from Johns Hopkins, *Diacritics* from Cornell, *Sub-stance* from Michigan, and *boundary 2* from the State University of New York at Binghamton—that their position began to be defined. While the first three journals tended to be critical in orientation, the last, under the direction of William Spanos, made a serious effort (which continues) to disseminate postmodern art itself. One way to describe the project of this book, then, is to say that I have been trying to define the ways in which this intellectual poststructuralist elite was responding to a recognizably postmodern, avant-garde art, and how both aligned themselves against, on the one hand, formalist criticism and, on the other, the high modernist art—the avant-garde of Poggioli and Greenberg—that formalist criticism championed. I have been trying to suggest that poststructuralist criticism and the art I have described in these pages (even if, for the most part, they have ignored each other) are part and parcel of the same general state of affairs. Together, as David Antin I think rightly suggested in 1978, both the poststructuralist critics and the postmodern artists defined the enemy in essentially social, if not political, terms. If the Johnson and Nixon White Houses were the overt threat, the academy generally and the New York art establishment (museums *and* publishers) in particular constituted a cultural system in tacit alliance with and in support of the political aims of both administrations.

A casual glance at some of the more widely read books and essays of the early seventies makes this abundantly clear. Susan Sontag had published *Styles of Radical Will* in 1969, which began with a call for an "aesthetics of silence." "Language," she wrote, "is experienced not merely as something shared but as something corrupted . . . [and] modern art thus transmits in full the alienation produced by historical consciousness. . . . Silence undermines 'bad speech.' . . . As the prestige of language falls, that of silence rises."[2] She ended the book with the long and overtly political essay "Trip to Hanoi," in which she describes how it became clear to her that for radical Americans Vietnam had become something like "an ideal Other" because it offered "the key to a systematic criticism of America" itself.[3] Between the two essays she touched on pornography, any number of films but particularly the work of Bergman and Godard, and several more or less literary topics. But the book is bracketed by this concern for the authenticity of language (or, more precisely, its lack of authenticity) and the war.

The same holds true for Richard Poirier's *The Performing Self*, published in 1971. His name for Sontag's "aesthetics of silence" is "the politics of self-parody," but they are close to the same thing. He is interested in a literature which "shapes itself around its own dissolvents," which parodies any "truth" it discovers because of its own inevitable status as contingent and fictional.[4] And the literary and academic issues he discusses are "inseparable," he claims, "from larger cultural and political ones."[5] In perhaps the book's most quoted passage, he wonders:

Where does Nixon's fictional self-creation end and the historical figure begin? Can such a distinction be made about a man who watches the movie *Patton* for the third or fourth time and then orders an invasion of Cambodia meant to destroy the Vietcong Pentagon, which he told us was there, but which has never been found? . . . Why should literature be considered the primary source of fictions, when fictions are produced at every press conference; why should novelists or dramatists be called "creative" when we have had Rusk and McNamara and Kissinger, the mothers of invention, "reporting" on the war in Vietnam? . . . What can I invent that the Kennedys haven't actually accomplished?[6]

And George Steiner's *Extra-territorial*, also published in 1971, likewise centers on this same problem of language and its relation to fictions of state. By his title he means to refer "to the general problem of a lost center" imaged in the literature of exile of writers like Nabokov, Borges, and Beckett.[7] Steiner detects a profound sense of "linguistic crisis" which is generated partly by this feeling of decenteredness but which he ties explicitly to totalitarian politics:

Totalitarian politics . . . have set out to master language. They must do so precisely because a totalitarian model of society lays claim to the care and entirety of the human person. Modern tyrannies have re-defined words, often in a deliberate grotesque reversal of normal meaning: life signifies death, total enslavement stands for freedom, war is peace. . . . Moreover, the planned falsification and dehumanization of language carried out by totalitarian regimes have had effects and counterparts beyond their borders. These are reflected, though in a less murderous way, in the idiom of advertisement, wish-fulfillment and consensus-propaganda of consumer-technocracies. We live under a constant wash of mendacity. Millions of words tide over us with no intent of clear meaning.[8]

It is no step at all from Steiner's "constant wash of mendacity" to Nixon's "whitewash at the White House." It is hardly a much greater step to the recognition that if totalitarian politics set out to master language, then formalism set out to master the arts in a comparably totalitarian gesture.

The ur-text for all this worry about the decline of the language and its relation to the apparent collapse of society as a whole is George Orwell's "Politics and the English Language," an essay notably absent from the first two, 1965 and 1969, editions of the *Norton Reader*—probably the most widely taught essay collection of those years—but prominent in the 1973 third edition. If Orwell provided most of us with an entrée into the problem

adoptable for use in most Freshman Composition courses (and a simplistic advocacy of "clear meaning" along with it), it was poststructuralism which finally provided a theoretical model—Derrida's deconstruction—for exploring the problems we faced as students of language in the United States at a time when language itself, in the public domain at least, seemed to be draining itself of all meaning. Michel Foucault, in his studies of the "operations" of meaning upon which institutions and institutional power are constructed, provided one variation on the model; Jacques Lacan, another, this time in terms of psychology; and Roland Barthes, a third, in his sweeping analyses of the myths upon which popular culture is constructed. As Barthes put it in the 1956 epilogue to his *Mythologies*, a work which appeared in English in 1972 as if in response to the very political climate I have been outlining, "Is myth always depoliticized speech? In other words, is reality always political?"[9] Certainly such questions helped us to see the ways speech could be used to mask reality. And, as a result, they helped to explain Nixon as well, his rhetorical power and tactics—especially insofar as he sought to depoliticize himself by accusing everyone else of playing "politics." Nixon, it was clear, like all great liars, was something of a poststructuralist naïf: he understood that he could invoke transcendent values—our common political *langue*—and disguise any actualization of the *langue* (any *parole*) beneath the fiction (the mythologies) of the *langue* itself. He knew he could make anything *mean* whatever he wanted it to mean. Oliver North would become his very capable student. As the Watergate story unfolded, the quest for a semantic center—the "smoking gun" it was called—became more and more obviously a false search, so that when "the smoking gun" was finally discovered, still no meaningful story could be formed around it, only a fabric of erased tapes and semantic evasions, a plot constructed around phrases like "at that point in time," "I don't recall," and "to the best of my memory."

What no one in the White House foresaw, of course, is the kind of imaginative power such ellipses, such silences, possess. Silence, Susan Sontag had reminded her readers, is a strategy in art designed "to promote a more immediate sensuous experience." It prompted the audience to "confront the artwork in a more conscious, conceptual way." That is, confronted with silence, most audiences will "fill in the gap" for themselves.[10] As Nixon learned, it is not always politically expedient for such power to rest with the public at large. Photography came to dominate Sontag's interest during the seventies because it seemed to her that the presence of the photograph called up its subject matter's absence. There is, of course, a "neutral" photography, in which the meaning is "clear." But good photography provides a different kind of experience. As Roland Barthes put it in his own 1980 study of photography, a "good" photograph "*speaks*, induces us, vaguely, to think." What he recognizes is that this can be perceived as

dangerous: "The editors of *Life* rejected Kertész's photographs when he arrived in the United States in 1937 because, they said, his images 'spoke too much'; they made us reflect, suggested a meaning—a different meaning from the literal one. Ultimately, Photography is subversive not when it frightens, repels, or even stigmatizes, but when it is *pensive*, when it thinks."[11] The famous eighteen-minute gap in Nixon's tapes was ultimately damaging not because it said so little but because it said so much. It allowed us to reflect upon its meaning. My argument, in this book, has been that the majority of the most interesting works of art produced over the course of the last two or three decades ask us to fill in the gaps they produce in much the same way. They are *pensive*, to use Barthes's word. Or, to use Derrida's, they acknowledge their status to be that of the *trace*. As a kind of free-floating signifier, the trace cannot be pinned down; it can never be "put to rest." It demands a more conscious and conceptual approach to art. It demands *critical performance*.

II

In American critical practice, the demand for critical performance can probably be traced back to an essay which appeared in the early sixties in the *Evergreen Review*, Susan Sontag's "Against Interpretation." That essay ends with a call for a new relation to art based on the immediacy of art's experience as opposed to the questionable permanency of its content. "We must learn to *see* more, to *hear* more, to *feel* more. In place of a hermeneutics we need an erotics of art."[12] This is a profoundly anti-New Critical position, one which shifts our attention away from the art object per se in order to focus on our responses to it. To many it seemed to promise only the most profoundly subjective kind of criticism and threatened to atomize the experience of art so completely that the necessity for criticism itself would become obsolete. It seemed narcissistic and self-indulgent—it was anything but. What almost every reviewer of Sontag failed to understand at the time—just as they later failed to understand the similar sense of self-indulgence apparent in a work like *Roland Barthes by Roland Barthes*— was that Sontag was above all else a writer, someone whose thought enters the public forum in order to be heard, debated, tested against other responses. It was this dialogue which Sontag wished to inspire, the spirited dialogue of convictions deeply felt. "Against Interpretation" was *against* a much more truly narcissistic criticism that claimed to have the final word, to fix meaning, to close discourse. Sontag was asking that art be allowed to *live on*.

On this point turns the autobiographical thrust of the best recent criticism. In a 1976 essay on the sculptor Jackie Ferrara, Robert Pincus-Witten put the matter this way: "Until late in the sixties, solemn formalism was assumed to be the only way one talked about art. The mandarin tone ob-

tained as the signal characteristic of distinguished critical and historical dis-
cussion. Disinterestedness. I don't get it anymore—well, not exclusively.
There's this other side of me, the other avenue—work perceived as signifi-
cant must be invested with the value deriving from biography, the really
lived, the idiosyncratic datum, the human."[13] Note the shift in rhetorical
posture in the middle of this statement. In fact, the mandarin tone applies
until the eruption of a series of most unprofessional writerly faux pas—an
incomplete sentence, a contraction, a colloquial expression for understand-
ing or feeling ("get it") and for the more mandarin "at any rate" ("well"),
all followed by an expression of gross imprecision ("there's this other side
of me"). Pincus-Witten may be talking about Jackie Ferrara, but his own
autobiographical position as a writer is obviously at stake in the essay. His
dilemma stems from the fact, as he admits, that in Jackie Ferrara's work he
has confronted "an art for which [formalist] criticism . . . had not devel-
oped a vocabulary." Only in conversation with the artist does he begin to
understand what he sees. Ferrara explains to him how she came to make
her erotic, hairy, hanging forms:

I lived on the lower East Side. It was Succoth (the Jewish Thanksgiving Feast of
Tabernacles). To celebrate the holiday, people came downtown to buy lemons from
Israel, I mean big ugly lemons. Some people examined them with a magnifying
glass to make sure that they were unblemished. A perfect fruit sold up to thirty
dollars apiece. It was unbelievable. Bad ones, I mean where the point of contact
with the tree had fallen off the fruit, were dumped for ten dollars. It's all about this
lower East Side lore. Anyway, they were packed in a packing material, hairy raw
flax, laid out in skeins. I started using this hairy stuff.[14]

By telling this story, by taking the time to *listen* to this story, Pincus-
Witten refuses to fall victim to the kind of misreading which the chairman
of Judy Chicago's art department—the man who read bloody Kotexes as
"white material with red spots"—had earlier. He is not so dissociated from
"the ability to see content" that he sees only the formal dimension of the
work. In fact, Pincus-Witten's piece on Jackie Ferrara is at least half com-
posed of quotations from the artist. She speaks for herself, and Pincus-
Witten's criticism is a dialogue with her. This story transforms Ferrara's
work from merely a formal examination of the potentialities of a certain
material into an assemblage, an example of what Laurence Alloway has
called "junk culture," an art composed of "the throwaway material of cities,
as it collects in drawers, cupboards, attics, dustbins, gutters, waste lots, and
city dumps. Objects," he says, "have a history. . . . Assemblages of such
material come at the spectator as bits of life."[15]

The refusal to see art as connected to life is the mark, of course, of
formalist criticism, and it is, as Pincus-Witten calls it, the "formalist dys-
function."[16] Feminist critics have recognized this dysfunction more rapidly
than most because they have had to react, as Carolee Schneemann had to

react, to a formalist-oriented art world which discounted "the personal clutter / the persistence of feelings / the hand-touch sensibility / the diaristic indulgence" of their art in favor of "the system of the grid / the numerical rational / procedures" which dominated the minimalist sensibility of the late sixties and early seventies. For a writer like Lucy Lippard, whose work since the early seventies has taken a more and more feminist and political tack, it seems obvious that art by women has been caught up in the same historical matrix that has entangled criticism itself. In the introduction to her 1976 collection, *From the Center*, a decade after Sontag's "Against Interpretation" first received widespread attention, Lippard would admit: "The woman's movement changed my life in many ways, not the least being my approach to criticism. It may not show . . . but from the inside, from where I live, there is a new freedom to say how I feel and to respond to art on a far more personal level. I'm more willing to be confessional, vulnerable, autobiographical, even embarrassing."[17]

All of these critics have recognized their own implication in the work they discuss, and they have defined their own activity, at least implicitly, as a performance generated by the work itself. Of all critics, Roland Barthes has probably tested this terrain most rigorously. One of the most persistent metaphors in Barthes is his sense of writing as a performance. "At the crossroads of the entire oeuvre," he says of his own work in *Roland Barthes by Roland Barthes*, "perhaps the Theater" (*RB*, 177).[18] What he means by this is perhaps best understood by looking at his response to a 1963 interviewer from *Tel Quel* who asked him to explain his interest in theater and theatricality: "At a certain point in the performance, you receive at the same time six or seven items of information (proceeding from the set, the costumes, the lighting, the placing of the actors, their gestures, their speech), but some of these remain (the set, for example) while others change (speech, gesture); what we have, then, is a real informational polyphony, which is what theatricality is: *a density of signs*" (*CE*, 261–62). He approaches the art object—the text, the photograph, a film, a painting, the Eiffel tower—as if it were a stationary item of information—the set, if you will—before which his own gestures and speech perform. His relation to the work is like the Mabou Mines' relation to traditional drama. As Ruth Maleczech explained: "[When] it's no longer necessary for the actor to realize the author's intention when he wrote the part . . . a piece becomes the story of the lives of the performers. . . . You see the life of the performer. We're not really working with any material except ourselves." Over his career, Barthes's interest has more and more turned to the self, or rather to the many selves, which speaks before the art object. Of *Roland Barthes by Roland Barthes*—that examination of one figure for the self by another—he would say: "All this must be considered as if spoken by a character in a novel—or rather by several characters" (*RB*, 119). Similarly

criticism is not so much about the work it examines as it is about the critic himself: "How could we believe . . . that the work is an object exterior to the psyche and history of the man who interrogates it? . . . Criticism is not at all a table of results or a body of judgments, it is essentially an activity, i.e., a series of intellectual acts profoundly committed to the historical and subjective existence (they are the same thing) of the man who performs them" (CE, 257).

For Barthes, as I suspect would be the case for most of us, the "historical and subjective existence" to which his criticism was committed was by no means uncomplicated. Barthes is not always sure, in fact, that he likes the person he sees. He is not sure he can even trust the character who is "himself." He wonders if he is *posing* before his own pen. He encounters his subjectivity, as he explains at the end of *The Pleasure of the Text*, "at the conclusion of a very complex process of biographical, historical, sociological, neurotic elements (education, social class, childhood configuration, etc.)." And what he discovers is "a subject at present out of place, arriving too soon or too late (this *too* designating neither regret, fault, nor bad luck, but merely calling for a *non-site*): anachronic subject, adrift" (PT, 62–63). This sense of his own displacement, his own marginality, his status as a wanderer, homeless in his own world, derives in large part from the seemingly ceaseless intrusion of bourgeois values into his thought. "Pleasure" is one word for these values, and its constant presence in his writing, at least after about 1970, is manifested in his sense of being "adrift." This is a writer, after all, who would summarize, in 1971, the direction of his thinking in the forties and fifties in these terms: "I [was] . . . a Sartrian and a Marxist . . . trying to "commit" literary form . . . and to marxify Sartrian commitment, or at the very least—and is it not perhaps enough?—to give it a Marxist justification."[19] Two years later, in *The Pleasure of the Text*, he would announce his longing for a kind of writing which would allow him "not to devour, to gobble, but to graze, to browse scrupulously, to rediscover—in order to read today's writers—the leisure of bygone readings: to be *aristocratic*" (PT, 13). It is not easy to bring such a diversity of desires together.

In fact Barthes never tried to. In his book on Barthes, *The Professor of Desire*, Steven Ungar has gone a long way toward describing a "break"—more accurately, a slow shift in the direction of Barthes's thought that in retrospect reveals itself to be radical in nature—that occurred over the years which span the publication of *Mythologies*, in 1957, and *S/Z*, in 1970. This was a break largely lost on Barthes's American audience (*Mythologies* appeared in translation in 1972, and *S/Z* only two years later). For Ungar, it could be described as a shift from "criticism to figuration": "Because it was based in a view of language that valued the fixity and closure of denotation over the more elusive phenomena of connotation, the

positive linguistics Barthes fashioned from the work of Saussure . . . proved to be less and less suitable to what Barthes saw as the production of meaning."[20] For Barthes, it amounted to the rejection of "any semiology that takes 'scientific' objectivity as its intention," a kind of semiology he felt he had practiced in *Writing Degree Zero* (1953), *Mythologies, On Racine* (1963), and *Elements of Semiology* (1965)—and its replacement by a more "general and systematic enterprise, polyvalent, multidimensional" (*GV*, 130). It is perhaps easiest to understand this shift by considering together, as an example of the development of his thought, the series of essays on photography and film that compose the opening section of *The Responsibility of Forms*—"The Photographic Message" which dates from 1961, "The Rhetoric of the Image" from 1964, and "The Third Meaning" from 1970—and his later *Camera Lucida: Reflections on Photography*, which was published in 1980, the year of his death.

His project, initially, is clearly formalist in both intention and scope. "The Photographic Message" opens with a brief consideration of what constitutes the "message" of the press photograph "as a whole." There are, he says, three parts to the message: "a source of emission," which consists of the newspaper staff, those who select the photo, crop it, compose captions, and so on; "a channel of transmission," which is the newspaper itself; and "the medium of reception," which is the public at large (*RF*, 3). At first, Barthes writes as if he were obligated to ignore both the photograph's origin and its destination, both "the source of its emission" and "the medium of its reception":

The three traditional parts of the message do not call for the same method of exploration; both the emission and the reception of the message pertain to a sociology: a matter of studying human groups, defining motives, attitudes, and trying to link the behavior of these groups to the total society to which they belong. But, for the message itself, the method has to be a different one: whatever the origin and the destination of the message, the photograph is not only a product or a channel, it is also an object, endowed with a structural *autonomy*: without in any way claiming to sever the object from its use, we must provide here a specific method *prior* to sociological analysis—this method can only be the *immanent* analysis of that *original* structure which the photograph constitutes. (*RF*, 3–4; my emphasis)

The structural analysis of the photograph that Barthes promises us here is closely akin to the poetics of immanence which dominated American New Critical literary criticism in the same years. The "immanent object" is autonomous, purified of its potential "use," untarnished by "sociology." And yet, even in 1961, this is not the kind of analysis that Barthes proceeds to give us. Such an analysis, Barthes says, encounters some "initial difficulties" (*RF*, 5).

The primary difficulty is that the photographic message seems to possess a connotative dimension. Connotation, for Barthes, constitutes a "supple-

mentary message" (*RF*, 5): "a certain 'treatment' of the image as a result
of the creator's action, and whose signified, whether aesthetic or ideological,
refers to a certain 'culture' of the society receiving the message. . . . The
code of the connoted system is most likely constituted by either a universal
symbolic or by a period rhetoric, in short by a stock of stereotypes" (*RF*,
5–6). This "supplement" threatens the structural analysis of the photo-
graph from the outset. Sociology, as it were, intrudes. Barthes discovers
that he must leave an analysis of the photograph proper and turn his atten-
tion to a connotation that occurs at "different levels of photographic pro-
duction (selection, technical treatment, cropping, layout)" (*RF*, 9). Barthes
devotes the majority of the essay, then, to elaborating these connotative
procedures—the pose, the accompanying text, and so on—and comes to
the conclusion that "thanks to its code of connotation, the reading of the
photograph is therefore always historical; it depends upon the reader's
'knowledge'" (*RF*, 16–17). The photograph raises a number of questions,
as a result, which Barthes feels unprepared to answer: "How do we read a
photograph? What do we perceive? In what order, according to what itin-
erary? What is it, in fact, to 'perceive'?" (*RF*, 17). In other words, by the
end of this early essay, Barthes has begun to query the larger context of
the work, to recognize its implication in "sociology." "Like any well-
structured signification, photographic connotation is an institutional ac-
tivity; on the scale of society as a whole, its function is to integrate, in
other words to reassure, humanity. . . . By trying to reconstitute in its
specific structure the connotation-code of a communication as broad as the
press photograph, we may hope to recognize in all their complexity the
forms our society employs to reassure itself" (*RF*, 20). The aims at the end
of the essay seem almost diametrically opposed to those outlined at the end
of its first paragraph. It is as if the essay embodied Barthes's talking himself
out of his own formalism.

 In "The Rhetoric of the Image," written three years after Barthes's first
essay on photography, he complicates his theory by concentrating now not
on just the single "photographic message" but on the photograph's "three
messages"—the literal message, the symbolic message, and the linguistic
message. The literal message is purely *denoted*—that is, it represents an
"Adamic state of the image; utopianly rid of its connotations, the image
would become radically objective, i.e., ultimately innocent" (*RF*, 31).
Barthes is especially interested in the ways in which this utopian form—an
unencoded message that amounts to the visual equivalent of Derrida's *s'en-
tendre parler*, a simultaneity of seeing and understanding—is mytholo-
gized in the popular imagination so that it provides a means of "masking
the constructed meaning [of the image] under the appearance of the given
meaning" (*RF*, 35). Like the immanence of speech for the poet, for its
viewer the photograph seems to render the world and its meaning fully

present. It is, in this sense, a nostalgic medium.[21] Its symbolic messages—or culturally encoded and connoted messages—*appear* natural, innocent, immediate, and unmediated. As Barthes so eloquently puts it, "The discontinuous world of symbols plunges into the narrative of the denoted scene as into a lustral bath of innocence" (*RF*, 40). And the linguistic message serves to *anchor* this feeling of the natural and the innocent:

> Every image is polysemous; it implies . . . a "floating chain" of signifieds of which the reader can select some and ignore the rest. Polysemy questions meaning, and this question always appears as a dysfunction. . . . Hence, in every society a certain number of techniques are developed in order to *fix* the floating chain of signifieds, to combat the terror of uncertain signs: the linguistic message is one of these techniques. On the level of the literal message, language answers, more or less directly, more or less partially, the question *What is it?* Language helps identify purely and simply the elements of the scene and the scene itself. . . . The text *directs* the reader among the various signifieds of the image, causes him to avoid some and to accept others. . . . Anchoring is a means of control, it bears a responsibility, confronting the projective power of the figures, as to the use of the message; in relation to the freedom of the image's signifieds, the text has a *repressive* value, and we can see that a society's ideology and morality are principally invested on this level. (*RF*, 28–29)

It is important to recognize here that polysemy threatens to stymie the structuralist analysis of the image as well, that structuralism itself constitutes the repression of the image. Just as the "sociology" of the image seemed beyond the capabilities of Barthes's analysis in "The Photographic Message," here the image's inability to arrive at the utopian condition of the purely denotative—Barthes's very realization that denotation is in fact a social myth, embedded in ideological and moral values—forces Barthes to recognize the incapacities of structuralist methodology. Connotation, he realizes, is constituted in "the variability of readings" the image receives, and "the language of the image," therefore, "is not merely the entirety of utterances emitted," as it is for Saussure, but "it is also the entirety of the utterances received." For Barthes, "such language must include the 'surprises' of meaning" (*RF*, 36).

By 1964, in other words, Barthes had begun to discover in images a certain *excess*, a signifying, or a quality of signification, larger than the resources of structuralism particularly and formalist analysis generally. And he had opened himself to what amounts to a theory of signification based on the idea of *reception*. That is, though initiating his criticism in the desire to describe objectively the signifying procedures of the sign, he inevitably finds himself face to face with the receiver's response to the sign, with his own subjectivity. "The Third Meaning" is his first metaphor for this subjective response. The "first" and "second" meanings of the image— this time, stills from motion pictures—should be by now relatively predictable. The "first" meaning is more or less denotative and corresponds to

the "informational level" of the image. The "second" meaning is connota-
tive and corresponds to the "symbolic" level of the image. But "Is this all?"
Barthes asks. "No," he says, a theory of reception announces itself, "for I
cannot yet detach myself from the image. I read, I receive (probably
straight off, in fact) a third meaning, erratic yet evident and persistent. I do
not know what its signified is, at least I cannot give it a name, but I can
clearly see the features—the signifying accidents of which this heretofore
incomplete sign is composed. . . . I propose calling it the obtuse meaning.
The word comes readily to my mind" (RF, 42, 44). The rhetoric here is
distinctly different from anything else we have seen in Barthes's writing so
far. It is dominated by the first-person singular, instead of the mythical
"we" which marks all supposedly objective discourse, as if "we" can all
"see" what the critic describes for us. "As we shall see more clearly in a
moment," Barthes writes in "The Rhetoric of the Image" (RF, 28), and,
having made his point a few pages later in the essay, he inaugurates a sec-
tion by declaring, "We have seen . . . " (RF, 31). Now we track his mind,
watch it operate, but no longer is there any pretense of our *complicity* in
its operations:

I first had the conviction of the obtuse meaning with regard to image V [from
Eisenstein's *Potemkin*, reproduced here with Barthes's image VI as Figs. 90 & 91].
A question occurred to me: What is it about this old woman weeping that raises the
question of the signifier for me? . . . I quickly decided that, however perfect they
might be, it was neither the countenance nor the gestural repertoire of grief (closed
eyelids, drawn mouth, fist over the breast): all that belongs to full signification, to
the obvious meaning of the image, to Eisensteinian realism and decorativeness. I
felt that the penetrating feature—disturbing as a guest who persists in staying at
the party without uttering a word, even when we have no need of him—must be
located in the area of the forehead: the kerchief had something to do with it. Yet in
image VI the obtuse meaning vanishes, there is no more than a message of grief. I
realized then that the "scandal," the supplement or deviation imposed upon this
classical representation of grief, derived quite explicitly from a tenuous relation:
that of the low kerchief, the closed eyes, and the convex mouth . . . from a relation
between the "lowness" of the kerchief, worn abnormally close to the eyebrows as
in those disguises which seek to create a foolish and stupid expression, the circum-
flex accent formed by the old, faded eyebrows, the excessive curve of the lowered
eyelids, close-set but apparently squinting, and the bar of the half-open mouth
corresponding to the curve of the kerchief and to that of the brows, metaphorically
speaking, "like a fish out of water." All these features (the absurdly low kerchief,
the old woman, the squinting eyelids, the fish) have as a vague reference a some-
what low language, the language of a rather pathetic disguise. United with the noble
grief of the obvious meaning, they form a dialogism so tenuous that there is no
guarantee of its intentionality. (RF, 48–49)

As Barthes describes it, there is nothing at all curious about the power
which he discovers in this still. His "obtuse" meaning is a function of the
formal relation among various elements in the composition of the image—
the correspondence and repetition among the arched elements of the old

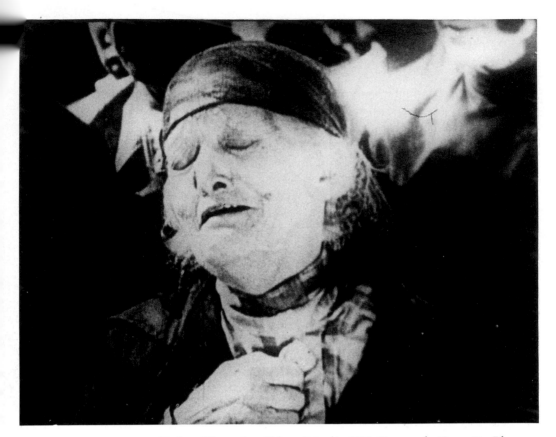

FIGURE 90. Sergei Eisenstein, still from *Potemkin*, 1925. Courtesy the Humanities Film Collection, Center for the Humanities, Oregon State University.

woman's face. By "disguise" I think Barthes means to suggest the *construction* of the image, his feeling that it is, as it were, com*posed*, duplicitous. Just as in the press photograph connotation receives the "objective mask" of denotation, here the "obtuse meaning" hides behind the mask of the "obvious meaning," but it does not merely hide. It is so constructed that the artifice of the image announces itself. That is, if the image signifies first grief and then disguise, it threatens to subvert its own signification. It threatens to announce its "grief" as a sham, a pose, an "act." The image becomes, in Barthes's word, *signifying*, describing nothing specific, nothing nameable, only something *other* than what it *appears* to be. "In other words," says Barthes, "the obtuse meaning is not structurally situated, a semantologist would not acknowledge its objective existence. . . . The obtuse meaning is a signifier without a signified; whence the difficulty of naming it: my reading remains suspended between the image and its description, between definition and approximation" (*RF*, 54–55).

Here Barthes announces the full thrust of his break from structuralism—

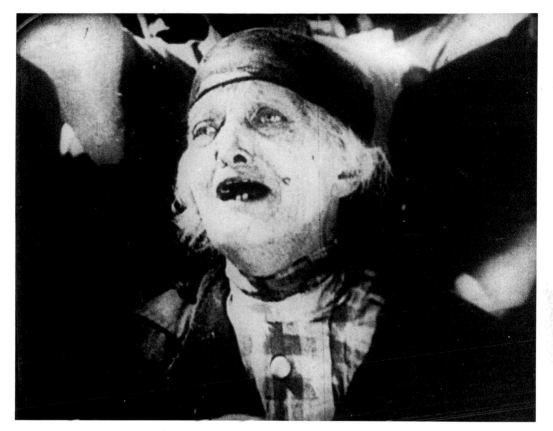

FIGURE 91. Sergei Eisenstein, still from *Potemkin*, 1925. Courtesy the Humanities Film Collection, Center for the Humanities, Oregon State University.

to be "structurally situated" is to have "objective existence." But Barthes's reading is above all *subjective*. In an interview conducted the same year as this essay was written, Barthes elaborated on the distinction he had made between the writer (*écrivant*) and the author (*écrivain*). The writer is, in effect, a structuralist, "someone who thinks that language is a pure instrument of thought." But for the author, "language is a dialectical space where things are made and unmade, where the author's own subjectivity is immersed and dissolved" (*GV*, 105). Barthes would like to be, he admits, an author, someone who "works in the *volume* of language . . . and is willing to renounce the guarantees of transparent, instrumental writing," someone who "performs the text," someone whose work "is essentially tied to a criterion of indeterminacy" (*GV*, 106–07). It is worth suggesting, I think, that Barthes's reading of the Eisenstein stills takes place, then, on two levels. He locates in the stills the very indeterminacy—what I have called undecidability—to which he himself aspires. In other words, there are *two authors* here: the first is Eisenstein, the second Barthes; the former inspir-

ing and *authorizing*, as it were, the latter. And the old woman in *Potemkin*, furthermore, becomes a figure for the author—both, in a sense, perform Eisenstein's text. And across the features of both is written the question of disguise. As he would describe his use of the first-person singular pronoun in an interview in 1977, his writing is "the discourse of a subject who says *I*, who is thus individualized on the level of utterance, but the discourse is nevertheless a composed, feigned, or, if you prefer, a 'pieced-together' discourse (the result of montage)" (*GV*, 285). It is no accident, of course, that Barthes defines the authorial self here in terms of Eisensteinian montage. In "The Third Meaning" he quotes Eisenstein on audiovisual montage: "Art begins the moment the creaking of a boot (on the sound track) accompanies a different visual shot and thereby provokes corresponding associations" (*RF*, 56). If the "obtuse meaning" is the creaking boot accompanying the obvious meaning of the image, then Barthes's own writing constitutes, in relation to the still, the same sort of *noise*.

III

From 1970 on, everything in Barthes's writing revolves around this disruptive set of personae or characters which constitute the Barthesian self. There is Barthes "the structuralist he may never have been," as Steven Ungar puts it;[22] Barthes the author (*écrivain*); Barthes the talker— "Language is a skin: I rub my language against the other. It is as if I had words instead of fingers, or fingers at the tip of my words"; Barthes the reader, the lover of nineteenth-century literature—"For hours on end I read Zola, Proust, Verne, *The Count of Monte Cristo*. . . . This is my pleasure" (*PT*, 40); Barthes the petit bourgeois—"no one is safe from this evil" (*RB*, 144); Barthes the actor—"I am speaking of myself in the manner of the Brechtian actor who must distance his character: 'show' rather than incarnate him" (*RB*, 168); and so on. Presented with this plethora of selves, who *is* Roland Barthes? As Barthes puts it, ultimately, in *Camera Lucida*: "In front of the lens, I am at the same time: the one I think I am, the one I want others to think I am, the one the photographer thinks I am, and the one he makes use of to exhibit his art" (*CL*, 13). Or, better perhaps, in *Roland Barthes by Roland Barthes*: "All this must be considered as if spoken by a character in a novel—or rather by several characters. . . . The image-repertoire is taken over by several masks (*personae*), distributed according to the depth of the stage (and yet no one—*personne*, as we say in French—is behind them)" (*RB*, 120). As Ungar explains, "the essential feature of the *Roland Barthes* involves the implementation of an autobiographical mode as a ploy against false objectivity, a move which recalls Nietzsche's conclusion that the objective is, in fact, merely a form of the subjective."[23] In other words, Barthes is himself comparable to the photograph or the document. He is, on the one hand, the "trace" of those "bio-

graphical, historical, sociological, neurotic elements (education, social class, childhood configuration, etc.)" which he "mirrors" in his very being. What he writes can never be "objective." It must submit itself to its "prejudices," its "points-of-view," its subjectivity. But he is, as well, a *projection*—the trace *as* a kind of projection: "For him," he writes in *Roland Barthes*, "it is not a question of recovering a pre-meaning, an origin of the world, of life, of facts, anterior to meaning, but rather to imagine a post-meaning" (*RB*, 87).

Barthes, then, is preoccupied with situating, theoretically at least, this potentiality of the image—from the photographic message proper to the image repertoire which, to invoke the rhetoric of disguise, *makes up* the self. Portrait photography becomes, in *Camera Lucida*, the focus of this interest. "Photography," he says, "began, historically, as an art of the Person: of identity, of civil status, of what we might call, in all senses of the term, the body's *formality*" (*CL*, 79). In the photographic portrait, in other words, Barthes is able to read a *rhetoric*, a conscious formal construction of the self. Or rather, he can detect a *body* or *corpus* of competing rhetorics—what the photographer saw, what the subject of the portrait wished to convey, what Barthes is himself able to see. This is perhaps the most personal of all Barthes's books, and the most suggestive. Like his earlier works, it revolves around "one of those voluntarily artificial oppositions" for which, he says, "I've always had a certain predilection . . . for example, between *écriture* and *écrivance*, 'denotation,' and 'connotation'" (*GV*, 206). This time his opposing terms are the *studium* and the *punctum*. Closely related to the obvious and obtuse meanings, the *studium* derives from "an average affect, almost from a certain training" (*CL*, 26), a reading of the photograph that is culturally derived and generalizable, while the *punctum* is an element which disrupts or pierces the affects of the *studium*. "The *studium* is ultimately always coded, the *punctum* is not." The effect of the latter, like the effect of the "third meaning," is "certain but unlocatable, it does not find its sign, its name" (*CL*, 51–53).

Barthes's procedure here is almost exactly analogous, at least initially, to the critical procedures of the "The Third Meaning." He presents us with a series of photographs which possess, for him, a *punctum*. "Starting from a few personal impulses, I would try to formulate the fundamental feature, the universal without which there would be no Photography" (*CL*, 8–9). Where earlier Barthes had conceived of sociology and psychoanalysis as beyond the competence of his own structuralism, now this "personal" approach stands categorically against the critical languages of sociology, semiology, and psychoanalysis as a group; they are all too systematic; his personal approach represents, he says, "a desperate resistance to any reductive system" (*CL*, 8). And yet, by the end of the first half of the book, Barthes feels that he has failed. Summarizing his project, he says, "I had

perhaps learned how my desire worked, but I had not discovered the nature (the eidos) of Photography. I had to grant that my pleasure was an imperfect mediator, and that a subjectivity reduced to its hedonist project could not recognize the universal." The second half of the book will represent, he says, "my recantation, my palinode" (*CL*, 60). But rather than returning to a more systematic and objective level of discourse, as we would expect given this admission, Barthes becomes even more personal. The implication is unmistakable: his error was not so much in concentrating on his own subjective responses to photographs as it was in seeking "the universal," the totality which, at the end of *Roland Barthes*, he denounces as a "monster" (*RB*, 180). Instead of investigating the public photograph, then, our common photographic heritage—the work of Avedon, Mapplethorpe, Kertész, and Klein which had occupied him in the first half of the book—he turns to *private* photographs, namely to photographs of his mother. I would like to quote from the opening sections of part 2 at some length in order to underscore the shift in rhetoric that occurs here:

Now, one November evening shortly after my mother's death, I was going through some photographs. I had no hope of "finding" her. . . . I could not even say about these photographs . . . that I loved them: I was not sitting down to contemplate them, I was not engulfing myself in them. I was sorting them, but none seemed to me really "right": neither as a photographic performance nor as a living resurrection of the beloved face. . . .

There I was, alone in the apartment where she had died, looking at these pictures of my mother, one by one, under the lamp, gradually moving back in time with her, looking for the truth of the face I had loved. And I found it.

The photograph was very old. The corners were blunted from having been pasted into an album, the sepia print had faded, and the picture just managed to show two children standing together at the end of a little wooden bridge in a glassed-in conservatory, what was called a Winter Garden in those days. My mother was five at the time (1898), her brother seven. He was leaning against the bridge railing, along which he had extended one arm; she, shorter than he, was standing a little back, facing the camera; you could tell that the photographer had said, "Step forward a little so we can see you"; she was holding one finger in the other hand, as children often do, in an awkward gesture. The brother and sister, united, as I knew, by the discord of their parents, who were soon to divorce, had posed side by side, under the palms of the Winter Garden (it was the house where my mother was born, in Chennevières-sur-Marne).

I studied the little girl and at last rediscovered my mother. The distinctness of her face, the naïve attitude of her hands, the place she had docilely taken without either showing or hiding herself, and finally her expression, which distinguished her, like Good from Evil, from the hysterical little girl, from the simpering doll who plays at being a grownup—all this . . . had transformed the photographic pose into that untenable paradox which she had nonetheless maintained all her life: the assertion of a gentleness. In this little girl's image I saw the kindness which had formed her being immediately and forever, without her having inherited it from anyone; how could this kindness have proceeded from the imperfect parents who had loved her so badly—in short: from a family? (*CL*, 62–63, 67–69)

The prose here is no longer critical but novelistic, like Proust, Barthes himself remarks, leaning over one day to take off his boots, and suddenly remembering "his grandmother's true face" (*CL*, 70). In this very old photograph of a very young girl, the past is made present. Distinctions, oppositions, dissolve. We "overhear" the photographer instructing his mother to step forward into the light-filled room (*camera lucida*); we sense the intimacy between brother and sister, their unity in the face of their family's dissolution. We "oversee" Barthes discovering this photograph in the darkness of a room in his mother's apartment, the photograph "coming to light" under the lamp; we sense his love for her in the face of her own dissolution, her death. Static idealizations of the experience of looking, Barthes's selection of photographs, like his selection of Eisenstein stills, collapses time, removes the image from history, defeats, even—preeminently in the Winter Garden photograph—death itself. "The Winter Garden Photograph was indeed essential," Barthes writes, "it achieved for me, utopically, *the impossible science of the unique being*" (*CL*, 71).

But—and this is the point—Barthes's narration, the lyric, idealizing persuasion of his voice, must be taken as a *pose*, as if spoken by a character in a novel (and, of course, Barthes's first-person singular here is very much the novelistic "I," the speech of a potentially unreliable narrator). Barthes is not Proust, nor does he aspire to the Proustian moment (though, for a moment, he adopts Proust's style as a sort of disguise). What matters to him, Barthes insists, is "not the photograph's 'life.' . . . The Photograph does not call up the past (nothing Proustian in a photograph). The effect it produces upon me is not to restore what has been abolished (by time, by distance) but to attest that what I see has indeed existed" (*CL*, 81–82). The photograph does not transcend history, collapse distinctions between past and present; rather, it *recuperates* history: "Perhaps we have an invincible resistance to believing in the past, in History, except in the form of myth. The Photograph, for the first time, puts an end to this resistance: henceforth the past is as certain as the present, what we see on paper is as certain as what we touch. It is the advent of the Photograph—and not, as has been said, of the cinema—which divides the history of the world. . . . The important thing is that the photograph possesses an evidential force, and that its testimony bears not on the object but on time" (*CL*, 87–88). What the Winter Garden photograph presents to Barthes is not, after all, his mother's "unique being." It is the uncontestable evidence that she was there, "*on that day*" (*CL*, 82), in 1898. It presents, in other words, a unique moment—a sort of vernacular "still"—from the history of her being. This, Barthes realizes, constitutes another, different sort of *punctum*: "This new *punctum*, which is no longer of form but of intensity, is Time, the lacerating emphasis of the *noeme* ("*that-has-been*"), its pure representation" (*CL*, 96).

Hence Barthes's taste, as an author, for the fragment. The fragment, like

the photograph, is "lifted" out of a hypothetical, larger discourse. It is always more than it says, leaving around itself an indefinite space, the projective possibility of its going on. "I have long had a taste for discontinuous writing," Barthes told an interviewer in 1975, "a tendency reactivated in *Roland Barthes*. . . . My mode of writing [is] never lengthy, always proceeding by fragments, miniatures, paragraphs with titles, or articles. . . . The implication from the point of view of an ideology or a counter-ideology of form is that the fragment breaks up what I would call the smooth finish, the composition, the discourse constructed to give a final meaning to what one says" (*GV*, 209). The still, the photograph, the fragment all reject the finality of "meaning." They resist what Barthes labels the "*oeuvre*," the unified body of work. "I delight continuously, endlessly, in writing as in a perpetual production, in an unconditional dispersion. . . . But in our mercantile society, one must end up with a work, an '*oeuvre:*' one must construct, i.e., complete, a piece of merchandise" (*RB*, 136). The fragment allows Barthes to write, as it were, *hors d'oeuvre*—"Liking to find, to write *beginnings*, he tends to multiply this pleasure: that is why he writes fragments: so many fragments, so many beginnings, so many pleasures" (*RB*, 94). The Winter Garden photograph is just such a fragment, such a beginning, such a pleasure. It initiates writing. And because Barthes refuses to publish it, it exists for us, literally, only as writing. We experience it, that is, as an absence which Barthes's writing fills, a sort of necessary, generative, and disseminative nonsite at the center of his book. If Barthes has withdrawn from our scrutiny the very object of his critical performance, it is only to demonstrate that his real object is to *enliven* that photograph, to ensure its *living on*, not as an object per se but in his performance of it. Barthes's Winter Garden photograph, taken in 1898, is, in this sense, a final and ideal figure for postmodern art, an unreproducible specter projected onto the stage of the present—vernacular, open-ended, undecidable, and eliciting, finally, like *Camera Lucida* itself, its own production in us.

EPILOGUE

The film opens in the middle of nowhere. The landscape is entirely flat, almost totally empty. We are positioned above the center of a dirt road. It leads straight away, directly toward the horizon, disappearing in an almost perfect vanishing point. The scene is reminiscent of Robert Frank's *The Americans*, his photo of *U.S. 285, New Mexico*, heading off into the heart of the land.

Just as in the Frank photograph, where a lone car emerges out of the oblivion of the distance, headed toward us, down this dirt road comes a little girl. Where does she come from? How did she get way out here? She is dressed all in white, and she is humming, making little noises that seem to answer the sounds of the invisible insects and birds that inhabit the place. Her hands are clasped together, and she weaves her arms in front of her, in a rising snake-like coil, as if in homage to the resident rattlers. She begins to sing a song, a repetitive motif that is, shortly, taken up by musical instruments on the soundtrack, a thirteen-note sequence in 4/4.

The choreography, in fact, is by performance artist Meredith Monk. It recalls *Songs from the Hill*, a solo performance of the mid-seventies in which Monk, dressed all in white like the little girl here, evokes the desert world. To create the work she had spent days on a New Mexico hilltop, listening to the birds, the insects, "tuning," to borrow David Antin's word, to the landscape itself.

As soon as it is taken up by musical instruments, the score begins to sound as if it were composed by Philip Glass for an opera by Robert Wilson. It continues, becoming more and more insistent, behind a voice-over:

This whole area was once under water. . . . Kind of looks like it, doesn't it? After that there was a period when dinosaurs roamed over the landscape. . . . I used to be fascinated by dinosaurs when I was a kid . . . a lot of guys were. . . . Early inhabitants here referred to themselves as "the people." Other groups were referred to as "friends." The word "Texas" comes from the Caddoan word for friend. The Caddo were among the first to be wiped out by the early white settlers. . . . One group of Spanish settlers offered the Indians the chance to become slaves. . . . The Indians thought about it . . . decided it was not a good idea, and killed the Spaniards. . . . The Spaniards fought the Mexicans. The Mexicans fought the "Americans." The "Americans" fought the Wichitas. The Wichitas fought the Tunkowas. The Tunkowas fought the Comanches. The Comanches fought everyone.

As this narrative progresses, a montage of photographs, archival stills, and old film footage fills the screen: a clip of a growling dinosaur from the Victor Mature classic *One Million B.C.*, directed by Hal Roach in 1940; a

publicity photo of Raquel Welch, suitably decked out in prehistoric leathers, in her 1966 remake of the same film; a still from the TV show, *Little House on the Prairie*; documentary footage of Buffalo Bill Cody; and all manner of sequences from black-and-white Wild West films of yesteryear. The name of this film is *True Stories*.[1] It is, the credits explain, "A film about a bunch of people in Virgil, Texas." The film is directed by David Byrne, the lead singer of the rock band the Talking Heads, a graduate of the Rhode Island School of Design (where he was involved in performance art, one time shaving his beard as Russian messages were flashed on cue cards), and here, in *True Stories*, the narrator of his own film. One critic described him, in his black Stetson and string tie, as looking like "the earthly offspring of Mr. Rogers and E. T."[2]

True Stories is a film about performance—performance in everyday life, a vernacular *Gesamtkunstwerk*. In order to celebrate the state sesquicentennial, and its own "Special-ness" as a community at the same time, the city of Virgil is staging a series of events over the course of two or three days, with Byrne, in pseudodocumentary fashion, acting as our guide. There is a lip-sync contest at the local disco, to the tune of the Talking Heads' "Wild Life," in which everyone gets a chance to put themselves in the position of lead singer Byrne, who sits in the audience and watches. But they do not so much imitate Byrne as rock stars in general—Billy Idol, Madonna, Michael Jackson, and Prince. "Odd to think," Byrne writes in the screenplay, "that some lip-synchers are imitating characters in Videos, who are really musicians imitating other characters" (50). Later in the movie, the Talking Heads themselves perform the rock video "Love for Sale," in which the band "imitates the movements and attitudes of ads. . . . Occasionally, real IMAGES FROM ADS are mixed in . . . confusing the issue even further" (120). There is a parade down Main Street, an evangelical revival meeting, and a fashion show at the local mall, this last a Texas-style parody of the famous fashion show in Fellini's *Roma*. And next to these group or community performances, there are individual ones: a lying woman constructs a new identity for herself at every opportunity; the mayor, played by Spalding Gray (himself a reference to performance within the performance), seems to have appropriated every hand gesture known to public speaking and reassembled them into what Byrne calls "an almost abstract dance" (158). All of this culminates in a grand finale Friday night Talent Show. On a temporary stage, constructed on the outskirts of town, with only the vast flatness of the Texas landscape behind it, recalling great contemporary earthworks such as Michael Heizer's *Complex One/City* in south-central Nevada, we are treated to performances by the Apache Belles from Tyler, Texas (familiar to football fans everywhere for their halftime shows), the Dueling Auctioneers, amateur ventriloquists, a yodeler, a Tex-Mex band called Los Vampiros, a Yo-Yo duet, a shadow dancing act, a senior citizens

dance ensemble called the Garland Blue Star Line Dancers, and finally the film's star, Louis Fyne, accompanied by the Country Bachelors, singing "People Like Us."

Like the idea of the family constructed by Nicholas Nixon, or the multiplicity of characters that constitutes Cindy Sherman's ongoing series of "filmic" self-portraits, every person in this film is composed of a fabric of "found" identities (with the possible exception of Fyne, who is described as an "honest man" (140) who believes "in the joys and contentment of matrimony" (124)—but whose authenticity we have to question given the Texas-style breadth of his character's cliché). Byrne himself, at any rate, is no exception. Carter Ratcliff has described Byrne's stage presence this way: "He insists on something that the painterly lather of neo-Expressionism often tries to hide: in a world of institutions, 'lifestyles,' and scenes designed to absorb the self, all selves with even a trace of authenticity must acknowledge that they are—but must also object to being—patched together. . . . Byrne's self-images are definitely images."[3] Byrne is always, obviously, playing a role.

Even in its formal dimensions, the film is constructed as a pastiche of other artists' work. If the score, initially, sounds like a remake of a Robert Wilson opera, that is because the film's director, David Byrne, had just finished collaborating with Wilson, as he began the film, on the music and lyrics for the "Knee Play" interludes of Wilson's *The Civil Wars*. Wilson, in fact, had an even greater influence. In the introduction to the book, Byrne says: "The way this film framework was constructed was inspired by my work with Robert Wilson, by his working process. He often begins work on a theater piece with mainly visual ideas and then layers the sound and dialogue on top of that. I used a similar method" (9). And if the visual world of the movie also seems curiously familiar, that may be because in putting the movie together Byrne "began to look, over and over again, at books of photography and the work of various photographers. Two recent books— surveys of new color photography—were really useful. With these I could show somebody a photograph by William Eggleston or Len Jenschel or Joel Sternfeld or Stuart Klipper, among others, and say, 'This is the kind of color I want in this scene, and this is the way I envision this room' "(12).[4] Eggleston's color photography (Color Plate IV), examples of which Byrne used to illustrate the introduction to *True Stories* the book, derives much of its power, as John Szarkowski noted in the catalogue to Eggleston's first show at the Museum of Modern Art in 1976, "from commonplace models . . . on the surface as hermetic as a family album."[5] They also address, as if innocently, the highest forms of modernist art, as if Mondrian were himself a Tallahatchie County architect. But precisely because his photographs are at once so familiar and so formal, so much a part of our common experience and yet aesthetically grounded in the modernist tradition, they

evoke what I described in my discussion of oral poetics as "the wisdom of everyday life." As in Garry Winogrand's earlier work, or Barthes's Winter Garden photograph, the vernacular rhetoric of such images undermines their own formality, even as the very formality of their presentation elevates the vernacular image into the realm of art.

Again like Barthes's Winter Garden photograph and the other documents and traces of performance considered in these pages, the visual record generates narratives. But if this film is constructed of "true" stories, we very quickly lose track of just where that truth resides. Whoever "people like us" are, we are probably undecidable. We are like Varicorp Corporation, the microchip firm largely responsible for funding the Celebration of Specialness. Its name sounds as if it has something to do with the truth, *veritas*. But its actual root is from the Latin *varius*, various, variable. "I'm saddened and disappointed to have to admit," Byrne says in an "Author's Note" which appears in small print on an acknowledgments page at the rear of the *True Stories* book,

that a lot of the stories are made up. Although I was indeed inspired by newspaper articles, and books and magazine articles that are purported to be about real people, I used the stories mainly as inspiration. It seems to give the movie an extra little bit of excitement to think that maybe it could be true. . . . You know, I'm not even sure the magazine articles are accurate. To tell you the truth, I don't even really care. What's important is that I believed they were true when I read them. And what's important in this book and in the film is that the spirit rings true. (189)

So, then, in something of the same spirit, let me end with a story of my own.

This is, I think, a parable about postmodern art. It wasn't meant to be. It's just a story—or a story within a story—told to me by a woman who was seated next to me one day on a plane flying into Houston, Texas. Suddenly, just as we were landing, she turned to me and laughed and said, "I know the cutest story." She had explained, already, that many years ago she had grown up in Texas, in "a one-horse town" thirty or forty miles north of Dallas. She had left the state about forty years ago when she got a letter from her husband telling her that he had met a Korean girl and married her. He didn't know how that would affect her feelings for him, but he thought she'd understand. She didn't. She'd put her kids in the car and headed west until she found a town she liked. "I'd never seen but a little bitty tree maybe six feet tall in all my life," she explained, and when she found a place with a lot of tall trees, she stopped. She told me this story by way of explaining, I think, her own encounters with a new world, what it was like to raise the kids, off on her own, in a new place, with nothing to rely on much but her instincts, her intelligence, and her own good humor. You've probably heard this story before:

There were these two fellows who got on a train for the first time in their lives. And they were amazed at everything about it—the speed, the

convenience, the comfort. And they were even more amazed when another fellow came around selling food—bananas in particular. They had never seen bananas. But they each bought one, and just as they went into a tunnel, one managed to get his unpeeled and to take a bite. "Billy," he asked his buddy, "did you eat any of that banana yet?" "No," Billy replied. "Well, it's a good thing," said the other, "cause I just took a bite of mine, and I've gone plumb blind."

NOTES

PREFACE

1. Hal Foster, "Postmodernism: A Preface," in *The Anti-Aesthetic: Essays on Postmodern Culture* (Port Townsend, Wa.: Bay Press, 1983), xi. For a later, more developed argument along these same lines see Foster's essay "Against Pluralism," in *Recodings: Art, Spectacle, Cultural Politics* (Port Townsend, Wa.: Bay Press, 1985), 1–32.

2. Jean-François Lyotard, "Presenting the Unpresentable: The Sublime," *Artforum* 20 (April 1982): 69.

3. Roland Barthes, *The Responsibility of Forms: Critical Essays on Music, Art, and Representation*, trans. Richard Howard (New York: Hill and Wang, 1985), 153.

INTRODUCTION

1. Michel Benamou, "Presence and Play," in *Performance in Postmodern Culture*, Theories of Contemporary Culture, vol. 1, ed. Michel Benamou and Charles Carmello (Madison, Wis.: Coda Press and the Center for Twentieth Century Studies, University of Wisconsin—Milwaukee, 1977), 3; and Th. W. Adorno, *Philosophy of Modern Music* (New York: Continuum, 1973), 30.

2. Susan Sontag, *On Photography* (New York: Farrar, Straus and Giroux, 1978), 149. Subsequent page references to this edition are included in the text.

3. Walter Pater, *The Renaissance* (London: Macmillan, 1910), 235–36.

4. Murray Krieger, *Theory of Criticism: A Tradition and Its System* (Baltimore: Johns Hopkins University Press, 1976), 212.

5. The best discussion of art as an immanent object is by Charles Altieri in his *Enlarging the Temple: New Directions in American Poetry during the 1960s* (Lewisburg, Pa.: Bucknell University Press, 1979).

6. Harold Rosenberg, *The Anxious Object: Art Today and Its Audience* (New York: Mentor Books, 1966); Lucy Lippard, "The Dematerialization of Art," *Art International* 12 (February 1968), rpt. in *Changing: Essays in Art Criticism* (New York: Dutton, 1971), 255–276; and Barbara Rose, *American Art since 1900* (New York: Praeger, 1975).

7. See "Situation Esthetics: Impermanent Art and the Seventies Audience," *Artforum* 18 (January 1980): 22–29.

8. Michael Fried, "Art and Objecthood," *Artforum* 5 (June 1967), rpt. in *Minimal Art: A Critical Anthology*, ed. Gregory Battcock (New York: Dutton, 1968), 140, 146.

9. Barbara Rose, *American Painting: The Eighties* (Buffalo: Thoren-Sidney Press, 1979), unpaginated.

10. Clement Greenberg, "Avant-Garde and Kitsch," in *Art and Culture* (Boston: Beacon Press, 1961), 7.

11. William Seitz, *The Art of Assemblage*, catalogue to an exhibition at the Museum of Modern Art, October 2–November 12, 1961 (New York: Museum of Modern Art, 1961), 23.

12. As Kay Larson has recently put it: "It's fascinating to watch the habitual misuse of this term [postmodernism] in the art world. Over several decades historical Modernism became conflated with Greenberg's definition of it. The modern-

ist impulse has not yet exhausted itself; what is 'post' is Greenbergian formalism"; "The Dictatorship of Clement Greenberg," *Artforum* 25 (Summer 1987): 76.

13. Greenberg, "Avant-Garde and Kitsch," 9.

14. Michael Fried, "How Modernism Works: A Response to T. J. Clark," *Critical Inquiry* 9 (September 1982): 229 n. 17. Together with Clark's side of the debate, the essay is reprinted in *Pollock and After: The Critical Debate*, ed. Francis Frascina (New York: Harper and Row, 1985).

15. Ibid.

16. Howard N. Fox, *Metaphor: New Projects by Contemporary Sculptors (Acconci, Armajani, Aycock, Ewing, Morris, Oppenheim)* (Washington, D.C.: Hirshhorn Museum and Sculpture Garden, Smithsonian Institution Press, 1982), 16.

17. Seitz, *The Art of Assemblage*, 88–89.

18. Thomas Crow, "Modernism and Mass Culture in the Visual Arts," in *Pollock and After*, 257–58.

19. Quoted in Suzi Gablik, *Has Modernism Failed?* (New York: Thames and Hudson, 1984), 109–10.

20. Ibid., 107.

21. Steven Vincent, "Fashion/Moda at the New Museum," originally printed in the *East Village Eye*, 1980, rpt. in *ABC No Rio Dinero: The Story of a Lower East Side Art Gallery*, ed. Alan Moore and Marc Miller (New York: ABC No Rio with Collaborative Projects, 1985), 16–18.

22. Quoted in Gregory Galligan, "Jean-Michel Basquiat: The New Paintings," *Arts* 59 (May 1985): 140.

23. Interview in the videotape "New York/New Wave," *Art/New York* 5 (1981).

24. Thomas Lawson, "Last Exit: Painting," *Artforum* 20 (October 1981): 40.

25. Peter Bürger, *Theory of the Avant-Garde*, trans. Michael Shaw (Minneapolis: University of Minnesota Press, 1984), 57. Subsequent page references to this book are included in the text.

26. Arthur R. Rose, "Four Interviews with Barry, Huebler, Kosuth, Weiner," *Arts Magazine* 43 (February 1969): 22–23; quoted in Joseph Kosuth, "Art After Philosophy," in *Conceptual Art*, ed. Ursula Meyer (New York: Dutton, 1972), 161.

27. Douglas Davis, "The Avant Garde Is Dead! Long Live the Avant Garde!" *Art in America* 70 (April 1982): 17.

28. For a more detailed discussion, see Moira Roth, "Toward a History of California Performance," *Arts Magazine* 52 (February 1978): 94–103, and (June 1978): 113–24.

29. Irving Shustick, "The Bad Humor Truck is Coming," *East Village Other*, February 1–15, 1967, 11. A partial listing of Angry Arts sponsors and participants accompanies Shustick's article. Among many others, the list includes the likes of Yvonne Rainer, Stan Brakhage, Carolee Schneemann, Andy Warhol, Steve Reich, Allan Kaprow, Claes Oldenburg, Paul Blackburn, Allen Ginsberg, Denise Levertov, and Susan Sontag.

30. Lucy Lippard, "The Art Workers' Coalition," in *Idea Art*, ed. Gregory Battcock (New York: Dutton, 1973), 103.

31. Quoted by Lippard in ibid., 111.

32. I should perhaps make it clear that I am treating conceptual and performance art as one. Many have implicitly linked them (see Fried's "Art and Objecthood," for instance), but RoseLee Goldberg has stated the connection most satisfactorily: "It is difficult to separate where 'conceptual' art ends and performance begins. For conceptual art contains the premise that the idea may or may not be executed.

Sometimes it is theoretical or conceptual, sometimes it is material and performed."
See "Space and Praxis," *Studio International* 190 (Summer 1975): 136.

33. See Richard Cork, "What does *Documenta* Document?" *Studio International* 194 (1978): 39.

34. Lucy Lippard, "The Structures, the Structures and the Wall Drawings, the Structures and the Wall Drawings and the Books," in *Sol LeWitt*, ed. Alicia Legg (New York: Museum of Modern Art, 1978), 27.

35. Jacques Derrida, *Of Grammatology*, trans. Gayatri Spivak (Baltimore: Johns Hopkins University Press, 1976). For another, briefer example of Derrida's deconstruction of speech's priority, see *"La Parole soufflé,"* in *Writing and Difference*, trans. Alan Bass (Chicago: University of Chicago Press, 1978), 177–78.

36. Allen Ginsberg, *Allen Verbatim: Lectures on Poetry, Politics, Consciousness*, ed. Gordon Ball (New York: McGraw-Hill, 1974), 26. Compare Charles Olson's famous distinction between "language as the act of the instant and language as the act of thought about the instant," in "Human Universe," *Selected Writings of Charles Olson*, ed. Robert Creeley (New York: New Directions, 1966), 54.

37. Allen Ginsberg, *Mind Breaths: Poems 1972–1977* (San Francisco: City Lights, 1977), 30. Subsequent page references to this edition are included in the text.

38. Allen Ginsberg, *First Blues: Rags, Ballads and Harmonium Songs 1971–74* (New York: Full Court Press, 1975). The recording is *Allen Ginsberg First Blues*, John Hammond Records, W2X 37673.

39. George Quasha, "Dialogos: Between the Written and the Oral in Contemporary Poetry," *New Literary History* 8 (Spring 1977): 485–506.

40. Linda Birnham, "Editor's Note," *High Performance* 1 (February 1978): 1.

41. Gerald L. Bruns, *Inventions: Writing, Textuality, and Understanding in Literary History* (New Haven: Yale University Press, 1982), 44, 55–56.

42. Ibid., 52–53.

43. John Ashbery, *Self-Portrait in a Convex Mirror* (New York: Penguin, 1976), 68–83.

44. "Sherrie Levine Plays with Paul Taylor," *Flash Art* 135 (Summer 1987): 56.

45. Quoted by Steven Henry Madoff, "What Is Postmodern about Painting: The Scandinavia Lectures, III" *Arts* 60 (November 1985): 72.

46. Fredric Jameson, "Postmodernism and Consumer Society," in Foster, ed., *The Anti-Aesthetic*, 115.

47. Jean Baudrillard, "The Ecstasy of Communication," in ibid., 133.

48. Hal Foster, "The Expressive Fallacy," in *Recodings*, 72.

49. Steven Henry Madoff, "What Is Postmodern about Painting: The Scandinavia Lectures," *Arts* 60 (September 1985): 117.

50. Steven Henry Madoff, "What Is Postmodern about Painting: The Scandinavia Lectures, II," *Arts* 60 (October 1985): 60; and III, *Arts* 60 (November 1985): 68. While I have not dealt, in this book, with postmodern architecture, any discussion of it would have to begin in terms something like those I am developing here. In an article on postmodern architecture written for the British journal *Architectural Design*, Charles Jencks has explicitly compared the work of James Sterling, especially his new Clore Gallery for the Turner Collection at the Tate, to Salle's painting: "Salle characteristically uses the diptych to set up a dualism of themes that are self-cancelling. Images lifted equally from pulp fiction and high art are juxtaposed, not synthesised, and presented with a studied neutrality. Exotic photographs of the figures are overlaid with graffiti, maps, modern furniture, quotes from Modern art, and all of these contrasts are heightened by the flat, acid colours asso-

ciated with advertisements. . . . [Sterling's] additions for the Tate Gallery take inconsistency to a new level of poetry. Instead of simply providing a different front, back and sides, as any good urban building celebrated by Venturi might do, Sterling even breaks up these consistent parts into opposed areas. . . . In nearly every case he has emphasised discontinuity by breaking up a theme at an unexpected point." See Charles Jencks, "Post-Modernism and Discontinuity," *Architectural Design*, Profile 65 (1987): 6. Of all American architects, probably Michael Graves most thoroughly embodies the aesthetic of discontinuity described by Jencks. But Frank Gehry, in his use of chain-link mesh, cement, asphalt, and so on, is the most vernacular. His design for his own home in Santa Monica is the most notable example, but not accidentally, I think, he has also incorporated these same elements into his design for the Los Angeles Museum's so-called Temporary Contemporary in order to create a self-consciously postmodern space for contemporary art. The public sculpture of Siah Armajani, in its use of such materials as corrugated sheet metal, fabricated screening, house paint, shingles, and common cuts of lumber—and in its reference to architecture itself—could be said to mark the meeting place between postmodern architecture proper and postmodern art. See Margo Shermeta, "An American Dictionary in the Vernacular: Utilitarian Ideas and Structures in the Sculpture of Siah Armajani," *Arts* 61 (January 1987): 38–41.

51. "Ecriture et Revolution: Entretien de Jacques Henri avec Philippe Sollers," in *Théorie d'ensemble* (Paris: Editions du Seuil, 1968), 67. Subsequent page references to this edition are included in the text. The translations are my own.

52. Hal Foster, "Between Modernism and the Media," in *Recodings*, 41–42.

53. "Salle," an interview with David Salle by Peter Schjeldahl (New York: Elizabeth Avedon Editions, Vintage Contemporary Artists, 1987), 48. For a much more theoretical version of many of the arguments I am developing here, see Gregory L. Ulmer, "The Object of Post-Criticism," in *The Anti-Aesthetic*, 83–110.

54. "Fischl," an interview with Eric Fischl by Donald Kuspit (New York: Elizabeth Avedon Editions, Vintage Contemporary Artists, 1987), 6–9.

55. Ibid., 36. Subsequent quotations are from this same interview.

56. Richard Schechner, *Between Theater and Anthropology* (Philadelphia: University of Pennsylvania Press, 1985), 45.

57. Spalding Gray, *Sex and Death to the Age 14* (New York: Vintage, 1986), 14–16.

58. Richard Schechner, *Essays on Performance Theory 1970–1976* (New York: Drama Book Specialists, 1977), 145–46.

59. Spalding Gray, *Swimming to Cambodia* (New York: Theatre Communications Group, 1985), 22, 50–51. Gray's explanation of the title can be found in his "Author's Note" to this book, xvi.

60. Helen Mayer Harrison and Newton Harrison, statement in the catalogue of an exhibition organized by Cynthia Jaffe McCabe, *Artistic Collaboration in the Twentieth Century* (Washington: Smithsonian Institution Press, 1984), 186.

61. "The Seduction of Mimi: Mimi Rogers by Jann Wenner," *Interview* 17 (December 1987): 103.

62. Sandra Stich, *Made in U.S.A.: An Americanization of Art, the '50s & '60s,* catalogue to an exhibition at the University Art Museum, Berkeley, California, April 4–June 21, 1987 (Berkeley: University of California Press, 1987), 91.

63. David Bourdon, "Andy Warhol and the Society Icon," *Art in America* 63 (January–February 1975): 42–45; and Peter Schjeldahl, "Warhol and Class Content," *Art in America* 68 (May 1980): 118.

64. Andy Warhol and Pat Hackett, *POPism: The Warhol '60s* (New York: Harcourt, Brace and Jovanovich, 1980), 195.

65. Andy Warhol, with Bob Colacello, *Andy Warhol's Exposures* (New York: Andy Warhol Books, 1979), 19. The idea of reading Warhol's *Exposures* as a document underscoring his status as a fan is Carter Ratcliff's; see his "Starlust: Andy's Photos," *Art in America* 68 (May 1980): 120–22.

66. Paul de Man, *Allegories of Reading* (New Haven: Yale University Press, 1979), 242.

67. Walter Robinson and Carlo McCormick, "Slouching toward Avenue D: Report from the East Village," *Art in America* 72 (Summer 1984): 135.

68. Craig Owens, "Commentary: The Problem with Puerilism," *Art in America* 72 (Summer 1984): 163.

CHAPTER ONE

1. Friedrich Nietzsche, *Thus Spoke Zarathustra*, trans. R. J. Hollingdale (New York: Penguin, 1961), 142.

2. John Szarkowski, *Mirrors and Windows: American Photography Since 1960* (New York: Museum of Modern Art, 1978), 146–47; "A Project by Nicholas Nixon," *Artforum* 20 (December 1981): 44–48; and "Four Sisters, Continued," *Artforum* 25 (January 1986): 102–06.

3. Szarkowski, *Mirrors and Windows*, 11, 22.

4. Quoted in Szarkowski, *Mirrors and Windows*, 20.

5. This "other meaning" is related to what Roland Barthes has called the "third meaning" (see "The Third Meaning: Research Notes on some Eisenstein Stills," in *The Responsibility of Forms*, 41–62). For Barthes certain Eisenstein stills, as for me these photos by Nixon, sustain a level of interest, even fascination, which far transcends their overt content. As Barthes puts it, there is some "penetrating feature" which one's "intellection cannot quite absorb . . . both persistent and fugitive, apparent and evasive," and which "seems to open the field of meaning totally" (48, 44). While I share with Barthes a desire to describe this "feature," his essay has, nevertheless, always troubled me. For all its originality, its analyses and descriptions of various instances of the so-called third meaning seem to me almost always to rest upon the same notions of formal coherence—compositional symmetries and correspondences—which characterize most formalist aesthetics. It is hardly surprising that a structuralist should resort to formalist analysis in order to locate the power of an image, but, as I think will become clear later, Barthes is closer to the truth of the matter when he suggests that "the third meaning . . . has something to do with disguise" (48). I examine this essay, and its formalist tendencies, in the last chapter.

6. Ted Hedgpeth, "Modernist Strategies," *Artweek* 11 (May 24, 1980): 11.

7. Carol Duncan, "Who Rules the Art World?" *Socialist Review* 70 (July–August 1983): 99.

8. Ibid.

9. For an excellent history of the curatorial policies of MoMA's Department of Photography, see Christopher Phillips, "The Judgment Seat of Photography," *October* 22 (Fall 1982): 27–63. The discussion of Szarkowski's tenure, which suggested much of my own argument, constitutes the last ten pages.

10. Szarkowski, *Mirrors and Windows*, 21.

11. *Correspondance de Nicolas Poussin*, ed. C. Jouanny (Paris: J. Schemit, 1911), 143. This passage is discussed by Svetlana Alpers in *The Art of Describing:*

Dutch Art in the Seventeenth Century (Chicago: University of Chicago Press, 1983), 48–49.

12. John Szarkowski, *From the Picture Press* (New York: Museum of Modern Art, 1973), 5–6.

13. See Roland Barthes, "Rhetoric of the Image," in *Image-Music-Text*, 44–46.

14. Charles Baudelaire, *Oeuvres complètes* (Paris: Gallimard, Bibliothèque de la Pleiade, 1961), 1163. For a detailed analysis of Baudelaire's modernism, see Matei Calinescu, *Faces of Modernity: Avant-Garde, Decadence, Kitsch* (Bloomington: Indiana University Press, 1977), 46–58.

15. Szarkowski, *Mirrors and Windows*, 25.

16. Norman Bryson, *Vision and Painting: The Logic of the Gaze* (New Haven: Yale University Press, 1983), 55. The discussion of connotation which follows owes much to Bryson's book; see especially 67–71. I should probably point out, however, that Bryson discounts the applicability of his discussion of connotation in painting to photography (see, for instance, 61), but that is because he underestimates, I think, both the iconographic codes photography has developed (codes which allow us to recognize, for instance, a family) and the hermeneutical effort required to read such seemingly accessible images more than superficially. That is, it seems to me that photography (at least modern photography) requires interpretation just as surely as painting, and this essay is in part meant as an example of the kind of interpretation photography ought now to elicit.

17. This summary of Papageorge's argument, which is not stated nearly so cogently in the catalogue essay, is indebted to Pepe Karmel's review of the 1981 Winogrand retrospective at New York's Light Gallery, in *Art in America* 69 (November 1981): 39.

18. "Monkeys Make the Problem More Difficult: A Collective Interview with Garry Winogrand," ed. Dennis Longwell, in *The Camera Viewed: Writings on Twentieth-Century Photography*, vol. 2: *Photography after World War II*, ed. Peninah R. Petruck (New York: Dutton, 1979), 121.

19. Quoted in "Expressionism Today: An Artists' Symposium," *Art in America* 70 (December 1982): 64.

20. David R. Smith, "Rembrandt's Early Double Portraits and the Dutch Conversation Piece," *Art Bulletin* 64 (June 1982): 264–65.

21. Ibid., 263–64.

22. William W. Robinson, "Family Portraits of the Golden Age," *Apollo* 110 (1979): 491.

23. For definitions of the conversation piece, of which mine is a composite, see Sacheverell Sitwell, *Conversation Pieces: A Survey of English Domestic Portraits and Their Painters* (New York: Scribners, 1937), 1–3; Mario Praz, *Conversation Pieces: A Survey of the Informal Group Portrait in Europe and America* (University Park: Pennsylvania State University Press, 1971), 39.

24. Elizabeth Anne McCauley, *Likenesses: Portrait Photography in Europe 1850–70* (Albuquerque: University of New Mexico Art Museum, 1980), 4.

25. Ibid., 10.

26. Ibid., 60.

27. John Ruskin, "Of Queen's Gardens," in *Sesame and Lilies, The Works of John Ruskin*, 18 (London: George Allen, 1905), 122.

28. The quotations from Marx are all taken from Jeffrey Mehlman's suggestive discussion of the *Eighteenth Brumaire* in *Revolution and Repetition: Marx/Hugo/Balzac* (Berkeley: University of California Press, 1977), 8, 9, 13.

29. Ibid., 21. These are Mehlman's words, not Marx's.

30. Roland Barthes, "Masson's Semiography," in *The Responsibility of Forms: Essays on Music, Art, and Representation*, trans. Richard Howard (New York: Hill and Wang, 1985), 154.

31. Craig Owens, "The Medusa Effect or, The Spectacular Ruse," *Art in America* 72 (January 1984): 104.

32. Roland Barthes, *Camera Lucida*, trans. Richard Howard (New York: Hill and Wang, 1981), 32.

33. Roland Barthes, *Mythologies*, trans. Annette Lavers (New York: Hill and Wang, 1972), 116–20.

34. Amy Golden, "The Post-Perceptual Portrait," *Art in America* (January–February 1975): 79.

35. Barthes, *Camera Lucida*, 13.

36. Liza Bear, "Ray, Do You Want To . . . An Interview with William Wegman," *Avalanche* (Winter–Spring 1972): 41.

37. The text of this video is taken from *Wegman's World*, catalogue of an exhibition at the Walker Art Center, December 5, 1982–January 16, 1983 (Minneapolis: Walker Art Center, 1982), 74. In their separate catalogue essays both Lisa Lyons and Kim Levin address the question of Man Ray as Wegman's alter ego; see, respectively, "Wegman's World," 40, and "Wegman's Video: Funny Instead of Formal," 65.

38. *Lady: Lisa Lyon by Robert Mapplethorpe* (New York: Viking Press, 1983), 8. Since I have just referred to her in the previous note, it is perhaps worth pointing out that the Walker Art Center's Lisa Lyons and the body artist Lisa Lyon are two different people.

39. My reading here is indebted to several feminist critiques of *Lady*, particularly Silvia Kolbowski's "Covering Mapplethorpe's 'Lady,'" *Art in America* 71 (Summer 1983): 10–11, and Dena Shottenkirk's "Fashion Fictions: Absence and the Fast Heartbeat," *ZG Magazine: Breakdown*, unnumbered, undated, and unpaginated [1983].

40. Allan Sekula, "Dismantling Modernism, Reinventing Documentary (Notes on the Politics of Representation)," *Massachusetts Review* 19 (Winter 1978): 866.

41. Ibid.

42. The text is reproduced in Janet Kardon's *Laurie Anderson: Works from 1969 to 1983* (Philadelphia: University of Pennsylvania, Institute of Contemporary Art, 1983), 49.

43. Roberta Bernstein, "Warhol as Printmaker," in *Andy Warhol Prints: A Catalogue Raisonné*, ed. Frayda Feldman and Jorg Schellmann (New York: Ron Feldman Fine Arts, Editions Schellmann, Abbeville Press, 1985), 16. Bernstein is quoting, in this passage, Robert Rosenblum's essay in the catalogue to Warhol's *Portraits of the 70s*.

44. Peter Schjeldahl, "Introduction: The Oracle of Images," *Cindy Sherman* (New York: Pantheon, 1984), 7–11.

45. Ibid., 11.

46. Derrida, *Of Grammatology*, 163.

47. See, particularly, Gilles Deleuze, *Logique du sens* (Paris: Editions de Minuit, 1969), 302, and J. Hillis Miller, *Fiction and Repetition: Seven English Novels* (Cambridge, Mass.: Harvard University Press, 1982), especially the first chapter, "Two Forms of Repetition."

48. Stephen W. Melville, "The Time of Exposure: Allegorical Self-Portraiture in Cindy Sherman," *Arts* 60 (January 1986): 20.

1. Carolee Schneemann, *More than Meat Joy: Complete Performance Works & Selected Writings*, ed. Bruce McPherson (New Paltz, N.Y.: Documentext, 1979), 238–39. Subsequent references to Schneemann's writings are from this work and will appear in the text.

2. T. J. Clark, *The Painting of Modern Life: Paris in the Art of Manet and His Followers* (New York: Knopf, 1985), 168–69. Subsequent references will appear in the text.

3. Emile Zola, "Edouard Manet: A Biographical and Critical Study," *Revue du XIXᵉ Siècle*, 1867; rpt. in *Realism and Tradition in Art 1848–1900: Sources and Documents*, ed. Linda Nochlin (Englewood Cliffs, N.J.: Prentice-Hall, 1966), 72, 76.

4. Reprinted in Ursula Meyer, *Conceptual Art* (New York: Dutton, 1972), 184.

5. The work of the Judson Dance Theater during its short life from 1962 to 1964 not only anticipates directions in avant-garde American art since 1970 but provides much of its theoretical foundation. The theater's work has been thoroughly documented in Sally Banes's remarkable *Democracy's Body: Judson Dance Theater 1962–1964*, Studies in the Fine Arts: The Avant-Garde, no. 43 (Ann Arbor: UMI Research Press, 1983).

6. Jill Johnston, "The Object," *Village Voice* (May 21, 1964): 12; quoted in Banes, *Democracy's Body*, 206.

7. Rosalind Krauss, *Passages in Modern Sculpture* (New York: Viking, 1977), 218.

8. Yvonne Rainer, "A Quasi Survey of Some 'Minimalist' Tendencies in the Quantitatively Minimal Dance Activity midst the Plethora, or an Analysis of Trio A," in Battcock, *Minimal Art*; rpt. in Yvonne Rainer, *Work: 1961–1973* (Halifax: Press of the Nova Scotia College of Art and Design, 1974), 63–69.

9. Warhol, *Popism*, 13–15.

10. David Antin, "Art & Information, 1: Grey Paint, Robert Morris," *Artnews* 65 (April 1966): 58.

11. Rainer, "A Quasi Survey," in *Work*, 63.

12. Bryson, *Vision and Painting*, 170.

13. Mary Ann Doane, "Woman's Stake: Filming the Female Body," *October* 17 (Summer 1981): 24.

14. These and related issues are developed much more fully in the catalogue to the New Museum's exhibition Difference: On Representation and Sexuality, which ran from December 8, 1984, to February 10, 1985, especially in Owens's introductory essay which is entitled, simply, "Posing," which I have quoted here, p. 12.

15. Eleanor Antin, "Carving: A Traditional Sculpture," reproduced with accompanying text in *TriQuarterly* 32 (Winter 1975): n.p.

16. Silvia Bovenschen, "Is There a Feminine Aesthetic?" trans. Beth Weckmueller, in *Feminist Aesthetics*, ed. Gisela Ecker (Boston: Beacon Press, 1986), 41–43.

17. John Howell, "Acting/Non-Acting," interviews with Scott Burton, Ruth Maleczech, Michael Smith, Elizabeth LeCompte, and Laurie Anderson, *Performance Art* 2 (1976): 11.

18. Kathy Acker, *The Childlike Life of the Black Tarantula by the Black Tarantula* (New York: TVRT Press and Printed Matter, 1978), 88, 91–92.

19. This excerpt from the script of *Vital Statistics of a Citizen, Simply Obtained* is reprinted from the documentation accompanying Martha Gerver's "Interview

with Martha Rosler," *Afterimage* 9 (October 1981): 13.

20. Eleanor Antin, *Being Antinova* (Los Angeles: Astro Artz, 1983), 1, 6.

21. Lucy R. Lippard, "The Pains and Pleasures of Rebirth: European and American Women's Body Art," *Art in America* 64 (May–June 1976), rpt. in Lippard's *From the Center: Feminist Essays on Women's Art* (New York: Dutton, 1976), 130. This essay is one of the few serious discussions of women's body art; it also has the merit of annotating a large number of works. But perhaps its most important contribution to the literature on the subject is the distinction it draws between male and female body art: "There are exceptions on both sides, but whereas female unease [with representations of self] is usually dealt with hopefully, in terms of gentle self-exploration, self-criticism, or transformation, anxiety about the masculine role tends to take on a violent, even self-destructive form" (134–35). Though she does not put it in these terms, her distinction amounts to saying— rightly—that men treat their own bodies as things (i.e., exactly as they treat the female body), while women consider their own in terms of process.

22. Nora R. Wainer, "Cosmetics and Revolution," *Against the Current* 1 (November–December 1986): 50.

23. Dick Hebdige, *Subculture: The Meaning of Style* (London: Methuen, 1979), 107.

24. These statistics have been compiled from the following sources: Judith K. Brodsky, "The Status of Women in Art, " in *Feminist Collage: Educating Women in the Visual Art*, ed. Judy Loeb (New York: Columbia University, Teachers College Press, 1979), 292–296, which is a summary of testimony Brodsky delivered before a congressional hearing on a proposed White House Conference on the Arts, December 17, 1977, at the Juilliard School, New York City; Grace Glueck, "Woman Artists '80," *Artnews* 79 (October 1980): 58–63; the Tamarind Lithography Workshop's *Sex Differentials in Art Exhibition Reviews: A Statistical Study* (Los Angeles: Tamarind, 1972); a "Forum" article in *American Artist* by Joyce Weinstein, "Is There Discrimination against Women Artists?" 42 (May 1978): 18–19; a brief report on the "Professional Page" in *American Artist* 46 (January 1982): 16; and Eleanor Heartley's article "How Wide is the Gender Gap?" *Artnews* 86 (Summer 1987): 139–45.

25. "Mary Boone, New Queen of the Art Scene," *New York* (April 19, 1982): 28. In 1987, Boone softened her position somewhat, taking both Barbara Kruger and Sherric Levine into her gallery.

26. Faith Wilding, "Talking of Artemisia," *Art and Artists* 15 (January– February 1986): 8–9.

27. Gisela Breitling, "Speech, Silence and the Discourse of Art: On Conventions of Speech and Feminine Consciousness," in *Feminist Aesthetics*, 162, 170–71.

28. November 2, 1985, quoted as the epigraph to Wilding, "Talking of Artemisia," 8.

29. Craig Owens, "The Discourse of Others: Feminists and Postmodernism," in *The Anti-Aesthetic*, 61.

30. Yvonne Rainer, "Looking Myself in the Mouth," *October* 17 (Summer 1981): 67–68.

31. *Interior Scroll* is described in *More than Meat Joy*, 234–39.

32. "Political Performance: A Discussion by Suzanne Lacy and Lucy R. Lippard," *Heresies* 17 (1984): 23.

33. This anecdote is related in Moira Roth, "Toward a History of California Performance: Part II," *Arts* 52 (June 1978): 117. Kaprow's idea about sweeping up

as a performance activity is probably a reference to a Happening scenario which can be found in his *Assemblage, Environments & Happenings* (New York: Abrams, 1965), 205.

34. Judy Chicago, *Through the Flower: My Struggle as a Woman Artist* (New York: Anchor Books, 1977), 62–63, 66.

35. Gerver, "Interview with Martha Rosler," 11.

36. The text of *Waiting* is reprinted as an appendix to Chicago's *Through the Flower*, 213–17.

37. Owens, "The Discourse of Others," 59.

38. Rainer, *Work*, vii.

39. Schneemann, *More than Meat Joy*, 52.

40. Merlin Stone, *When God Was a Woman* (New York: Harvest/HBJ, 1976).

41. Schneemann, *More than Meat Joy*, 234.

42. Judy Chicago, *The Dinner Party* (New York, Anchor Books, 1979), and *Embroidering Our Heritage: The Dinner Party Needlework* (New York: Anchor Books, 1980).

43. Lucy R. Lippard, *Overlay: Contemporary Art and the Art of Prehistory* (New York: Pantheon, 1983). See especially the second chapter, "Feminism and Prehistory."

44. Owens, "The Discourse of Others," 66–67.

45. Ibid., 66.

46. David Antin, "Narrative," May 1983, audiotape at the Center for Music Experiment, University of California at San Diego.

47. "Aztec Definitions: Found Poems from the Florentine Codex," *Some/Thing* 1 (Spring 1965): 5.

48. Owens, "The Discourse of Others," 70.

49. Salle told a group of students at the Whitney Museum in 1984 that they were wrong to pay attention to the subject matter of his work: "I don't think my work, strictly in terms of its subject matter—the images you keep talking about—I don't think this is all that interesting. . . . Instead of looking at my pictures, talking about them, we've been talking about subject matter. It's not the same thing. Look, and I'm talking strictly functionally now, things get juxtaposed with other things. I do think that there are things that exist in the world that relate to one another. And then there are things in my paintings that relate to one another. And I think what matters to me is that these are not the same." The painting becomes, in Salle's terms, totally cut off from the concerns of the world. It is wholly aestheticized and formalized terrain. Asked by Yvonne Rainer about the dunce caps he places on women's breasts, as an example of the ways in which women are demeaned in his work, Salle replied, "I never thought of them as dunce caps, I thought of them as cones." That is, Salle would like to think of them as content-less, as pure forms, and he would maintain that Rainer's reading these cones as dunce caps is her problem, not his. See Gerald Marzorati, "The Artful Dodger," *Artnews* 83 (Summer 1984): 48.

CHAPTER THREE

1. Susan Sontag, "For *Available Light*: A Brief Lexicon," *Art in America* 71 (December 1983): 110.

2. The inflation of contemporary cultural values is the subject of Charles Newman's *The Post-Modern Aura: The Act of Fiction in an Age of Inflation* (Evanston, Ill.: Northwestern University Press, 1985). For Newman, the most "elemental way of regarding Post-Modernism . . . is in terms of *climax inflation*—not only of

wealth, but of people, ideas, methods, and expectations—the increasing power and pervasiveness of the communications industry, the reckless growth of the academy, the incessant changing of hands and intrinsic devaluation of all received ideas" (6). Newman's critique, which is largely restricted to prose fiction, represents, I think, something like the negative potentiality of the large-scale works with which I will deal in this chapter. That is, given Newman's assumptions—that the American avant-garde is "now decay when it is not imitative nostalgia" (49), that it has no "social and political ingredient," that it "has become nothing more or less than bourgeois self-criticism" (52), and so on—his conclusions may be inescapable. I obviously see the avant-garde in different terms, though I would be the first to agree that a great deal of what passes for "avant-garde" art is susceptible to Newman's analysis.

3. Thomas McEvilley, "Art in the Dark," *Artforum* 21 (Summer 1983): 66. McEvilley's essay amounts to a virtual compendium of contemporary artworks having to do, in one way or another, with self-mutilation and self-sacrifice.

4. Maurice Tuchman, *Art and Technology* (New York: Viking Press, 1971), 269.

5. Robert C. Hobbs, "Rewriting History: Artistic Collaboration since 1960," in Cynthia Jaffee McCabe, *Artistic Collaboration in the Twentieth Century*, catalogue of an exhibition at the Hirshhorn Museum, June 9–August 19, 1984 (Washington, D.C.: Smithsonian Institution Press, 1984), 79.

6. David Shapiro, "Art as Collaboration: Toward a Theory of Pluralist Aesthetics, 1950–1980," in ibid., 58. For a history of Rauschenberg's collaborations with Cage, Cunningham, and others see Nina Sundell, *Rauschenberg/Performance 1954–1984* (Cleveland: Cleveland Center for Contemporary Art, 1984).

7. The importance of dada performance as an antecedent to this work cannot be overemphasized. By the beginning of the sixties, dada had become a seminal force in avant-garde experimentation, spurred on especially by the publication, in 1951, of Robert Motherwell's *The Dada Painters and Poets* (New York: Wittenborn), and, in 1959, of Robert Lebel's *Marcel Duchamp*, trans. George Heard Hamilton (New York: Grove Press), a lavish survey of Duchamp's work which had a considerable influence on Rauschenberg.

8. Shapiro, "Art as Collaboration," 54.

9. Lawrence Alloway, *Robert Rauschenberg* (Washington, D.C.: National Collection of Fine Arts, Smithsonian Institution Press, 1976), 5.

10. John Cage, *Silence* (Middletown, Conn.: Wesleyan University Press, 1961), 101.

11. William Wilson, "Operational Music," in *Breaking the Sound Barrier: A Critical Anthology of the New Music* (New York: Dutton, 1981), 92–93.

12. Quoted in Calvin Tomkins, *The Bride and the Bachelors: The Heretical Courtship in Modern Art* (New York: Viking Press, 1965), 113. Tomkins's book remains the most readable treatment of Cage's early career, and I have relied on his account throughout.

13. "Interview with Roger Reynolds," in *John Cage*, a catalogue of Cage's compositions through 1962 (New York: Henmar Press, Editions Peters, 1962), 50.

14. John Cage, "Composition as Process," in *Silence*, 53.

15. Cited in Roger Copeland, "Merce Cunningham and the Politics of Perception," *The New Republic*, November 17, 1979, rpt. in *What Is Dance? Readings in Theory and Criticism*, ed. Roger Copeland and Marshall Cohen (New York: Oxford University Press, 1983), 321.

16. *The Dancer and the Dance: Merce Cunningham in Conversation with Jacqueline Lesschaeve* (New York: Marion Boyars, 1985), 17–18. This is an invaluable

addition to the literature of dance, containing Cunningham's account of his various performances over the years. In many ways it does for Cunningham what Sally Banes's *Democracy's Body* does for the Judson Dance Theater.

17. Ibid., 96–97.

18. Dale Harris, "Merce Cunningham," in *Contemporary Dance*, ed. Anne Livet (New York: Abbeville, 1980), 80.

19. Quoted in Michael Nyman, *Experimental Music: Cage and Beyond* (New York: Schirmer, 1974), 83.

20. Cunningham, *The Dancer and the Dance*, 175.

21. Harris, "Merce Cunningham," 80.

22. Cunningham, *The Dancer and the Dance*, 137.

23. Quoted in Copeland, "Cunningham and the Politics of Perception," 312. Copeland has expanded upon this argument, quoting Brecht again in full, in his "A Community of Originals: Models of Avant-Garde Collaboration," in the *Next Wave Festival Catalogue* (New York: Brooklyn Academy of Music, 1983), 6–12.

24. Copeland, "Community of Originals," 8.

25. The description of the traditional elements in Cunningham's technique is from Sally Banes, *Terpsichore in Sneakers: Post-Modern Dance* (Boston: Houghton-Mifflin, 1979), 7; and the definition of "task" dances is from Noel Carroll and Sally Banes, "Working and Dancing: A Response to Monroe Beardsley's 'What Is Going On In Dance?'" *Dance Research Journal* 15 (Fall 1982): 37.

26. Perhaps the most thoughtful analysis of Cage's influence on the subsequent generation of musicians is English composer Michael Nyman's in his *Experimental Music*.

27. Dick Higgins, "A Child's History of Fluxus," in *Horizons: The Poetics and Theory of Intermedia* (Carbondale: Southern Illinois University Press, 1984), 87. Fluxus is itself another collaborative model which for some was at least as influential as the Cage/Cunningham/Rauschenberg example. Consisting, in Higgins's words, of a "strangely diverse group of artists from disparate origins and disparate ages . . . unbound by a coherent ideology," it was based on a principle of interaction among and between the arts: "One key assumption of fluxus works is that there are close analogies among things. . . . Projected onto the aesthetics of art (and of course not all aesthetics are the aesthetics of art) and viewed from this perspective, the behavior of the different arts (including the art of thought, philosophy) is sufficiently close that these are properly seen as media, with the ground between such media, then, the *inter*-media"; see "Some Thoughts on the Context of Fluxus," in *Horizons*, 93. The notorious Fluxconcerts, then, were "intermedia" events designed to expose if not a unity of the arts, then a basis of analogy among them. In this way, they represent a middle ground between the totalizing impulses of the Wagnerian *Gesamtkunstwerk* and the total independence of media in what I have called here the new *Gesamtkunstwerk*, though in practice, because of their frank debunking of high art traditions, they usually approach the latter in effect. In Fluxus "leader" George Maciunas's words, Fluxus "is a fusion of Spike Jones, gags, games, Vaudeville, Cage and Duchamp" (quoted in Adrian Henri, *Total Art: Environment, Happenings, and Performance* [New York: Praeger, 1974], 159). For a brief history of Fluxus, see Barbara Haskell, *Blam! The Explosion of Pop, Minimalism, and Performance 1958–1964* (New York: Whitney Museum of American Art, 1984), 48–59.

28. Quoted in Nyman, *Experimental Music*, 69.

29. Quoted in Haskell, *Blam!*, 53.

30. "Interview with Roger Reynolds," 52.

31. Quoted in Michael Nyman, "Hearing/Seeing," *Studio International* 192 (November–December 1976): 234.

32. Dick Higgins, "Boredom and Danger," in *Breaking the Sound Barrier*, 21.

33. Ibid. The score for *Vexations* appeared on p. 77 of Cage's "On Erik Satie," *Artnews Annual* 27 (1958): 74–84. The text (without the score) is reprinted in *Silence*, 76–82.

34. Jacques Attali, *Noise: The Political Economy of Music*, trans. Brian Massumi, Theory and History of Literature, 16 (Minneapolis: University of Minnesota Press, 1985), 128.

35. Ibid., 45.

36. Ibid., 135–37.

37. Roland Barthes, "Listening," in *The Responsibility of Forms*, 259.

38. "Musica Practica," ibid., 265.

39. Nyman, *Experimental Music*, 119.

40. Quoted in Brian Eno and Russell Mills, *More Dark than Shark*, commentaries by Rick Poyner (London: Faber and Faber, 1986), 43. Eno has also twice performed Brecht's *Drip Music (Drip Event)*, first at Wolverhampton College of Art in the summer of 1968, where Brecht was himself then teaching, and a second time at Winchester, where he constructed an enormous 1,000 cubic-foot cube through which rainwater dripped.

41. Ibid.

42. Quoted in Richard Kostelanetz, "Two Tonal Composers," in *Breaking the Sound Barrier*, 298–99.

43. Brian Eno, "Generating and Organizing Variety in the Arts," *Studio International* 192 (November–December 1976): 287.

44. Eva Rieger, "'Dolce Semplice'? On the Changing Role of Women in Music," in *Feminist Aesthetics*, 137–38.

45. "Form," in *Musik in Geschichte und Gegenwart* (Kassel, 1956), cited in ibid., 139.

46. Rieger, "'Dolce Semplice,'" 138.

47. Luigi Russolo, *The Art of Noises*, in *Futurismo and Futurismi*, catalogue to an exhibition organized by Pontus Hulten, Palazzo Grassi, Venice, 1986 (Milan: Bompiani, 1986), 561.

48. Ibid. The italics are Russolo's.

49. Jacques Derrida, *Positions*, trans. Alan Bass (Chicago: University of Chicago Press, 1981), 26. It is perhaps worth noting here the similarity between Derrida's usage and Pater's description of the "condition" of music, cited in the introduction, that "continual vanishing away, that strange, perpetual weaving and unweaving of ourselves."

50. Ibid., 27.

51. The phrase "living on" derives from Derrida's essay "Living On: *Border Lines*," trans. James Hulbert, in *Deconstruction and Criticism* (New York: Seabury Press, 1979), 175–76. "Becoming-space" is a phrase he employs in his discussion of the trace in *Positions*, 27.

52. Quoted in Michael Nyman, "Hearing/Seeing," 238.

53. Interview with Sally Banes, *Democracy's Body*, 89.

54. Quoted in ibid., 89–90.

55. Ibid., 91.

56. Ibid. At about the same time as she wrote "Rreeppeettiittiioonn," in the program for Two Evenings of Dances by Yvonne Rainer at the Wadsworth Atheneum in Hartford Connecticut, March 6 and 7, 1965, Rainer reprinted an article on

her by Jill Johnston which had appeared shortly before in the *Village Voice*. Johnston writes: "I wondered why there was so much repetition [in Rainer's work]. I wasn't accustomed to *exact* repetition. Why should I want to see so much of *one* thing? But Yvonne says that repetition was her first idea of form. 'Seeing it again you can see more what it is.' And then I learned about LaMonte Young, the composer, who was obsessed even before he came to New York, as a student in California, with music as a continuum of a single sound. And I had forgotten about Gertrude Stein. The next time I saw Yvonne perform . . . I happened to be reading Stein's 'Lectures in America' and I like what she said about familiarity. She said: 'From this time on familiarity began and I like familiarity. It does not breed in me contempt it just breeds familiarity. And the more familiar a thing is the more there is to be familiar with. And so my familiarity began and kept on being.' " The program is reproduced in Rainer, *Work*, 316.

57. Maurice Merleau-Ponty, *Phenomenology of Perception*, trans. Colin Smith (London: Routledge and Kegan Paul, 1962), 100–102.

58. Carter Ratcliff, *Robert Longo* (New York: Rizzoli, 1985), 16.

59. Derrida, *Positions*, 96.

60. Quoted in Nyman, *Experimental Music*, 69.

61. Schneemann, *More than Meat Joy*, 21.

62. Quoted in Banes, *Democracy's Body*, 67. The text of *Ordinary Dance* is quoted in full by Banes, 66, and is included in Rainer, *Work*, 288–89.

63. This "score" is also reprinted in *Work*, 54–61. Subsequent page references to Rainer's "scores" are from *Work* and are included in the text.

64. Rainer's "Quasi Survey of Some 'Minimalist' Tendencies in the Quantitatively Minimal Dance Activity midst the Plethora," quoted in the last chapter, was written in 1965 as she was working on *The Mind Is a Muscle* and is an explanation of its aesthetic posture. *Mat* was choreographed after the essay was completed.

65. For a history of the Grand Union, as well as other projects and collaborations in which Rainer was involved at the time, see Annette Michelson, "Yvonne Rainer, Part One: The Dancer and the Dance," *Artforum* 12 (January 1974): 57–63, "Yvonne Rainer, Part Two: *Lives of Performers*," *Artforum* 12 (February 1974): 30–35, and Sally Banes, *Terpsichore in Sneakers*, 202–34.

66. Roland Barthes, "The Death of the Author," in *Image/Music/Text*, trans. Stephen Heath (New York: Hill and Wang, 1977), 145.

67. Ibid., 146.

68. Ibid., 148. See also, in connection with the "death of the author," Michel Foucault's essay, "What Is an Author?" in *Language, Counter-Memory, Practice: Selected Essays and Interviews*, trans. Donald F. Bouchard and Sherry Simon (Ithaca, N.Y.: Cornell University Press, 1977); and Jacques Ehrmann, "The Death of Literature," *New Literary History* 3 (Autumn 1971).

69. Rainer, *Work*, 68.

70. Ibid.

71. Quoted in Thomas DeLio, "Avant-Garde Issues in Seventies Music," in *Breaking the Sound Barrier*, 258. Probably the single most successful use of Reich's music in dance has been Laura Dean's 1975 realization of the 1971 composition *Drumming*, a extraordinarily rich score which consists of a complete cycle of phase relationships built upon a single drum rhythm that is played on bongos, marimbas, and glockenspiels.

72. Quoted in Eno and Mills, *More Dark than Shark*, 44.

73. Rosalind Krauss, *Passages*, 266–67.

74. Julie Lazar, "Interview: Lucinda Childs," in *Available Light*, catalogue of

the performance at the Museum of Contemporary Art, Los Angeles, including a recording of John Adams's score *Light over Water* (Los Angeles: Museum of Contemporary Art, 1983), 32.

75. Sally Banes, *Terpsichore in Sneakers*, 136–37.

76. Transcribed from the 1985 film by Mark Obenhags, *Einstein on the Beach: The Changing Image of Opera*, produced for PBS and aired as part of its Great Performances series.

77. Ibid.

78. Craig Owens, "Robert Wilson: Tableaux," *Art in America* 68 (November 1980): 115.

79. Ibid., 116.

80. Transcribed from the Mark Obenhags film, *Einstein on the Beach.*

81. For descriptions of these two dance sequences, see Stefan Brecht's long description of the entire performance in *The Theatre of Visions: Robert Wilson* (Frankfurt am Main: Suhrkamp, 1978), 339–41 and 352–53.

82. Philip Glass, "Notes on *Einstein on the Beach*," in the booklet accompanying the recording of *Einstein on the Beach* (New York: Tomato Music, 1979), 10.

83. Susan Sontag, "For *Available Light*," 102.

84. Sally Banes, *Terpsichore in Sneakers*, 82.

85. I have transcribed this narrative from a videotape of Brown's performance of *Accumulation with Talking plus Watermotor* at the Brooklyn Academy of Music, October 22, 1983. The tape is housed in the Archives of the New Wave Festival at BAM. Ellipses indicate narrative material that I have left out for the sake of clarity in my own presentation.

86. Trisha Brown and Yvonne Rainer, "A Conversation about *Glacial Decoy*," *October* 10 (Fall 1979): 33–34.

87. Ibid., 33.

88. Don McDonaugh, untitled transcript of lecture, in *Contemporary Dance*, 180–82.

89. Brown and Rainer, "A Conversation about *Glacial Decoy*," 33.

90. Craig Owens, "The Pro-Scenic Event," *Art in America* 69 (December 1981): 129. The other significant discussion of framing in postmodern dance is Sally Banes's comparison of the work of the Grand Union and the theories of Erving Goffman in his *Frame Analysis* in her *Terpsichore in Sneakers.*

CHAPTER FOUR

1. Jacques Attali, *Noise*, 132; Friedrich Nietzsche, *The Gay Science*, trans. Walter Kaufmann (New York: Vintage, 1974), 317; Jacques Derrida, *Spurs: Nietzsche's Styles*, trans. Barbara Harlow (Chicago: University of Chicago Press, 1978), 71.

2. *The Catherine Wheel* premiered at New York's Winter Garden Theater on September 22, 1981, and the Knee Plays for *Civil Wars* were first performed at the Walker Art Center, April 26–28, 1984.

3. Gilles Deleuze, "Nomad Thought," in *The New Nietzsche: Contemporary Styles of Interpretation*, ed. David B. Allison (New York: Delta, 1977), 142–49. All subsequent references to this essay will appear in the text.

4. Laurie Anderson, *United States* (New York: Harper and Row, 1984). All subsequent references to *United States* refer to this edition. Since the book is unpaginated, I will try, in the text, to indicate general location of the passages quoted. The work is also available on tape and record from Warner Brothers (25192–1).

5. "Laurie Anderson, *United States*: A Talk with John Howell," *Live* 5 (1981): 6.

6. Nietzsche, *Zarathustra*, 43.

7. "A Talk with John Howell," 8.

8. "Laurie Anderson," *View: Interviews*, vol. II, April 1979–March 1980 (Oakland, Ca.: Crown Point Publishers, 1980), 5.

9. Craig Owens, "Amplifications: Laurie Anderson," *Art in America* 69 (March 1981): 123.

10. Charles Dickens, "The True Bohemians of Paris," *Household Words: A Weekly Journal Conducted by Charles Dickens* 4 (15 November 1851): 190–192. For a particularly revealing study of the myth of the bohemian, from which I have taken the Dickens citation, see Marilyn R. Brown, *Gypsies and Other Bohemians: The Myth of the Artist in Nineteenth-Century France* (Ann Arbor, Michigan: UMI Research Press), 1985.

11. "Laurie Anderson," *View*, 19.

12. In a 1986 production for Public Broadcasting's "Alive from Off Center," Anderson has gone even further, creating a "clone" who is a mustached, male version of herself, capable of composing and writing while Anderson "meets the press."

13. Annette Kuhn, *The Power of the Image: Essays on Representation and Sexuality* (London: Routledge and Kegan Paul, 1985), 54.

14. Jacques Attali, *Noise*, 122–24.

15. "Laurie Anderson," *View*, 13.

16. All quotations from *El Desdichado* are from a working script generously provided to the author by Eleanor Antin.

17. Richard Schechner, *Essays on Performance Theory 1970–1976* (New York: Drama Book Specialists, 1977), 145–47.

18. Eleanor Antin, *Being Antinova*, 59.

19. Review by Thomas McEvilley, *Artforum* 22 (April 1984): 77.

20. Quoted in Calvin Tomkins, "The Space around Real Things," *New Yorker* (September 10, 1984): 56. The remaining quotations from Stella's lectures are from my own notes. The lectures have since appeared, somewhat revised, in book form: Frank Stella, *Working Space* (Cambridge, Mass.: Harvard University Press, 1986). The arguments corresponding to the material I've quoted here can be found on 11, 34, 40, 43 and 51.

21. Michael Fried, *Absorption and Theatricality: Painting and Beholder in the Age of Diderot* (Berkeley: University of California Press, 1980). Fried admits in the introduction that his argument about eighteenth-century French painting informs "the most ambitious and exalted art of our time," including the work of Stella, whose paintings are "in essence *anti*-theatrical, which is to say that they [treat] the beholder as if he were not there" (5).

22. Clement Greenberg, "Modernist Painting," in *The New Art*, ed. Gregory Battcock (New York: Dutton, 1973), 68, 70.

23. Quoted in Tomkins, 95.

24. Fredric Jameson, "Criticism in History," in *Weapons of Criticism: Marxism in America and the Literary Tradition*, ed. Norman Rudich (Palo Alto, Ca.: Ramparts Press, 1976), 34–35.

25. Quoted in Kim Levin, "The Angel of Mercy and the Fiction of History," in *The Angel of Mercy*, catalogue of an exhibition at the La Jolla Museum of Contemporary Art, September 10–October 23, 1977, unpaginated.

26. Roland Barthes, "The Photographic Message," in *The Responsibility of Forms*, 14–15.

27. Jane Belo, *Trance in Bali* (New York: Columbia University Press, 1960),

quoted in Schechner, *Essays on Performance*, 128.

28. Schechner, *Essays on Performance*, 128.

29. Roland Barthes, "Rhetoric of the Image," in *The Responsibility of Forms*, 28.

30. Ibid., 29.

31. Barbara Herrnstein Smith, "Narrative Versions, Narrative Theories," in *On Narrative*, ed. W. J. T. Mitchell (Chicago: University of Chicago Press, 1981), 228–29.

32. Schechner, *Essays on Performance*, 86.

33. Victor Turner, *From Ritual to Theatre: The Human Seriousness of Play* (New York: Performing Arts Journal, 1982), 83–84. Turner's definition of "ceremony" is in turn derived from the book *Secular Ritual*, ed. Barbara Meyerhoff and Sally Falk Moore (Amsterdam: Royal van Gorcum, 1977), 16–17.

34. An early version of the text to *Fresh Blood* is reprinted in *Dreamworks* 2 (Fall 1981): 67–75. All quotations, however, are from the 1983 videotape of performance, which considerably revises the early version.

35. Sigmund Freud, *The Interpretation of Dreams*, trans. James Strachey (New York: Avon, 1965), 390.

36. Ibid., 409.

37. Ibid., 394.

38. Freud, "The Uncanny," in *On Creativity and the Unconscious: Papers on the Psychology of Art, Literature, Love, Religion*, ed. Benjamin Nelson (New York: Harper Colophon, 1958), 148.

39. Ibid., 132.

40. Schneemann, *More than Meat Joy*, 10.

41. Quoted in Ted Castle, "Carolee Schneemann: The Woman Who Uses Her Body as Her Art," *Artforum* 19 (November 1980): 70.

42. Julia Ballerini, "Introduction," *Carolee Schneemann: Recent Work* (New York: Max Hutchinson Gallery, Documentext, 1983), n.p.

43. Ted Castle, "Introduction," *Carolee Schneemann: Early Work 1960/1970* (New York: Max Hutchinson Gallery, Documentext, 1983), n.p.

44. Schneemann, *More than Meat Joy*, 234.

45. Ibid.

46. The format of this quotation is from the *Dreamworks* version of the text, 73.

47. Jacques Derrida, *Spurs: Nietzsche's Styles* (Chicago: University of Chicago Press, 1979), 97. Schneemann, incidentally, dislikes being labeled "dionysiac," preferring instead "aphroditean": Dionysius was the son of Aphrodite, and, as she has pointed out, "his attributes were derived from her and eventually absorbed into the succeeding patriarchal infrastructures"; see her letter to *Artforum* 22 (October 1983): 2.

48. *Spurs*, 123. Subsequent citations will appear in the text.

CHAPTER FIVE

1. Jerome Rothenberg, *That Dada Strain* (New York: New Directions, 1983), 83.

2. John Ashbery, *As We Know* (New York: Penguin, 1979), 74.

3. Ibid., 12.

4. William Coco and A. J. Gunawardana, "Responses to India: An Interview with Yvonne Rainer," *Drama Review* 15 (Spring 1971): 139–40.

5. Lucy R. Lippard, "Talking Pictures, Silent Words: Yvonne Rainer's Recent Movies," *Art in America* 65 (May–June 1977): 86.

6. Yvonne Rainer, "Looking Myself in the Mouth," 74.

7. Transcribed from a videotape interview with Yvonne Rainer, conducted by

Lyn Blumenthal, produced by Lyn Blumenthal and Kate Horsfield, from the series *On Art and Artists*, Video Data Bank, School of the Art Institute of Chicago, 1984.

8. Yvonne Rainer, "Looking Myself in the Mouth," 72–73.

9. Ibid., 74.

10. The oral poetry movement has also received surprisingly little critical attention. Aside from its treatment in its own little magazines (*New Wilderness Letter* and *Alcheringa*, for instance), a fairly complete bibliography would look something like this: George Quasha, "Dialogos: Between the Written and the Oral in Contemporary Poetry," *New Literary History* 8 (Spring 1977): 485–506; *boundary 2: The Oral Impulse in Contemporary American Poetry* 3 (Spring 1975); Richard Kostelanetz, *The Old Poetries and the New* (Ann Arbor: University of Michigan Press, 1981); Marjorie Perloff, "'No More Margins': John Cage, David Antin, and the Poetry of Performance," in *The Poetics of Indeterminacy*, 288–339; Stephen Fredman, "The Crisis at Present: Talk Poems and the New Poet's Prose," in *Poet's Prose: The Crisis in American Verse* (Cambridge: Cambridge University Press, 1983), 134–47; and *The Poetry Reading: A Contemporary Compendium on Language and Performance*, ed. Stephen Vincent and Ellen Zweig (San Francisco: Moma's Press, 1981).

11. David Antin, "Modernism and Postmodernism: Approaching the Present in American Poetry," *boundary 2*, no. 1 (Fall 1972): 128. Hereafter cited in the text as *MP*.

12. Allen Tate, "Poetry Modern and Unmodern," *Hudson Review* 21 (Summer 1968): 256. The essay is reprinted in Tate's *Essays of Four Decades* (Chicago: Swallow Press, 1968), 222–36.

13. Robert Pinsky, *The Situation of Poetry: Contemporary Poetry and Its Traditions* (Princeton: Princeton University Press, 1976), 166. Pinsky is acutely aware, incidentally, of the academic currency of this "surrealist" vision: "Somewhere, on some campus in America, a young poet is writing a sentence with all of nearly all the totemic words, something like: 'The silence of my / blood eats light like the / breath of future water'" (165). Needless to say, poets do not come by this way of writing naturally. They are trained to it, not only in the MFA writing classes, but by the example of what gets published most often in the most prestigious little magazines.

14. Dennis Tedlock, "The Way of the Word of the Breath," *Alcheringa* 1, no. 2 (1975): 4–5; Gary Snyder, "The Politics of Ethnopoetics," in *The Old Ways* (San Francisco: City Lights, 1977), 15–43, hereafter cited in the text as *PE*; and Jerome Rothenberg, "Pre-face to a Symposium on Ethnopoetics," *Pre-faces and Other Writings* (New York: New Directions, 1981), 129–36, hereafter cited in the text as *PSE*.

15. Jerome Rothenberg, "Beyond Poetics," *OA.Rs #1: Coherency* (Cambridge, Mass.: OA.Rs, 1981), 150.

16. See Renato Poggioli, *The Oaten Flute: Essays on Pastoral Poetry and the Pastoral Ideal* (Cambridge, Mass.: Harvard University Press, 1975).

17. The definition of wilderness as an "untamed realm of total freedom" is actually Snyder's, but is wholly endorsed by Rothenberg in his 1979 essay "Indians & Wilderness," in *Pre-faces*, 180.

18. Gary Snyder, *Earth House Hold: Technical Notes & Queries to Fellow Dharma Revolutionaries* (New York: New Directions, 1969), 123.

19. Allen Ginsberg, *Mind Breaths* (San Francisco: City Lights, 1977), 27–31.

20. The most sustained application of speech act theory to oral poetry and performance is Richard Palmer's "Toward a Postmodern Hermeneutics of Perfor-

mance," in *Performance in Postmodern Culture*, 19–32.

21. Jerome Rothenberg, "From A Dialogue on Oral Poetry with William Spanos (1975)," in *Pre-faces*, 10.

22. Gisela Ecker, "Introduction," *Feminist Aesthetics*, 17.

23. Schechner, "From Ritual to Theater and Back," *Essays on Performance Theory*, 75.

24. Ibid., 74.

25. Victor Turner, *From Ritual to Theater: The Human Seriousness of Play*, 69–70, hereafter cited in the text as *RT*.

26. For a description of Turner's work at Schechner's institute, see Turner's essay "Dramatic Ritual/Ritual Drama: Performative and Reflexive Anthropology," in *From Ritual to Theater*, 89–101. It is probably worth recalling that in 1977 Spalding Gray and Elizabeth LeCompte produced *Rumstick Road* while still actively engaged with Schechner's Performance Group.

27. Rothenberg, *Pre-faces*, 167.

28. Renato Poggioli, *The Theory of the Avant-Garde*, trans. Gerald Fitzgerald (Cambridge, Mass.: Belknap Press, Harvard University Press, 1968), 27, hereafter cited in the text as *TA*.

29. Schechner, *Essays on Performance Theory*, 146.

30. Ibid., 89.

31. Rothenberg, "A Dialogue with William Spanos," *Pre-faces*, 37.

32. Allan Kaprow, "Performing Life," introduction to *Performance Anthology: Source Book for a Decade of California Performance Art*, ed. Carl E. Loeffler (San Francisco: Contemporary Arts Press, 1980), x. Kaprow acknowledges his debt to Goffman in "Participation Performance," *Artforum* 15 (March 1977): 26. Rothenberg speaks of the connections between his work and the Happenings in an interview with Barry Alpert in *Vort* 7 (1974): 104.

33. Jerome Rothenberg, *Poems for the Game of Silence 1960–1970* (New York: New Directions, 1975), 171.

34. Allan Kaprow, "The Real Experiment," *Artforum* 22 (December 1983): 38.

35. This performance was tape-recorded by Paul Blackburn. It is preserved as Tape 207 in the Paul Blackburn Tape Collection, Mandeville Special Collections, University of California, San Diego. The transcription here is my own.

36. Rothenberg, *Pre-faces*, 167–70.

37. Rothenberg, "The 12th Horse-Song of Frank Mitchell (Blue)," *Poems for the Game of Silence*, 154.

38. Rothenberg, "Pre-face V: A Big Jewish Book (1978)," *Pre-faces*, 119.

39. Ibid., 122–23.

40. Bruns, *Inventions*, 22.

41. Ibid., 29.

42. *A Big Jewish Book: Poems & Other Visions of the Jews from Tribal Times to Present*, ed. Jerome Rothenberg (Garden City, N.Y.: Anchor Books, 1978), 452.

43. Bruns, *Inventions*, 37.

44. Jacques Derrida, *Dissemination*, trans. Barbara Johnson (Chicago: University of Chicago Press, 1981).

45. Ibid., xxxii.

46. Bruce Ferguson, "Wordsmith: An Interview with Jenny Holzer," *Art in America* 74 (December 1986): 111.

47. Jeanne Siegel, "Jenny Holzer's Language Games," *Arts* 60 (December 1985): 64.

48. *Fiction International* 16, no. 1 (1985).

49. Siegel, "Holzer's Language Games," 67.

50. David Antin, "Video: The Distinctive Features of the Medium," in *Video Art* (Philadelphia: University of Pennsylvania, Institute of Contemporary Art, 1975), 64–66.

51. Siegel, "Holzer's Language Games," 65.

52. Ibid.

53. My transcription from *Skypoem: An Aerial Literary Event*, videotape produced and directed by Laura B. Greenfield, a City of Santa Monica Cable TV Production, 1987.

54. David Antin, *tuning* (New York: New Directions, 1984), 167.

55. David Antin, *talking at the boundaries* (New York: New Directions, 1976), 195–96.

56. David Antin, "Talking in Roy Harvey Pearce's Seminar on 'The Long Poem,'" August 1, 1978, audiotape in the Archive for New Poetry, University of California, San Diego. All references to this tape cite the discussion which took place after the performance and are my transcription.

57. David Antin, "how long is the present," *tuning*, 94. Subsequent citations to this talk-poem occur in the text.

58. David Antin, "and ive called this talk tuning," *Alcheringa* 3, no. 2 (1977): 92.

59. David Antin, "Talking about 'The Cut-off Finger Piece,'" November 10, 1980, audiotape in the Center for Music Experiment, University of California, San Diego; my transcription.

60. Altieri, "The Postmodernism of David Antin's *Tuning*," 21–22.

61. Mac Low, "Statement," 385.

62. For an extended discussion of this principle, see Jacques Derrida, "La Double Séance," in *Dissemination*.

CHAPTER SIX

1. Jean-François Lyotard, "The Sublime and the Avant-Garde," *Artforum* 22 (April 1984): 43. The legend, imaging the future status of Christo's *Running Fence* in the social imagination, is the creation of Dominque G. Laporte, in his *Christo*, trans. Abby Pollak (New York: Pantheon, 1986), 70.

2. Brian O'Doherty, "Inside the White Cube, Part I: Notes on the Gallery Space," *Artforum* 14 (March 1976): 25.

3. Michael Heizer, "The Art of Michael Heizer," *Artforum* 8 (December 1969): 37.

4. Brian O'Doherty, "Inside the White Cube, Part III: Context as Content," *Artforum* 15 (November 1976): 42.

5. Heizer, "The Art of Michael Heizer," 34, 37.

6. "Discussions with Heizer, Oppenheim, Smithson," in *The Writings of Robert Smithson*, ed. Nancy Holt (New York: New York University Press, 1979), 173.

7. Ibid.

8. Ibid., 175.

9. A guide to the location of many of the works discussed in this chapter is included at the end of John Beardsley's *Earthworks and Beyond: Contemporary Art in the Landscape* (New York: Abbeville, 1984), 137–38.

10. Walter De Maria, "The Lightning Field," *Artforum* 18 (April 1980): 58.

11. Ibid.

12. Roland Barthes, *The Responsibility of Forms*, 259.

13. John Beardsley has specifically connected the kinds of earthworks I discuss in this chapter to the sublime in his *Earthworks and Beyond*, 61–3, where he

briefly considers De Maria's *Lightning Field* in terms of Edmund Burke's theories of the sublime. Beardsley, however, is more interested in the "picturesque" as a category for considering contemporary earthwork than in following up the implications of the sublime for the work of other artists such as Smithson himself, and he quickly turns his attention to James Pierce's Pratt Farm in Maine, Ian Hamilton Finley's Stonypath in Scotland, and Isamu Noguchi's garden/plazas. My reasons for ignoring "picturesque" earthworks in this book have to do with their "scenic" qualities, their tendency to "compose" space as if it were a "picture" (the very idea of making nature after a painting by, say, Claude Lorrain gave rise, in the writings of Uvedale Price, to the word "picturesque" in the first place). They are "pastoral" in the same way that the poetry of Jerome Rothenberg or Gary Snyder is pastoral. Alan Sonfist's *Time Landscape* (1978), for instance, is the re-creation, on one square block at the corner of La Guardia Place and Houston Street in New York City, of a pre-Colonial forest. He is trying to re-create the very origins of the site, return us to what amounts to "a state of nature." The works I deal with here are less nostalgic. They certainly reject the coherencies of the "picturesque." As Elizabeth C. Baker has put it in an essay on Smithson, De Maria, and Michael Heizer, their works, rather, "have an ambiguous relationship with the land they occupy . . . they are not involved with 'landscape' in any pictorial sense . . . [they have] very little to do with the specifics of 'view.' " See Elizabeth C. Baker, "Artworks in the Land," *Art in America* 64 (January–February 1976): 93.

14. *The Writings of Robert Smithson*, 172. Subsequent citations to Smithson's writings will occur in the text. My discussion of Smithson owes much to Marjorie Perloff, who has dealt with much of the same material I confront here in the last chapter of her book, *The Futurist Moment: Avant-Garde, Avant Guerre, and the Language of Rupture* (Chicago: University of Chicago Press, 1986).

15. For a discussion of Burke, see Smithson's essay "Frederick Law Olmstead and the Dialectical Landscape," ibid., especially 118–19.

16. Lyotard, "The Sublime and the Avant-Garde," 37, 40.

17. Ibid., 40.

18. Lucy Lippard, *557,087*, catalogue to an exhibition organized for the Contemporary Art Council of the Seattle Art Museum, September 5–October 5, 1969 (Seattle: Contemporary Art Council, 1969). This "catalogue" is actually composed of a small manila envelope containing ninety-five 4 x 6 index cards in random order, including sixty-four cards contributed by sixty-four different artists, including Smithson, twenty text cards by Lippard, a title card, a bibliography, and so forth, all designed to be reordered, rearranged and variously shuffled by a "catalogue"-reading exhibition audience of potentially 557,087 people (the population of Seattle in 1969), to make 557,087 different "works," or art experiences, out of the exhibition/catalogue itself.

19. In *The Writings of Robert Smithson*, "Incidents of Mirror Travel" is mistakenly dated September 1968.

20. Lawrence Alloway, "Robert Smithson's Development," in *Art in the Land: A Critical Anthology of Environmental Art*, ed. Alan Sonfist (New York: Dutton, 1983), 130.

21. For a catalogue of this documentary material see *Christo: Editions 1964–82*, ed. Jörg Schellmann (Munich: Verlag Schellmann & Klüser, 1982).

22. Rosenberg, "Time and Space Concepts in Environmental Art," in *Art in the Land*, 203–5, 208.

23. Ibid., 206.

24. Ibid., 197–98.

25. Klaus Kertess, "Earth Angles," *Artforum* 24 (February 1986): 77.

26. Kertess, "Earth Angles," 79.

27. Stanley Cavell, *The World Viewed* (New York: Viking, 1971), 24.

28. Alloway, "Smithson's Development," 139. Smithson's documentary essay on the *Jetty* was first published in Gyorgy Kepes's *Arts of the Environment* (New York: Braziller, 1972).

29. Alloway, ibid.

30. André Malraux, *Museum without Walls*, trans. Stuart Gilbert and Francis Price (London: Secker and Warburg, 1967), 11.

31. Robert Morris, "The Present Tense of Space," *Art in America* 66 (January–February 1978): 70. Subsequent citations to this essay will appear in the text.

32. Roland Barthes, "Rhetoric of the Image," *The Responsibility of Forms*, 33.

33. Ibid., 34.

CHAPTER SEVEN

1. Roland Barthes, *Camera Lucida*, 20.

2. Susan Sontag, *Styles of Radical Will* (New York: Farrar, Straus and Giroux, 1969), 15, 20.

3. Ibid., 271.

4. Richard Poirier, *The Performing Self: Compositions and Decompositions in the Languages of Contemporary Life* (New York: Oxford University Press, 1971), 27.

5. Ibid, xv.

6. Ibid., 30.

7. George Steiner, *Extraterritorial: Papers on Literature & the Language of Revolution* (New York: Atheneum, 1971), viii.

8. Ibid., 95–96.

9. Roland Barthes, *Mythologies*, trans. Annette Lavers (New York: Hill and Wang, 1972), 143.

10. Susan Sontag, *Styles of Radical Will*, 13.

11. Roland Barthes, *Camera Lucida*, 38.

12. Susan Sontag, *Against Interpretation and Other Essays* (New York: Farrar, Straus and Giroux, 1966), 14.

13. Robert Pincus-Witten, *Postminimalism* (New York: Out of London Press, 1977), 128.

14. Ibid., 137.

15. Quoted in William Seitz, *The Art of Assemblage* (New York: Museum of Modern Art, 1961), 73.

16. Pincus-Witten, *Postminimalism*, 137.

17. Lucy Lippard, *From the Center*, 2.

18. Quotations from the following works by Roland Barthes are cited in the text using the following abbreviations:

CE: *Critical Essays*, trans. Richard Howard (Evanston, Ill.: Northwestern University Press, 1972)

CL: *Camera Lucida: Reflections on Photography*, trans. Richard Howard (New York: Hill and Wang, 1981)

GV: *The Grain of the Voice: Interviews 1968–1980*, trans. Linda Coverdale (New York: Hill and Wang, 1975)

PT: *The Pleasure of the Text*, trans. Richard Miller (New York: Hill and Wang, 1985)

RB: *Roland Barthes by Roland Barthes*, trans. Richard Howard (New York: Hill and Wang, 1977)

RF: *The Responsibility of Forms: Critical Essays on Music, Art, and Representation*, trans. Richard Howard (New York: Hill and Wang, 1985)

19. Roland Barthes, "Réponses," *Tel Quel* 47 (1971): 92. The translation is Steven Ungar's, from his book *Roland Barthes: The Professor of Desire* (Lincoln: University of Nebraska Press, 1983), 7.

20. Ungar, *The Professor of Desire*, 47, 43.

21. The landscape tradition in American photography, from Clarence Watkins to Ansel Adams, is particularly susceptible to this analysis. Nowhere are the utopian aspirations of the photographic image more consistently realized, and nowhere have the connotative levels of the sign been more successfully repressed.

22. Ungar, *The Professor of Desire*, 65.

23. Ibid.

EPILOGUE

1. David Byrne, *True Stories* (New York: Penguin Books, 1986), 24–26, hereafter cited in the text. All quotations from the film follow this published script, although the dialogue in the film itself varies in minor ways.

2. Bill Wyman, "Byrne's Town," *Film Comment* 22 (September–October 1986): 63.

3. Carter Ratcliff, "David Byrne and the Modern Self: 'How Do I Work This?'" *Artforum* 23 (May 1985): 97.

4. The two books Byrne refers to are probably both by Sally Eauclair, *The New Color Photography* (New York: Abbeville, 1981) and *New Color/New Work* (New York: Abbeville, 1984).

5. *William Eggleston's Guide*, essay by John Szarkowski (New York: Museum of Modern Art, 1976), 10.

INDEX

(Page references in italics refer to illustrations.)